DOLPHINS

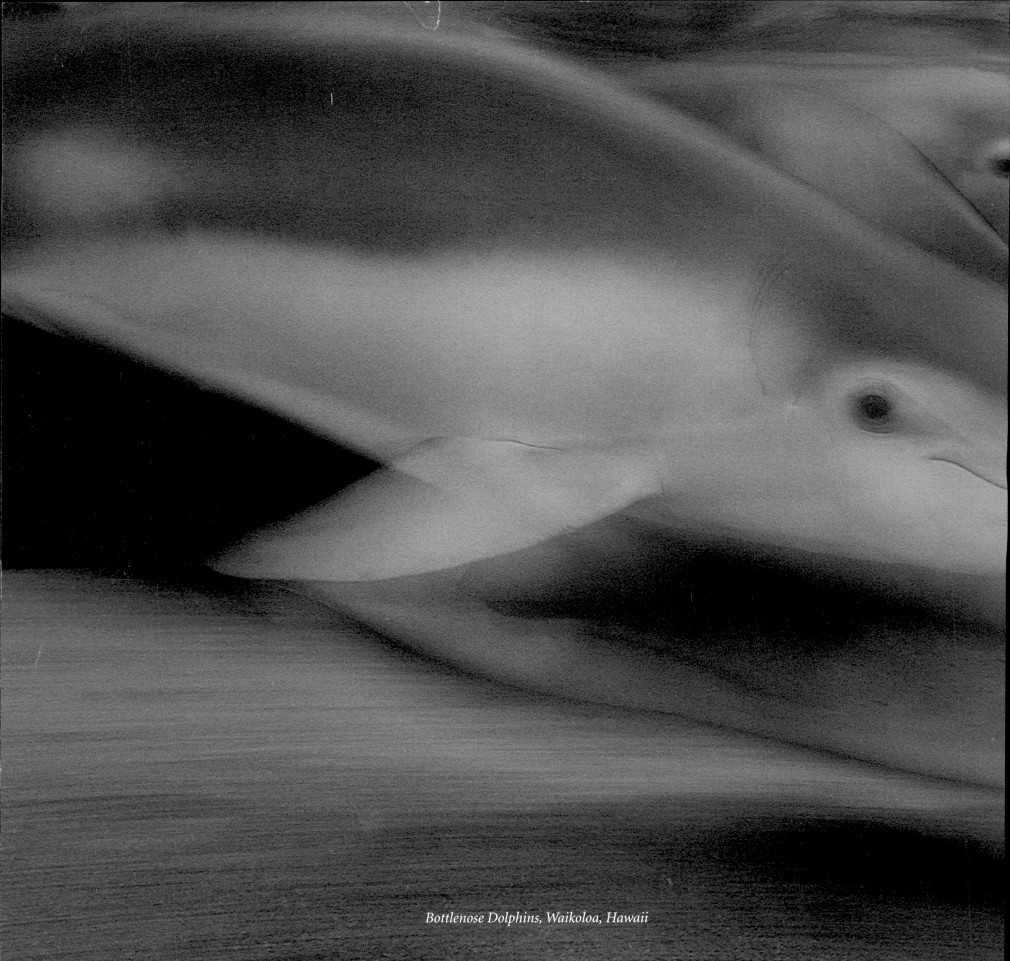

Bottlenose Dolphins, Waikoloa, Hawaii

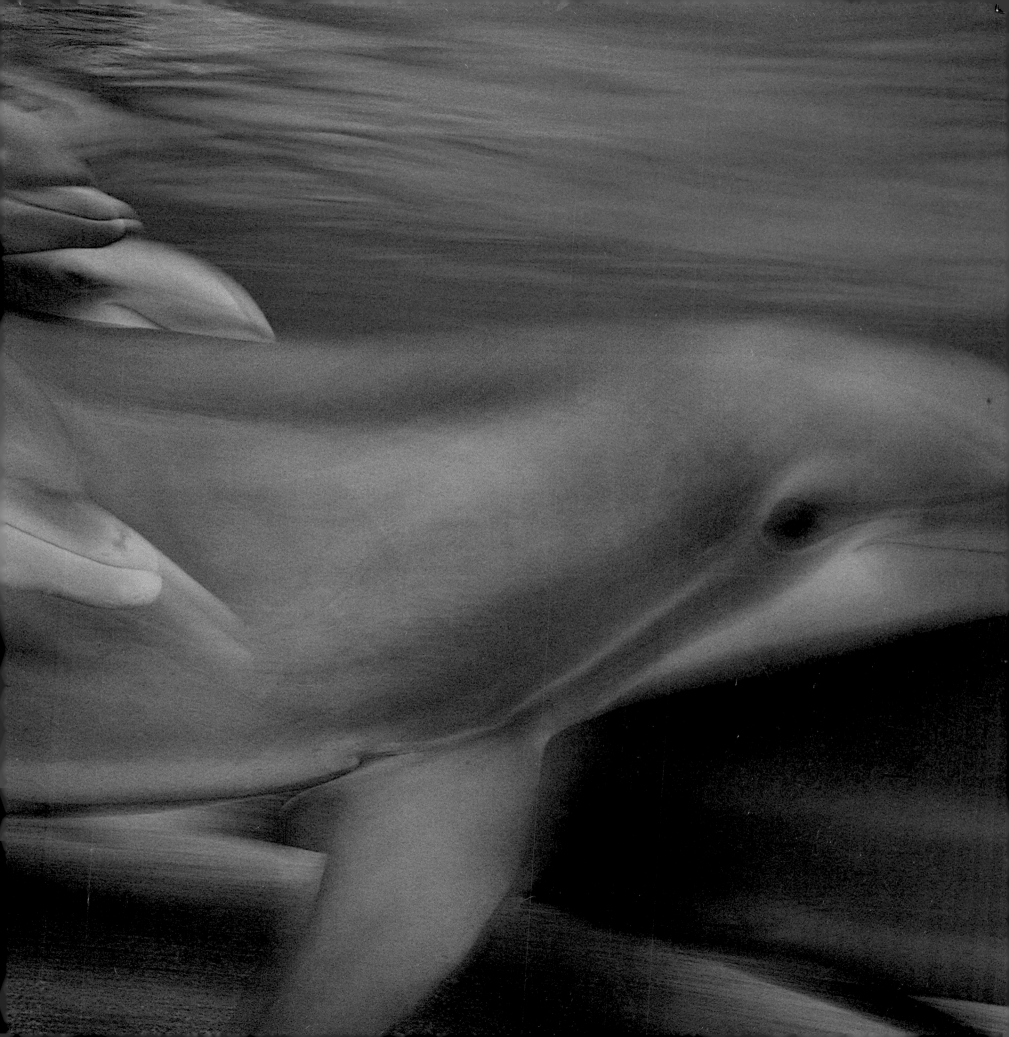

"Sometimes I dream I'm swimming along, alone,
when I hear dolphins near me,
and I understand what they're saying to each other.
I can understand their language. It's farfetched, I know…
What can I say? That's my dream."
—KATHLEEN DUDZINSKI

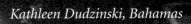
Kathleen Dudzinski, Bahamas

Common Dolphin, Southern California

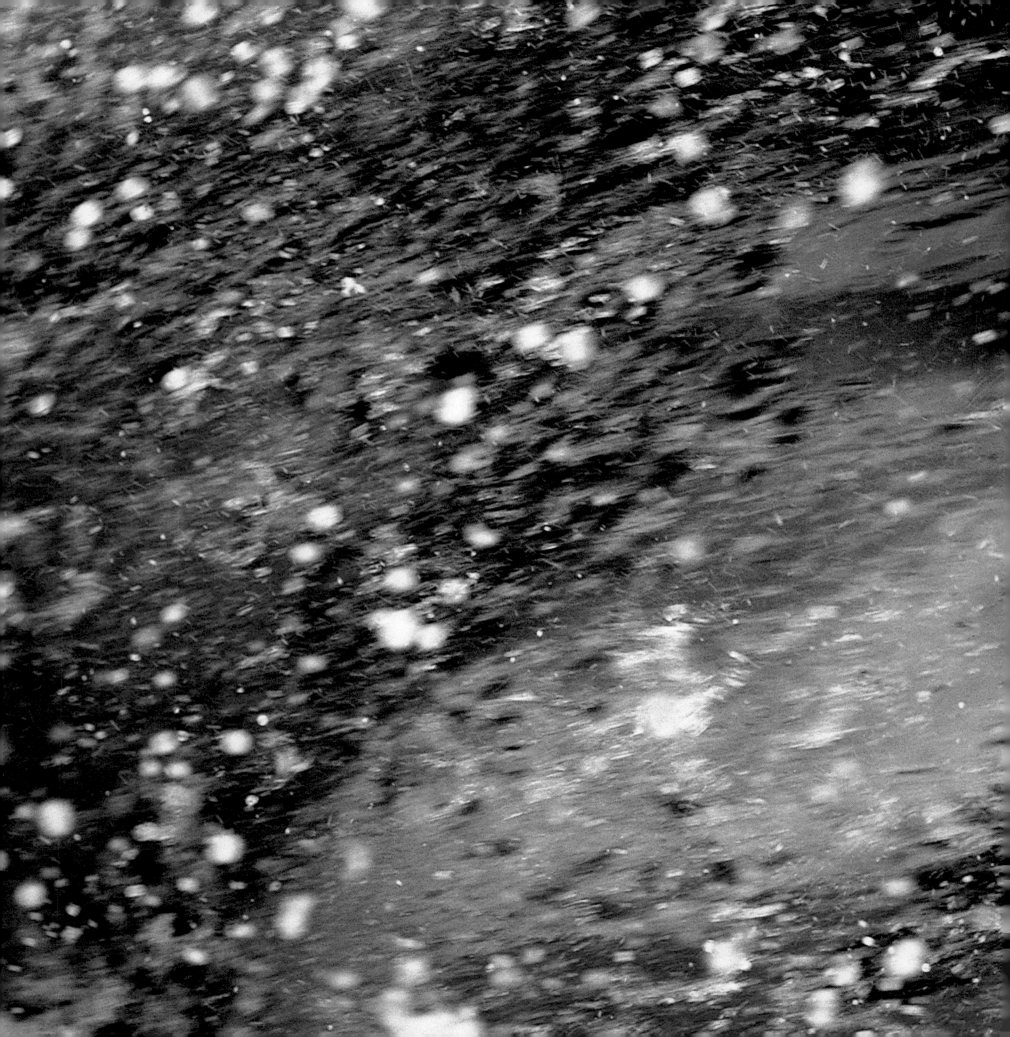

Atlantic Spotted Dolphin, Bahamas

Pantropical Spotted Dolphins, Kona, Hawaii

Bottlenose Dolphin, Caribbean

DOLPHINS

TIM CAHILL

NATIONAL
GEOGRAPHIC
WASHINGTON, D. C.

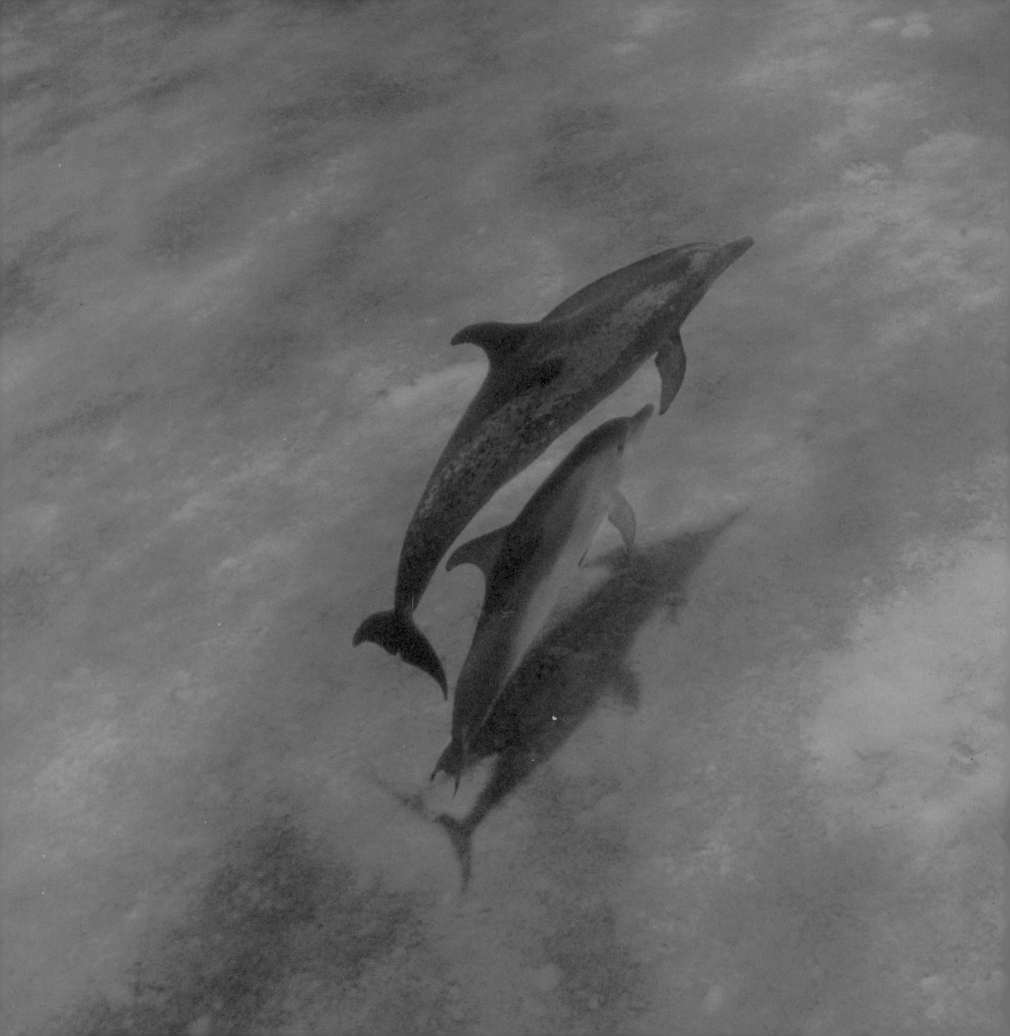

CONTENTS

Atlantic Spotted Dolphins, Little Bahama Bank

SCIENCE OF THE HEART

There is a moment in this book when Tim Cahill, in the role of amateur scientist Everyman, finds himself standing at the rail of a scientific research vessel trying to count dolphins. When the dolphins appear, he is so overcome by their grace and power that he loses count. The researcher appears and asks how many Cahill saw. He hedges, qualifies, inserts caveat after caveat, admitting finally that he is a nincompoop of little use to science. We smile at his humanity and sense that his enthusiasm is not as misplaced as he seems to think. ❡ It's vintage Tim Cahill. Readers who know and love his humorous travel pieces and books will recognize him immediately. Embracing the role of the novice with self-deprecating gusto, he infects us with the joy of discovery. Where some observers are detached, Cahill is involved. The objective point of view flies out the window as he—literally— dives into his material to give us the info from the inside out. It's messy, it's honest, it's fun. ❡ And it's important. Cahill not only spins a witty and engaging narrative but also gives us an accurate picture of science in the field—how data are collected— and mingles this with a deceptively breezy survey of hard research. This is not lightweight stuff, but it goes down easily. ❡ We also learn about the nuts and bolts of documentary filmmaking, and how it can work hand-in-hand with science to broaden people's understanding of the world they inhabit. In the end, what we get is a picture of a very diverse and fascinating community—not only that of dolphins but also that of the humans who care about them. ❡ As nonchalant as he may appear, Cahill is no mere passenger on a whalewatching excursion. He is an explorer on a quest for the soul of Cetacea. ❡ His journey takes us around the world from Argentina to the Bahamas, and from Japan to the Turks and Caicos Islands. But his intellectual inquiry reaches far beyond even this to encompass the entire world of dolphins and whales—the belugas of the St. Lawrence River, the baiji of China's Yangtze, the dusky dolphins of New Zealand, and the boto of the Amazon and its tributaries. ❡ Along the way, he debunks many commonplace fallacies and illuminates even more enduring truths. His guides on this quest are a group of devoted marine scientists, and it is perhaps inevitable that we learn as much about them and the nature of their work as we do about the dolphins they study. ❡ He follows the lineages of scientific inquiry as one might the genealogy of a distinguished family. Research that inspires and spawns other research. People whose passion and commitment influence the hearts and minds of the next generation. Questions that lead to answers. Answers that create new questions. ❡ What drives these people? Curiosity and the urge to learn, surely. But Cahill uncovers something more profound:

an unflagging determination to protect dolphins. ❡ *The fate of the world's dolphins, as Cahill concludes after a survey of threats to their survival, is largely in human hands. Fifty million years after they entered the sea, cetaceans find themselves dependent upon a bunch of primates who have proved they can lay waste to rain forests as easily as they can compose symphonies.* ❡ *Not very encouraging, some might say. But humans have the capacity to learn and to put that knowledge to work. The scientists whom Cahill finds hard at work with dolphins do not wear the conservation ethic on their sleeves. They are—perhaps a little too willfully—not "whale huggers." But their idealism shows through in their integrity. Whereas the press may reduce dolphins and whales to "issues," Cahill's scientists see them as complex living beings whose actions do not always fit the political bill.* ❡ *Cahill also transmits these scientists sense of purpose. In an age of get-rich-quick schemes, there is something heroic in their decision to devote their lives to the humble search for truth—and these men and women are racing against the clock of extinction.* ❡ *In the oceans and rain forests, we are losing many species before we get a chance to understand their roles in those ecosystems. It's a little like removing the rivets of a 747, one by one, in random fashion. We know that at some point, the plane will no longer be able to fly, but we don't know what that point is, or which rivet will mean the point of no return.* ❡ *These scientists realize that human hegemony on Earth is not just a privilege. It is also a responsibility of epic dimensions, and it is crucial that we develop the informational and ethical tools to live up to it. Education is the key to conservation, Cahill observes, because the better we know a species, the more responsive we can be to its needs for food and habitat. And thus, the better we can protect it.* ❡ *Conservation today is a bureaucratic process that too often depends upon public funding and political will. Without the means to protect a beloved animal, all the science in the world is useless.* ❡ *This is where media come in. It was my father, Jacques-Yves Cousteau, who once remarked to me: "People protect what they love." And to love something, you have to get to know it. Film, books, and television can heighten the profile of animal species and wider environmental issues. Most people will never travel to the Bahamas or Patagonia, but through the miracle of large-format IMAX filmmaking and the artistry of filmmakers like Greg MacGillivray, they can experience a bit of the rapture of swimming with dolphins in the wild.* ❡ *In the end, Cahill's unabashed wonder at the sight of free-swimming dolphins isn't the antithesis of science. It's the key. Ultimately it is love that inspires us to study, celebrate, and protect the creatures of our water planet.*

—JEAN-MICHEL COUSTEAU

Dancing with Dolphins

Kathleen Dudzinski uses a motorized scooter to study how dolphins use subtle posture shifts and gestures when swimming as a group. She finds that even a subtle movement of one individual's rostrum to the left or right is enough to direct the group in that direction.

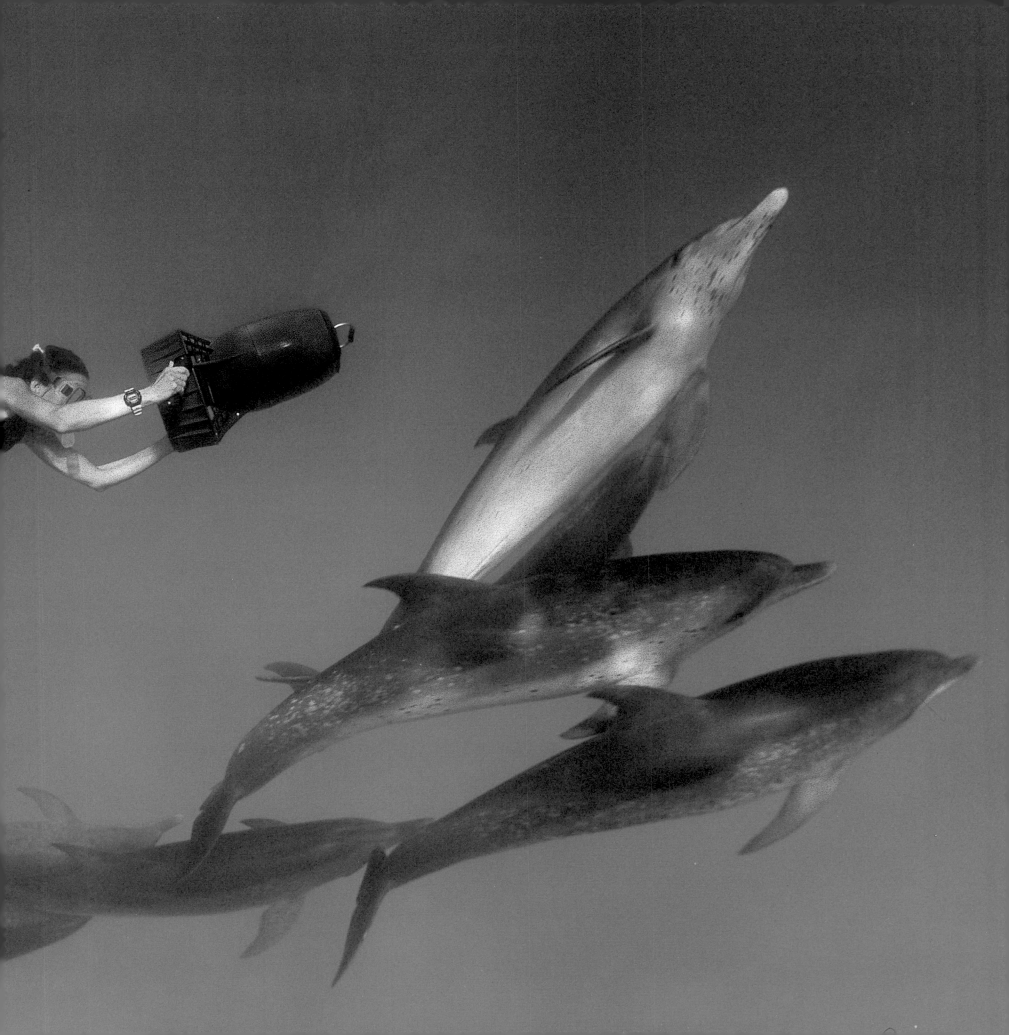

I had never been in the water with wild, free-swimming dolphins before. There were half a dozen of them, and they came out of the blue-gray distance, moving straight and fast, sweeping by me like so many jet fighters. *Flash. Zoom.* One of the dolphins peeled off from the group in a wide gliding U-turn. It might have weighed in excess of a thousand pounds. The big dolphin slid slowly past me, moving at a less threatening oblique angle. Then it dove languidly, as if inviting me along to some merry subaquatic frolic. But I was too slow, and a little too buoyant in the water. In the time it took me to descend 10 feet, the dolphin had dissolved into the unseen depths below. I needed to breathe but wasn't desperate yet, and let my slight positive buoyancy pull me to the surface. Suddenly the dolphin abruptly appeared from below. It rose with me, and we danced pas de deux, belly to belly, in the water. There was another dolphin to my left now, and still another approaching from the right. I felt slow and awkward and entirely out of my element, rather the way I might have felt had I been thrust on stage during a performance of *Swan Lake* and asked to mimic the movements of the prima ballerina.

A tight-knit group of adult spotted dolphins moves toward the photographer. During low-level socializing and daytime rest, dolphins are close together and often touching. Contact, such as a flipper against the side of another dolphin, could express short-term association such as "acting as a team."

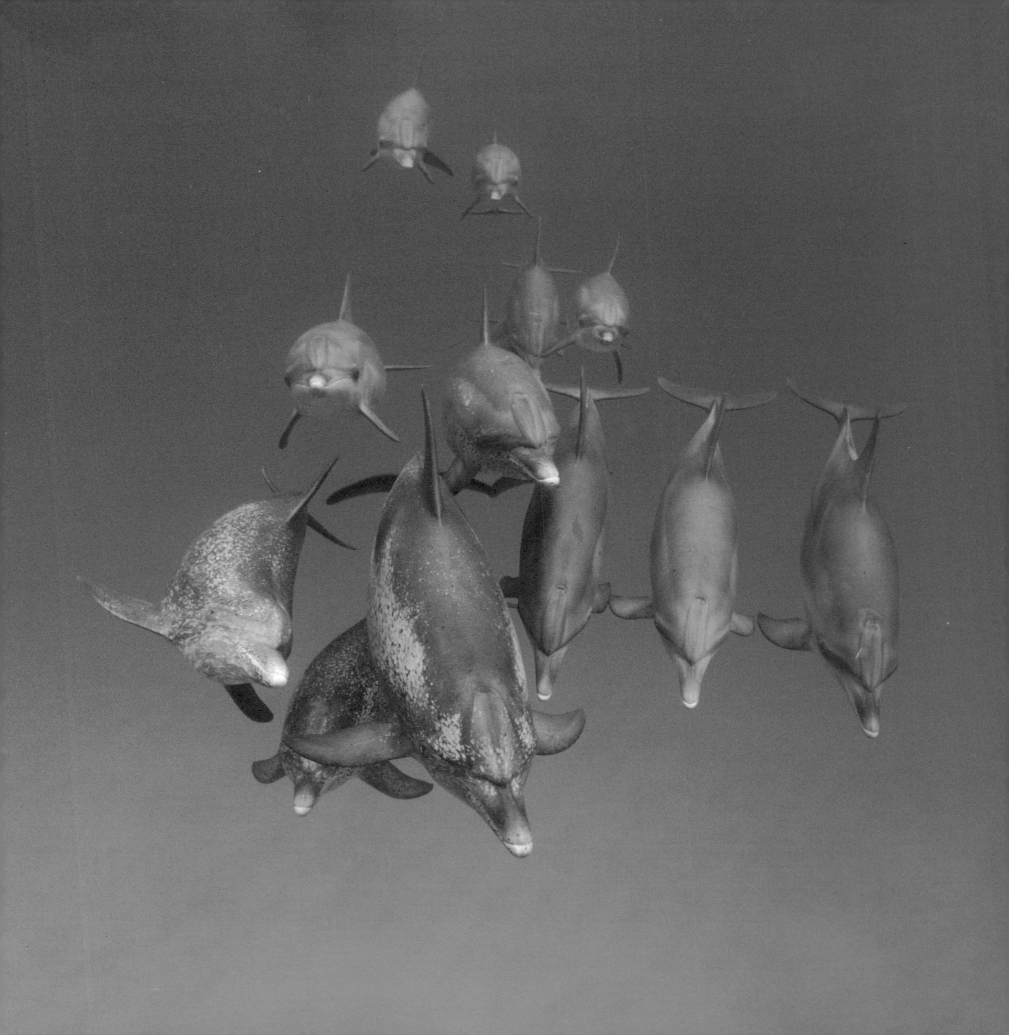

I calculated that I had enough air left to perform a quick acrobatic pirouette and swept over backward as the dolphin swam by my side. Its penetrating round, dark eye regarded me with what I imagined was a kind of gentle pity. I thought: If I can't follow these dolphins, well, they just might follow me. *Yes!* I was too slow and bungling to keep up. What I'd have to do was *lead* the dance.

I curved out to my left, running critically short on air but absurdly anxious to prolong the encounter because the dolphins were now following me in what seemed to be an attitude of amused tolerance. Animals on either side moved at precisely my own speed, and another whirled around my body as if it was a ball on a string and I the tether. This maneuver seemed to cost it almost no effort at all. We reached the surface en masse, and the dolphins rolled over the roiling sea. As I emerged, the waves washed over my snorkel, and I gulped down what felt like half a pint of seawater.

The dolphins circled slowly below, waiting, it seemed, for me to stop coughing and spitting. I could do another big loop, maybe two, and they'd follow. I knew that as surely as I had ever known anything in my life. This knowledge caught in my throat like a great blade of sorrow—and it came out as a brief snort through my snorkel. And then there I was, laughing aloud, helplessly, somewhere out in the middle of the ocean.

My guide on this adventure was Kathleen Dudzinski, a young Ph.D. marine scientist and my advisor on matters of dolphin etiquette. She pointed off into the murky distance. And there they came again, more dolphins swimming directly toward us. Most of the animals in this group were moving their heads from side to side. I thought I could hear the sounds they made: the squeaking of a rusty hinge, a whistle, a squawk. I knew they were scanning me, echolocating: bouncing the sounds they made off my body and reading the echo in very much the same way submarines use sonar.

Looking long and slender and as streamlined as any cetacean, Kathleen swiftly dived straight down about 15 feet.

Kathleen's research boat and skiff at peaceful anchor inside one of the coral reefs that fringe much of the Bahamas. Spotted dolphins do not often come this close to shore, but it is a superb place to snorkel and enjoy the abundant tropical life associated with these reefs.

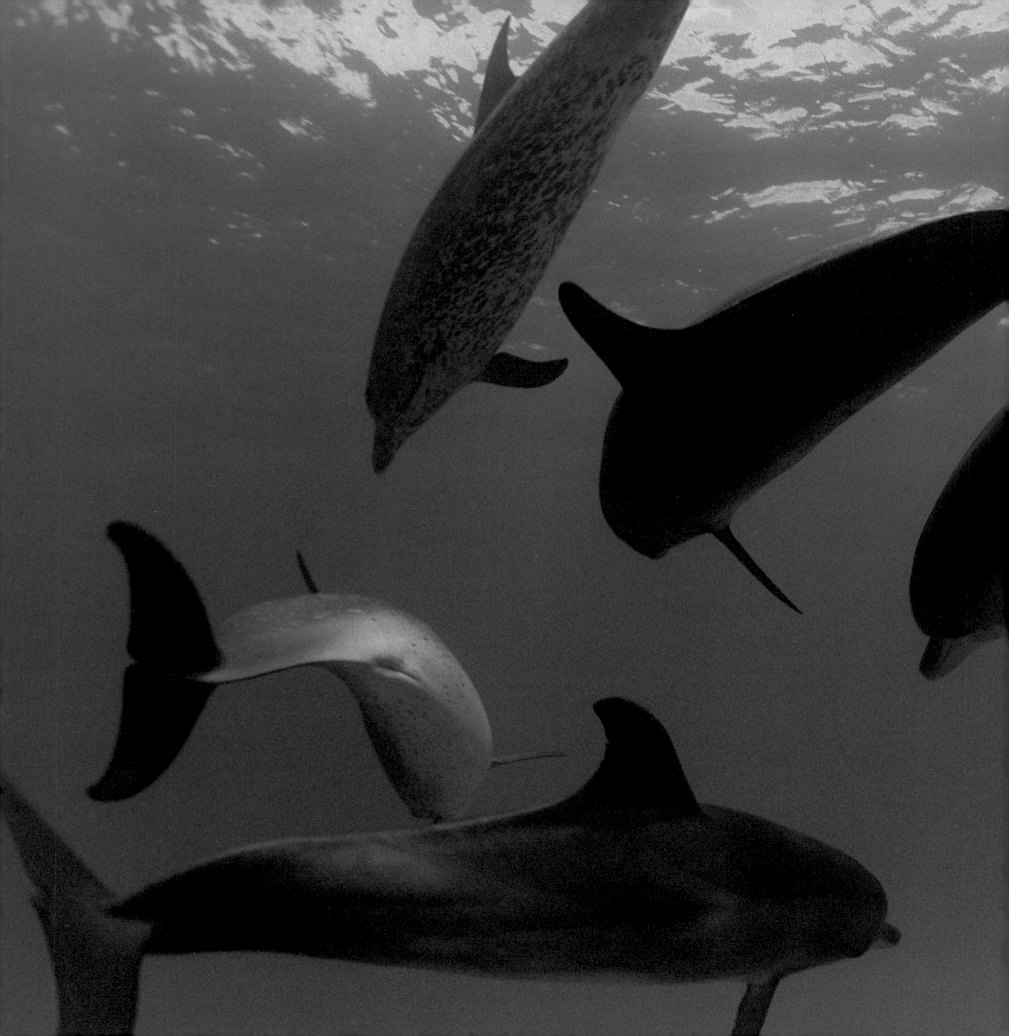

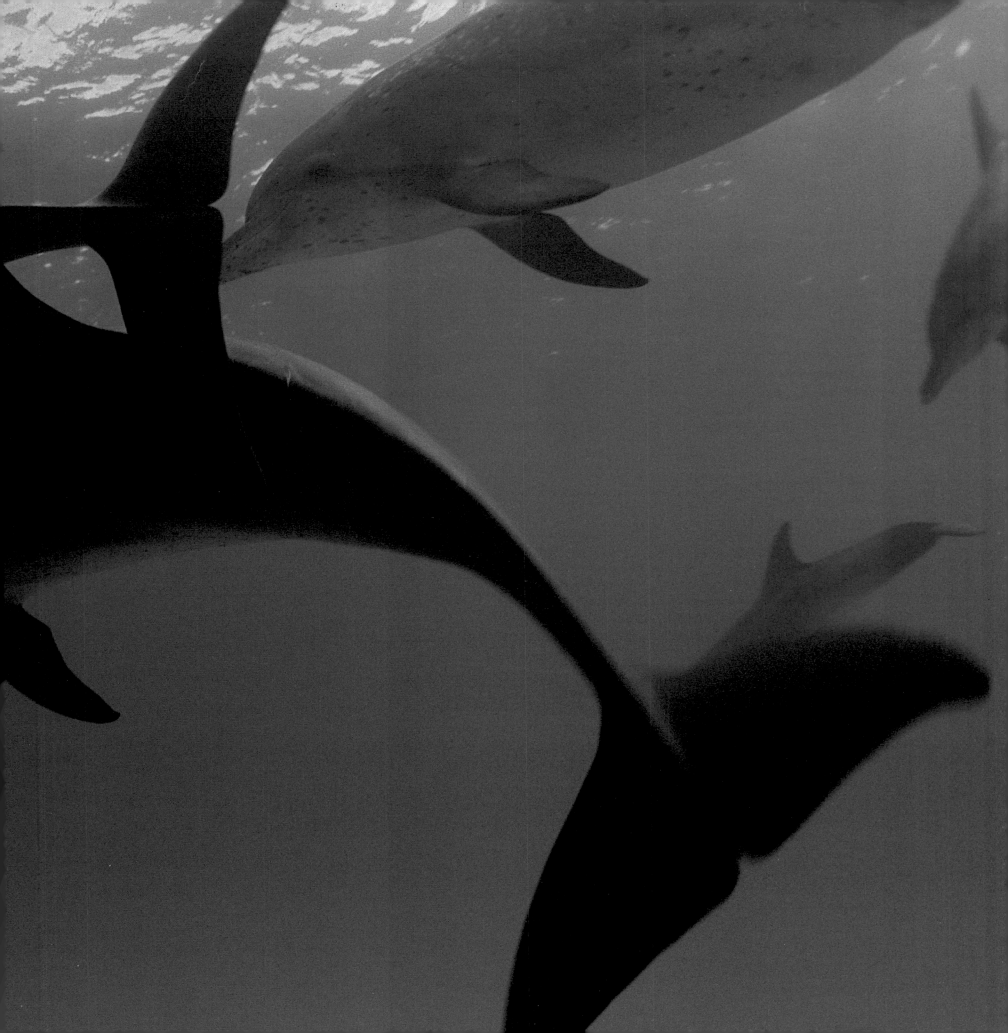

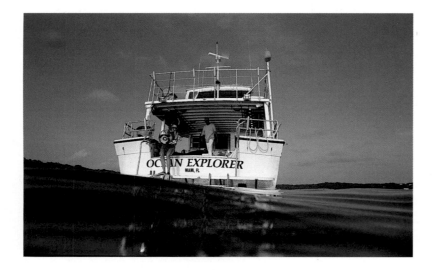

From the vessel's stern(above) Kathleen prepares to enter the water (facing page)with her mobile video-acoustic array. She gauges the "mood" of the dolphins before her assistants follow her into the water. (Preceding pages) Views such as this allow Kathleen to determine the identity, relative age, and gender of nearly each spotted dolphin in a study group.

The dolphins, more than a dozen now, seemed to understand the dive as an invitation. They swarmed about her, swimming in slow sinuous curves.

Kathleen went directly to work. She muscled her big video/audio recorder about, following one dolphin—her focal animal—as it looped over backward, swimming slowly in a vertical circle that was at least 20 feet in diameter. The two of them swam together, human and dolphin, belly to belly, only inches apart. Kathleen tried to get some distance on the animal, but it wanted to dance slow and close. They surfaced together, both of them taking a breath—Kathleen through her snorkel, the dolphin from its top-mounted blowhole. I could hear the sound of Kathleen drawing a ragged breath into her lungs through her snorkel and the slight pop of the dolphin's blowhole opening and closing. Hey, I thought, we're *all* mammals and air breathers here.

Kathleen dived, looping over in a great gliding back flip as the dolphins spun about. Some approached her in slow glancing angles. Others swam together, touching or vocalizing, and Kathleen recorded the sounds they made and their behavior, because that was the nature of her work. For her, it was just another day on the job.

Later, she'd study her tapes and try to correlate the dolphins' vocalizations with their behavior. My own first impressions had to do with body language and dance. The dolphins seemed to me to be playful, curious, and—quite unlike the first reconnaissance runs—not at all threatening. I could read in their swirling grace some few half-formed ideas that had been drifting weightless through the shadowy sea of my own mind. Dolphins—intelligent, social animals who suckle their young, vocalize, and seem inordinately fond of sex (especially after a good meal)—are the creatures humans might have been had we somehow opted to live in the sea. Swimming with these dolphins was a revelation. It was like looking into some strange shimmering mirror positioned right there at the entrance to the Funhouse of Geological Time.

The poet-scientist Loren Eiseley, reflecting on this idea of our parallel evolutionary paths, wrote that "had man sacrificed his hands for flukes, he would not have the devastating power to wreak his thought upon the body of the world." Instead, he would have lived and wandered like a dolphin, "homeless across currents and winds and oceans, intelligent, but forever the lonely and curious observer of unknown wreckage falling through the blue light of eternity." Eiseley considered it a wistful thought that someday the dolphin may "talk to us and we to him. It would break, perhaps, the long loneliness that has made man a frequent terror and abomination even to himself."

This long loneliness is the reason we aim radio telescopes at the stars searching for evidence of life on other planets; it is why we find the idea of teaching a gorilla sign language engaging, and why Jane Goodall's work with chimps moves us. It is why so many of us feel passionate about communicating with dolphins. There is a certain urgency, perhaps a perceived obligation to communicate with nonhuman but self-aware life forms. It seems that the need increases according to the frequency of our private terrors: the alienation of humans from their own animal nature and from others of their species. I think this is the motive and purpose behind the work of Kathleen Dudzinski.

She would never put it that way, though, and perhaps doesn't believe it is so. As a scientist, she studies the manner in which dolphins communicate with each other. A lot of research has been done with captive dolphins, but Kathleen's dream, her passion (not-so-scientific reasons very often inspire and compel

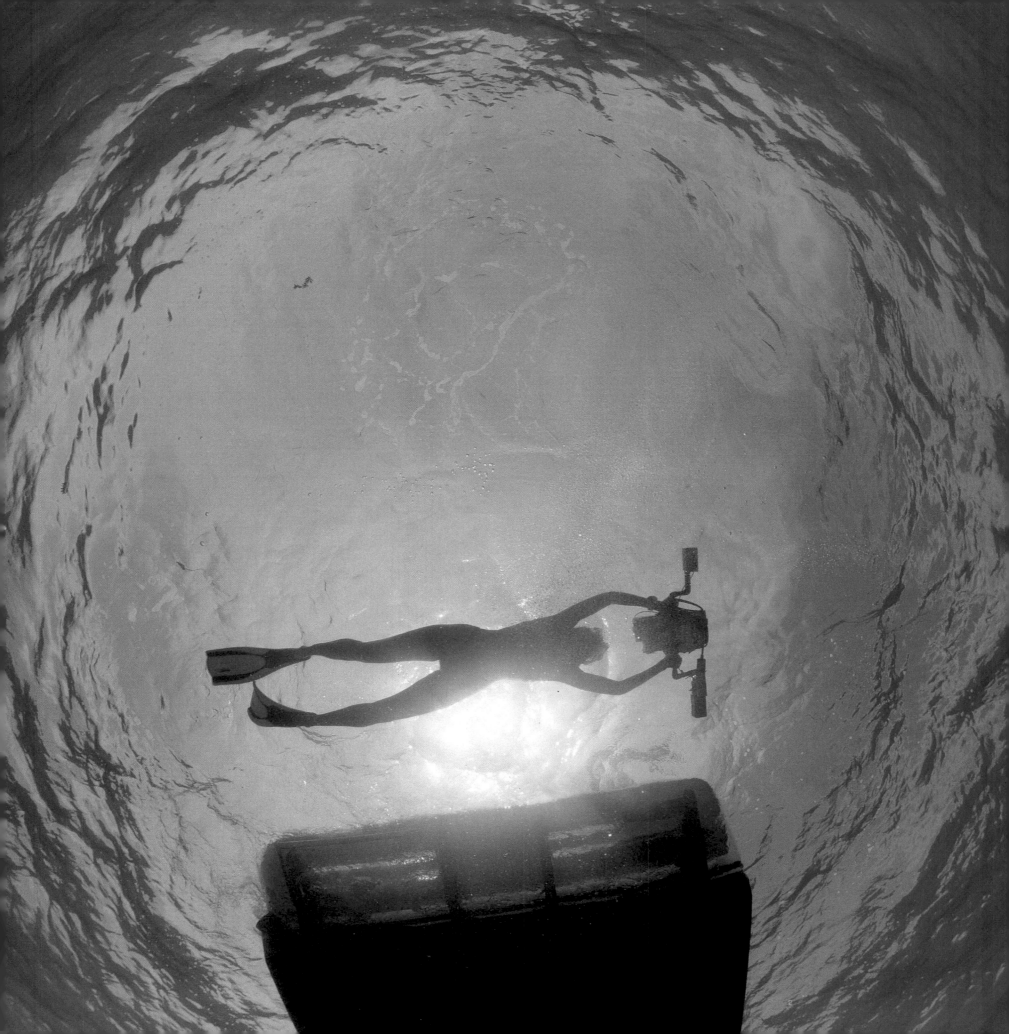

DOMAINS OF THE DOLPHINS

BERND WÜRSIG, PH.D.—*Professor of Marine Mammalogy and Director of the Marine Mammal Research Program, Texas A&M University*

Something brushed my leg, then it was gone. Another brush, more of an insistent push, on my thigh. I was on a leisurely swim in a tributary of the upper Amazon, in the Samiria River, and I could guess but not see through the dark-tea waters laden with the tannic acid of decomposing leaves that floating beside me was a playful Amazon River dolphin, a boto.

Then I saw, maybe 15 meters away, its head in-air, coming up for a breath—*chuff!*—a very long upturned rostrum, or beak, and a dark yet speckled back with bright pink along the dorsal ridge. Then it was out of sight, heading upriver.

Such encounters are common for the local children who splash and play beside their stilt huts along the mighty river, but they are very uncommon for middle-aged dolphin researchers who are used to working with spotted dolphins in the crystal clear waters of the Grand Banks of the Bahamas, or with dusky dolphins in the green plankton-rich deep waters of the Kaikoura Canyon, New Zealand.

I returned to the shore, and as I watched three boto chasing schools of fish onto a mud bank several yards upriver, I reflected on the diversity of ecological settings that dolphins inhabit. There are 45 species of dolphins and porpoises found throughout Earth—and it is amazing to realize that dolphins not only inhabit different environments, but they have developed specific behaviors, lifestyles of social organization and reproduction, and morphologies that are attuned to their special domains.

The small-group boto of fresh water is literally a relic from a former era—18 million years ago —when all dolphins had long jaws to snap at and trap prey. Boto are chunky, relatively slow dolphins with only a low dorsal hump, a body morphology that may help them to glide effort-lessly through waterways choked with vegetation, and through and underneath the roots and branches of flooded forests during high water. Boto, rather singularly gray-colored or mottled pink, have no need for acquired gradations or variations of pigmentation to camouflage and protect them in deeper waters. They occupy only the shallow riverine waters in the Amazon. Such countershading would be quite useless in the murky waters anyway. Boto seem to have no natural predators, save perhaps the occasional caiman, an up to 6-meters-long relative of alligators that may now and then prey on river dolphin young.

The sleek spinner, spotted, and striped dolphins that roam across thousands of kilometers of open predator-filled seas and oceans differ dramatically from riverine boto dolphins. Dolphins inhabiting the vast oceanic domains are beautifully countershaded to survive all manner of threats within the tropical-sun dappled blue crust of the water's upper 200 meters. These pelagic animals live in a virtual biotic desert, for wherever they roam, the food concentration is low. And perhaps that's why they roam—in groups of as many as 10,000 individuals—much like the herds of their migrating evolutionary land-locked cousins, the caribou, wildebeest, and bison. For the boto, however, group size does not need to be large for protection or because of food concentrations; and highly developed social hunting techniques may also not be needed because much, but not all, feeding is on single fishes and invertebrates.

Yet for ocean-going cetaceans, behaviors such as roaming are required—and may, in fact, protect them from predators. This theory of roaming as a developed protective behavior has also been considered, but remains unproved, for mass migrating plains ungulates in North America, which, it is surmised, roam at least in part to keep their nemesis wolf populations from having them as an easy meal in any one place; and, in the Serengeti, to keep wild dogs and lions and tigers from being even more efficient predators than they already are. False killer whales (pseudorcas) and killer whales (both dolphins) and large sharks feed on little dolphins.

In addition to riverine and deep ocean habitats are the shallow ocean shorelines and shoals that, for example, bottlenose, dusky, and Hector's dolphins frequent. Like riverine dolphins, the lifestyles and morphologies of coastal dolphins are attuned to this domain as well. Shallow coastal regions provide protection from the dangers of the open sea; but while coastal dolphins will rest and socialize where a sandy or pebbly bottom is visible immediately below— and sharks cannot as easily surprise them—they may feed in deeper oceanic waters. They tend toward being less chunky than the river dolphins, but are not as sleek as the oceanic ones. Some blend beautifully into their environments. The gray-bodied bottlenose is a good example; while others, such as the diminutive Hector's dolphin found in New Zealand, have alternating white and black markings on their bodies that belie their true shapes in the gloom, and thereby confuse both predators and prey. Their group sizes and social affiliations also change with habitat: Hawaiian spinner dolphins, for example, aggregate and go out to sea to feed (often at night) in groups of hundreds, but split apart into subgroups of only dozens in order to fit comfortably into shallow bays and shoals to rest. Dolphins that stay close to shore at all times, such as the little Hector's, maintain smaller groups of a few to the low dozens. ∎

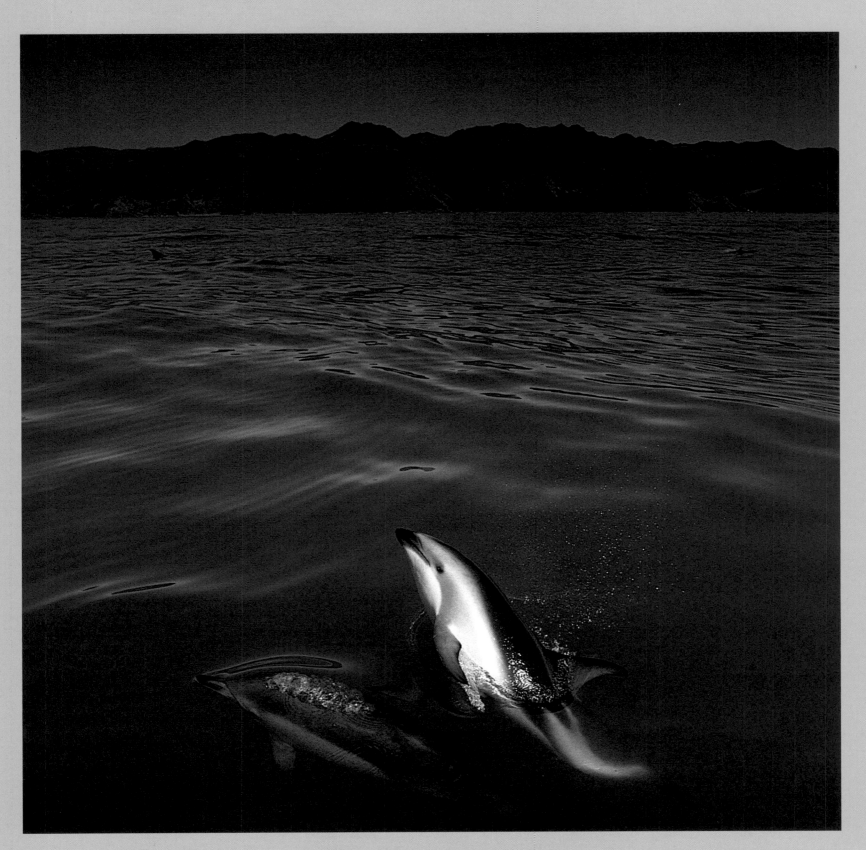

New Zealand dusky dolphins inhabit deep oceanic waters that are nevertheless close to shore.

scientists' lifelong careers) is to study the behavior of and the communication among wild, free-swimming dolphins.

Aside from access to wild dolphins, this work requires an office with a desk, a television monitor, and a computer. Dolphin vocalizations are tabulated and compared with coterminous behavior. Numbers are crunched. Statistical analysis is invoked. Results are stated cautiously, as they should be. Kathleen does not speculate on the "intelligence" of dolphins or their degree of self-aware consciousness. Leave that to the philosophers. Or the writers: people who are comfortable saying that Kathleen Dudzinski's work may one day help define the soul of the dolphin.

DOLPHINS ARE AQUATIC MAMMALS THAT ARE classified scientifically as a type of whale, or cetacean; and there are two sub-classifications to differentiate the whale types—determined, surprisingly, by their anatomically distinct eating capabilities. Cetaceans that filter massive amounts of food—small oceanic organisms like krill—through a comblike sieve in the mouth are called baleen whales; the other class of whale, toothed whales, usually grabs the prey with teeth, although some only have vestigial or unerupted teeth and use a suction action of the mouth to pull in prey. All dolphins—and their mistaken twin, the porpoise—are a type of toothed whale, most familiarly identified by their common names such as bottlenose dolphin, spinner dolphin, dusky dolphin, and Atlantic spotted dolphin.

Over time and as a result of emerging research findings on genetic differences among these animals, new species can be added or names changed, so there is some argument among cetologists (like Kathleen and all other scientists who study cetaceans) when it comes to the number of dolphin species that exist. For now we can say that there are about 70 kinds of toothed whales, of which there are at least 45 species of dolphins and porpoises. To continue this riddle of sorts, some of the species of dolphins are known as *true* dolphins but—adding to the confusion—are called "whales": the killer whale, also known as the orca; the pseudorca, or false killer whale, the pygmy killer whale, short-finned pilot whale, long-finned pilot whale, and melon-headed whale. *All* are dolphins.

Now, if these labels leave you confused, and the riddle, like most riddles leaves you feeling baffled, it is because science is not as set in stone as we sometimes believe. Perhaps it's more like set in water—changing, merging, transforming. Keeping the thinking fresh and new ideas flowing is essential. So science can be a fractious endeavor, with scientists inclined to quarrel just enough to get as close to the truth as possible.

A Ph.D. candidate, for instance, is instructed to contrive a project calculated to create surety out of what appears to be chaos. In, say, the cacophony of sounds produced by a school of swirling dolphins, can we state with any assurance that a squawk means something substantially different than a squeal? The student scientist observes and quantifies; she presents her proofs and conclusions to a committee of professors, often the best minds in the business. It is their job to evaluate the data-gathering methods (and, at times, methodology); attempt to ascertain whether the results have been fairly obtained and analyzed; and evaluate whether the conclusions or hypotheses are warranted by the results. It is supposed that, if a Ph.D. candidate can successfully defend her dissertation, one more true thing has emerged out of the swirling chaos, and this intelligence is another brick that can be added to the edifice of science. The process is better known as the academic exercise of disputation: a logical defense of one's theses and ideas.

So if scientists disagree with one another, it is because they are trained to do so. Papers presented for publication in scientific journals are "peer reviewed," which is to say that other scientists debate or assess the value of the research presented. Perhaps for this reason, scientific papers are, on the whole, among the least evocative documents ever produced by intelligent mammals… such as in, "Concurrent use of vocal and tactile behaviors is exemplified by the socially aggressive encounters witnessed…. Multi-looped whistles and chirps were recorded with bouts of affiliative contact alternating…."

It is only after a long and distinguished career of producing one solid brick of knowledge after another that a scientist of any stripe is allowed to stand back and examine the dimensions of the edifice as a whole.

Kathleen, who earned her Ph.D. in 1996, is in the early, brick-producing stage of her career, and currently favors precision over poetry, at least in describing her own work. She talks about "concurrent vocal and tactile behavior." But sometimes, swimming with the dolphins in the late afternoon, when the light is gone and filming is useless, she feels like a kid living out a dream.

KATHLEEN ALWAYS LOVED ANIMALS, AND IN HIGH school she asked her parents if she could take vocational agriculture courses. Kathleen's father, Pete, didn't quite get it. VoAg? Wasn't that like a trade school for farmers? (The Dudzinskis lived in the Connecticut suburbs.)

But Kathy was thinking about vet school and was already working part-time with a veterinarian who allowed her to sit in on complex surgeries, where most teenage girls would be going, "*Ohhh,* gross!" But not Kathy. In fact this kind of revulsion in others was something she didn't quite understand. One day when the Dudzinskis had a big dinner party, Kathy came running in all excited because she'd just successfully completed her first artificial insemination of a cow. All the guests were sitting over their dinners as they listened to this excited 14-year-old girl rattling on in graphic detail about how she stood on a stool and reached so far inside the vagina that the instructor thought she was going to get lost in there. Her dad thought one of the guests was going to be sick.

But you couldn't tell Kathy to tone it down. She even put together a petting zoo for inner-city kids who'd never seen a cow before—or goats or chickens—all of which could at that time be found in the Dudzinskis' suburban backyard. Eventually Kathy took the little traveling exhibit to inner-city parks, showing the kids something of the natural world.

By 1987 Kathleen had achieved the level of Honors and University Scholar as an undergraduate at the University of Connecticut and was inducted into Phi Beta Kappa. Then in the summer, she went off to the Gulf of Maine to do field research on the behavior and regional distribution of marine mammals— which meant, in effect, that she was the assistant naturalist on a summer-long series of whale-watching cruises. One day a blue whale, the largest animal ever to live on earth, surfaced near her boat. The creature was nearly as long as the 100-foot boat (85 feet at the longest), and its blowhole was a slit of about five feet. Kathleen has never been able to explain it, her feelings that day, because it was like something she had already dreamed. But she'd never actually dreamed of blue whales so it was more like déjà vu, like she'd been there, standing there, watching this huge creature all her life—or if she hadn't, she should have been.

Oh, there was this guy, too. Kathleen was going to get married right after college, but she also wanted to continue her studies. There was a brief emotional tug of war between the little house with the white picket fence and a potential Ph.D. In the end, it wasn't much of a contest. The guy didn't really see the value of further study, and Kathleen called off the wedding a month before the scheduled event because it seemed that she and her would-be husband were already traveling in different directions. The direction Kathleen was traveling in moved her to write Kenneth Norris, the reigning dean of dolphin studies, asking if he could take her on as a Ph.D. candidate. Norris was too busy and nearing retirement, so he suggested the respected scientist Bernd Würsig, a man who was to play a pivotal role in Kathleen's life. She wrote Würsig at Texas A&M and was accepted to the program. Kathleen's interest began to shift from baleen whales to dolphins—and then she became obsessed with researching dolphin-to-dolphin communication.

Kathleen wanted to study *wild* dolphins, though, which presented more than a few obstacles. Such research, for instance, requires boats, which are expensive to rent, and you pay whether dolphins are sighted or not. In addition, it is illegal to swim with dolphins in U.S. territorial waters, and has been ever since the Marine Mammal Protection Act of 1972. There were, however, "swim with the dolphins" tours being conducted in the Bahamas and Japan. The Bahamas was considerably closer to the campus of Texas A&M, so Kathleen spent five six-month seasons studying wild dolphins off Grand Bahama Island. She gathered research material for her Ph.D. dissertation and paid for her boat time by working as a shipboard naturalist. She was responsible for the safety of the paying guests *and* the dolphins.

One of the tourist organizations that Kathleen worked with in the Bahamas was Oceanic Society Expeditions. Passengers, whom the society called "participants," would aid shipboard scientists in collecting valuable data on wild Atlantic spotted dolphins, one of the species that swims over the Little Bahamas Banks in a shallow area about 40 miles from West End, Grand Bahama Island. If you had sailed on one of the society's ships, the *Jennifer Marie,* say, in the early 1990s, Kathleen might have been your scientist-guide. Here's what it would have felt like:

You're FOP, "fresh off the plane," in Freeport, Bahamas, where you meet with society representatives. They tell you: If the weather gods and goddesses are beneficent, we will depart for the Little Bahamas Banks tomorrow.

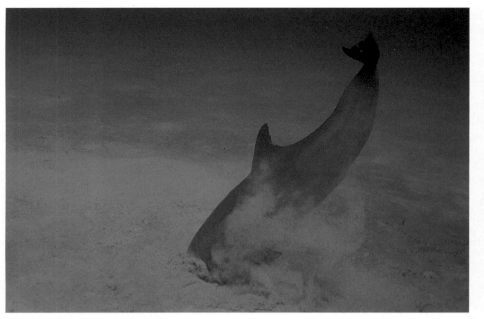

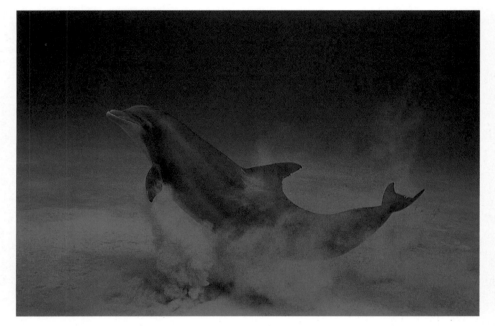

*Worldwide, dolphins employ many different strategies to catch fish, their primary prey.
Bottlenose dolphins in the Bahamas (above) and around Mikura Island, Japan, often practice
"crater feeding." Vertical and upside down, a dolphin will bury itself up to its eyeballs in
pursuit of a fish snack. Dolphins likely use their echolocation, or sonar, to find fish in the sea
floor. They may also use sounds to stun or coordinate fish for easier capture (right). Dol-
phins may forage singly (as shown in these photos) or work in a coordinated, cooperative
manner to contain fish in a tight group, as the dusky dolphins often do off Patagonia. In
some locations like South Carolina or Punta Norte, Argentina, dolphins have been observed
chasing their prey right onto shore, only to slide back into the water while consuming their meal.
—Kathleen Dudzinski*

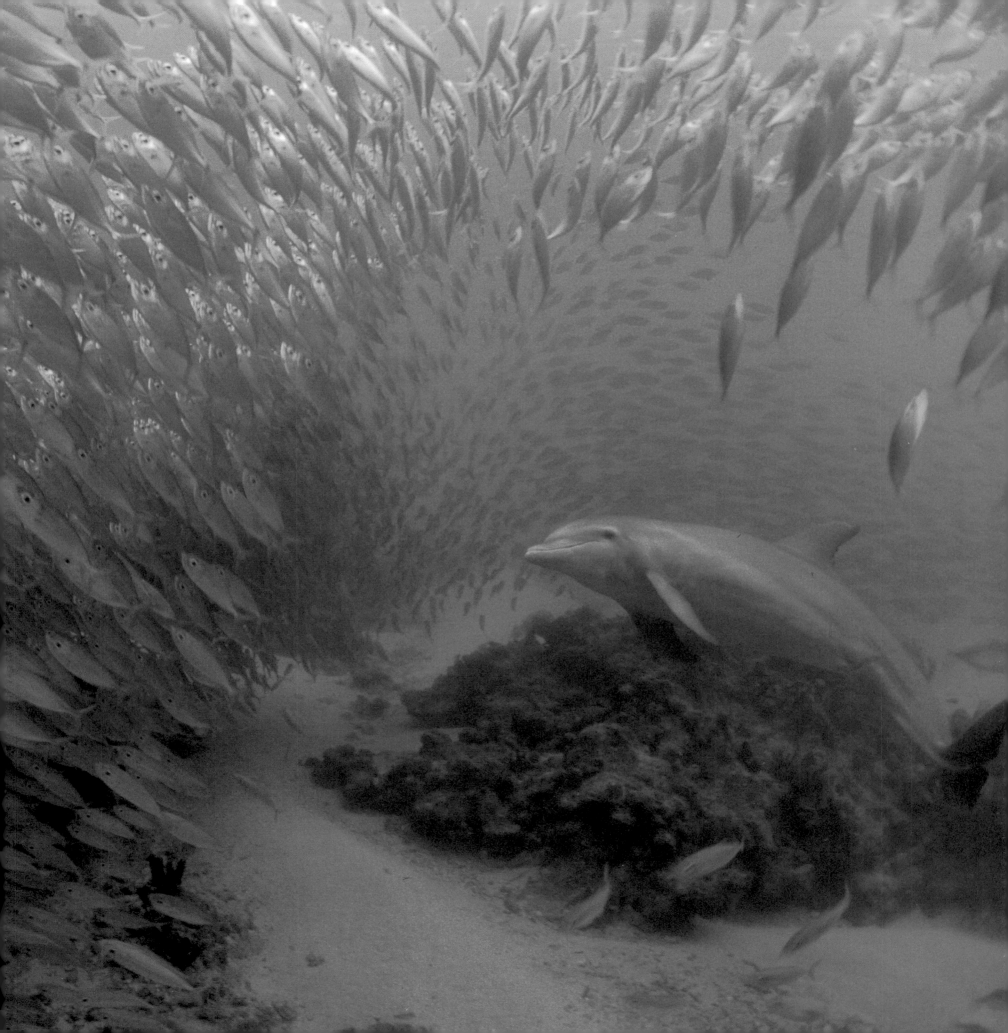

The next day, you're aboard ship and underway before you're even fully awake. The first order of business on the *Jennifer Marie* is the safety lecture. Participants' gear is checked out. Kathleen informs the passengers that, theoretically, none of us are here.

"This is the Bermuda triangle. Some folks say we're off the radar scopes now, out of time and out of place. No one knows where we are, and time will just stand still. We'll come back and no one will ever know we've been gone."

But, she assures you, you'll come back with memories as well as a more profound appreciation of dolphins, and specifically Atlantic spotted dolphins. This is privileged stuff because, for the most part, wild dolphins and other cetaceans spend about 95 percent of their lives below the surface of the waters they inhabit and are mostly inaccessible to scientist and layperson alike. The Atlantic spotted dolphin, she says, comes to the shallow banks to rest and relax and socialize both before and after feeding —which, she tells the participants, is lucky for us. The spotted dolphins return to the same areas and have been swimming with humans here for over 30 years.

Other dolphins, she says, live in rivers like the Amazon or the Ganges or the Yangtze. Some are found in deep water, far from land; and others, like the familiar bottlenose, spend much of their time in coastal waters. Habitat and ecological setting, Kathleen says, are a key to understanding the differences among all of the wild dolphins of the world. You'd take some notes on all this if you weren't feeling just a tad, oh, queasy.

The *Jennifer Marie* sails all day, sometimes through the cobalt blue of deep water, sometimes over the emerald washes of shallow seas. It takes most of the first day to get to the Little Bahamas Banks, and by sometime around noon, your breakfast informs you that it wants out. Kathleen advises you to pick a point on the far horizon and fix on it. You've been focusing on the rising and falling bow, and this made you feel really disoriented. Kathleen issues sickly seafarers small books of brain teasers, irritating little puzzles that don't lend themselves to easy solutions. And, by God, it works! (For some, anyway.) With your mind otherwise occupied, the urge to vomit recedes in the wake.

"But, hey, if you have to be sick," Kathleen says, "be sick. Go right to the rail and feed the fish. Get it over with as soon as you can and I guarantee, you'll feel better. I do it occasionally

myself." It's comforting to think that this professional naturalist and guide, a veteran of literally years at sea, sometimes gets sick too.

The *Jennifer Marie* anchors off somewhere in the Little Bahamas Banks just as the sun begins bleeding to death in the west. There is no land in sight. The calm sea is a mirror to the burning sky: all gaudy reds and oranges fading into a color like fine red wine. Dinner is served—fresh fish, simply prepared —and Kathleen suggests folks might want to get some sleep. Tomorrow's going to come early, and there will be a lot to learn.

But it's hard to just trundle off to bed. The full moon throws a trail of pale light across the black water. There are more stars overhead than you've ever seen, and they are all reflected in the water as well. It feels as if you are floating somewhere in space.

Standing there, alone on the deck, immersed in the stars, it is tempting to be philosophical. To think about humans and their place in the universe. The terrible loneliness of the human race. The meaning of life….

If I'm lucky, you think, *tomorrow I'll swim with the dolphins for the first time.* There is a slight thrill and strum of excitement felt deep in the belly, perhaps the soul. You can't help smiling.

"Do dolphins have a language?" one of the participants asks.

"I don't know," Kathleen says. "If they do, it's certainly not something like French or German. And, if they do, I don't believe we'll ever decipher it. Not in my lifetime, anyway."

What Kathleen does, she says, is listen to the sounds that dolphins make and compare those vocalizations with their behavior at the time. In the interests of accuracy, she records the sounds while filming simultaneous behavior. In analyzing this record, she looks for consistent match-ups between a particular action and a vocalization. The dolphin vocabulary thus far tabulated is spare. For example, there are certain sounds a dolphin makes when it approaches another dolphin it hasn't seen in some time. We might call that a greeting: "Hi, how are ya?" Kathleen calls it a type of "affiliative behavior."

These adult spotted dolphins in a tight group are surfacing in almost complete synchrony on an incredibly flat-calm day.

DOLPHIN VOCABULARY

Kathleen Dudzinski, Ph.D.

I study how dolphins interact, how they communicate, and therefore have come to believe that they do not use a language like ours—a language filled with words and grammar and syntax. This is not to say, however, that dolphins do not *understand* grammar and syntax.

In Hawaii, Louis Herman and his colleagues have been working with two captive dolphins, Akeakamae and Phoenix for several years. Their work has shown that bottlenose dolphins are capable of understanding vocal labeling (i.e., naming objects) and word order. For example, dolphins know the difference between "Take the surfboard to the person" and "Take the person to the surfboard." Still, we have no evidence that dolphins use grammar or a structured "word" order in the wild. By observing the complex web of signals that dolphins use and how those signals vary with activity, associates, and situations, I believe dolphins may not need a language like ours in the wild.

For communication to occur, three things are required: a signal, a sender and a receiver. Let me get a bit technical here, but just briefly. A signal can be anything perceived—a head nod, a sound or vocalization, or a touch of some type. A signal is the *vehicle* for communication to occur and contains two parts: the message and the meaning. The *message* is the signal that the sender transmits, but the *meaning* of a signal is what the receiver gets or understands. These two parts are often not exactly the same because of the differences in context, or history, for both the sender and the receiver. Confusing, I know, but let me give you an example. Walking down a busy street you see a mother and child on the opposite sidewalk. Suddenly they grab hands. Why? Many explanations pop to mind—danger crossing the street, excitement at a shop window display. Now, if I tell you the mother and child are in a huge park with lots of birds and trees but no cars, the possible meaning of their exchange

Signal/Behavior	Potential Meaning	Signal/Behavior	Potential Meaning
1) Contacts between two or more dolphins		Chirps	Short in length sounds that resemble the sound of bird chirps, these sounds may signal a dolphin's emotions...sort of an "okay" message.
Rubbing bodies	Affection or affiliation, strengthening social bonds, reaffirming relationships, quieting an excited peer (usually a youngster)		
Pectoral fin to pectoral fin rub	A greeting between two dolphins	Click trains	Short pulsed vocalizations of high and wide-band frequency that are used to investigate objects or search for fish. Often these sound like creaky old doors opened slowly and have been called echolocation.
Pectoral fin to side of peduncle	A solicitation for a favor or help sometime in the near future (I call this "contact position" in my research.)		
Hits, rams, slams, bites	Usually irritation or aggression from older dolphins but when accompanied by soft angles of approach these are playful.	Squawks	Pulsed vocalizations that sound like "squawks" and are very high in repetition rate. They are used mostly in fights or during play by younger dolphins and may signal irritation or anger.
Melon to genital contact	When a mom and her calf are swimming in echelon, the calf will often touch her genital area with its melon maybe indicating it wants to nurse. If the mom initiates contact then maybe it is telling the calf to nurse.	**3) Bubbles**	
2) Dolphin vocalizations		Bubble stream or trail	A stream or trail of little bubbles that escape from a dolphin's blowhole...often seen from young dolphins during excited and playful swimming.
Whistles	Often dolphins produce a stereotypic whistle that is usually called a "signature" whistle. We now know this is used for maintaining contact among individuals.	Bubble clouds	Large pockets of air from the dolphin blowhole ("clouds") that are used to express anger or warning. They may also be used as a "shield" from another dolphin's harsh vocalizations.

is likely to be different. Context includes not only the environment but the ongoing activity and relationship between sender and receiver. Similarly, a signal's message and meaning depend heavily on who is the initiator (sender) and who is the receiver. As in our example above, if you know the *mother grabs* the child's hand on the busy street sidewalk, then your range of possible explanations would be different if in fact the *child grabbed* the mother's hand. This is how we study communication—or at least, how we learn what messages dolphins are exchanging. We watch not only how they *interact*, but what *roles* each individual assumes and what the surrounding activity or *setting* includes.

In dolphins, communication occurs through sound and, especially, by touch. While traveling, resting, socializing, or playing, dolphins are often seen in contact with other dolphins. Touch can occur with almost any body part but some areas may have special significance. For example, placement of a pectoral fin (flipper) against another dolphin's side between the dorsal fin and the flukes (tail) is a form of solicitation or request. The actual favor being asked depends on the context, but the touching dolphin initiates the request with the pectoral fin.

I would not say there is a specific dictionary of signals or a specific vocabulary of words that dolphins use: at least we have not yet found the Rosetta Stone to help us communicate directly with dolphins verbally. There are some recurring themes in dolphin behavior, however, that lead us to certain assumptions regarding their interactions. In the table at left are some of the more common signals and behaviors and what we routinely observe as their meanings. Remember that many of the potential meanings depend on the context in which the signal is sent. ■

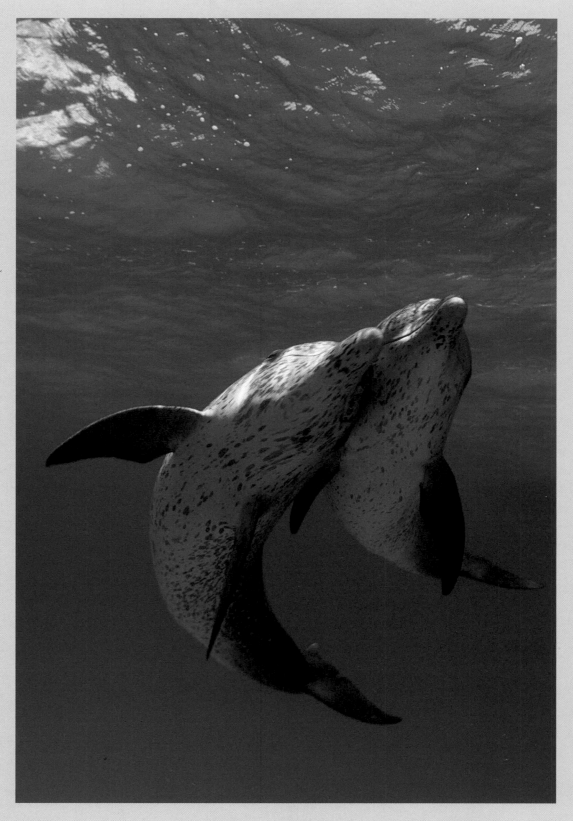

Dolphins are exceptionally tactile animals. Due to well-developed skin sensitivity, where and how they are touched, and how intensely, conveys different levels of information, or signal content, to each dolphin.

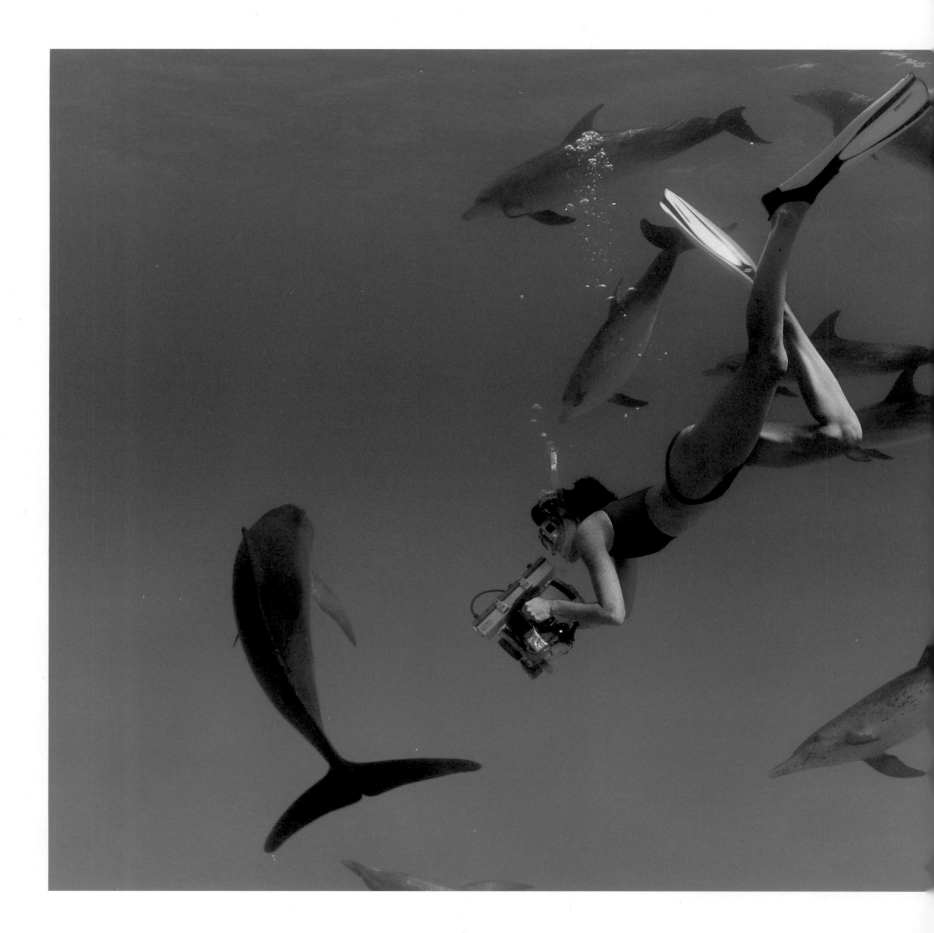

Dolphins sometimes make sounds when they evacuate their bowels, when they meet, part, and when they are socializing. Much of the communication is non-vocal and is more akin to dance than language. Dolphins are highly tactile creatures, always touching, rubbing, caressing, and sometimes biting one another. Occasionally, one or two adult females swim with half a dozen or more juveniles, as if baby-sitting. Adult dolphins sometimes drive juveniles to the ocean floor, and hold them there momentarily in what might be a form of discipline—a "time-out," if you will. And then there are the times when the dolphins approach at speed, in groups of 20 or more, and swirl about the human diver emitting a confusion of squeals, pulsing tones, and trains of clicking sounds. Often they swim in pairs, sometimes mimicking one another, or, more rarely, copying the actions of a human diver.

All this generally happens quickly. People who think dolphin encounters are leisurely —a kind of effortless underwater ballet—have seen too many dolphin movies and documentaries. Typically the chaos and confusion is presented in slow motion, which serves to emphasize the grace of the dolphins.

Real dolphin-to-dolphin encounters are often complex and bewildering to the human observer, which is one reason Kathleen produces a permanent visual and aural record. Other reasons relate to the limitations of human hearing underwater and the physics of sound. In air, sound travels at about 1,100 feet per second. The human auditory system is designed to take advantage of that fact. When we hear a sound from our left, for instance, we turn in that direction because the noise reached the left ear first. Unbidden, our brain directs us toward the sound.

Underwater sound travels 4.5 times faster than it does in air. Human ears are used to hearing and isolating slower-moving sound, which makes underwater noises seem to come from everywhere at once. Another reason has to do with our own thick skulls. Most mammalian tissue is approximately 800 times more dense than air: our heads "shade" or muffle the airborne sound reaching the far ear, so that it seems less loud than in the near one. Seawater, however, is almost precisely as dense as mammalian tissue, so that underwater sound

As a welcome presence, Kathleen gracefully joins in the dolphin dance while recording their sounds and behavior. She can in no way, of course, match the speed and diving capabilities of her subjects.

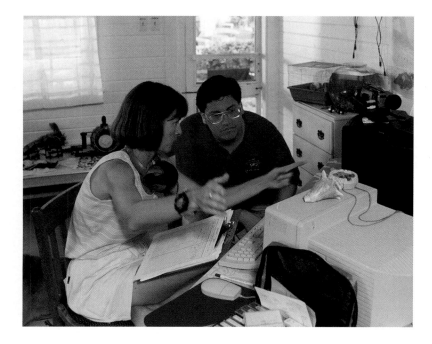

Marine biologist Alejandro Acevedo-Gutiérrez visits Kathleen in the field in the Bahamas. Here they are listening to and examining her earlier recordings of vocalizations—whistles and clicks and chirps—and images of dolphins interacting to determine a match for the sound to the animal and behavior shown on the video screen.

moves through our heads at the very same speed that it moves through the ocean itself. The sound is equally loud in each ear, which is another reason why underwater sound seems to be coming from everywhere at once.

What all this means is that when dolphins vocalize underwater, it is impossible for humans to tell who's talking. Is it, for instance, the nearest dolphin or the female to the left, or perhaps the big male to the right?

Kathleen's solution to the problem—with a nod here to the great marine biologist Kenneth Norris—is simplicity itself.

Years ago, in the sixties, Norris had the idea of listening to dolphins using underwater microphones, or hydrophones imbedded in great copper Dumbo ears, each a foot in diameter. This might have worked with tank-bound, captive creatures but not as easily with dolphins in the wild. And it is very difficult, of course, to swim while holding such a cumbersome contraption.

The man who was to become Kathleen's Ph.D. advisor, Bernd Würsig, talked with Norris about the idea and suggested putting a pair of hydrophones 4.5 times farther apart than

human ears, and marrying this array with video, in order to assess sound directionality. It might then be possible to accurately tell which dolphin was vocalizing on the audio-visual record.

As a doctoral candidate at Texas A&M, Kathleen came up with pretty much the same idea. She had been diving off Belize, filming dolphins with a video camera she'd borrowed from Würsig. The sound on her tapes seemed to be coming from everywhere at once. She thought there ought to be a way to isolate sound using the new generation of smaller and more sensitive hydrophones. It might be simply a matter of increasing the distance between the recording devices to enhance the stereo effect to account for the rapidity with which sound travels underwater.

Back in Texas, Kathleen discussed the idea of an effective mobile video/acoustic array with Würsig, who, as it turned out, had been thinking about such a device for over a decade. Together, the two of them designed the array. The hydrophones, mounted on a long bar, would be widely separated and placed out in front of the camera. There would, of course, be no mammalian tissue between to conduct sound and create an omnidirectional effect.

Ideal stereo separation was a function of the fact that underwater sound travels 4.5 times faster than airborne sound. What this meant, in practice, is that Würsig measured the distance between Kathleen's ears and multiplied by 4.5, which yielded a figure of about three feet.

Kathleen ran with the idea. She built the first mobile video/audio array with Würsig, in his garage, using his tools. The whole contraption might have cost as much as $7,000, but with Kathleen on a graduate student's budget, many generous people got involved and helped. A Houston man named John Clarke and his company, Underwater Video Vault, donated time and materials. The major purchases included O rings from a hardware store and a ship chandler, and hydrophones, though not the more expensive, top-of-the-line hydrophones she might have wanted.

The cost of the entire rig? About $2,000. And it worked! It was like listening to a good stereo system. The music was New Wave, old wave, whatever—the best of aquatic rock 'n' rrrrroll.... *click click click click.* Here comes a whole train of dolphin vocalizations running audibly from screen-left to screen-right, the sound following one particular dolphin swimming directly in the

foreground. The interactions, of course, were still chaotic, with dolphins darting in and out of the frame and some swimming too close together to distinguish the voices while still others mingled so far in the distance that their vocalizations were a jumble.

Yet by studying her audio-visual record, Kathleen calculated that she could identify vocalizing dolphins 38 percent of the time. She recruited other grad students to monitor her videos and corroborate her findings—that is, to confirm her identification of the vocalizing dolphin. And 80 percent of the time they agreed with her assessment, which in scientific circles is considered significant.

Kathleen was set: she could swim with dolphins in the wild, record their interactions, and identify vocalizing animals.

"IN THE DISSERTATION I'M WRITING," KATHLEEN TELLS her shipmate-participants, "I call this gadget a mobile video/ acoustic array. The MVA. Most of the time, I just say, 'the array.'" Other participants on these cruises like the color. They call it 'the green machine.' Or the 'mean green machine,' depending, I guess, on their attitude toward me. Or science in general." She smiles.

All of the *Jennifer Marie's* participants have gathered around her as she displays the device. The thing about the green machine that strikes you immediately is how very simple it is— and that anyone could have thought of it. Kathleen now has the thing apart on the deck so the participants can see it. She's cleaning the O rings and polishing the stainless-steel parts. There are switches, just bent pieces of metal inserted into the water- proof housing that hold the camera: move the lever, it turns on the record button on the video camera inside the housing.

So simple and uncomplicated. In fact, when Kathleen (and her array) won the Fred Fairfield Memorial Award for Innovative Research at the Galveston Marine Mammal Conference in 1993, the presenter said something like this: This just goes to show you what a person can do with a roll of duct tape and a few trips to the hardware store. And, by God, there she is now on the deck of the *Jennifer Marie,* putting the mean green machine back together using a Leatherman tool, a kind of glorified Swiss Army knife, and a roll of duct tape, which she insists is the one essential material in every field scientist's kit bag.

Once the MVA is back together, Kathleen lets a few people lift it so they can get a feel for its weight. The mean green machine weighs about 20 pounds, and Kathleen is forever carrying it around, cradling it like a baby, and checking this or that little attached thing. Kathleen is slender, sure, but there are ropes of wiry muscles in her arms.

She tells everyone that she will be using the array to collect material on the dolphins and that all the participants are just that, her research assistants: everyone is expected to help collect data, and everything must be recorded. The date. The time. The location. A Global Positioning System (GPS) will be used to determine the exact latitude and longitude of the encounters and sightings. There's a system to measure water temperature. Cloud cover must be noted. Science wants to know where the dolphins go, and when, and under what water and weather conditions.

Participants are expected to stand watch and spot dolphins. Each watch is two hours long, which seems an eternity of staring at the wide, expansive sea. There is no reading or knitting or inattentive chatter tolerated. These are serious watches, and participants are asked to call the positions of approaching dolphins by the clock. "*Dolphins!...* At one o'clock! Dolphins at 9 o'clock!"

"WE'VE HAD VERY GOOD LUCK IN THIS PLACE," REPORTS Kathleen. "We'll remain anchored here. The weather's been good. No big storms to keep the animals down. I think we'll be swimming with dolphins pretty soon. If not today, probably tomorrow."

It is, Kathleen tells the participants, a privilege to swim with wild dolphins, and not even legal to do so in the United States, not since the 1972 Marine Mammal Protection Act. The law, though, was not promulgated because there were *too many* people swimming with dolphins in the U.S. Not in 1972. It had to do with unthinkable abuse: dolphins drowned in thousands of fishing nets meant for tuna. The law—and public outrage— eventually put a stop to the worst of the slaughter.

Still, harassment of any marine mammal is against the law in U.S. territorial water—which means that "if you chase dol- phins off the coasts of the United States, for any purpose, and you are caught, it will cost you $10,000 and your equipment will be confiscated. "Here in the Bahamas," Kathleen says, "there are no such laws. But—I warn you—if we abuse our privileges, there may soon be."

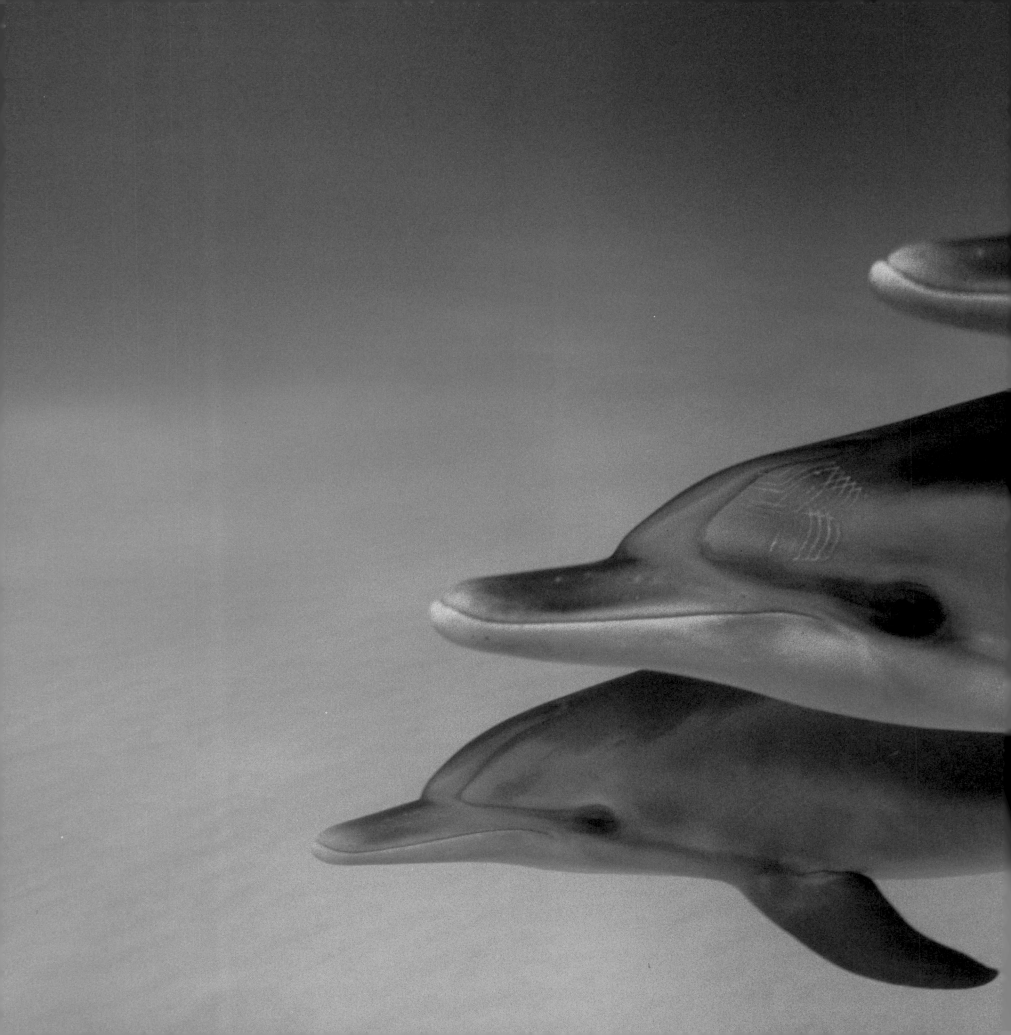

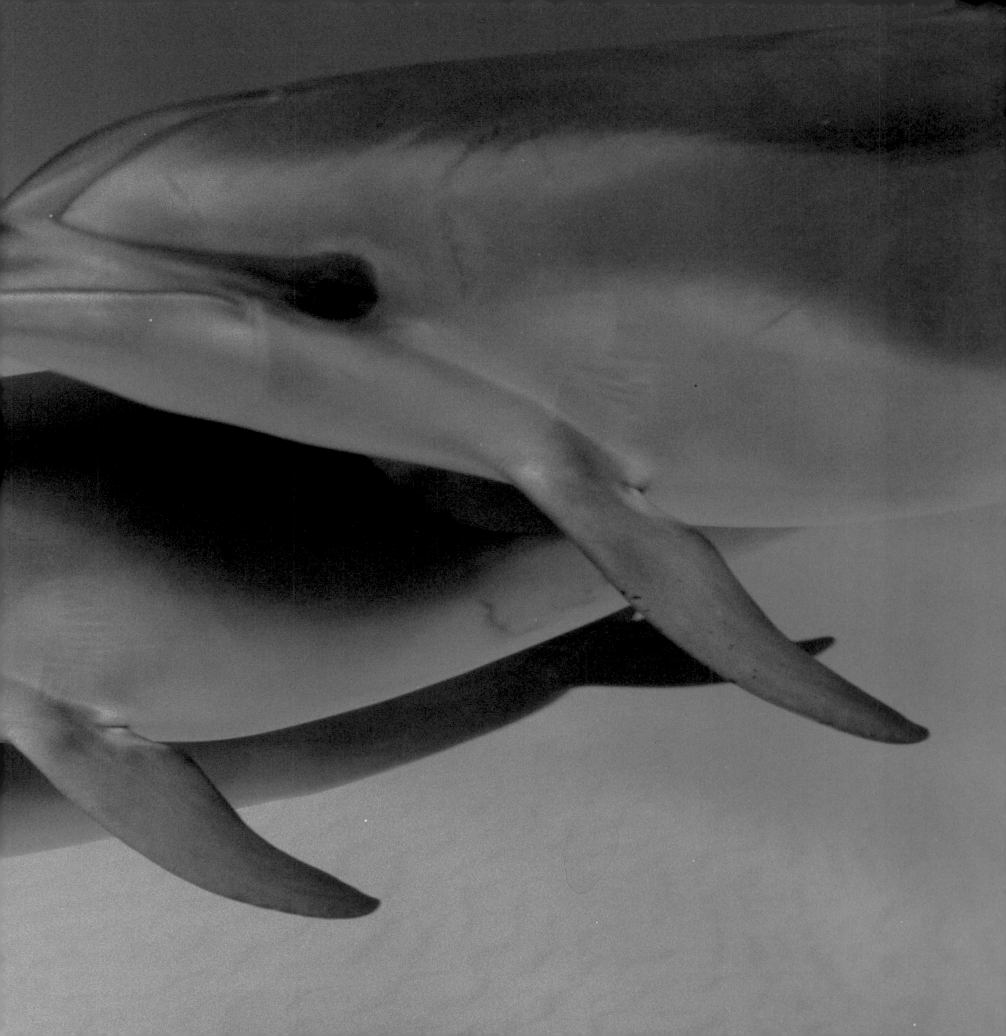

THE MAKING OF DOLPHINS

JANNA EMMEL—*MacGillivray Freeman Films*

The warm, shallow, crystalline waters and white sandbanks of the Bahamas contrast sharply to Argentina's dry, wind-swept landscape and its coastline's dark, deep water. Producer/Director Greg MacGillivray chose these film locations for *Dolphins* "to give audiences a glimpse of the variety of dolphin habitats that exist in the world, as well as to take viewers to places they may never experience firsthand."

Sounds rather exotic, even idyllic, doesn't it?

Enter "the pig"—the 250-pound, large-format IMAX camera, affectionately named by the film teams who must lug it from the boat into the water and, of course, out again. Brad Ohlund, who has participated in every large-format film production for MacGillivray Freeman Films, dating back more than 20 years, was a cameraman and technology supervisor for this film. "I've been in photography situations in this format," he

says, "where it might take an hour between takes to winch the camera out of the water, replace the film, and get it back into the water."

Patience, a strong back, and a sense of humor are undoubtedly occupational requirements for these specialized film teams when you learn that the film magazine, or film roll, contains only three minutes of footage. If the director chooses to shoot in slow motion to capture the beauty of dolphin physiology and movement, for example, the resulting film time for each magazine is even shorter. During slow-motion cinematography, the film charges through the camera at 48 frames per second rather than the standard 24 frames each second. A three-minute film roll now yields just 90 seconds of action!

Renowned marine-mammal photographer Bob Talbot led the first film crew to the Bahamas to film Atlantic spotted dolphins. Their challenge

was to film in clear water with cloudless skies (for best lighting) while engaging wild dolphins in the vicinity of their lens. Talbot has pursued perfect dolphin moments for better than half his life, though *waiting* might be a better description. He explains, "We'd generally spend all day motoring from here to there, waiting for the dolphins to engage us. The best time was about 5:30 each evening; the dolphins had rested, hunted and seemed ready to play."

"Dolphins love speed," Talbot shares, "If you don't move fast enough, they often lose interest and take off, so it was a real challenge for us to keep the dolphins interacting *and* keep film in the camera." Though Ohlund and the film crew set record film-loading times—they could hoist the 250-pound camera housing back into the boat, remove the camera, clean the port, change batteries, and pull the new film in under five minutes—this seemed like an eternity to a waiting cinematographer and the dolphins.

The free-diving water dance of assistant cameraman Pete Zuccarini kept our stars from bolting in boredom. More than a year later, Zuccarini joined another film team off the shores of Argentina. Emmy award-winning cinematographers Paul and Grace Atkins were there to film dusky dolphins cooperatively hunting and feeding on anchovies. The crew searched for weeks, through rolling to raging seas, hammered by merciless wind and the boiling sun.

Though duskies cooperate with one another when hunting for food, they don't necessarily cooperate with filmmakers. Atkins, a natural history cinematographer for several BBC and National Geographic productions, has found that "No creature in the wild ever seems to cooperate when you're making a film. This is particularly true when you're trying to shoot very specific

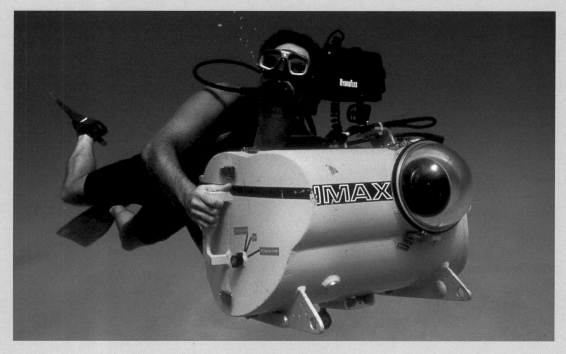

Filming underwater makes a 250-pound camera feel light, but sheer bulk makes it difficult to maneuver.

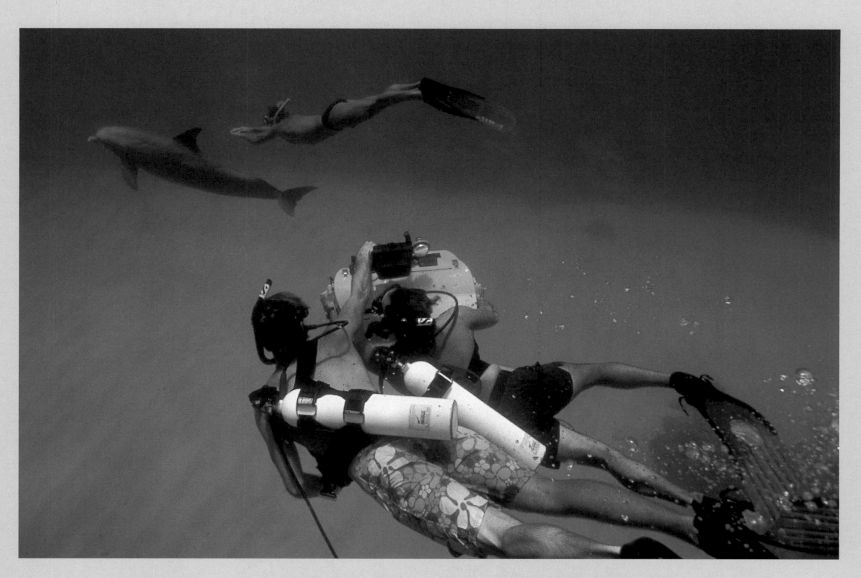

The camera's size generates momentum as currents and waves buffet the camera and crew while filming Dean and JoJo in the Turks and Caicos.

behavior. Nothing seems to distract them when they're intent on hunting schools of fish, and during this phase they are difficult to approach. After feeding, their mood shifts dramatically. They socialize with one another, and they are playful and curious: they'll approach within a few feet, inches sometimes, of the camera. This would be a gift in any format except this one, where approaches can result in close-ups that are simply too much for the big screen. We often found ourselves wishing the duskies would stop being so attracted to the camera!"

One of the more memorable moments in Argentina came when Atkins and Zuccarini were trying to get close to duskies circling their dinner. "In Patagonia," says Zuccarini, "it feels like there's no bottom. The water is dark, deep, and filled with plankton. You just don't know what's around and underneath you." The visibility underwater was only about 10 feet. Zuccarini and Atkin's seemed to be experiencing the murky, uncertain water depths very much like predator-wary dolphins.

Suddenly, as if cued by thought, something slammed into Atkin's ribcage. According to Zuccarini, "Paul felt it, though he didn't see what hit him. Then, when we went back under, the dolphins started circling us really tight, like we were the anchovies, which probably cued the shark that it was feeding time. Once again the shark hit Paul's arm. He saw it that time! I wouldn't say it was a terrifying experience, though. Paul and I have been in a lot of ocean situations over the years. I'm sure the shark quickly realized Paul wasn't the soft, squishy fish he was expecting and immediately backed off. But it is definitely intense to see a shark swimming vertically toward you…because you know it's after *some*thing!" ∎

This may not be so, of course. Dolphin tourism brings a goodly amount of money into the Bahamas and is kind to the environment in the way that massive construction projects and the run-off from them are not. Even so, Kathleen wants every participant to consider his or her dolphin encounter in the water as a rare privilege.

"There are marine biologists, very respected ones, who oppose the very idea of human-dolphin interactions in the wild," Kathleen says. "Why? Because we are in danger of loving dolphins to death. People want to see them. They want to interact with them. And…they chase them in boats. It's been found that boat-based dolphin watching can be extremely stressful, sometimes driving dolphins out of the bays in which they have come to rest during the day. The sounds of outboard engines—dozens of them, screaming in pursuit of the dolphins—can disrupt communication between the animals, at times separating calves from mothers.

"On our dives here, we will follow certain rules. Most particularly, we do not chase or attempt to interact with nursing mothers. Infants, like human babies, are easily frightened and very vulnerable to stress. You might not be able to see it right away. Some dolphins live as long as we do, and the stress may not become apparent for many, many years."

Kathleen pauses for a moment. "OK," she says finally, "let's not forget we're entering the dolphins' realm. It is their home. Think of it this way: suppose you're home, sleeping, and a stranger walks into your bedroom. He wants to talk with you, to interact, to touch you. He loves you and thinks that you ought to love him in return. Well, maybe you just want to sleep. If he really loves you, he'll let you make the decision about whether you'll talk to him or not.

"And that's the rule here. The dolphins make the decision. Yes, there are times when dolphins approach human swimmers. We started swimming with them here over three decades ago when *they* approached treasure divers working the Little Bahamas Banks. It was their decision and they've always come back over

the intervening years, in part, I think, because we are careful to mind our manners in the water.

"I'm going to give you simple rules, and you must follow them, for your own safety and for that of the dolphins.

"First and foremost: never, never, never approach a dolphin broadside and at a right angle. We know that dolphins use head-butts in aggressive encounters, and we know that they interpret a head-first, broadside approach as a threat. When you find yourself swimming with a group of these guys, be sure that every angle you take on every dolphin is smooth and oblique. No sharp angles, and no right angles.

"Many people—I've seen this a lot—stay on the surface and look directly ahead. This may seem obvious, but you're going to see a lot more of the dolphins if you look down. Also, if you dive deep, the dolphins are more likely to swim with you and mimic your movements. It helps to swim in horizontal circles or vertical loops.

"Dolphin etiquette rule number two: don't touch. Sometimes you'll find yourself in the midst of a lot of them, and things happen very quickly. A few of the animals may be close enough for you to touch them. Don't do it. My research suggests that a lot of dolphin-to-dolphin communication is tactile, which means that touching sends a message. We don't yet know what those messages are."

"Do they ever touch people?" someone asks.

"Sometimes. Very rarely. Usually it happens after a long encounter, half an hour or more."

"Has it ever happened to you?"

"Well, I'm trying to record vocalizations and behaviors with my array, so I need to keep my distance from them."

"Yes, but do they ever touch you?"

"It's happened," she says quickly, as if dismissing the idea, but there is a small, radiant smile tugging at her lips.

"Finally," Kathleen says, "don't chase. It's bad manners, and it's stupid and impolite. Sometimes the dolphins will just sweep by, check us out, and leave. Often they come back. Encounters may last for three or ten or fifteen minutes. We also have rare days when they swim with us for hours. When they've had enough of us, they'll book.

"Sometimes the dolphins seem to be leaving, and if we turn and swim back toward the boat, they'll often come back.

You could get another ten or twenty minutes. But—and I've noticed this time after time—if someone chases these guys, they are gone. Like *that*!—" she snaps her fingers, "which is why chasing is also impolite to others who want to prolong their encounter with the dolphins."

Kathleen goes on about safety: how each swimmer should know his or her limitations, how it is possible to become so excited during a dolphin encounter that a swimmer can quickly become exhausted and not be aware of it.

"The last rule is that no one should ever get more than 100 yards from the boat. Even if you are a good swimmer," Kathleen says, "I want you to stay in that 100-yard radius. There are several reasons why you may need to get out of the water fast. Sometimes we have sharks here. And sometimes a squall can hit us in a matter of minutes. We have people topside watching the weather and the water, and when someone tells you to get out of the water, believe me, there's a good reason for it."

THE FIRST DOLPHIN WATCH IS LATE THAT AFTERNOON. Two hours of staring intently at the entirely empty sea. The sun sets, the water turns that bloody Caribbean color, and the dolphins fail to make an appearance. Luckily, dinnertime has come.

After dinner, Kathleen presents a slide show. There are pictures of dolphins. To learn to identify individuals, she explains that participants should look for distinctive scars, called rakes, on dolphins' bodies. Other animals, she says, also have singular features, such as a certain pattern of spots or a dorsal fin that is oddly shaped. Stuff like that.

You've been up since dawn. The sea air and the heat and the good dinner are all tugging at your eyelids, and you're off somewhere far away, gently swaying with the ocean rhythms… swaying, on and on, and on … Until suddenly your whole body jerks upright. You're back in a boat, somewhere in the Bermuda Triangle, and Kathleen is saying something about Class 2 and Class 3 dolphins, and how to tell males from females. It's hard to concentrate.

Even a Ph.D. student finds time to relax, putting aside the rigors of fieldwork and analysis. Here Kathleen dozes beside Rodney, a canine companion, along the shaded shores of Tahiti Beach on Elbow Cay, Hopetown.

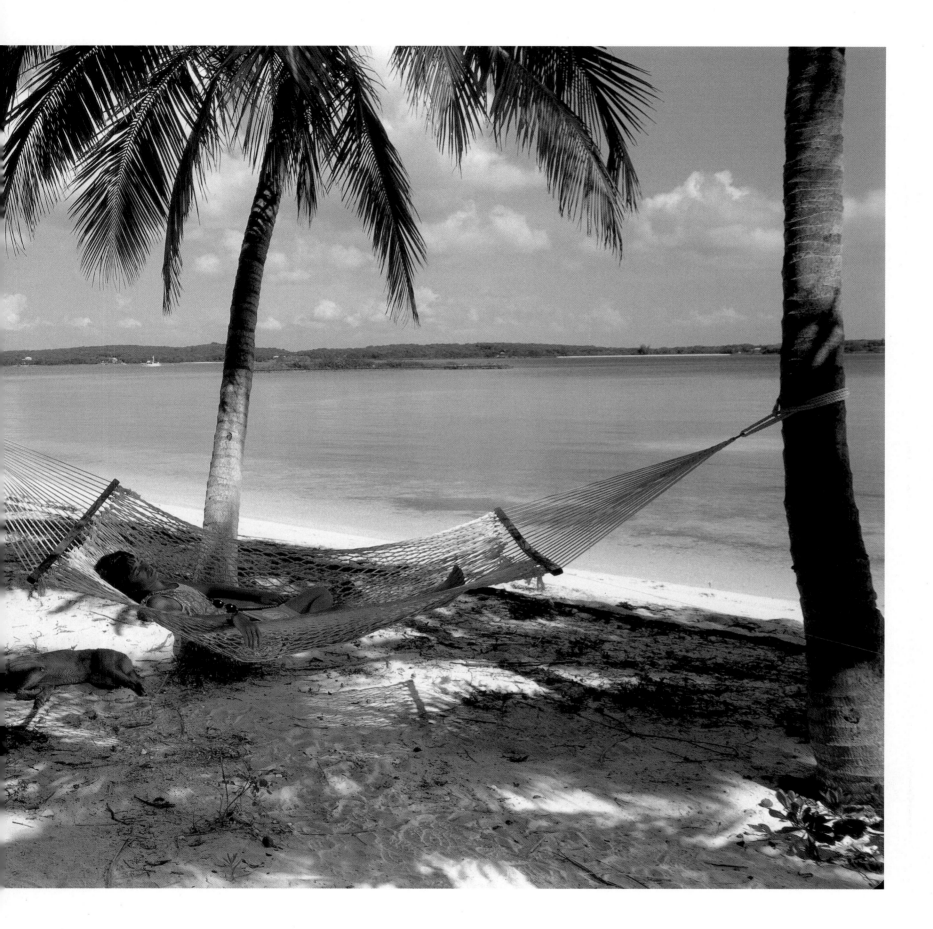

COMMUNICATION

Two of the spotted dolphins here are beginning a rub, maybe reassuring each other of their friendship bond.

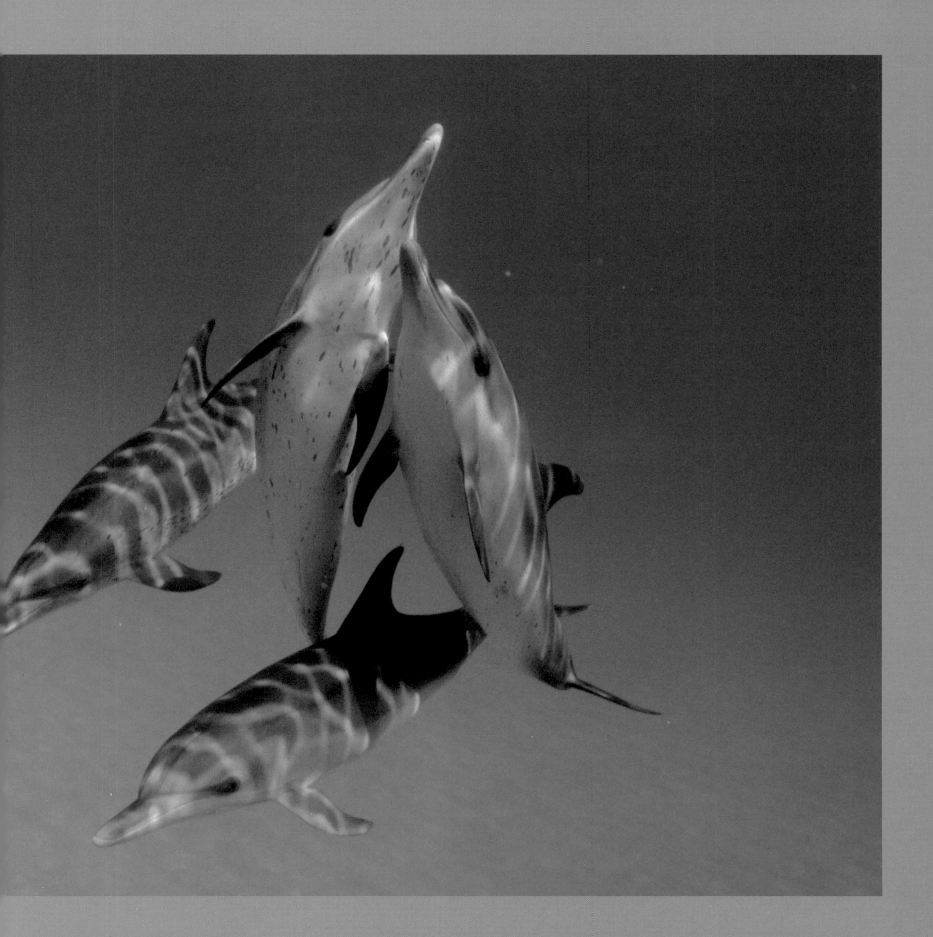

Ever since childhood, the idea of being a passenger in the consciousness of another being has fascinated me. Today I know that by observing another animal's behavior and its reactions, we can get glimpses of its thoughts. I have come to believe that dolphins do not use a language like ours, but by studying their complex web of signals and how they vary, we may better understand these social animals and their minds.

One afternoon while swimming on the Little Bahamas Bank, several dolphins zoomed toward me as they twisted and curled around each other. They squawked, whistled, and clicked at each other. With their jaws gnashing, they faced off, head-to-head. Clouds of bubbles rose from their blowholes. Like street gangs, they fought in small groups, in pairs and triplets. Just as quickly as they darted into my view, they stopped fighting and the noise died: individuals within the pairs and triplets began caressing! But the gang members of the opponent group could have interpreted the rubbing not as caressing but as, say, a gesture of agreement or a conference in which one said, "Hey, we still have to fight the others. Stay ready." Sure enough, about a minute after this rubbing, the opposing groups began fighting again.

Dolphins may use the same behaviors for play that they use when they fight: they can hit, bite, ram, jaw clap (snap open and close), vocalize loudly and intensely, chase each other, and emit bubbles of varying sizes and shapes from their blowholes. To understand how dolphins communicate, we need to watch how they interact, define what roles each individual assumes, and determine the context.

There are subtle differences between play and aggression behaviors; the way dolphins approach each other, as well as the type and amount of contact, will vary. During fights, approaches are head-to-head or perpendicular, as though they are trying to intimidate each other; when dolphins play, they approach at oblique angles or from behind or below, never at a harsh angle, and they often rub body parts. One dolphin fighting or being aggressive toward another would probably never body-rub. Yet two members within one group may rub bodies or pectoral fins over each other between bouts with the opposing group.
—Kathleen Dudzinski

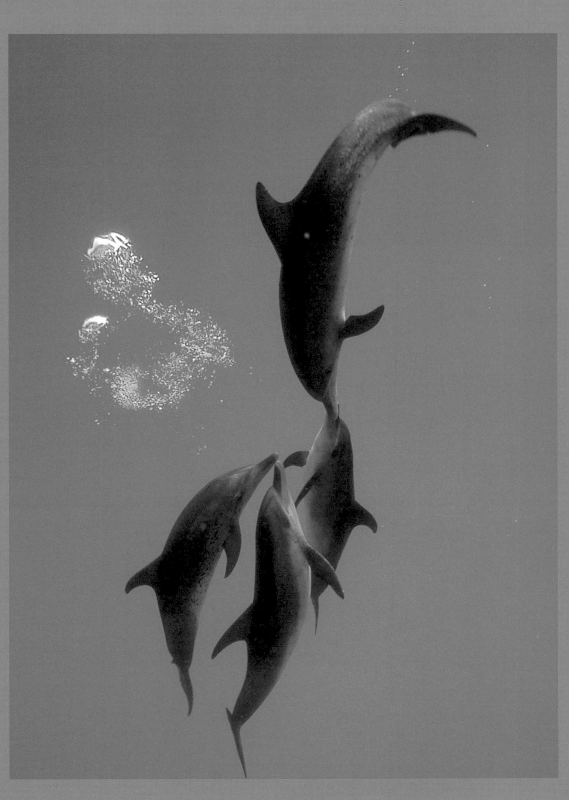

When dolphins fight, they "face-off" head-to-head, often producing clouds of bubbles, and flaring their flippers. These signals may make the fighting dolphin appear bigger.

When dolphins communicate with sounds, whistles, squawks, and click trains, they usually have no external signs that they are vocalizing. Occasionally, however, dolphins emit a stream of bubbles with whistles. From young dolphins, like the spotted juvenile shown here, the bubbles are often a signal of excitement.

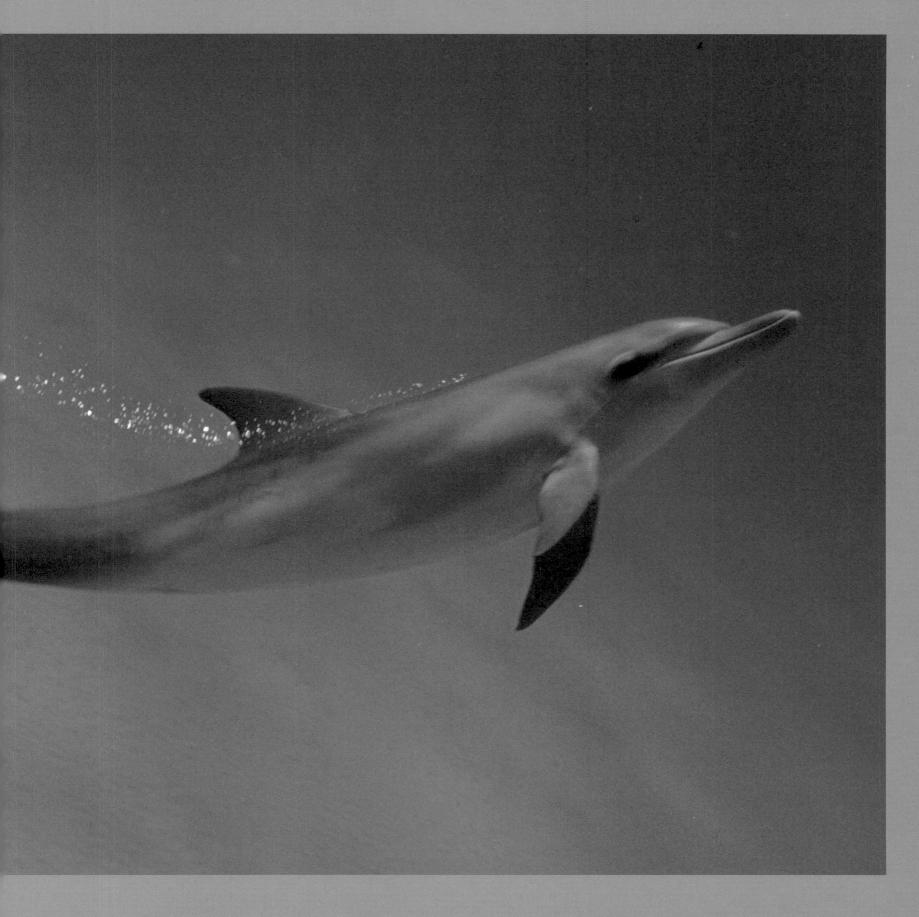

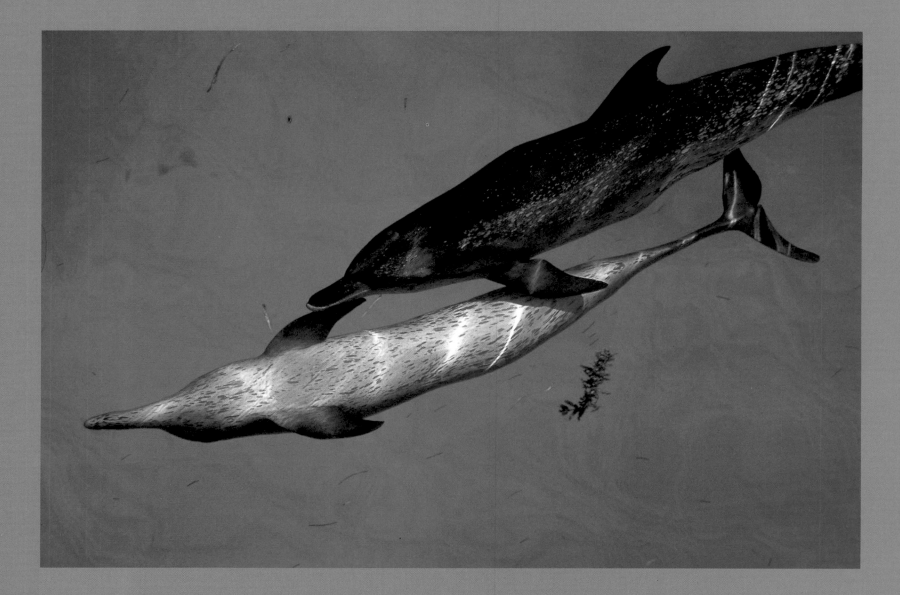

Before mating, dolphins usually caress and touch one another. The lower dolphin (above) is a male and may be courting the female with him. Touch is very important between mothers and calves (right). During its first year of life, a calf will usually remain within a few body lengths of its mother. This contact likely serves to keep the bond between mother and calf strong while also communicating to others that the mother will defend her calf.

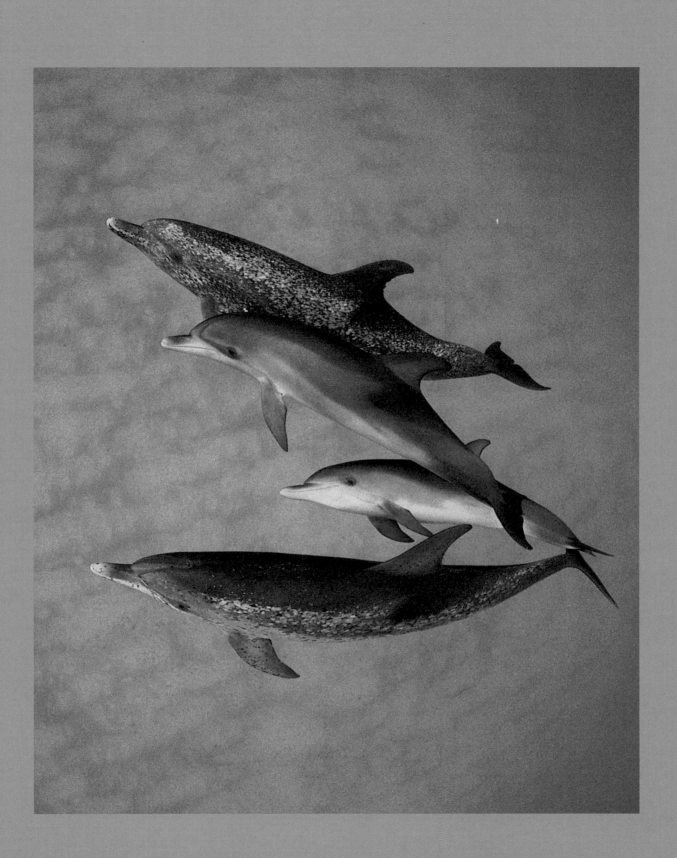

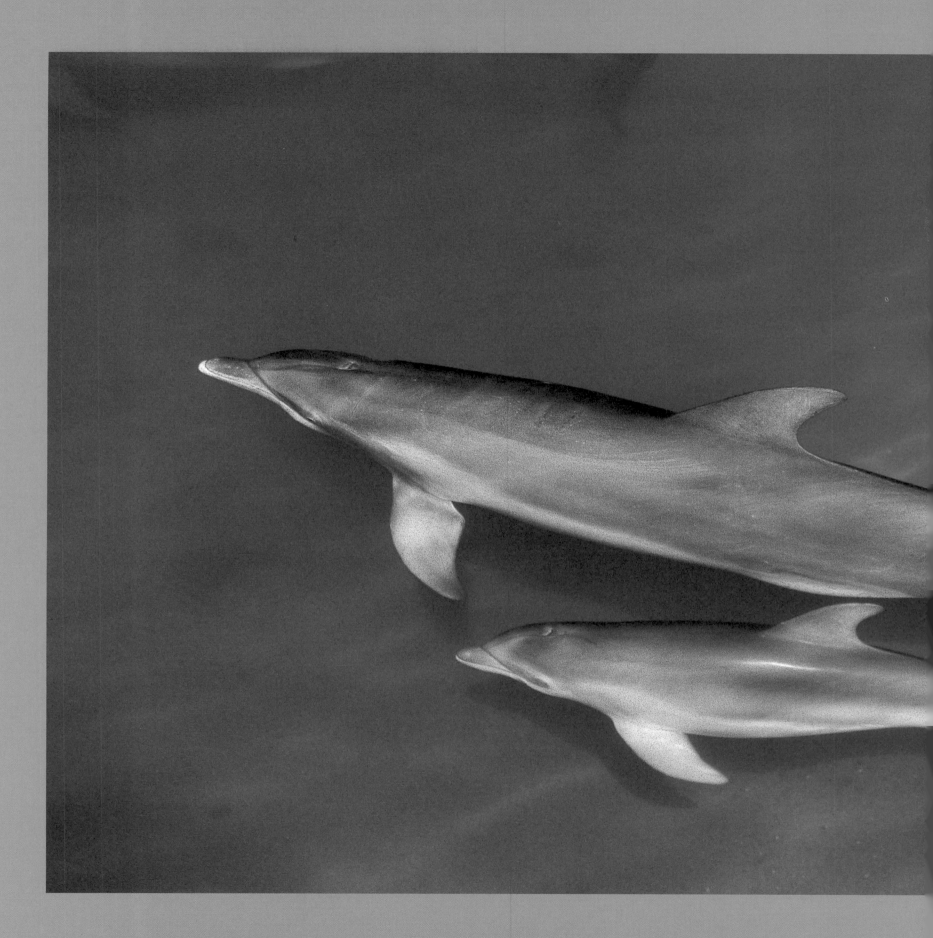

Just above the calf's dorsal fin are the mother's mammary slits. On this bottlenose dolphin, her mammary slits are slightly distended with milk and visible as a white area. The calf swims in echelon to the mom and often touches its melon to the mammary area. With this type of contact behavior, the calf may be asking to feed.

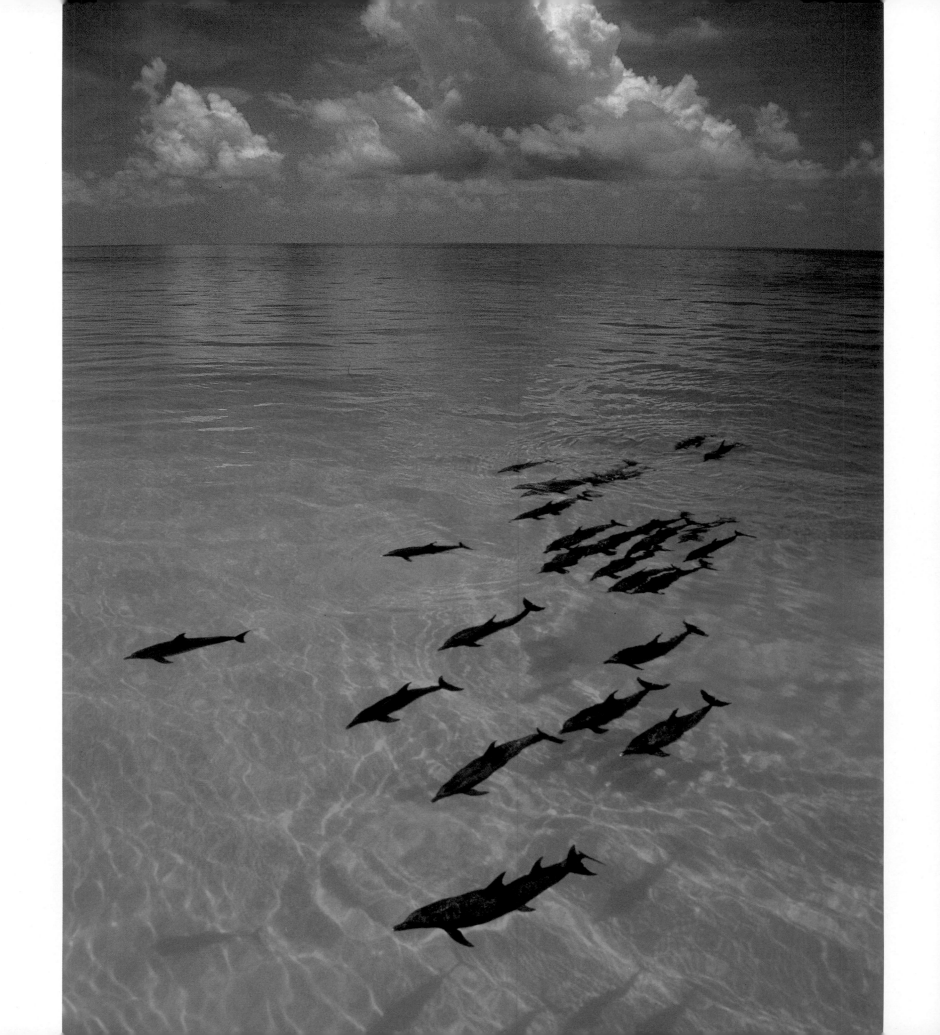

When the slide show finally ends, you walk back to your cabin through a sea of stars, and think, *Tomorrow is the day, tomorrow…* It's almost like the dolphins are speaking to you through the magical glittering night. You don't think dolphins communicate with humans telepathically or anything like that. It's just a feeling you have. Like something pulsing in the night.

"Dolphins! Dolphins at 3:00 o'clock," the person on watch calls. It's the most ebullient of the women, the one in her late 60s who calls herself a recycled teenager. There is such excitement and joy in her voice that, sure enough, she sounds like a kid.

People are dashing for their masks and fins and weight belts. Kathleen is already overboard, watching as the participants come splashing into the water in all manner of odd leaps, splats, and belly flops. In their flippers, they're all a bit clumsy. Everyone is in such a rush to get into the water that they look like penguins plunging off an ice floe.

You're in the water now, looking in all directions, but there's nothing there, just clear water fading off into a distance of blue and green, the color of the sky before a tornado. And then here they come! Several waterborne creatures swimming toward you, moving fast. They're bigger and faster than you expected. One shoots directly by your side…. *Whoa. Is this guy coming at me broadside, is he going to head-butt?* No, its head is turned a bit, and the whole body curves away from you as it sweeps past. But you saw the animal's round black eye staring at you…and in that couple of seconds, your emotion has gone from fear to a kind of strange elation—because this is a big animal, much faster in the water than you ever imagined, and it could kill you if it wanted. But—and this is probably what Kathleen would call anthropomorphism—there was something in the dolphin's eye. The creature seemed curious. Intelligent. As if it were inviting you to dance, and to swim as you've only swum in your dreams.

It's over in a flash…that dreamy feeling. Now there are a bunch of dolphins all around. Some have spots, some don't.

The incredibly clear waters of the Bahamas make it possible at times—when water is calm enough—to not only view but also count an entire school of dolphins from the vantage point of a mast.

Strange… They're swirling about you and the other participants. Kathleen is deep below you, swimming in a looping circle, following a couple of dolphins, filming them with her array. There is another group of dolphins behind her, swimming on the same path. It looks like they're all on rails, each a linked train car traveling in tandem.

Every once in a while, Kathleen surfaces and yells numbers, which her shipboard assistant jots down in a notebook.

As you reach the water's surface for another breath, a silky cetacean rises nearby—*Is this the same dolphin that swam with me before?…Has he…she? come back?* The one that gave you that Picasso-like *mirada fuerte*? That *strong gaze*. Well, it's hard to say. You find it difficult to identify this dolphin and, in a flash, it rolls over the surface, breathes, and dives. You throw your feet in the air so that gravity will help pull you into a dive, but the dolphin is already gone and you have almost no time to register that loss before another one is at your side, moving at your speed, sort of actually swimming with you; and you keep going down until there is a pain in your ears, and you know this is as deep as you've ever gone on a single breath, which reminds you that it is time to breathe again. *Whew.…*

As you loop over and head for the surface, the morning sun breaks through the water in dozens of slanting shafts, like the light falling through stained-glass windows in a great cathedral. A dolphin is by your side again—and then it is gone, as are all the others. When you reach the surface, all the other participants are treading water with you, breathing hard.

Somebody whistles. Someone else shouts, "*WAA*-hoo-OOO!" And then almost everybody is doing it, everyone shouting like kids and splashing with excitement.

"They swam with us! Did you see them?"

"Yes," you say, laughing, "I saw them." But maybe you didn't. You never did identify the dolphin with the *mirada fuerte*, the penetrating stare. Well, maybe you haven't *really* seen the dolphins yet. Not in the scientific sense, anyway.

And this is confirmed right away when you climb back onto the boat and there's Kathleen asking you a whole barrage of questions like some bad cop in the biology lab.

"What did you see?"

"Uh, some dolphins…

"How many?"

"I guess…well, I really don't know."

"More than two?"

"Oh, yes, lots more than two."

"Less than ten?"

You find yourself hesitating. *How many were there?*

Kathleen writes something down in her notebook, and it occurs to you that you're not, in fact, much use to her. Didn't even count the dolphins.

"I think maybe half a dozen," you say finally.

Kathleen looks up from her notes.

"But…I'm not *really* sure."

Then you say something that sounds very strange: "So don't quote me on that." Like Kathleen is going to put your observations into some scientific paper…sure. "According to reliable observers, there were more than two dolphins and less than ten." You feel like a nincompoop.

"Can you describe what you saw?" Kathleen asks.

You realize again that, while you experienced the dolphins, you didn't actually *observe* them. "Well," you say, "I noticed this one's eye…when it swam by me I could see the eye. It was round and black. I felt like it was, I mean, the eye just looked like there was a lot of intelligence behind it…."

"Was it an adult or juvenile?"

"I didn't really notice." How would I know that?

"Did some have spots and others none?"

"Uh…everything happened so quickly…."

"Was there any contact *between* the dolphins?"

"Well, yes. I think I saw one, it was sort of swimming on top of the other. Off to the side and on top. And it kinda touched the other one, the lower one, behind the head. You know, with its flipper."

"Its pectoral flipper," Kathleen adds. "And did you manage to sex either of the animals?"

You never even looked. It didn't occur to you. What use are you? Your observations can't be reliably reported.

Distinct features of the Atlantic spotted dolphin are a long white-tipped beak, pronounced melon, and a tall falcate dorsal fin. The dark gray coloration on the top of the body is the cape. These adult spotted dolphins, Class 5, are heavily spotted with spots coalescing and forming different and bigger spot patterns throughout their lives.

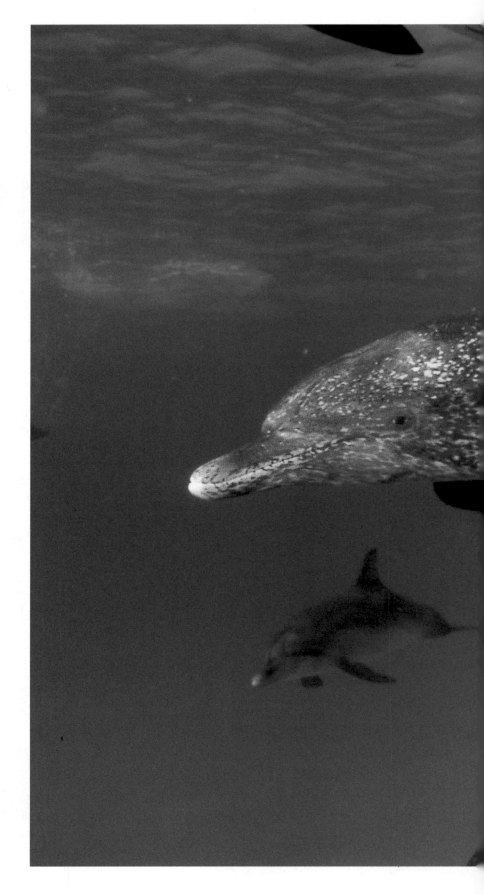

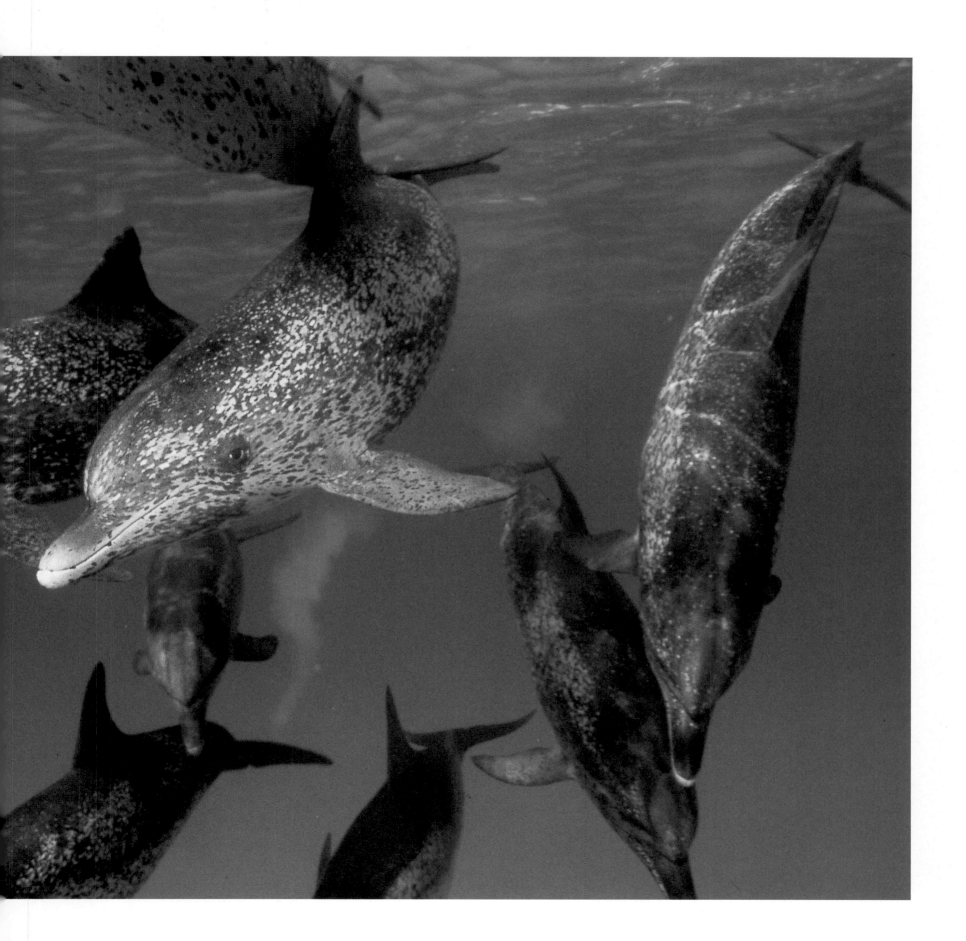

CLOSE YOUR EYES, YOU'LL HEAR THEM

BRENDA PETERSON—*author of* Living By Water *and* Intimate Nature

For decades we have studied cetaceans, of which both whales and dolphins are examples, on our human terms—capturing them in their wild habitat and bringing them into our element to determine their intelligence, social structures, and communication skills. We have also sought out wild populations of whales and dolphins and moved amidst them in research vessels—from quiet kayaks to noisy Zodiacs. But Paul Spong and his research partner and wife Helena Symonds have changed all that.

For the past 17 years, they have listened to the complicated patterns of orca vocalizations, using hydrophones strategically placed along British Columbia's Johnstone Strait. Their world-renowned OrcaLab on remote Hanson Island is a new model for cetacean study—one that is non-invasive and seeks to understand animal intelligence not defined only by our standards.

Twenty-four hours a day, OrcaLab records and tracks the many subpods of this Nothern resident A1 superpod off the wild coast of Vancouver Island. OrcaLab's land-based research requires more communication skills on the part of the human researchers because it places Spong and Symonds in an acoustic world, very much like the highly sophisticated world of sound which defines orca life and survival. In this long-term study, listening is not a limit; it opens us to fathoming an underwater world at once familiar and alien to our human, terrestrial existence.

"We can discern from their vocalizations where the whales are," Helena explains, "with whom they are gathering, what they're doing, whether they're resting, fishing, or socializing."

Over the years, OrcaLab has acoustically identified this superpod so expertly that they can recognize each orca among over a hundred by its signature whistle. And they have identified the sophisticated orca social structure as well, subdividing these long-lived matrilineal family groups into clans.

Helena identifies each whistle and call. "Even linguists can't explain to us how we know a person's voice. But after 17 years of listening to these orcas, their voices are very familiar to me."

Orca vocalizations are a doorway humans have not yet understood how to enter. Societies are related by dialects and the mother's signature whistle is inherited by her offspring, both male and female, who remain by the matriarch's side. With a big brain and communications skills still not totally understood by our own species, the orca has managed to figure out how to live within highly complex families without dominance struggles or international aggression.

OrcaLab's acoustic recordings have proved to be often more accurate than photographs. Helena Symonds and Paul Spong have given us an acoustic portrait of this mammalian society that helps us understand just how complex is this other mind in the waters. It is astonishing to imagine the depth of familial communication and the cooperation of orca clans who share fishing grounds, escort other pods, and gather together with an intricate chorus of dialects. ■

A young male killer whale, orca, identified by its erect but not yet very tall dorsal fin, cruises near shore.

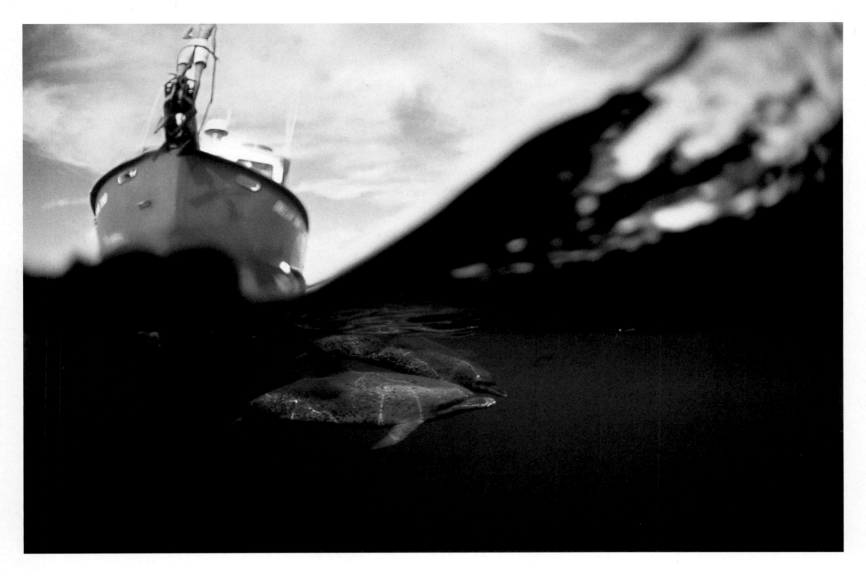

Atlantic spotted dolphins have been swimming with humans in the Bahamas since the 1960s, when treasure divers first began underwater salvaging of a Spanish galleon. Today, dolphins are often seen waiting near boats for their human friends to join them.

Kathleen has stopped writing altogether. You feel like you've let her down, like you're some kind of a disgrace to science as well as a complete and utter dolt.

"I'm sorry," you say.

But a smile lights up Kathleen's face. "Nobody's observations are very good the first time. Mine weren't. It's all just excitement and adrenaline the first time."

"And it happens so fast."

Nobody else, it seems, got any real scientific observations. According to you and all your fellow participants: "An unknown number of dolphins approached from an unknown direction.

The age and sex of the dolphins was unknown. The encounter lasted an unknown amount of time."

Later you and most of the other participants are chattering away in the language of pure exhilaration. You're all talking about the morning's interaction, and what you each did, and what the dolphins did, and how it all felt. Everyone is jazzed. All most can say are things like, "awesome," "fantastic," "unbelievable." Others talk about how they felt—not what the dolphins did but how the dolphins made them feel and how it was to be in the water with them, and to feel their presence. There are others like you who feel the need to do more, to

65

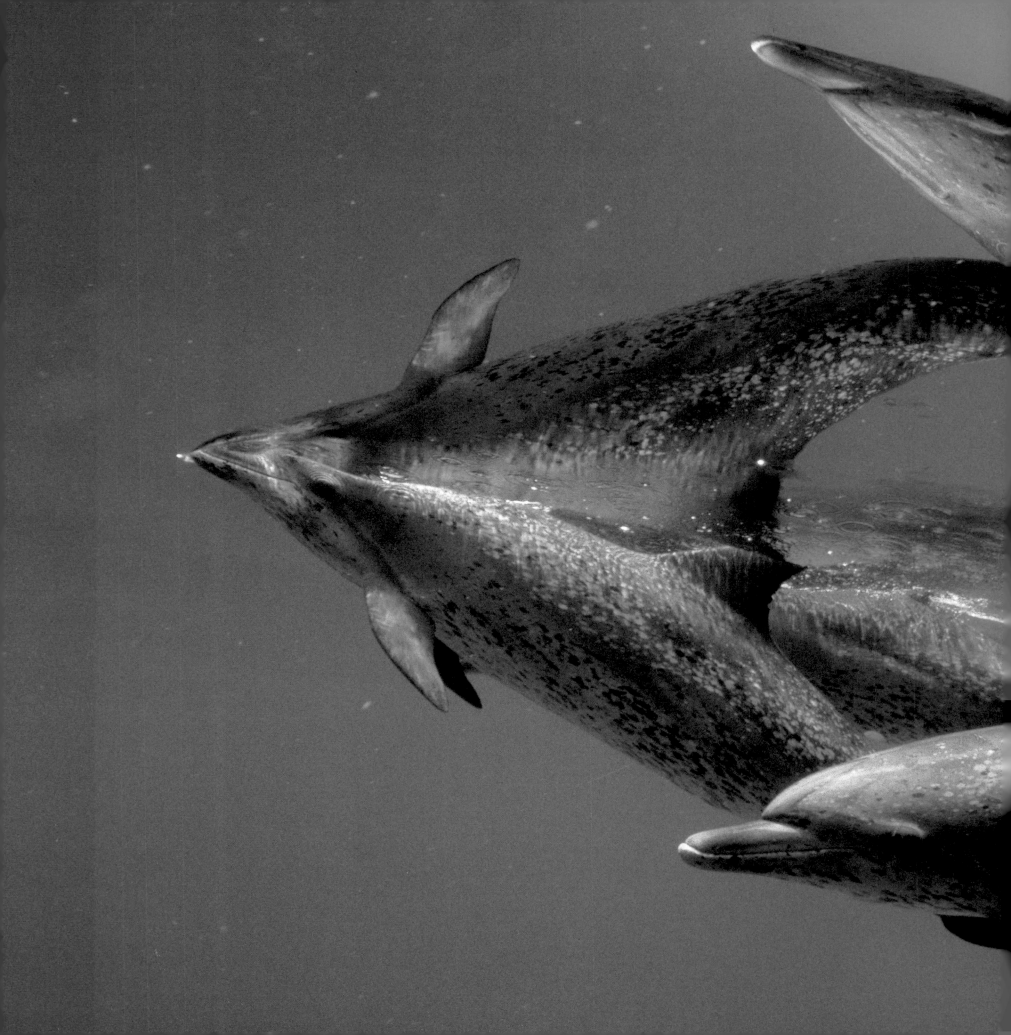

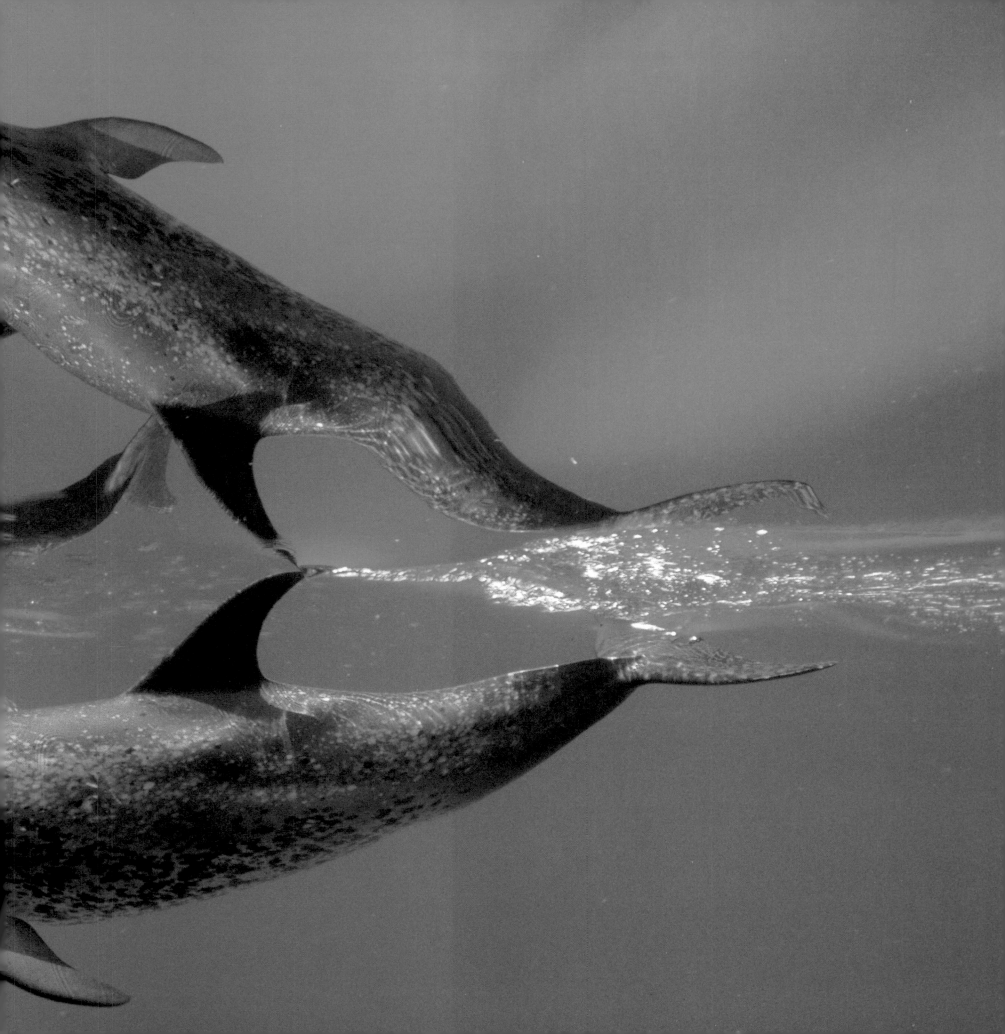

observe more closely. It's probably the difference between a scientific and a spiritual mindset. One group believes that if there is a message being communicated between humans and dolphins—if that sort of interspecies communication actually exists—then it is the feeling and emotion imparted that are the important things. Not very scientific, but, well, perhaps valid nonetheless.

It's clear, though, that the science oriented group needs to work on small, concrete details in order to be true participants. You make a vow to yourself: *Next time I'll have something scientifically significant to tell Kathleen.*

The participants who share your view have a brief confab and a delegation is dispatched to talk with Kathleen. Could she, *please*, do the slide show again after dinner. The one about how you can tell the age of the dolphins by their spots. And…well, a lot of people are still confused about how to sex the animals, how to tell a male from a female.

So there you are, that night after dinner, with a pen and pencil in your hand, taking notes in the dark as Kathleen shows slides and patiently goes over what is essentially last night's lecture one more time.

In her work, she says, the first thing she does is identify the animal. In the Little Bahamas Banks group of spotted dolphins, there are about 125 animals that have been named and numbered. Kathleen herself after three six-month periods diving with the creatures can identify at least 60 dolphins by sight.

"The animals you've been swimming with are called Atlantic spotted dolphins, *Stenella frontalis*, is the scientific name, or more accurately, the name of the species." She shows a slide of a one of these *Stenella* guys, and he's covered with spots. The next slide shows a dolphin with no spots at all.

"The first and easiest way to start sorting these dolphins out is by looking at their spots. We have five classes of dolphins. Class 1 is an infant, up to about one month old with fetal folds or lines on the body from being curled in the womb. These are

(Facing page) Kathleen sorts through her photo album of dozens of recognizable individual dolphins. She attempts to match the one in her hand with another in the catalog. A match tells her when and where it was recorded previously. (Preceding pages) Glassy seas make identification of species easier. Here we see three adult, Class 5, Atlantic spotted dolphins.

going to be hanging with mom; and as you can see in this slide, these infants have no spots."

You are making notes as fast as you can now.

"Class 2s are calves, also with no spots, but without fetal folds, though still with mom. Class 3s are older, like teenagers, and they are just beginning to get their spots. Class 4s are sub-adults, the equivalent of human teenagers, maybe, and they have distinctive but widely separated spots; while Class 5s are adults with many spots pretty much all over, all meshing one into the other."

"Why," someone asks, "do these dolphins have spots?"

"For some of the same reasons zebras have stripes or leopard have spots," Kathleen says. "Protective coloration, for one thing.

"Did you notice that the younger individuals are white on the belly and dark on the back? Well, this is a kind of oceanic camouflage. You know when you look down into deep water it seems to sink into a kind of blue-black color. Well, when a dolphin is diving deep, its dark back may make it invisible to predators swimming above. When the dolphin is swimming near the surface, its white belly tends to blend in with the sun's glare, and that shields them from predators looking up from below."

"What predators?"

"Sharks, mostly," Kathleen says. "Also, their cousins, orcas. Killer whales. They hunt in packs and prey on smaller dolphins."

"Smaller dolphins?"

"Oh, yes," Kathleen says, "Killer whales are dolphins."

This is a bit of a shock to the more mystical participants: dolphins killing dolphins. The watery kingdom of peace has sprung a leak.

"And, of course," Kathleen says, "the same protective coloration allows them to ambush their own prey. We won't see a lot of feeding here—I think they feed at dusk or in the evening and then come to this shallow water to rest and socialize after gobbling up schools of bait fish in the deeper water."

The shallow water, Kathleen explains, is probably a comfort to dolphins. "Remember when you were in the water? I bet it was all pretty confusing to you if you're not a real experienced diver. On the ground, you basically look around you or up; you've got solid ground under your feet. In the ocean, there's a whole other dimension to your field of vision.

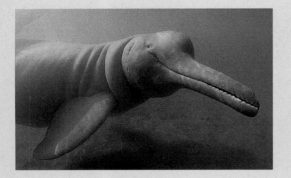

Amazon river dolphin

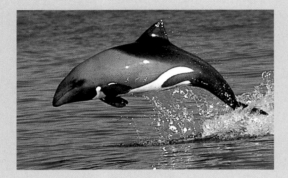

Heaviside's dolphin

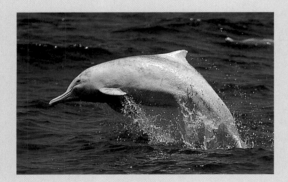

Indo-Pacific humpback dolphin

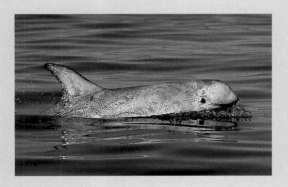

Risso's dolphin

SEEING CETACEANS

Bernd Würsig, Ph.D.—*Professor of Marine Mammalogy, Texas A&M University*

Snub-nosed short gray shapes came gliding out of the green gloom, whirled around me, and disappeared. Others came, some circled three or four times, quickly, with one round dark eye peering intently as they pirouetted. I identified several individuals by a nick on a flank, a blotch pattern on a head, a tooth rake mark on a dorsal fin. Several disappeared only to return a minute or two later, still curious, still whirling. They were dusky dolphins, and this was my first view of them in their own special oceanic habitat.

Heck, it was my first underwater view of any dolphin, and as I recall this experience now, almost 30 years ago, I can still feel the excitement and joy of that first encounter. I was enveloped in an ill-fitting wet suit, 8 degrees Celsius (cold!), water trickling from my neck to my arm pits through an unfortunate rip at the inseam. But this did not matter. Although I knew precious little about these swift little marine mammals, I was glad to at least have the basics down: I could identify this species—one of the 40 or so species found worldwide—in these waters off the Patagonian coast of Argentina.

Back in the early 1970s, few good books on dolphin identification were available to the general public; and rarer still were information-filled large-format books containing high-definition, close-up shots of wild dolphins. If you wanted to encounter wild dolphins, you would probably need to have a scientist friend who worked in the field. I did, and he was also the scientist who prepared me for my first dolphin encounter. He was William "Bill" Schevill, the First Father of marine mammal studies (and even a mentor to the great Ken Norris who became one of my teachers years later!). I had visited Bill at the Museum of Comparative

Zoology at Harvard, in his small office laden with books and research papers and charts, a scant month before my swim off Patagonia, in the southern Atlantic Ocean. I remember sitting beside him, furiously jotting down notes, as he picked up the various books and materials available at the time—tomes on anatomy, 19th-century drawings, photos he had taken on this or that expedition. He sifted through maps and talked and talked, preparing me for my first dolphin encounter, helping to fill my head with just what I needed to know about encountering dolphins and whales in the wild.

This is what we all need to know from the start: how to identify the waterborne creature in our midst, and what to say about it. How, from the sight of an approaching dorsal fin just above the water's surface, would I know a shark from a dusky dolphin? From Bill, I learned that the dolphin has a rounded dorsal fin that only briefly shows itself at the surface; a whoosh of air as the dolphin breathes out, then in, and it slips below. A shark, on the other hand, has a triangular, sharply-pointed dorsal fin that wiggles back and forth at the surface for some time before slowly disappearing, likely humping up and down gently as it sinks beneath the waves.

Dusky dolphins are found in near-shore waters of the Southern Hemisphere, and belong to a group (the genus *Lagenorhynchus*) of six species that are antitropically distributed—that is, they occur in colder waters of both hemi-spheres but not near the equator. "Duskies" (their friendly appellation) are one of the smallest of the group, reaching to only two meters at their longest. They are also the least strikingly colored (hence the term "dusky"), with a countershading of dark gray on the upper body, and on the underside, a lighter, whitish belly. This basic

coloration, common to many marine species, makes it difficult for prey and predators swimming above to see them against the black abyss; or, when swimming below, to notice them against the light-saturated water surface. The common term for this is cryptic coloration. Duskies also have a series of white lines or blazes along the flanks below and aft of the midbody dorsal fin, which are distinguishing features used by other dolphins as they swim in synchrony within the group and, looking out to their sides to their near and beyond swim partners, are used to coordinate group surfacings, dives, and turns within a large herd.

Bill Schevill had told me that I should be careful to distinguish duskies from their slightly smaller cousins in the near-shore waters of Patagonia, the Commerson's dolphins. These little strikingly black-and-white creatures belong to a group of four Southern Hemisphere cold-water species (of the genus *Cephalorhynchus*) that are disruptively colored to confuse predator and prey as to their exact body shape and whereabouts in a group. The Commerson's dolphin has a black head, black flippers, black dorsal fin and black tail. The neck and front part of the back is bright white, trailing down to the mid-flanks, and enveloping much of the belly. It has black patterning around the aft-belly genital area and —this is especially of interest—this patterning is different for males and females, presumably making it very easy for an individual Commerson's to ascertain the gender of another as they approach each other in the oft-murky waters of their preferred near-shore environment. From their sides and tops, it is rather impossible to tell gender, for Commerson's are built the same except for those belly spots.

So, even though both duskies and Commerson's are small, round-bodied, blunt-snouted dolphins, their different color patterns easily give them away. Not only this, but members of the genus *Cephalorhynchus* are almost always found in small groups and relatively only several hundred meters from shore; whereas their dusky and other *Lagenorhynchus* friends occur from a few up to several hundred kilometers from land and —as I mentioned—quite often in larger herds.

There are other species in near-shore Patagonia, but one large one stands out and has the pleasure of feeding on all others: the killer whale, often termed "orca," the single one of its like-named genus. The killer whale is the largest member of the taxonomic family Delphinidae, and is thus closely related to them. It is sexually dimorphic (or "two-bodied"), with adult females up to 8.5 and adult males up to 10 meters long. It too is disruptively colored, with a big white patch above each eye, a more subtly white and gray saddle patch under the dorsal fin, a white belly, white lower jaw, and even white undersides of the tail, or flukes. This coloration, perhaps especially the white eye patch and lower lips, may be particularly confusing to fish, penguins, seals, sea lions, and dolphins and porpoises that find themselves startled by this large predator's approach. Most striking of all of its morphology is the large, triangular, up to 1.8 meter-high dorsal fin of adult males. This is a secondary sexual characteristic (like facial hair of human males) that most likely serves an important male-male signaling function as males sort out dominance relationships for access to females in heat. In Patagonia, killer whales cooperate to hunt elephant seals and southern sea lion young, and they even beach themselves at times to snap up their pinniped prey in the upper reaches of the tur-

bulent surf zone. They also habitually feed on dusky dolphins, and our underwater microphones consistently picked up a particular dusky warning cry that alerted us—as it must alert duskies in an area—of killer whale presence.

These are the major animals that Bill Schevill had introduced to me, and which my wife, Melany, and I came to know so well during our four years of life in Patagonia. But there are so very many others: the spotted dolphin of the Bahamas that my graduate student Kathleen Dudzinski "made famous" with her studies on communication; the bottlenose dolphins of so many parts of Earth, both near-shore and far out to sea. Kathleen is now studying their communication and social ways off a small island in Japanese waters. The sleek, slim long-snouted tropical members of the genus *Stenella*; the large stately pilot, false killer whale, and dwarf killer whales of a group of blunt-snouted dolphins often termed "blackfish" (as they are mostly dark to black, but decidedly *not* fish); the ancient-appearing river dolphins of India, Pakistan, China, and the mighty Amazon. These dolphins split from the others 18 million years ago, and they retain a very long cage-type jaw for snapping at fishes and invertebrates some distance ahead of their eyes.

So, you see, dolphin and porpoise diversity is huge, from the diminutive Hector's dolphin of New Zealand to the giant killer whale; from the behaviorally and morphologically cryptic Burmeister's porpoise to the showy and exuberant leaps of the Hawaiian spinner dolphin and the flashy sides of the Commerson's. Bill Schevill tried to impress me with this diversity. I have become ever more impressed by it as I've wandered to other parts of this globe and seen what the world of dolphins has to offer. ∎

Danger can come from anywhere on the compass, from all 360 degrees. I think the dolphins come here because the water is so shallow. Its about 30 feet deep; there's a sandy bottom and over 100 feet of visibility. For these spotted dolphins, it must be like walking on the ground because they've eliminated the death-from-below aspect—that is, about 180 degrees of danger.

"The spots, I think, also provide another kind of protective coloration. Did you guys notice the way the sun fell through the water in those brilliant shafts of light? I mean, every time you look up, there they are dozens of them, flickering spots of sun spreading out in the water. And the dolphins take on this mottled, spattered look too. So sometimes these spotted dolphins are hard to see against the light at the water's surface if some predator were to look down from above.

"The spots may also be like the stripes on zebras. The theory is that when the zebras flee from predators, when they're running, the stripes all blend together and it's difficult for a lion or other predator to isolate just one animal. Maybe it's the same with dolphins. I haven't seen them flee from a shark here, so I'm just guessing, but it's one theory."

Kathleen clicks to other slides, the ones she uses to show folks how to sex the animals, to tell males from females.

"Dolphin sex organs are contained inside their bodies to eliminate drag as they swim. Their entire bodies are evolutionarily refined for swift, streamlined swimming. The organs are situated in a bed of capillaries that regulate the temperature and keep, for instance, the male dolphin's sperm cool and viable. The male dolphin has two slits on his lower belly: one long one above for the penis, and a shorter one below that hides the anus." This arrangement looks a little like an exclamation mark, and you draw one on your notepad and label it "male!"

"The female," Kathleen says, "has one long slit for her sex organs and anus, with two parallel slits on either side that hide her mammary glands." Draw this configuration: it doesn't look like punctuation. It could be an abstract-looking pitchfork.

Olympic swimmer Matt Biondi seems to be joining the dance with the spotted dolphins. It is said that he came to the Bahamas to swim with these gold-medal deserving cetaceans so that he could learn a trick or two about their superior and powerful hydrodynamic capabilities. Here, however, it seems that he is testing his neutral (won't rise or sink) buoyancy.

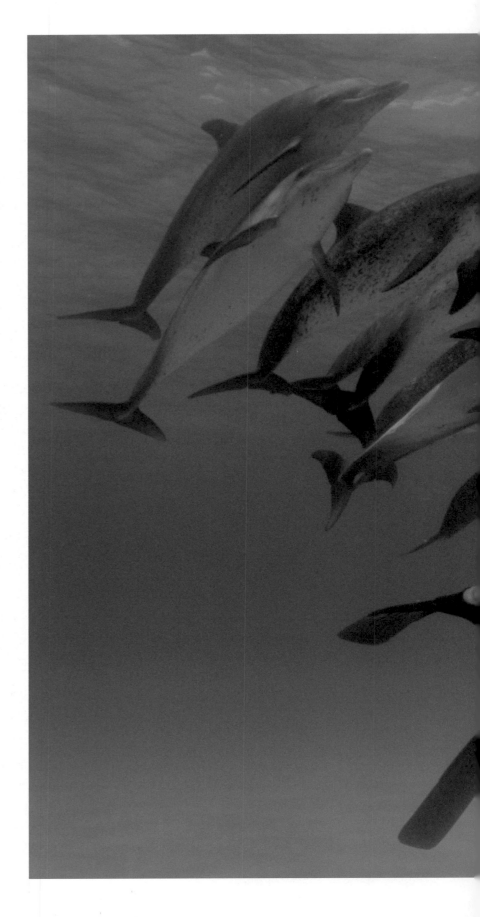

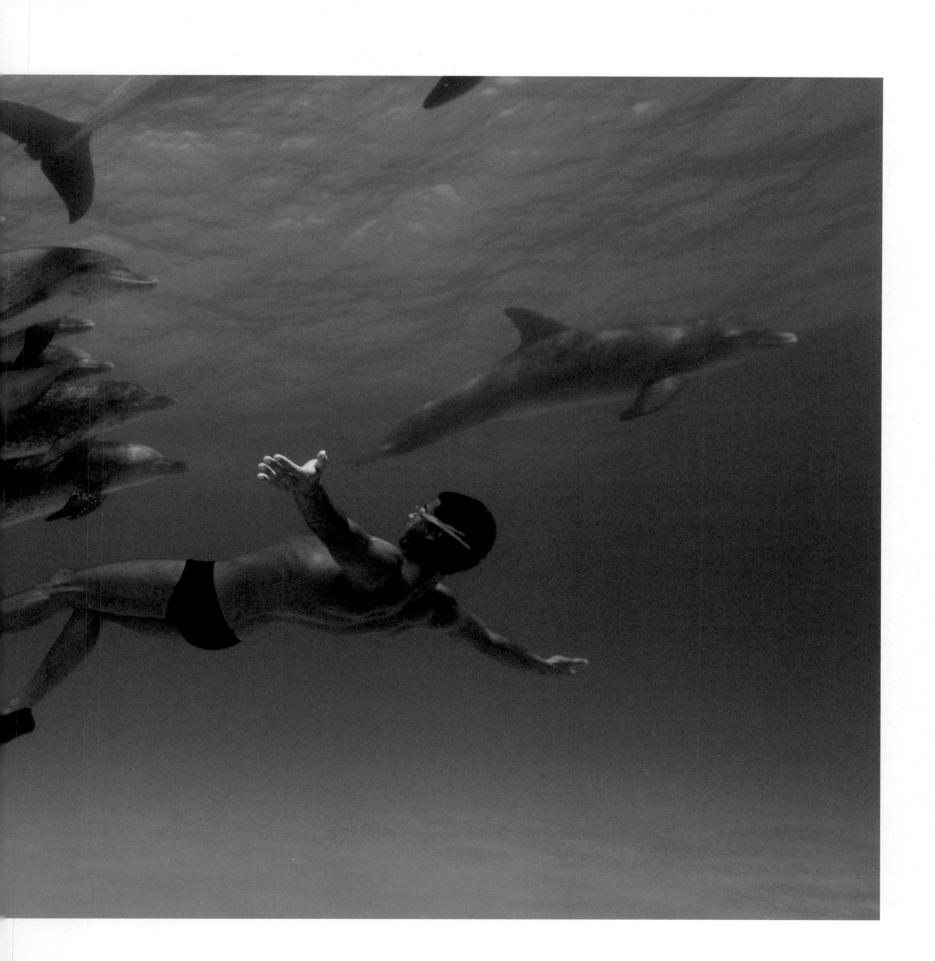

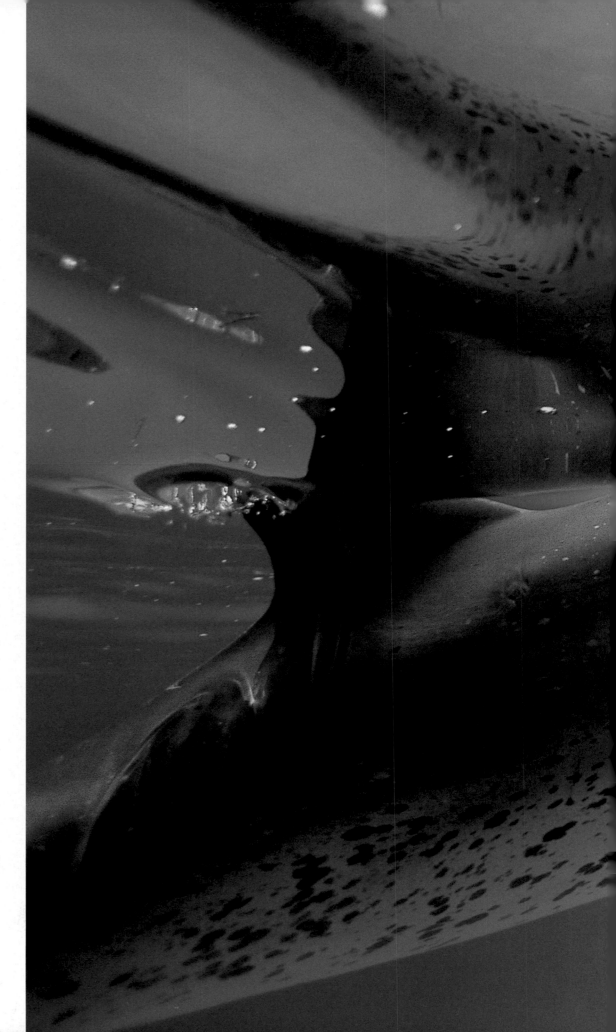

Are dolphins mammals or fish? This question makes me think of a day my family and I were standing on the beach when we heard the cry "Shark! Shark!" as several scared youngsters sprinted out of the water. But in fact they had encountered a small group of bottlenose dolphins just out of the surf line, moving parallel to shore in stately fashion, their dark dorsal fins glinting in the late afternoon sun.

The misidentification was understandable. Sharks too have dorsal fins, and the main one can look quite similar to that of the single one on top of a dolphin. Sharks can also be about the size of a dolphin—about 2.5 to 3 meters. Sharks and other fishes have pectoral fins that serve a similar steering function as dolphin flippers, and many have a rotund body plan similar to dolphins.

But, of course, sharks and other fishes are very different from dolphins. Fishes use gills to "filter" oxygen out of water whereas cetaceans are perfectly good mammals: warm blooded relatives of modern-day ungulates such as cows and hippos that develop from a placenta, give live birth, nurse their young with mother's milk, and breathe air. They all have blowholes (one single nostril in toothed whales, dolphins; but baleen whales have two). Most fishes have protective scales covering their bodies, dolphins and whales have a smooth skin overlying a thick coat of blubber, used for both thermoregulation and to store energy. Although dolphins do not have a coat of hair as do their relatives on land, they retain a few sensory bristles around their snouts, at least as newborn youngsters.

Most fishes tend to move with sideways undulations, as do sharks. Like most other mammals, dolphins and whales have an up-and-down "gait" as the body flexes, and this movement is translated to the hind part of the body and tail as the animal swims along. Think of a galloping horse or antelope, and imagine how that up-and-down movement of the back was changed to swimming over eons of evolution, as the mammal lost its hind limbs, modified the forelimbs into steering paddles and developed a propulsive tail.
—Bernd Würsig

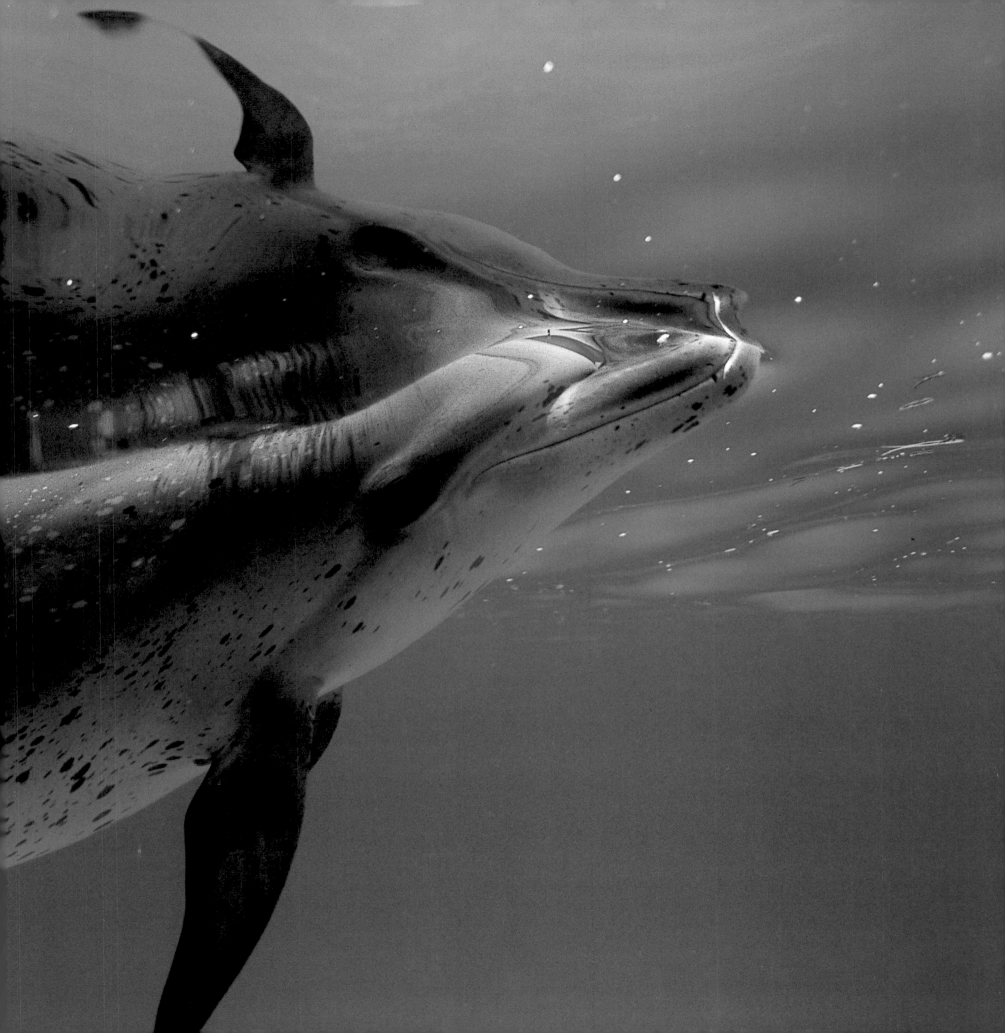

The slide on the screen shows the female with a calf whose underside you can't see. Class 5 female with a Class 1 of unknown sex, you decide. The two parallel lines on the Class 5 look a little swollen, and Kathleen says this is how you can spot a nursing mother.

"Now," Kathleen explains, "you have several ways to begin identifying the animals. You can classify them according to age, and to do that you look at their spots. Or their lack of spots. Secondly, you can separate them into males and females. In addition to sex and age, there are these seasonal marks called rakes."

The slide shows a Class 3 dolphin male with three perfectly parallel white scratches about three quarters of the way down the upper body of the animal, near the tail flukes. "During aggressive encounters," Kathleen says, "dolphins will *jaw* one another—that is, bite without really chomping down. These rakes are teeth marks, and almost every dolphin has a few. They are not usually very deep and will heal over in a matter of months. Still, we can use rakes to identify dolphins temporarily. This one, for instance, is an older Class 3, which means he's the equivalent of a teenager, so my guess is that he may have gotten a little out of line and one of the adults had to discipline him.

"See how you can narrow down the identification process. This is probably the only Class 3 male with three parallel rakes in exactly that area of the peduncle," which you figure out means the upper, thicker part of the tail. The next slide shows a Class 5, unknown sex with a long white scar running along its side. The scar is permanent, much deeper than a simple rake. Kathleen doesn't know what the scar is from—maybe brushing up against a coral knob; maybe the badge of survival from a shark attack. Still, it's a distinguishing mark, and one that, unlike the less serious rakes that heal over and disappear in a matter of months, can be used to identify the animal year after year.

The next animal on the screen has a scar on its side that looks as if it was made with a giant cookie cutter. "This," Kathleen says, "is almost certainly a shark bite. See the marks of the upper and lower jaws, here and here?"

Other slides show dolphins with nicks or cuts in their dorsal fin and on their flukes (tail) and melon, part of the head. Kathleen is running through the slides pretty quickly now, naming the animals as they flash up on the screen. As the scientist, Kathleen numbers the animals for her data collection, but as she flips through the slides she uses names the participants have given each animal:

There's Concordia, Blaze, Stubby, Keyhole, Fin, Echo, Mia, Rebecca, Virginia, Freckles, Lisa, Microm. Then there are ones named for their distinctive marks: Double Gash, Double Point, Little Gash, Ridge.

"OK," Kathleen says, as the slides flash by, "that's Charles, and this one's Brucie. Anyone notice anything a little strange about Brucie?"

You do. Brucie's a pitchfork, not an exclamation point.

Pretty nearly everyone says it at once: "Brucie's a female."

"Now," Kathleen says, "you guys are starting to get it."

THE DOLPHINS ARE COMING ALMOST EVERY DAY NOW. Sometimes they arrive in the early morning, check out the boat, and leave. Other times, they stay around, but only for a short while.

Time in the water with the dolphins is of two sorts: less than three minutes is a "sighting." More than three minutes is an "encounter." Kathleen only works with information derived from encounters. And now, when she asks her questions, people have better answers. They say things like: "Both animals were Class 3s, both females. They swam together for over three minutes, with one animal slightly below the other. There was contact. The animal above—it might have been Rebecca, I can't be sure—swam with its right pectoral flipper placed just behind the melon of the other one. It looked like the lower dolphin rose up and initiated the contact with the upper dolphin."

Now people are climbing back on board after an encounter and writing furiously in their own notebooks. Almost everyone uses Kathleen's dolphin mugshot book, a three-hole notebook with pictures of dolphins. *Where's the Class 5 male with the cookie-cutter scar on the left side of the peduncle?* Flip through the pictures and you can find him: his name as well as the number that Kathleen uses in her research. This book is invaluable: it contains the visual record of her research with the dolphins. Maintaining it and updating it is essential for good research methodology.

Participants are beginning to notice and describe behaviors now, and asking Kathleen about them. It occurs to you that this is what science is about. You have a question based on observation; then an experiment is designed to provide answers. For instance,

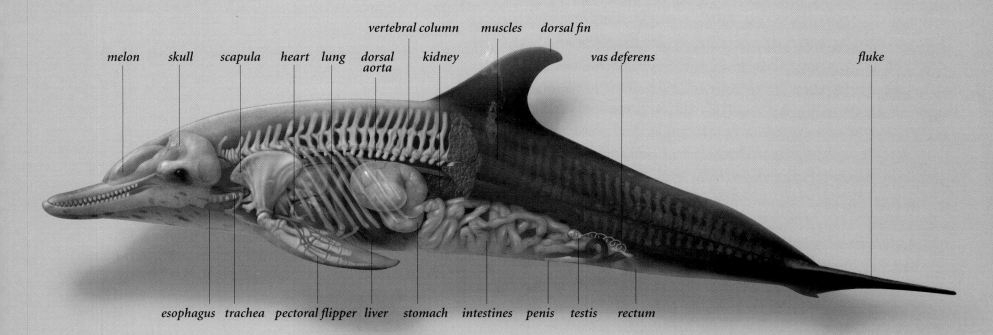

melon · skull · scapula · heart · lung · dorsal aorta · vertebral column · kidney · muscles · dorsal fin · vas deferens · fluke

esophagus · trachea · pectoral flipper · liver · stomach · intestines · penis · testis · rectum

About 60 million years ago, dolphin ancestors lived on land. Soon after the dinosaurs disappeared, dolphins entered the sea and over millions of years, they evolved fins, flippers (which have the same bones we have in our arms and hands), and a torpedo-like, streamlined shape. Legs were traded for a single tail that propels.

ANATOMY AND EVOLUTION

JOHN E. HEYNING, PH.D.—*Deputy Director of Research and Collections and Curator of Mammals, Natural History Museum of Los Angeles County*

Whales, dolphins, and porpoises may resemble fish, but they are mammals. Unbelievably, the closest living relative to cetaceans are ungulates, the hoofed mammals. However, the ancestors of whales and dolphins, four-legged mammals called mesonychids, more closely resembled short-legged wolves than living cows or horses. Some 50 million years ago, some mesonychids along the shores of the ancient Tethys Sea began to spend more and more time in the water. Over the next 10 million years this led the ancestral whales and dolphins to evolve streamlined bodies that allow modern cetaceans to move with apparent ease through the water.

The front legs of dolphins evolved into paddlelike flippers that are used to steer and brake. The broad tail of a cetacean is called the flukes. Both cetaceans and fish use their tails to swim, but in different ways. The tail of a fish is vertical and moves from side to side; cetaceans have horizontal tails that move up and down. The vertebral column, or backbone, extends into the center of the flukes, but there are no bones in the sides. Most of the tail is dense connective tissue that makes the flukes stiff yet flexible.

Most mammals have hair to keep their body warmth inside. Although whales, dolphins, and porpoises are essentially hairless, they do have a few whiskers on their heads. In the water, hair is not all that effective as insulation for a deep diver. Instead, cetaceans have a layer of fat just below the skin, called blubber, which provides far better insulation in the cold ocean. Blubber thickness varies for different species in different climates. In regions where the water temperature ranges widely during the year, the thickness of the dolphin's blubber changes seasonally. Whales and dolphins have a complex and dynamic system of blood vessels that allow these animals to precisely regulate their body temperature. When cold, some blood vessels serve to recirculate body heat back to the body core. When overheated, the dolphin's flippers, flukes, and dorsal fins serve as radiators, dumping heat into the water.

Cetaceans have lungs with which they breathe air. Through evolution, the nose moved from the tip of the snout on a land-dwelling mesonychid to the top of the head on a modern whale or dolphin and is now called its blowhole. When the whale or dolphin comes to the surface, the blowhole opens quickly to first exhale, then inhale. After a long dive, a whale or dolphin can exhale the air from its lungs through its blowhole at 100 miles per hour! In all the toothed whales, including dolphins, there is a complex series of air passages and sacs just beneath the blowhole. By passing air between these sacs, dolphins produce the sounds they use for communication and echolocation. ∎

where do these Atlantic spotted dolphins go when they are not socializing in these shallow waters? Someone suggests that a couple of the creatures could be captured and fitted with long-term radio transmitters. Then you could follow them, see where they go.

"Well," Kathleen says, "that's a good idea, and it might work. But there's one major problem." Kathleen is smiling, but it's clear the entire idea upsets her. "Personally, I couldn't do that. I mean, if we start capturing dolphins and putting transmitters onto their skin, the dolphins may become more wary. Understandably. And they may not come back. As I've told you, we've been diving with these dolphins for 30 years now…" She pauses. "There's a kind of a trust built up here between our two species."

In her years as a shipboard naturalist, Kathleen guided over 400 participants of all nationalities. We spent hours, Kathleen and I, talking about her interactions with these folks, some of whom became close friends. What struck me in our conversations is that Kathleen never gave a formal shipboard lecture on dolphin conservation. She didn't have to. It was more effective to let the participants come to her with their questions, as they invariably did. Are these dolphins in danger, participants wanted to know. What about other populations of other dolphins? The Atlantic spotted, she told the concerned participants, appeared to have healthy population densities, but other species were critically endangered, which is to say, at immediate risk of extinction.

The baiji, or Chinese river dolphin, confined to Yangtze River and its tributaries, is imperiled by boat traffic, sickened by pollution, and displaced from its habitats by harbor and dam construction. There are perhaps fewer than 300 Chinese river dolphins still surviving. Also critically endangered is the vaquita, a small porpoise native to the northern-most section of the Gulf of California where it is subjected to contaminated run-off from the Colorado River. Vaquita also die in gill nets set for other fish, which means they are considered a "by-catch." As few as 200 are alive today.

The Indus river dolphin—about 500 surviving individuals —is also endangered, and the diminutive Franciscana, a dolphin that lives off the east coast of South America is severely threatened, often taken as a by-catch, in shark fishing.

Over-fishing depletes the dolphin's food supply, while urban and agricultural run-off find their way to the sea and imperil coastal dolphins. The simplest waste can be deadly. Dolphins are sometimes found dead, washed up on the beach, their intestines clogged with indigestible plastic bags.

The participants knew there were things they could do. Between 1960 and 1972, for instance, an estimated five to six million dolphins drowned in nets set for tuna. They were considered a by-catch. Public outrage put a stop to the worst of the abuse. Consumers simply refused to buy tuna that was not labeled "dolphin safe." The boycott forced the fishing industry, in America and elsewhere, to change their methods.

So the participants went home, where some showed friends and neighbors the slides they'd taken of dolphins in the Bahamas. They talked about the things they'd learned there; many of them became deeply involved in conservation efforts focused on certain dolphin species, while others were more concerned with the health of the world's oceans as a whole. They wrote Kathleen letters, often including newspaper or magazine clippings about threats to their local dolphin populations.

There was something I found hopeful and encouraging and inspiring about these reactions. Kathleen doesn't preach, is seldom visibly angry, and while her reverence for the creatures she studies is deeply felt, it is expressed in a muted and understated manner. She doesn't shake her finger in anyone's face, and apparently believes that, once introduced to the reality of dolphins, most people will feel an obligation to ensure their continued existence in the oceans and rivers of the Earth. Of their own accord, such folks will ask what they can do.

Well, an informed activist is an effective activist, but there is more here. Dolphins, once encountered in a personal and visceral manner, invade our consciousness and engage our conscience, or at least that has been my experience. If this is the case with others —and it seems to be—then knowledge is the conservationist's most potent weapon, and people like Kathleen Dudzinski are gentle warriors on the front lines of the on-going battle. ■

Dolphins often leap to keep up with a rapidly traveling boat, or merely for the fun of it. Even though only one dolphin is visible here, do not be misled; dolphins are highly social creatures at almost all times, and there are probably at least half a dozen more beneath the water surface or nearby.

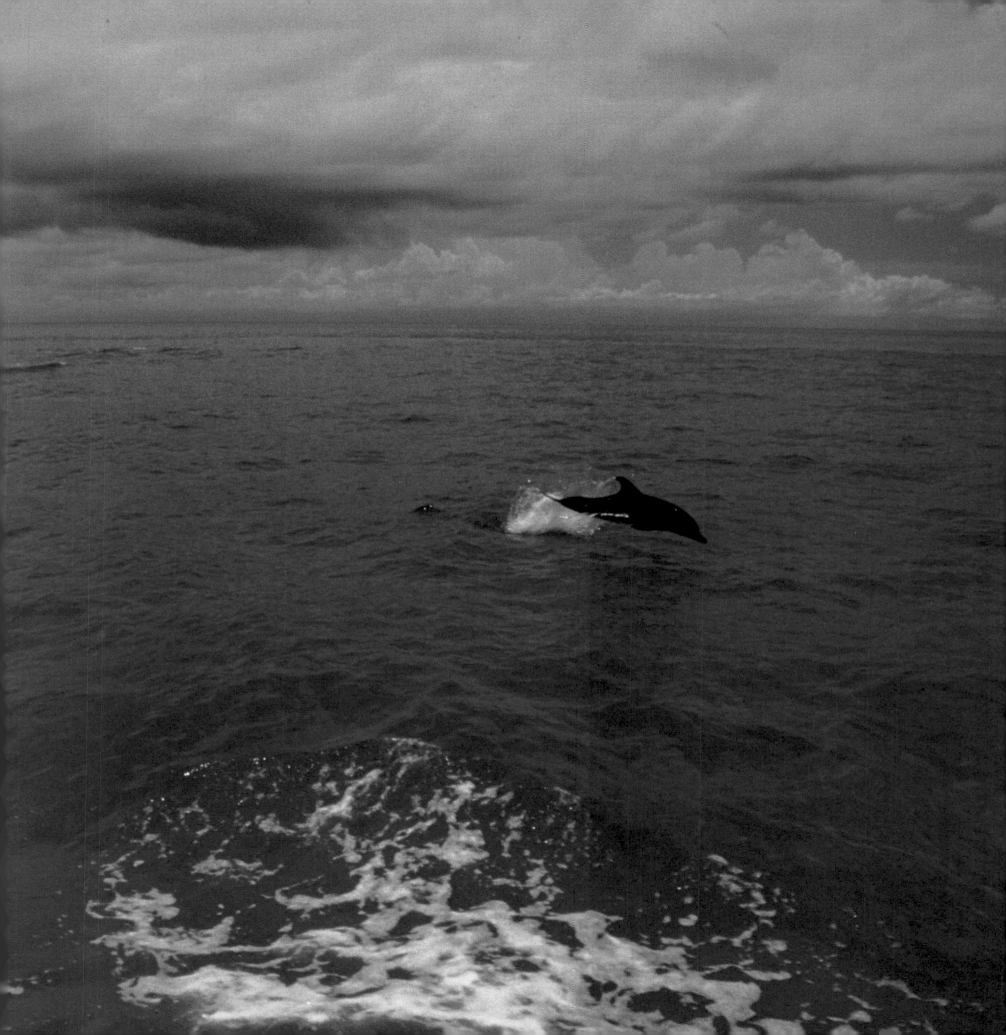

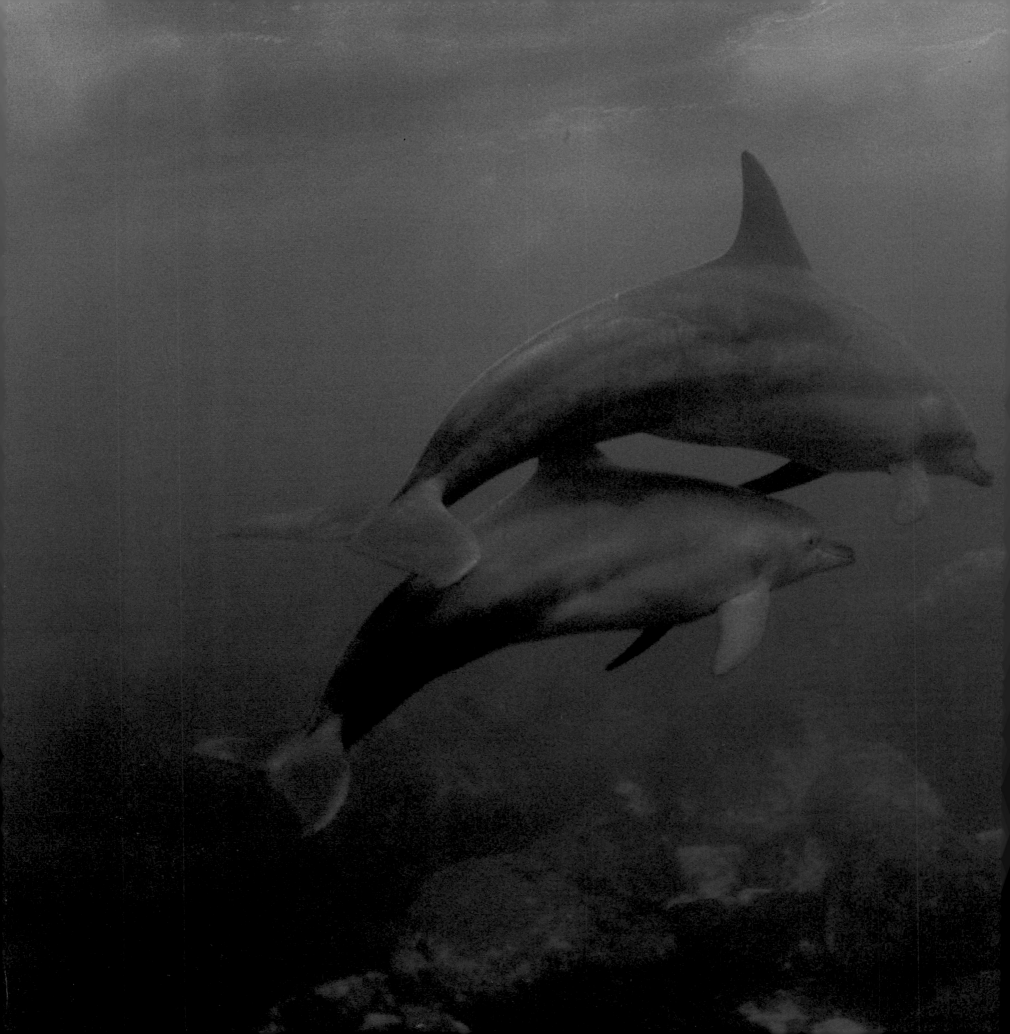

MATTERS OF MIND

Who's watching whom? These bottlenose dolphins that frequent the water around Mikura Island, Japan, are quite curious about swimmers.

In 1996, Kathleen did, indeed, earn her Ph.D. in marine biology—and, of course, she went immediately to work…as a waitress. The owners of the sports bar in Connecticut knew she'd just gotten her Ph.D.—it was on her application —but nobody else did. What was she going to say?… "Hello. My name is Kathleen, and I'll be you're waitperson today. I also have a Ph.D. in marine biology." It would be like an episode of *Cheers.*

At the time, Kathleen was 29 and back living in her parents' home in Connecticut after an absence of 10 years. Aside from her job as a waitress, she labored in a relative's apple orchard. Picking apples. Selling apples.

But she longed to be back on the front lines of dolphin research. At night, she'd go into her room and sit at her computer, typing applications for some postdoctoral fellowship or e-mailing her scientific colleagues about various issues—all the time wondering how on Earth she was ever going to finance what she knew was her life's work, because the tips a waitress makes don't add up to quite enough to purchase a research vessel. Or even buy an appreciable amount of boat time.

Small groups of five to ten dolphins are often seen resting or socializing along the rocky shoreline of Mikura Island (opposite). Besides playing among themselves, these bottlenose dolphins often chase fish, use octopuses as balls, and surf the waves near shore.

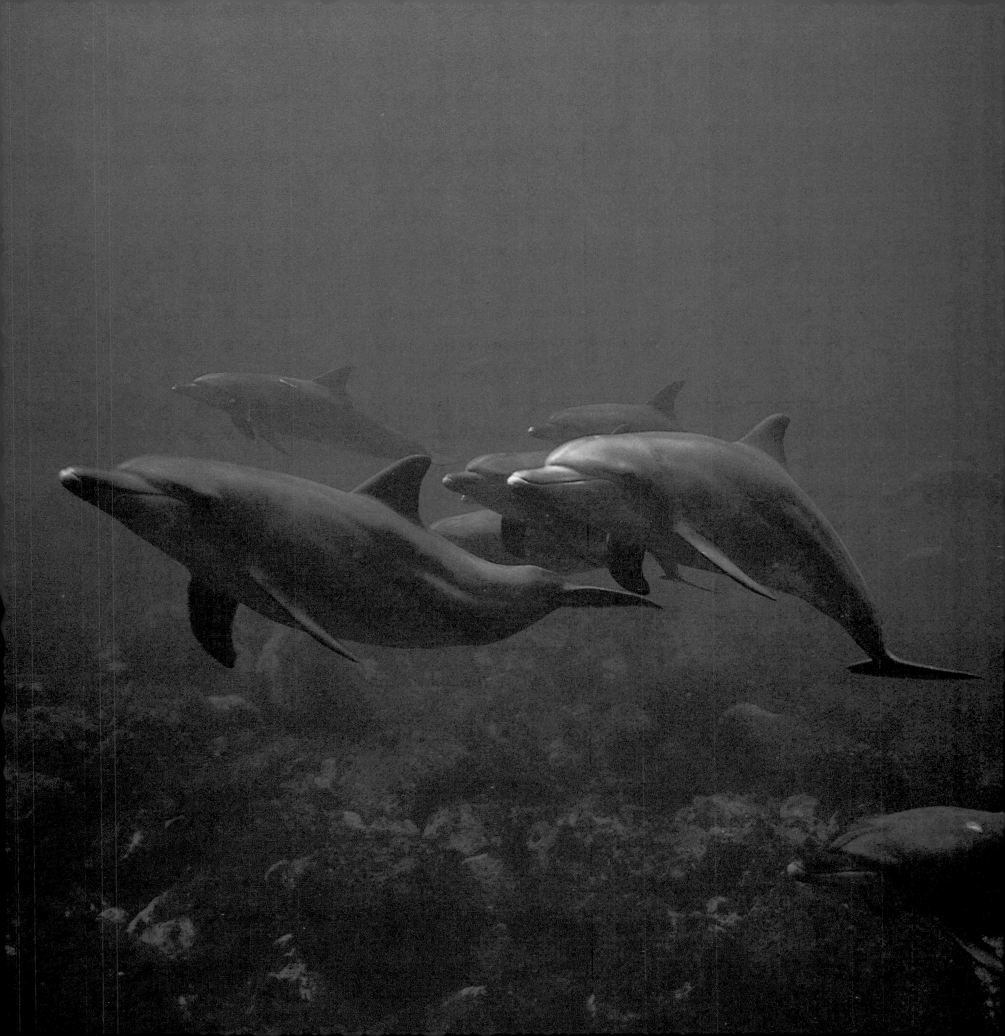

Because Kathleen works with wild dolphins, boats are an expensive necessity. The research requires long periods of waiting (all the while paying for the boats) and immense patience. In her four seasons working off the Bahamas, for instance, Kathleen calculated that she'd spent a tad less than 2,000 hours of waiting on the water. In that time, she gathered just 20 hours of good audio/visual recordings. This is a one percent return on her effort, and the reason why studying chimps or gorillas or orangutans is easier and cheaper than researching wild dolphins. You want to study, say, chimpanzees in Tanzania: sure, the airfare's expensive, but once you're there, research is mostly done on foot. Walking's free. You could follow the chimps 24 hours a day. Take notes. Watch behavior. Draw conclusions.

But a young scientist studying wild dolphins had to be able to talk her way onto various vessels; she had to have a talent for writing grants, had to be able to convince corporations and governments that there was some benefit in sponsoring her work. In short, she had to have a con man's expertise in the art of bumming boat time.

One day, after pouring beer and delivering any number of drinks and cocktails, she returned home to a call from MacGillivray Freeman Films. "Hi," Greg MacGillivray said. "We're making a large-format film for IMAX theaters about wild dolphins, and we understand that you're doing some of the most interesting work in the scientific community. Want to come out to California and talk about it?"

Kathleen's thought was, *Right, like this was really going to happen.*

But then the tickets came in the mail. And, *zoom,* there she was, out in Laguna Beach, California, sitting at a big table in a movie studio that looked more like an Italian villa. The windows looked out to the Pacific Ocean, and occasionally, dolphins passed by on errands of various urgency. Kathleen was all dressed up in her scientific symposium I-mean-business suit. Most of the MacGillivray folks were in their California casuals

As seen from Miyake-jima, Mikura Island in Japan resembles a giant muffin in the Pacific Ocean. Only 180 kilometers south of Tokyo, Mikura provides a shallow shoreline adjacent to deep, productive fishing grounds. Dolphins likely feed within a kilometer of land and rest, socialize, or play in shallow waters near Mikura after their meal.

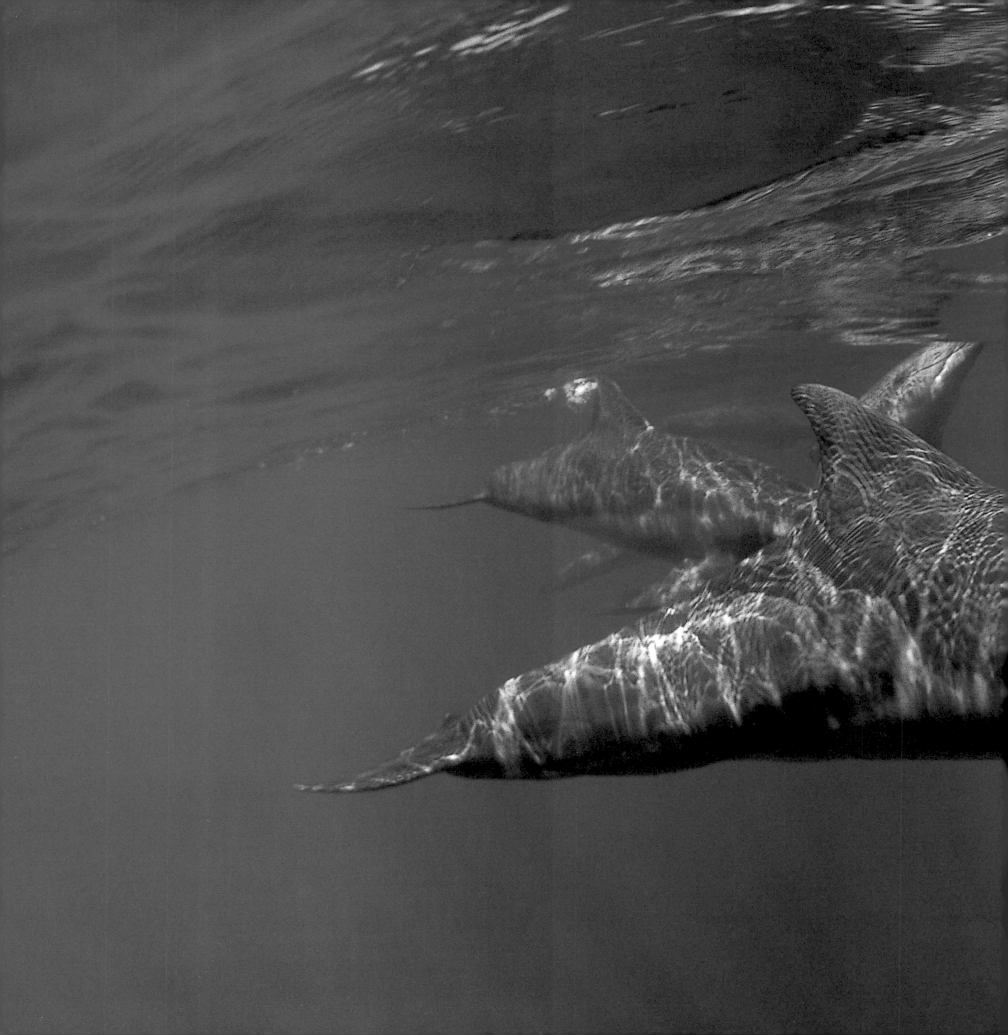

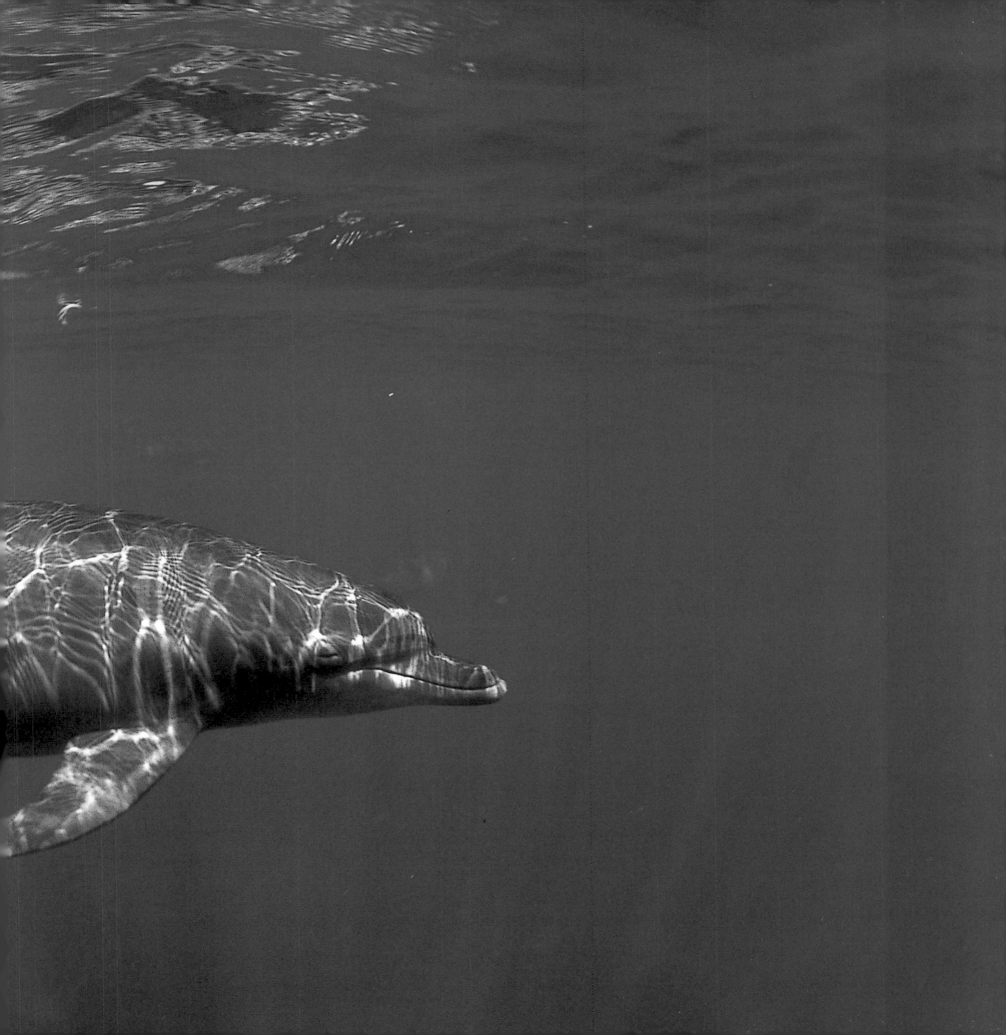

(Above) Okubohama is the beach closest to Kathleen and Umi's home on Miyake-jima, Japan. Both Miyake and Mikura Islands are volcanic, but only Miyake is still active. (Preceding pages) In small resting groups, dolphins swim slowly either just below the surface or closer to the sea floor and often breathe almost synchronously. Dolphins are voluntary breathers; they would drown or suffocate if they slept like humans. They often close one eye at a time (as seen here) while resting.

—Hawaiian shirts, jeans, T-shirts—talking about *her* work, *her* methodology; *her* mobile video/acoustic array. From key creative members of the team, editor-co-writer Steve Judson and co-producer Alec Lorimore, there were questions about the language of dolphins. And then they started asking her things about Kathleen Dudzinski. Was it true she lifted weights, for instance. Well, yes, but only because the array weighed about 20 pounds and she had to bundle it in and out of the water.

Did she really inline skate, they wanted to know. And paraglide behind a boat? What about her office? Did she have,

like, hamsters or something in her office? Kathleen began to imagine herself on the IMAX screen—a giant-size inline skating paraglider scientist who allowed hamsters to run all over her important papers—which, she thought, wouldn't exactly earn her the respect of her scientific peers.

The producers cajoled and tempted her, but mostly they tried to describe their goals as both filmmakers and educators. MacGillivray Freeman Films had long considered the movies they created as powerful educational tools. The experience of seeing their movies would be both informative *and* entertaining.

Science literacy and making the most current scientific knowledge available to the general public, not often privy to such specialized information, was certainly their higher intentions. As a co-writer on the film, I argued that scientists had personalities, just like real people. People want to know the scientists. Seeing them working in the field and listening to them talk about their work can make what seemed complicated actually quite easy to understand. Scientists, in fact, talk a lot like you and me. This all makes their work and their knowledge much less mysterious.

"But why me?" Kathleen wanted to know. "I've just earned my Ph.D. You should make movies about someone like Jane Goodall, who's spent her whole life working with chimps."

Our argument was that the film would be about the process of science, how questions are formulated and experiments devised. On screen, the audience would be learning things about dolphins as she did. We liked the immediacy and we liked the idea that, as a kid, Kathleen had organized a petting zoo for kids who'd never seen a cow. Maybe she could think of her role in the film as that of the educator she'd always been.

Kathleen would make up her own mind. She watched the MacGillivray Freeman production, *The Living Sea,* and that was the clincher. It was all luminous movement and radiant joy, and there was a wealth of scientific information in the film, all absolutely accurate and carrying a subtle conservation message. She could see why it had been nominated for an Academy Award. Kathleen weighed her personal apprehensions against the value of education and her concern for the future of the dolphins.

"Yes," she said, "I'll do it!"

THINGS HAPPENED ALL AT ONCE FOR KATHLEEN, as did her role as a minor celebrity. About the time that MacGillivray Freeman Films called, NATIONAL GEOGRAPHIC magazine ran a brief article on her work; then the Girl Scouts—who know a good role model when they see one—featured her on its Web site; *and* she was offered a post-doctoral fellowship in Japan sponsored by the Japan Society for the Promotion of Science.

The fellowship couldn't have been more perfect. The form of ecotourism in the Bahamas has existed for over 15 years in Japan, near the island of Mikura. In Japan, Kathleen could score boat time as a shipboard naturalist, as she had in the Bahamas, and she could study a different species, the bottlenose. She wondered

Jack Moyer has lived and worked as a naturalist on Miyake for nearly 35 years. Here, at the Miyake Nature Center, Dr. Moyer prepares for a fish-watching class in nearby Chotaroike, a tidal pool.

if signals and statistics she'd compiled with Atlantic spotted dolphins would carry over, or whether certain vocalizations and behaviors were species-specific.

That summer, 1997, the MacGillivray Freeman team whisked her off to the Bahamas to shoot some footage of her compiling more data on the Atlantic spotteds, and then she was off to Japan, specifically, Miyake-jima, a rugged volcanic island about 150 miles south of Tokyo. The island is lushly vegetated, about 22 miles in circumference, and dominated by a central mountain some 1,500 feet high. There have been two devastating

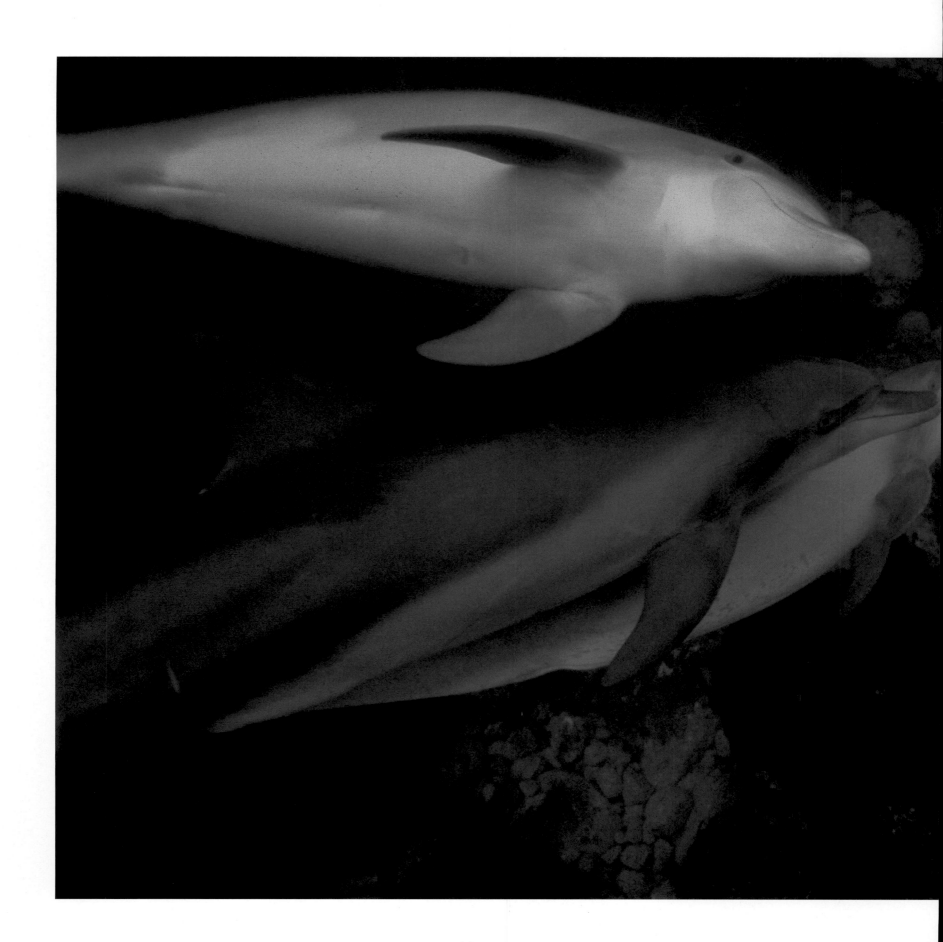

volcanic eruptions on Miyake-jima in the past 40 years. In one village, slow-moving lava poured over a high school. The shell of the place was still there, pretty much bisected by a mountainous streak of mounded black rock.

The lava that destroys school buildings eventually flows into the sea where, in a torrent of steaming water, molten rock solidifies into distorted Doric columns and blocky black coffins; into the shapes of fallen muffins and standing men and shark's fins: stark black monoliths staring out to sea. The road that follows the coast of the island had been cut through mounded rivers of hardened lava. I had the impression that Miyake-jima, seen from the air, would look like a scoop of fudge-ripple ice cream.

On the island, there is a hundred-year-old farmhouse that is now the Tatsuo Tanaka Memorial Biological Station. In fall 1997, during the first year of her post-doc fellowship, Kathleen was living at the station and just beginning her work with the local wild dolphins. She lived with Umi, a Japanese beagle puppy, whose name means "sea" in Japanese. Kathleen insisted her dog wrote haiku (well, sort of, but more on that later).

Tatsuo Tanaka's founder and director, Jack T. Moyer, then 69, was a scientist and an Asian studies scholar, who, though born in Kansas, is considered one of Japan's leading figures in the conservation movement. In 1952, while living in Japan after a stint in the Air Force, Moyer wrote a letter to various American officials protesting U.S. Air Force bombing of a small reef near Miyake-jima called Sanbondake, an important nesting site for an endangered seabird, the Japanese crested murrelet. The bombing was stopped. It is my impression that this is only one of the many reasons Moyer-san is loved and respected on Miyake-jima. Kathleen, a recent arrival, managed the station Moyer founded. It was an unpaid position that did not in any way interfere with her fellowship but did provide a farmhouse surrounded by the forest and sea.

Early in the spring of 1998, I visited Kathleen in Japan for the purpose of reviewing the film that had been shot earlier in

All dolphins are very tactile in nature, almost always in contact with other traveling companions or friends while interacting. These three dolphins were involved in body-to-body rubbing alternated with some rubbing on the rocks seen along the sea floor. Dolphin-dolphin rubbing may serve to strengthen social bonds while rock or sand rubbing may relieve an itch or just feel good.

Is There a Ball in the Pool?

BERND WÜRSIG, PH.D.—*Professor of Marine Mammalogy and Director of the Marine Mammal Research Program, Texas A&M University*

When we look into a dolphin's eyes, we see big bright unblinking orbs that remind us of a particularly intelligent school child, ready to answer the toughest questions. When we combine these eyes with a perpetually upturned mouth line, a "smile" that seems cheery and carefree, a sleek body as smooth as an innocent human baby's, then we have the makings of a myth of a kind and wise dolphin soul. This animal *must* be intelligent!

Researchers know that the large eyes are for gathering light in sunless waters, the upturned mouth line formed by eons of evolution, and the smooth round body are for the purposes of streamlining and thermoregulation as dolphins travel, dive, feed, socialize, mate, and take care of young in their dense watery world.

Nevertheless, at least some species of dolphins—for example bottlenose and rough-toothed dolphins, killer and pilot whales—are behaviorally flexible social mammals that can easily be termed "bright." While early speculation arose from descriptions of the large size and complex structure of the dolphin brain, we now realize that it is probably better to measure intelligence through behavior rather than anatomy.

And what is "intelligence"? Perhaps flexibility of behavior is the best criterion, because flexibility allows dolphins (and us) to quickly innovate even when faced with a new, never before encountered circumstance. Such innovation goes far beyond genetic programming of behavior, or acting from simple rote learning. Innovation allows for rapid assessment of a new situation, and reaction to it. Let's discuss what we know about this capability in dolphins.

Dolphins in aquaria easily learn things they could never have encountered in nature. Scientist Lou Herman has been training and testing bottlenose dolphins in Kewalo Basin Marine Lab in Hawaii for over 20 years now. Dolphins do not use words, so we "talk" to them with gestures—a sign similar to that used by deaf people and for language studies with chimpanzees and great apes. We have different gestures for different parts of speech. A bottlenose dolphin can distinguish "take the swimmer to the surfboard" from "take the surfboard to the swimmer" by pushing the appropriate object as directed. A rearrangement or elaboration of the sentence, including previously taught nouns or verbs never before used in combination ("carry the hat from the doll to the waterspout") are also quickly carried out. Such generalization indicates understanding of the conceptual framework of the sentence and is, by definition, "language."

A dolphin can also correctly answer simple questions expressed by gestures, such as "Is there a ball in the pool?" It does this by using its rostrum to press a different paddle for yes or no, thereby demonstrating an awareness of the physical, everchanging world. A dolphin can faithfully mimic another dolphin or a human when it receives the command "mimic what you just saw," even when the other image is on a television screen. As a matter of fact, only humans and dolphins appear to be able to spontaneously interpret images on a screen without prior teaching. A dolphin can repeat actions when the command is given, thereby indicating self-awareness that also goes far beyond simple learning of behaviors. Dolphins even grasp the concept of creating a new behavior and can synchronize behaviors in concert with other dolphins. Dolphins are capable of highly flexible behaviors and are therefore considered intelligent. How is this intelligence manifested in nature and does it set dolphins apart from other social animals?

In nature, dolphins have complex societies, full of relationships especially between mothers, sisters, and aunts. Males also form close bonds, and these appear to be beneficial in helping them to acquire mates. Dolphins can quickly shift food gathering techniques, either adapting to hunting alone—as in a large group that herds shoals or bait balls of schooling fishes—or in small social groups of two to six that encircle or isolate one to two larger fishes from a school. Killer whales, the largest of dolphins, teach their young how to hunt sea lions, seals, and porpoises by herding and isolating them. Adults will make sham rushes at prey, then wait as the youngsters try the same.

Dolphins also learn complicated repertoires of sounds as they grow to adulthood, and they learn to use the most advanced echolocation system on Earth to scan their environment. While anyone can argue that all of this behavior can be learned without great intelligence, it is the quick and everadaptive manner in which dolphins learn that indicates they are highly intelligent.

But when we say that a dolphin is intelligent, we must make sure that we do not lump all of the over 40 species together. The brightest ones appear to be bottlenose dolphins, killer whales, and a handful of other species. Most others—such as the oceanic forms that travel in huge herds, the near-shore Hector's and Commerson's dolphins, and the river dolphins—do not appear to be quite as behaviorally flexible or as socially adept. The brightest ones may be compared to the great apes in the brain-functioning department; the others might be thought of more like spider monkeys or howler monkeys on land. All are marvelously suited to their environments, all are social and behaviorally flexible. But only a few live up to the public perception. ∎

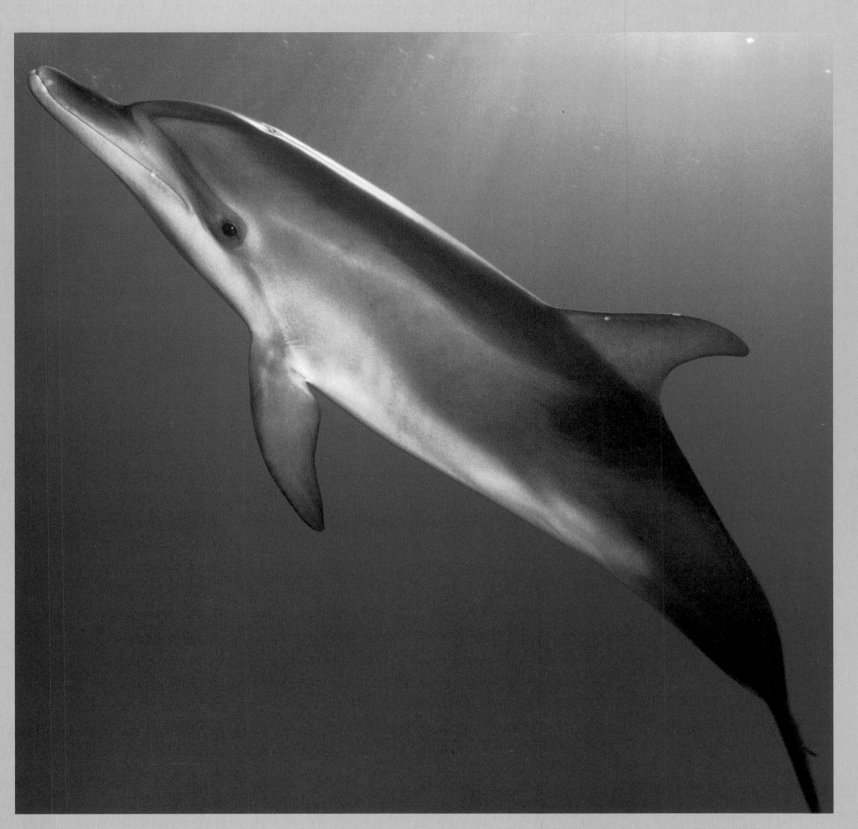

What is intelligence? It is best defined by innovative and flexible behaviors. Not all of the species of dolphins are equally "intelligent."
This bottlenose dolphin, among a few other species, is considered one of the brightest.

the Bahamas. We needed Kathleen to tell us what was happening, because, quite frankly, we couldn't make head nor fluke out of some of the footage. What were the dolphins doing in these shots. And why were they doing it?

I stayed at the station, in one of a series of rooms down a long hallway. There was a lamp in the room and a mattress on the floor. Every morning the first words out of my mouth as I walked down the hall to join Kathleen for breakfast were "Good morn—*Ouch!* (and then some other words best left unpublished). The doorways were obviously constructed for visitors not over six feet tall. Some days were worse for collisions than others. I called them bad-door days.

When I wasn't engaged in collisions, I sometimes sat with Kathleen in her A-frame office off the farmhouse and watched her analyze data, which is just as much fun as dental surgery. Because the tourist season hadn't yet started, Kathleen often worked with the 20 hours of good video she shot in the Bahamas. "I could get two more Ph.D.'s out of it," she said.

Analysis involves watching video, cataloging the behavior observed, and listening to concurrent dolphin vocalizations through headphones. The film is slowed, it is stopped, it is backed up. The sound, run through a computer, is then projected on the computer screen as a wave-form, which looks a little like the bar codes found on merchandise at the store. These observations are entered into a database for statistical examination.

Sometimes as Kathleen worked, I amused myself by flipping through her doctoral dissertation. The vocalization scientists call a click train, a creaking rusty-hinge sound, is most often used during approaches or "inquisitive behavior." Whines, high repetition click trains, are used by younger dolphins when they are excited or at play. Squawks, rather ducklike sounds, are heard in aggressive encounters and sometimes during what appears to be play. Chirps are exchanged when one dolphin is approaching another after some separation in time or space: they are used at play but never during aggressive encounters. Screams are heard from excited calves and juveniles, while whistles are emitted during every behavior and from all ages, but mostly during social and play activities. Whistles are apparently one way dolphins maintain social bonds. To complicate matters, a dolphin may often emit click trains and chirps simultaneously.

Information is also exchanged through physical contact. One conclusion I drew from reading Kathleen's dissertation is that dolphins loved to be touched…*by other dolphins.* Because their skin is extremely sensitive, how they are touched, and how intensely, conveys different levels of meaning. It is for this reason that Kathleen supports a public campaign to educate the humans: never touch a dolphin in the wild.

Tactile signals include petting, which is directed toward the melon, pectoral flippers, and lateral regions, like the peduncle. Rubbing, often used in greeting, may strengthen social bonds and signal that the rubbing pair has, at that time, a close association. Petting and rubbing are used by all age groups and both sexes. They are mostly seen during social activity and play, but not during aggressive interactions.

Kathleen had also tabulated the number of "signal exchanges." Females together in groups were more highly vocal than male groups. There were, in fact, 182 female to female signal exchanges compared to only 60 male-to-male exchanges. (And who says dolphins and humans don't have a lot in common?) Males initiated more signals with females (44 times), than females initiated with males (38 times).

Kathleen also had some tapes shot by a local couple who owned a dive shop on Miyake, and she studied them to get to know the animals she would meet during the coming summer season. She was seeing a lot of the same tactile behavior but, due to the fact that the sound on the tape was not in stereo, could not draw any conclusions about vocalization. One difference, however, was immediately apparent: while the Atlantic spotted sometimes emitted a stream of bubbles while vocalizing, the Mikura bottlenose bubble-streamed quite frequently.

I found that the tabulation of behaviors and the statistical analysis cheerless drudgery. It was more interesting when we talked about Kathleen's colleagues: her Ph.D advisor, Bernd Würsig, and a research associate Alejandro Acevedo-Gutiérrez. In the film we were working on—*Dolphins*—Kathleen would be the featured scientist; Bernd and Alejandro were consultants.

I guess, between the data analysis and the chatting, it all balanced out. Particularly because Kathleen's fieldwork seemed to me to be entirely glamorous. And fun! Now, having endured the drudgery, I longed again to experience some of the glamour of Kathleen's life.

During the summer months, the warm Kuroshio Current flows around Mikura (seen in the background above) and between Mikura and Miyake Islands. During the same time, dolphin mothers and their calves spend much time around Mikura Island, which likely represents a safe resting and play area for young while adults only need travel a few meters to an abundant fish supply in the surrounding deep (greater than 1000 m) waters.

She was already planning my underwater mystery tour with bottlenose dolphins off the nearby island of Mikura. Until the weather cleared, there were dinners, when one or the other cooked (Kathleen is great with fish); and afterward, while Kathleen worked, I'd review my own notes and research.

AMONG MY MATERIALS AT THE FARMHOUSE WAS AN article from the *New York Times* that lambasted dolphins along with people who love them uncritically, who, the article suggested, are a bunch of mush brains.

EVIDENCE PUTS DOLPHINS IN NEW LIGHT, AS KILLERS, the headline read, with a zinger of a subhead: SMILING MAMMALS POSSESS UNEXPLAINED DARKER SIDE. The story, a long front-page science-section offering, was continued seven pages later under the subtly refined headline, EVIDENCE REVEALS DOLPHINS IN A NEW LIGHT, AS SENSELESS KILLERS.

Nothing in the article was inaccurate and the evidence in question wasn't particularly new, though the prosecutorial zeal was certainly novel. There were three major allegations in the 1999 *New York Times* indictment:

The First Count: Certain bottlenose dolphins often kill their smaller cousins, harbor porpoises, seemingly for fun. Worse for the reputation of the bottlenose—our pals from the movie *Day of the Dolphin* and the television series *Flipper*—scientists don't believe the two species compete for the same food. It's not territorial but apparently a form of deadly bullying play.

The Second Count (and more damning still): Observations in both Virginia and Scotland confirm that bottlenose dolphins often kill bottlenose infants in the same way.

Infanticide is a common reproductive strategy among mammals, especially in those species, such as bears, lions, and dolphins, in which females are not sexually receptive while rearing young. Female dolphins become sexually attractive to males within days after losing a calf.

The Third Count: Dolphins don't like humans that much and never have.

In fact, people who have been in the water with wild dolphins have been bumped, rammed, bitten and, in one case, even killed by dolphins. The permanent smile on the faces of some dolphin species is purely anatomical, no more indicative of the animal's state of mind than are the tusks on an elephant. And you thought they were smiling at you, you moron, the article seemed to say.

I found the headlines incendiary, even irresponsible, given the global threats to the habitats and lives of many dolphin species. But as a journalist, they stuck in my brain. In fact, as I reviewed my notes, I was besieged by a mind swarm of new and even more disgraceful headlines, many of which wouldn't make the cut at the *New York Times*.

The article in question, for instance, didn't include information about gang rape among bottlenose dolphins because, while certainly sensational and shocking, the news probably wasn't fit to print. In Monkey Mia, a bay off Western Australia, some bottlenose dolphins herd females in estrous away from the group. They, the females, are subjected to repeated and apparently nonconsensual copulations. And the males sometimes band together in what are called coalitions to fight off other bands of male dolphins bent on the rape themselves. (Imagine the possible headlines! Behind the Smile: Unspeakable Abuse).

Additionally, dolphins do not mate for life as is sometimes supposed. The male's contribution to rearing his progeny stops at conception. The paintings one sometimes sees of a happy dolphin family—mom and dad swimming proudly with a new infant—are not entirely accurate. The female's reproductive strategy is to mate often and apparently indiscriminately. Monogamy is seldom if ever practiced; and each of a female's offspring is likely to have been sired by a different male. In the film, there is a brief, very typical mating scene. It consists of a few rapid pelvic thrusts and it's over in a matter of seconds. Blink and you'll miss it. (The Most Inconsiderate Mammal).

Nevertheless, dolphins are extremely sexual creatures. Before the orgy, however, they tend to eat like gluttons. Immense groups of dusky dolphins that swim off New Zealand's coast and off the southern coast of South America often herd their prey, driving them to the surface. They swirl about the fish, concentrating them into a compact ball. The duskies take turns swooping through the cluster of terrified fish, snapping up several in a single pass. (Dolphins Nip Marlins). After such a meal, duskies by the hundreds will leap acrobatically, each one erupting out of the water, sometimes dozens of times as if in ecstatic celebration. (Dolphins Fined for Poor Sportsmanship). After-dinner socialization and repartee consists of what appear to be flirtations, mock copulations, and repeated bouts of sex often initiated by females. (Sex for the Halibut).

Despite the bad press—and the undeniable evidence of what the paper seemed to consider dolphin iniquity—I admit to a certain mush-brained affection for the creatures, even a slight reverence. I am not alone. Stories of relationships between dolphins and humans are as old as the written word. I'm a sucker for them—and the more sentimental, the better.

Almost 2,500 years ago, the Greek historian Herodotus wrote about a musician named Arion, a lyre player sailing home after a concert tour. The ship's crew, music critics all, tell Arion that they are going to take his money and toss him overboard. Arion is granted his dying wish and is allowed to sing one

Continued on page 102

Round scars on this bottlenose dolphin are from a cookie-cutter shark—a small, deep-water shark (not more than 44 cms) that feeds by twisting its tail while biting prey. Dolphins can probably out-swim the sharks, but may be more susceptible while distracted by feeding themselves. Such permanent scars provide researchers with a reliable way to identify individual dolphins.

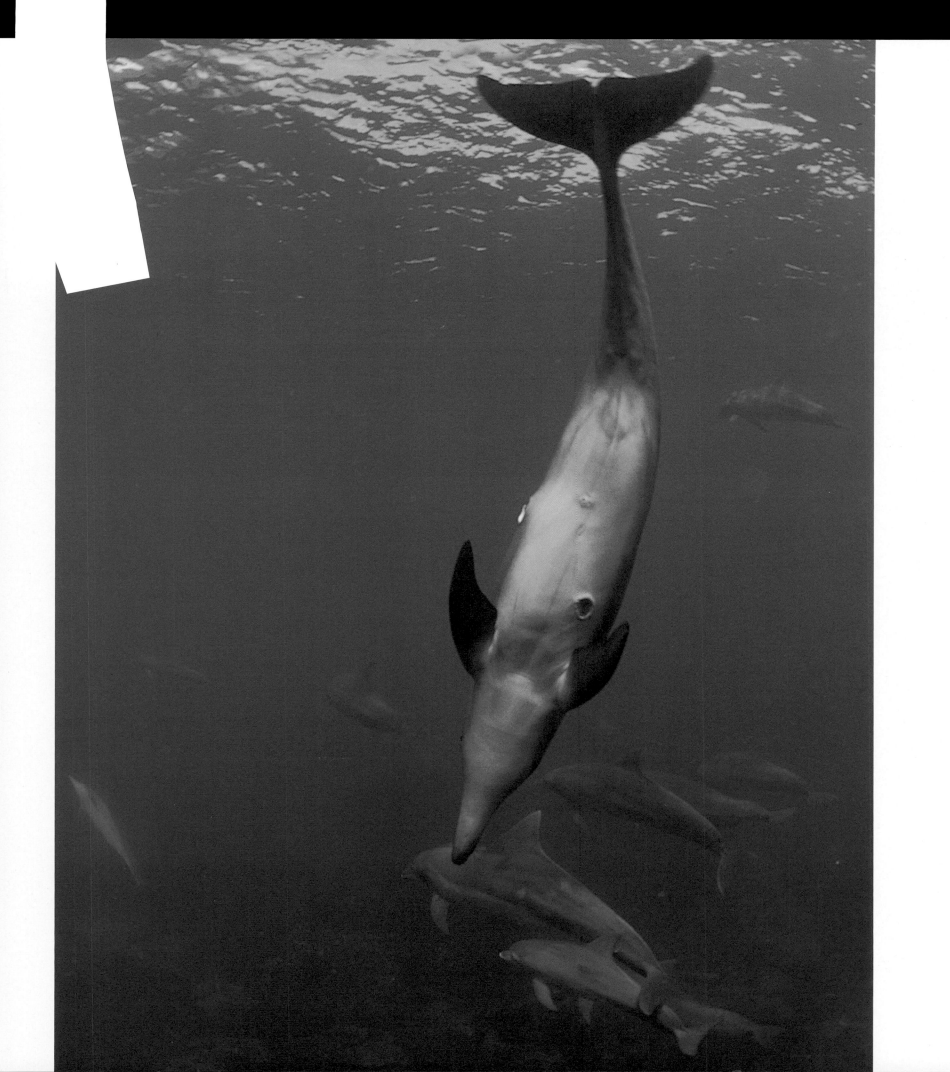

MATING AND REPRODUCTION

RANDALL WELLS, PH.D.—*Conservation Biologist, Chicago Zoological Society and Director, Center for Marine Mammal Research, Mote Marine Laboratory, Florida*

On a calm, sunny mid-May morning in Sarasota Bay, Florida, a baby dolphin's head breaks the water's surface alongside its mother's as it takes its first breath of air. This is the beginning of an association that will continue over the next three or more years, until the calf joins other newly independent juveniles —young dolphins that have left their mothers and are now making their own living. During a typical year, five other pairs of mothers and newborn calves will begin the same pattern during the annual breeding and calving season in Sarasota Bay, the site of the world's longest-running study of wild dolphins, and year-round home to a hundred resident bottlenose dolphins.

Female bottlenose dolphins begin to produce calves when they are 6-10 years of age, and may continue into their late 40s. Calves are born during the late spring and early summer, after a 12-month gestation. They are born tail-first, at a length of about 115 cm (45 inches), slightly less than half the mother's. Newborns weigh about 20 kg (40 pounds), only about 1/10th of mother's weight. The birth can take 45 minutes to several hours, after which the mother snaps the umbilical cord and the precocious calf swims unaided to the surface for its first breath. Within several hours the calf will begin taking rich, fatty milk from one of two nipples on the mother's belly. The duration of the period of nursing is variable from one calf to another. Typically, nursing will continue for the next year or two, until the calf derives most of its nutrition from fish that it catches on its own. In some cases, however, mothers have been found to produce milk for up to 7-year-old calves, apparently supplementing their fish diet.

Mothers invest most heavily in the rearing of their calves. Male participation appears to be limited to impregnating the female. This comes after extensive practice at copulations, beginning within the first few weeks of life. Heterosexual and homosexual copulations are common among dolphins, especially juveniles. Sexual interactions are apparently used to develop and maintain social relationships. Male-female copulations involve mounting, often with the male approaching the female from the side or underneath, belly to belly. Copulations involve rapid pelvic thrusts, and are completed within a few seconds. They may be repeated frequently; dolphin testes are large, and sperm concentrations are very high.

Adult males, as individuals or strongly bonded male pairs, move from one female group to another in search of receptive females. Once potential mates have been identified, males associate with adult females for periods of hours to weeks prior to conception. Male pair bonds form at sexual maturity (8-12 years of age), and are maintained for the life of the males (up to mid-40s)—members of a pair are nearly inseparable. Adult male pairs may guard the soon-to-be-receptive female by flanking her, one male on each side and slightly behind. In this way they guarantee their presence when she becomes sexually receptive, and can prevent other males from associating with her. Observations of captive male dolphins suggest that each member of the pair may mate with the female; the actual sire has not been determined in most cases. Paternity testing of males from Sarasota Bay indicates that unpaired males may also sire calves, though their strategy remains to be identified. While males from within the 100-member resident Sarasota Bay dolphin community sire most calves, up to about a third appear to have been sired by males originating from other communities, presumably from adjacent bays and coastal waters.

The process of mate selection has not been well defined for any dolphin species, but is best known for bottlenose dolphins. In particular, much of what we know about bottlenose dolphin mating systems originates from Sarasota Bay because of our 30 years of observations of the four generations of resident dolphins, and because of genetic paternity testing by Debbie Duffield of Portland State University. It has been shown that successfully breeding males tend to be full-grown individuals more than 20 years old, at least ten years beyond sexual maturity. The degree to which each gender controls mate selection is as yet unknown. Whether females are choosing these males because of their size or competitive abilities relative to other males, whether the males are using their larger size to coerce females, or some combination of these strategies remains to be determined. What is known is that monogamy is rarely if ever practiced by these dolphins. Males may associate with a variety of receptive females during a single breeding season. And typically, a different male will have sired each of a female's calves. ■

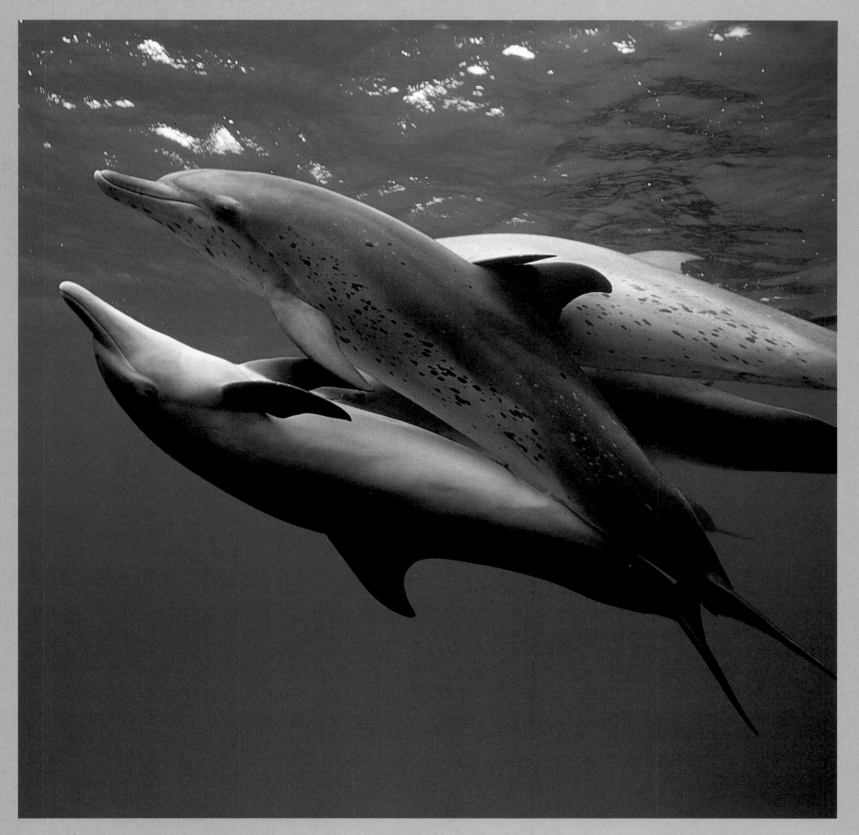

Dolphin mating is usually a quick affair, lasting no longer than several seconds to a minute at most. Generally, the male approaches from the side or underneath. A receptive female will have several males paying amorous attention to her, and she may mate with all of them in a short space of time.

When I took my first job as a freshly-baked Ph.D. in the late 1970s, I replaced a retiring professor well-known for his excellent research on feeding habits of dolphins, porpoises, marine birds, pinnipeds, and fishes. The way he had studied the animals was to go out and get them, cut open their stomachs, and see what had been eaten— at night, in the daytime, in deep versus shallow water. He would go out with a harpoon, lance several dolphins or porpoises as they rode the bow wave, and then he and his graduate students would sort squid beaks, scales, fish otoliths, and other remains recovered from their stomachs. He was not a "bad person"; he merely came from a different generation, a different paradigm of study, that we in our Western society simply do not engage in with dolphins and whales anymore.

Today, almost all of our studies tend to be more benign or less invasive. We used to drill holes through the dorsal fins of dolphins to fasten cumbersome radio transmitters to their bodies. Now we more often use smaller transmitters mounted onto streamlined saddles that are held to the base of the dorsal fin with an ingenious array of suction cups. We still lance and shoot finger-size hollow darts at dolphins and whales for genetic, body tissue toxin accumulation, and take small skin biopsies for biochemical genetic and protein analyses. But my student colleagues and I have recently developed a simple "skin swab" technique to gather small samples of sloughing skin without puncturing the body. Refinements in analyses are making it possible to obtain information from very small samples, and these new techniques appear to evolve in tandem with the general paradigm of our times: "Do as little harm as possible in your studies."
—Bernd Würsig

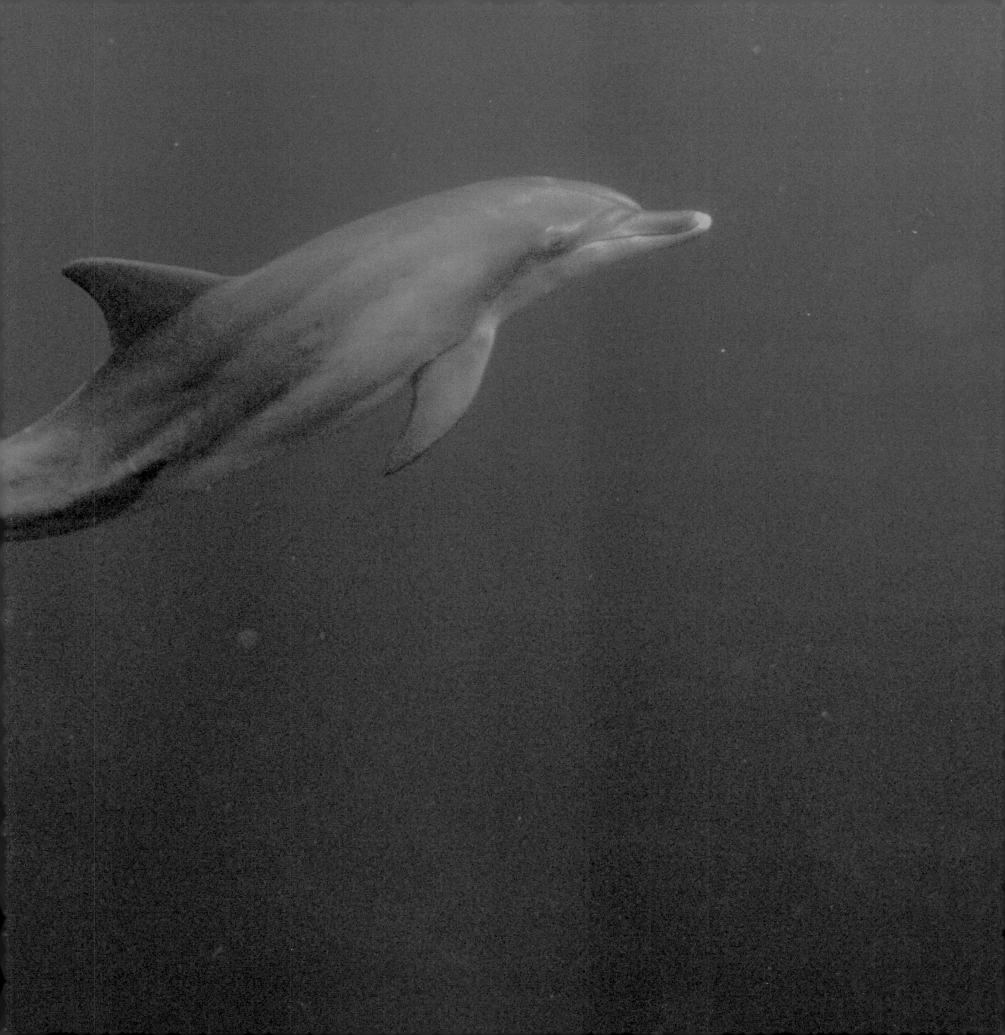

Continued from page 96

last song. His music summons friendly dolphins, and Arion steps over the side of the boat, to be carried ashore on the back of one of the cetaceans. (Dolphins Steal One from Mariners).

In the first century A.D., Roman naturalist Pliny the Elder wrote of a boy who rode a dolphin to school every day across the Bay of Naples. One day the boy died. Weeks later, the dolphin washed up on shore, dead, one is given to understand, from a broken heart. (Boy, Dolphin in Bizarre Suicide Pact).

Now, the truth of the matter, as the offending article reported, is that many people who have tried to swim with wild dolphins have been butted and bitten. Well, some people have been bitten by gorillas—and yet others sit in their midst unchallenged and unharmed. It is a simple matter of etiquette, and the interactions are different with each type of animal. Dolphins, for instance, find a direct approach threatening, not surprising in a creature that uses head-butts to drive off sharks, discipline unruly members of the group, and sometimes kill.

So why are there so many hostile encounters between wild dolphins and humans? The one reported death, as Kathleen has repeatedly told participants on dolphin diving trips, happened in Brazil, and the details are instructive.

In March 1994, a bottlenose dolphin named Tiao began appearing on the beach near São Paulo. Tiao did not seem to be associated with any nearby dolphin group and was obviously attracted to humans. Such animals, often called ambassador dolphins, are rare. No one knows why they prefer to associate with humans rather than their own kind. But the attraction was mutual. According to BBC's *Wildlife Conservation Magazine*, "At times, Tiao would be surrounded by up to 30 people, climbing on his back, tying things to his flippers, sticking things into his blowhole, hitting him with sticks, even trying to drag him out of the water to be photographed with the family and kids on the beach." In December, after nine months of this, Tiao rammed one man to death and injured several others. It is said there was drunkenness involved, and that the man who was killed had been trying to shove a stick into the dolphin's blowhole.

These days, when Tiao visits the beachfront near São Paulo, people get out of the water and accord him the respect due both ambassadors and wild animals.

One afternoon, Kathleen and I watched a film sequence involving an ambassador dolphin named JoJo in the Caribbean. The bottlenose dolphin appeared one day in 1980 near the beaches of the Turks and Caicos Islands. JoJo seemed to be soliciting human companionship, but when people attempted to touch him or swim with him, JoJo became obstreperous. Some people were butted or bitten. There were injuries.

A professional naturalist named Dean Bernal met JoJo while swimming. I'd already spoken with Dean at length. He has a degree from University of California, Santa Barbara, but he is not a scientist. He's a swimmer. It is necessary to point out that few humans swim as hard and tirelessly as Dean. He holds several professional diving instructor certifications, can hold his breath for more than five minutes underwater, and swims daily when he has the chance, often for miles and for hours, moving smoothly over reefs and sandbars and the cobalt blue of abysmal depths. Which is how he met the dolphin.

JoJo began following Dean, first at a distance, then moving ever closer until the dolphin eventually swam at the human's flank. "I never tried to touch him," Dean said, but occasionally, the dolphin touched him. On their long swims together, they encountered sharks and manta rays and occasionally hump-backed whales. Dean listened to JoJo mimic the whales' calls. And every once in a while, Dean would stop, tread water, and also sing. Nothing very fancy; just a few bars of some song. JoJo would rise up and mimic him. There they were, the two mammals, singing away in the middle of the ocean.

JoJo, meanwhile, was being called a "dangerous dolphin," by beachfront resorts anxious to prevent injuries to their guests. The lone dolphin approached humans in shallow water, but those who tried to touch him were often injured. "Dolphins," Dean told me, "often see unsolicited touching as aggressive. And they react defensively."

Plans were made to capture the dolphin. Bernal (like Jack Moyer) began a letter-writing campaign that culminated in 1989 with a declaration from the Minister of Natural Resources

Dean Bernal and JoJo have formed a unique human-dolphin friendship. They play often near coral reefs in the clear blue Atlantic off the Turks and Caicos Islands in the Caribbean. They communicate with postures, behaviors, bubbles, and maybe sounds.

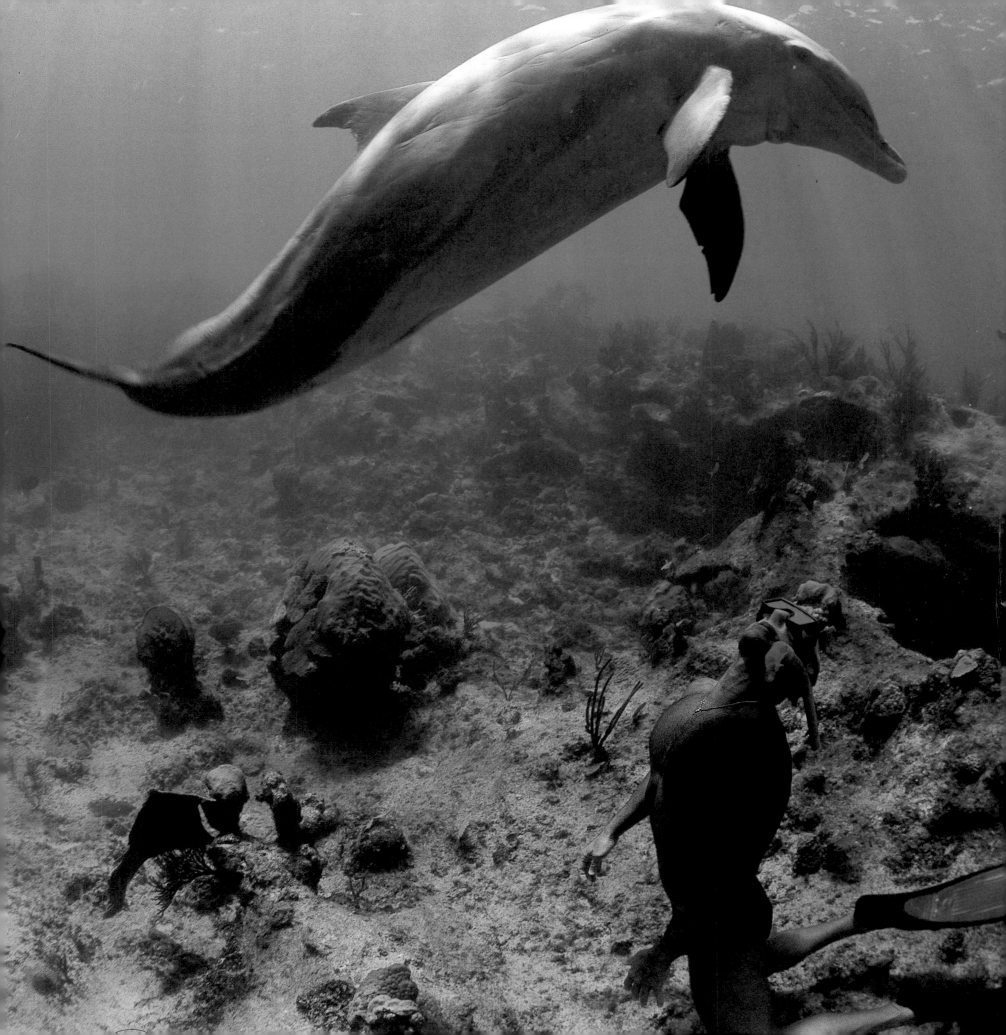

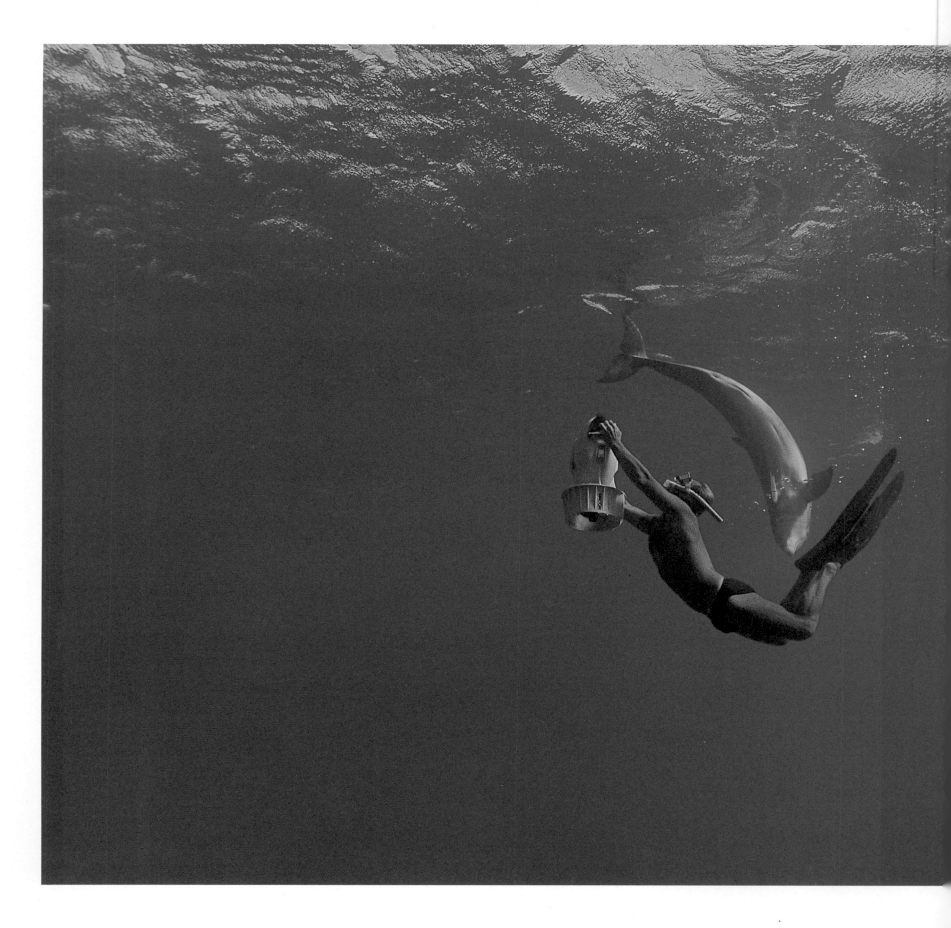

that JoJo would be protected as a unique resource to the Turks and Caicos Islands. The dolphin was declared a National Treasure, and Bernal was appointed Marine Mammal Warden and National Park Warden for the Turks and Caicos Islands.

Still, all is not well. Speedboats, jet-skis and other watercraft from beachfront resorts make swimming dangerous. JoJo has received 37 injuries since 1992 related to water skis and boat propellers, eight of which were life threatening. Dean has been able to provide medical attention that likely saved JoJo's life. "When JoJo's hurt," Dean said, "he usually seeks me out."

"Seems a proof of intelligence," I said.

"Well, dogs do that," Dean said. "Some horses too."

When JoJo needs medical attention, Dean tries to find a secluded beach to keep curious humans away. The doctoring is done very near shore, in a foot of water. Dean can call JoJo with a whistle or hand signals, which he likes to keep secret—"otherwise, people imitate my signals in order to play with the dolphin. JoJo doesn't get what he's expecting, and it breaks the trust we have. Our whole relationship is based on that trust."

Once JoJo is called into shallow water, Dean rolls him in the gentle surf, applying antibiotics to the wounds and giving the dolphin various antibiotic pills, which requires placing his hand in JoJo's toothy mouth. The dolphin accepts the pills passively. Perhaps JoJo perceives the handling as a form of comfort to his pain. Alternately, the dolphin may actually understand that these treatments somehow heal him.

In response to requests for consultation on dolphin welfare, Dean has been studying lone social dolphins, ambassador dolphins. He's swum with individuals off the shores of Norway, Japan, Egypt, Belize, Ireland, and Italy. He is just as puzzled by the phenomenon of the lone social dolphin as the scientists who study it. He has some ideas, though. After one ambassador dolphin was autopsied, it was found that it had only half a lung. "So maybe," Dean said, "it couldn't keep up with the other dolphins and sought human company." Another dolphin, off Egypt, gave birth to two calves, each of which died within a

Dean and JoJo swim together in the deeper waters off the Turks and Caicos Islands. Though an excellent swimmer with amazing breath-holding ability, Dean uses a motorized scooter to keep pace with JoJo when their play kicks into high speed. They often mimic one another during such play times.

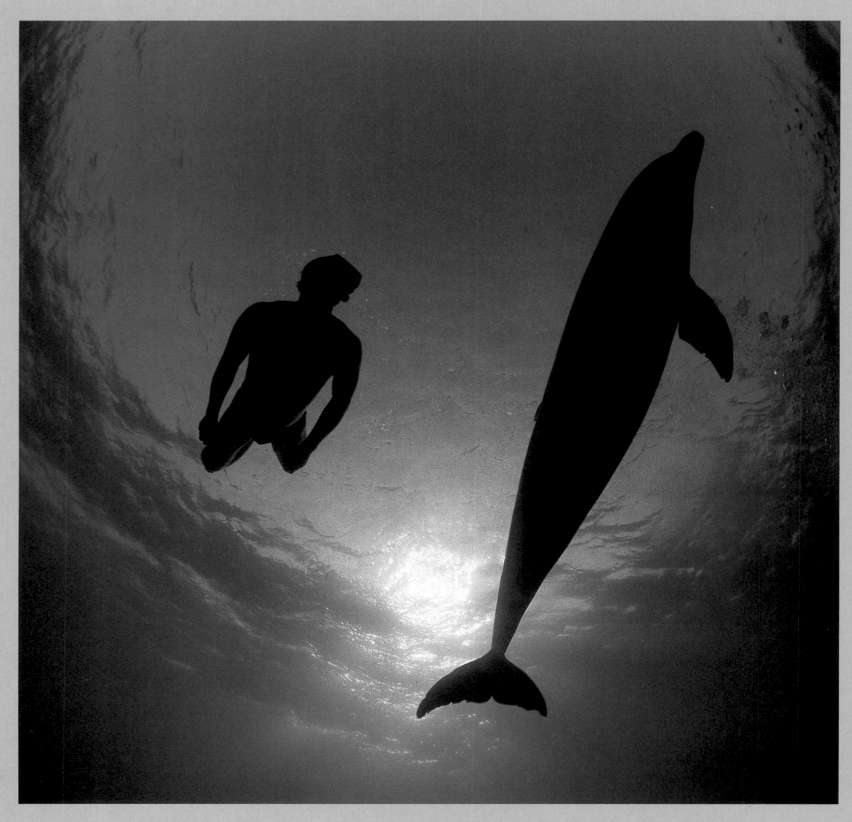

Since ancient times, humans have been fascinated with dolphins. Today, more people than ever before seek to interact with them. We can witness their aquatic grace, but we should not forget their potential for aggression and respect them for the wild animals they are.

SANCTUARY FOR DOLPHINS

Brenda Peterson—*author of* Living by Water *and* Intimate Nature

We are swimming in tropical waters warm as blood off a Hawaiian island lost in early morning fog. Whispering through this volcanic fog comes the sonorous *twoosh, twoosh* of surfacing spinner dolphins, bright breath from their sleek blowholes rising in 100 mph exhalations. Elegant acrobats, the spinners pirouette and propel sideways through mild waves, rocking us in their luminous wake.

This protected Hawaiian bay is a spinner dolphin sanctuary I've long visited. I am here as a journalist to profile a study of this sensitive dolphin habitat by Ocean Mammal Institute (OMI). From their land-based research perch on lush cliffs high above the bay, OMI researchers are documenting the effects of swimmers, kayaks, and motorized vessels on the wild spinner dolphins.

This morning the dolphins are sailing in from a night's frolicking and fishing in the open, more dangerous seas. In this shallow, sandy-bottomed cove, it is easier for them to see the shadows of sharks lurking. Here, the small pods of spinners retreat, silver-gray bodies rising and drifting in synch.

"We can tell the time of day by watching dolphin interactions." Leigh Calvez, Research Director for OMI has explained to us.

There are only two of us swimmers this morning in the bay. But in several hours the kayaks and motorboats will arrive, just at the time when the dolphins most need to rest. "For the dolphins, it's like coming home from a 15-hour workday to find people in your bedroom ready for a party who insist on being entertained," Calvez says.

From dawn to nine a.m. is the most unobtrusive time to enter this bay because that is also when the dolphins are transitioning from sea to sanctuary waters. They are still high spirited from the open seas and night feeding. And sometimes, as with us now, the spinners seek contact. The waves are full of dolphin talk—ultrasonic blips, bleeps, whistles, and clicks of their complex echolocation. Dolphins always know exactly where they—and their family pod—are.

They also know by simply scanning us awkward humans floating in their quiet bay, that we are here. Their sonar "sees" right through our skin, much like our ultrasound techniques, and they can actually read the tumult and gurgle of our gastrointestinal tracts.. Do dolphins delight in our presence as we do in theirs? Or, rather, do we intrude on their highly social and complicated system of communications?

Floating in the morning mists, my body is zinging with dolphin sonar, like a fast-paced Ping-Pong game played with sound. The first time I experienced this echolocation was two decades ago at a dolphin research facility in the Florida Keys. In that captive swim program bottlenose dolphins encountered hundreds of humans a month. On those early swims, I was troubled by the fact that these dolphins had been taken from their wild families and separated. Though they did not have to struggle with pollution, predators, or parasites and were given the best veterinary care, captive dol-phins did not live significantly longer than their wild cousins.

My personal conviction that captivity for dolphins was injurious to them came when I met my first captive-born dolphin. Still wrinkled from the womb, he swam close under his mother's protective pectoral fin as she taught him to take each conscious breath. Sadly, I realized this newborn dolphin would never know the freedom of traveling the wide, ocean world–with-out underwater fences. As exhilarating and instructive as it was to encounter captive dolphins, I had to ask this ethical question: Is my own fleeting pleasure worth a dolphin giving up a lifetime of freedom?

The Ocean Mammal Institute researchers are asking similarly difficult questions now of the wild dolphin sanctuaries into which many swimmers and kayakers daily venture. They've discovered that wild dolphins sometimes seek interaction with swimmers, especially in the early morning.

As I float now in this Hawaiian bay, I am with the few swimmers and Hawaiians who are working to protect these dolphins. Listening, face down, mask veiled by the sudden storm of sand, we are surrounded by dozens of spinners. Leaping over our backs as if to celebrate a night of good fishing, they flip tail-over-head and playfully splash us.

Such encounters are often moving and joyful. But after this exultant greeting, the spinners regroup and glide toward shore, toward refuge, rest, and privacy. In the distance now, we see their dorsal fins rising and falling in perfect rhythm.

The OMI researchers hope their data will help a concerned community protect this small bay and officially declare it off-limits to motorboat traffic and kayakers. By setting aside such sanctuaries for wild dolphins and by carefully scrutinizing all captive situations, we humans can help preserve the health and the very existence of our mammalian cousins and the sea we all share. ■

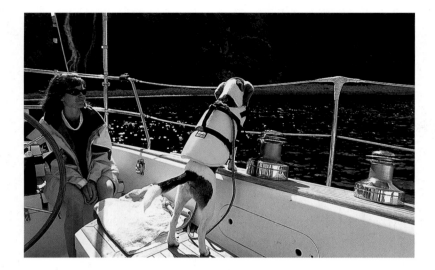

(Above) Umi, the mighty sea beagle, searches for dolphins around Mikura Island with Kathleen. (Facing page) Placement of the flipper (pectoral fin) against the side of another individual between the dorsal fin and tail is a "solicitation" or request for favor or aid at some future point. This behavior is the same in spotted, bottlenose, and dusky dolphins.

year. "Maybe she has some genetic defect that makes it difficult for her to swim with the others. But… she must have socialized at one time. I mean, how else could she have gotten pregnant?"

JoJo, however, is a dolphin who seems healthy enough, and humans aren't his only social contact. The dolphin often swims with other bottlenose, though he sometimes prefers to be completely alone. He has a personality.

So does Dean, of course. He's a man who drinks herbal tea, shuns alcohol, says he dreams of Atlantis, and believes in reincarnation. But he holds no special illusions about dolphins as a whole. He has personally seen bottlenose dolphins kill porpoises off Norway, for instance, and probably knows one single dolphin as well as any human being has ever known any wild dolphin. But he is no mush-brained romantic, and when he told me about the time JoJo saved his life, he did it unemotionally, in the manner of a scientist who observed an interesting behavior.

Dean was working on a film about breath-hold diving, and JoJo was just hanging around, curious as ever. They were out in about 200 feet of water, on a day when the underwater visibility was over 200 feet. The filmmakers were all aboard the support boat. Only Dean was in the water when a big hammerhead shark came gliding up. Dean heard people shouting at him, heard the

word "hammerhead," and saw the shark slowly approach, no more than 10 feet away. "Its head," Dean said, "was about three and half feet across, eye to eye."

Hammerheads are dangerous, certified man-eaters, and they are a sleek, cunning, efficient predator. The shark carries one eyeball and one nostril at either end of a hammerlike head, and that is what Dean saw, moving toward him. He turned for the boat, "and, I bumped into JoJo," he told me, laughing. "I think he was hiding from the shark, using me as a shield."

All of sudden, things began happening very quickly. JoJo moved around in front of Dean as he swam for the boat. Dean felt a scraping down the back of his legs, and when he turned to look, the skin there was scraped, as if he'd fallen and slid on pavement. The shark had somehow grazed him. *How?*

Dean looked down. JoJo was vertical in the water, his head pressed against the back of the shark, and he was driving it down. The shark was pinwheeling, but JoJo kept the contact rather more toward the shark's head than its tail. Dean watched as JoJo drove the shark 200 feet down, to the bottom of the sea. Sand was thrown up as the shark hit the sea floor.

Dean had swum to the boat, but only to get his small video camera. He has grainy pictures of the hammerhead being driven into the sand. The shark rose, and JoJo rose with it, always staying just behind one of the flanges of the hammer-like head, in the shark's blind area. Every once in a while, JoJo would scoot around in front of the shark's head, distracting and annoying it. And every time the shark got within 60 feet of Dean, JoJo would move on top of it and drive it back down.

This went on for about 10 minutes, and Dean has the film to prove it. He said it was like watching a crow harass a hawk, "only not so…flighty, I guess is the word." Finally the hammerhead, annoyed and distracted, swam away. JoJo took up a station about 60 feet from Dean and sent out numerous sounds, probably using echolocation to see if the shark was still in the area. Apparently satisfied that the hammerhead was gone, JoJo approached Dean and circled him for some time.

"You've saved JoJo's life, and he's saved yours."

"Well," Dean said thoughtfully, "mostly we just swim and play and sing."

"Sounds like a great relationship," I said.

"It is. Oh, it really is."

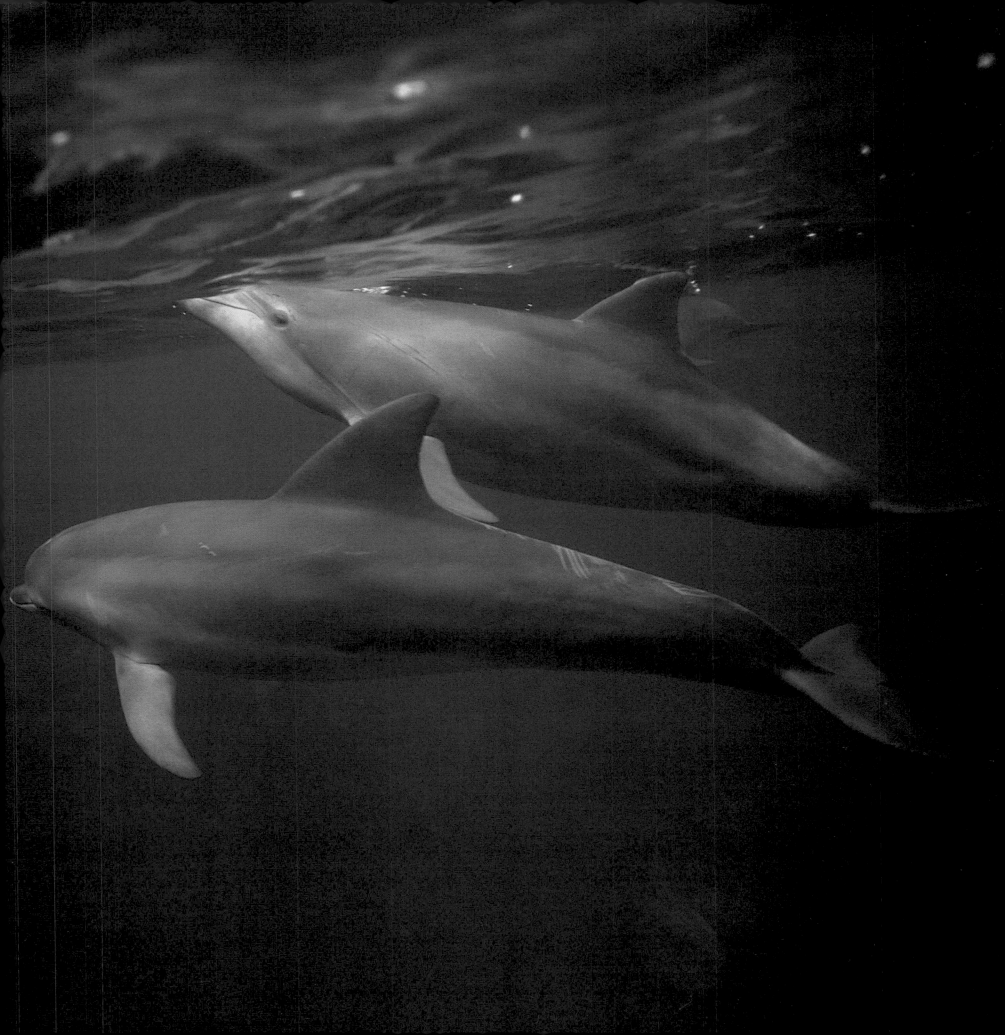

AGGRESSION

Like puppies or other young, dolphins often use the behaviors associated with adult fights during play. Here, two juvenile spotted dolphins display jaws while rubbing and rolling over each other.

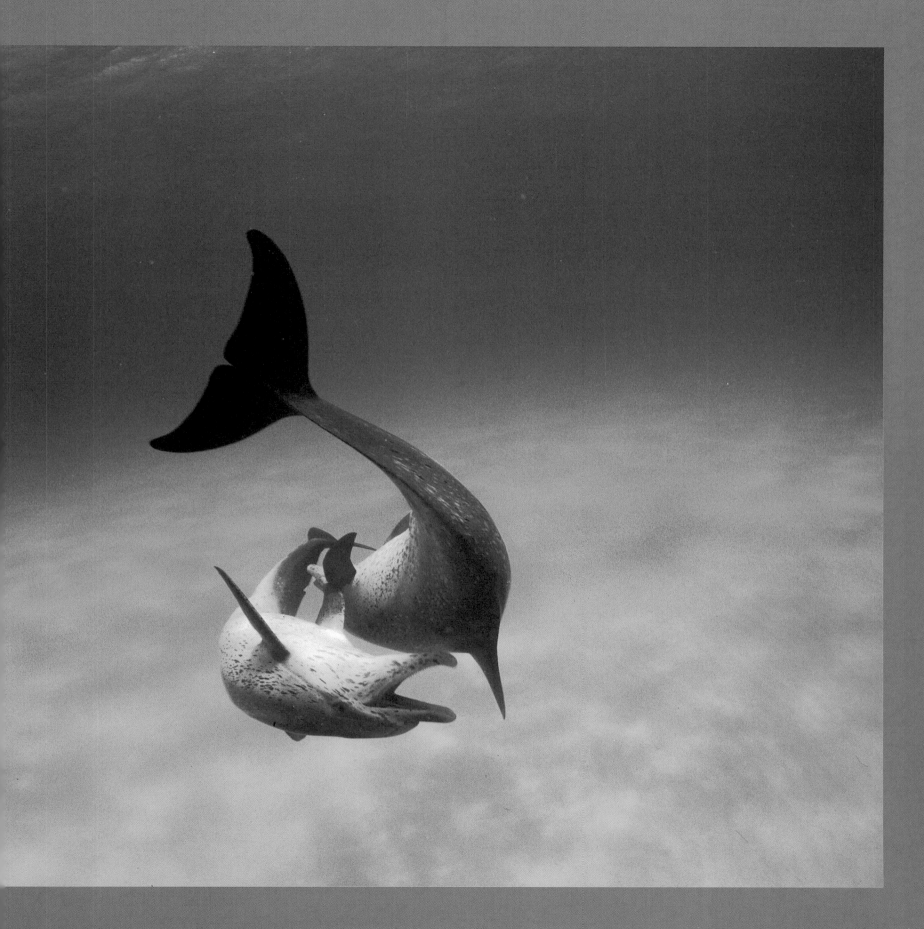

*Only a few years ago, researchers were surprised to discover that certain bottlenose dolphins of the Scottish coastline repeatedly encircled their smaller colleagues, harbor porpoises, singled out one porpoise and then rammed and tossed it around until serious injury, or even death, resulted. At this writing, dolphins are known to have been responsible for over a dozen harbor porpoise deaths, and the mystery is **why**? It may be that dolphins and porpoises compete for the same food, and dolphins are attempting to dissuade porpoises from invading their territory. It may simply be that the dolphins are having fun in an aggressive manner, but with gruesome results.*

Dolphins are animals living in challenging environments. Even the trained biologist who may have been studying dolphins for many years is taken aback by their occasionally brutal, or what seems to be brutish, nature. Scars and nicks on their bodies attest to almost continual raking, nipping, and biting of each other. In captivity, such harassment—of subdominant by dominant animals, often older males inflicting injury on younger or smaller animals—can result in serious injury and even death. It is believed, however, that while living in their natural environments, such aggression results in the structuring of wild dolphin societies. Males, for example, may be found more often stationed on the outer edges of a school, perhaps helping to protect others in the group from danger.

Aggression has been seen in many cetaceans. Pilot whales, false killer whales, and killer whales have all displayed, much like the Scottish bottlenose, aggression toward others; although, these toothed whales may simply be getting a meal. The apparently cruel manner in which they dispatch their prey, by flinging it high in the air or by repeatedly ramming it, or the aggression of the Australian bottlenose, is a reality far from the public's general belief that dolphins are gentle. We should avoid applying labels such as "cruel" or "nice" for behaviors we cannot at all times understand, and which are reflections of human sentiment. We should simply acknowledge that dolphins in the wild are animals trying to make a living and survive.
—Bernd Würsig

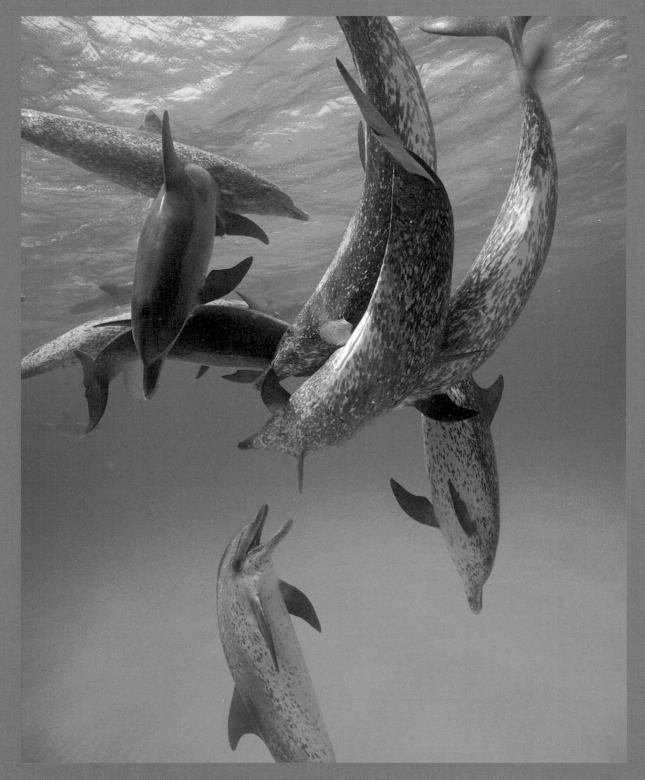

Dolphins often alternate affiliative behaviors with aggressive actions. They will hit, bite, rake, blow bubble clouds, and squawk, whistle or "pop" loudly, then suddenly break away and rub partners affectionately.

Dolphins are ever curious. Jaw displays were always considered aggressive displays, but many young dolphins will jaw peers and rake their jaws over each other in play. Similarly, direct approaches are associated with aggressive postures and intent. Young dolphins may need to practice these behaviors to learn their social significance.

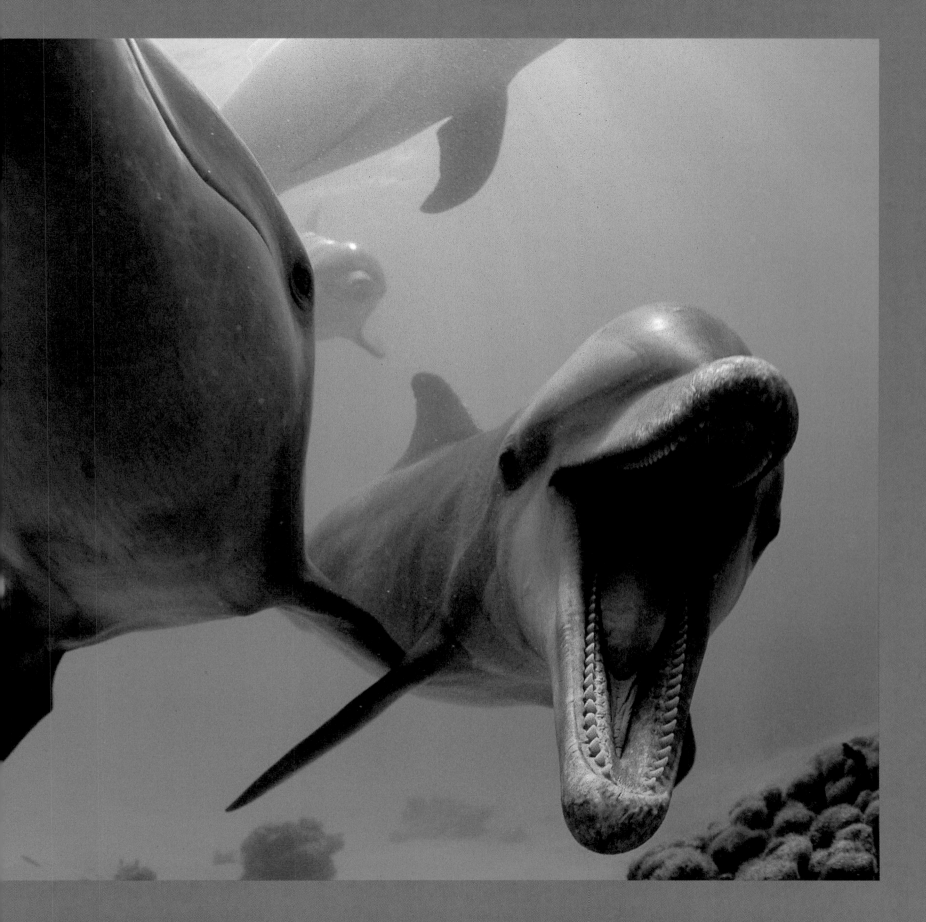

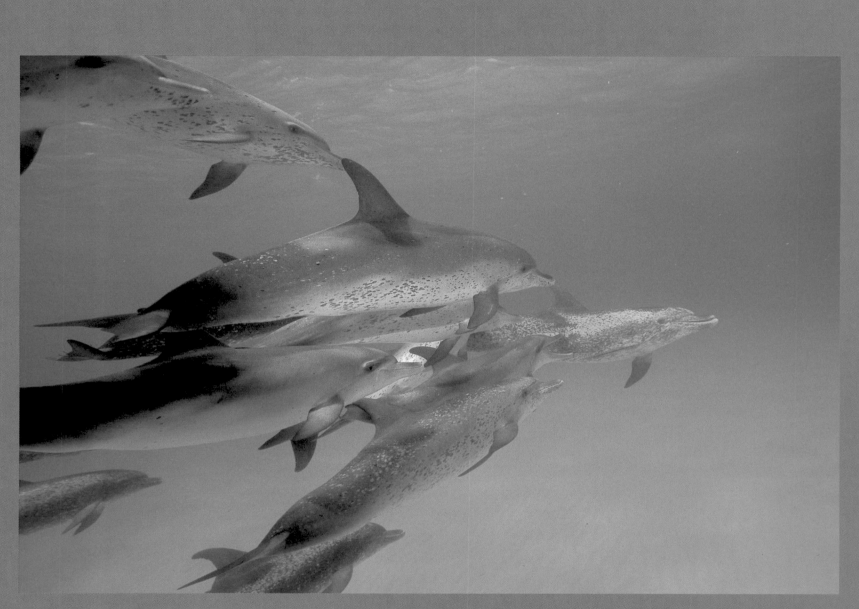

Aggressive interactions among dolphins are actually more common than many researchers had previously thought. A group of dolphins (above) appears to be bullying or herding another dolphin. An adult (right) aggressively confronts a submissive juvenile.

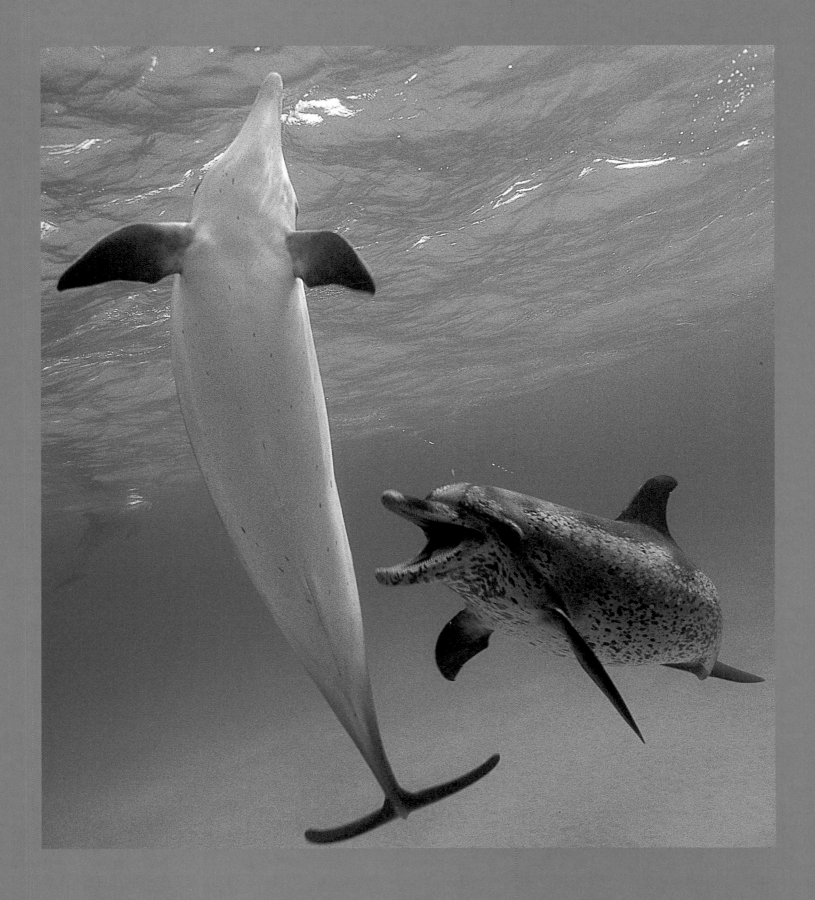

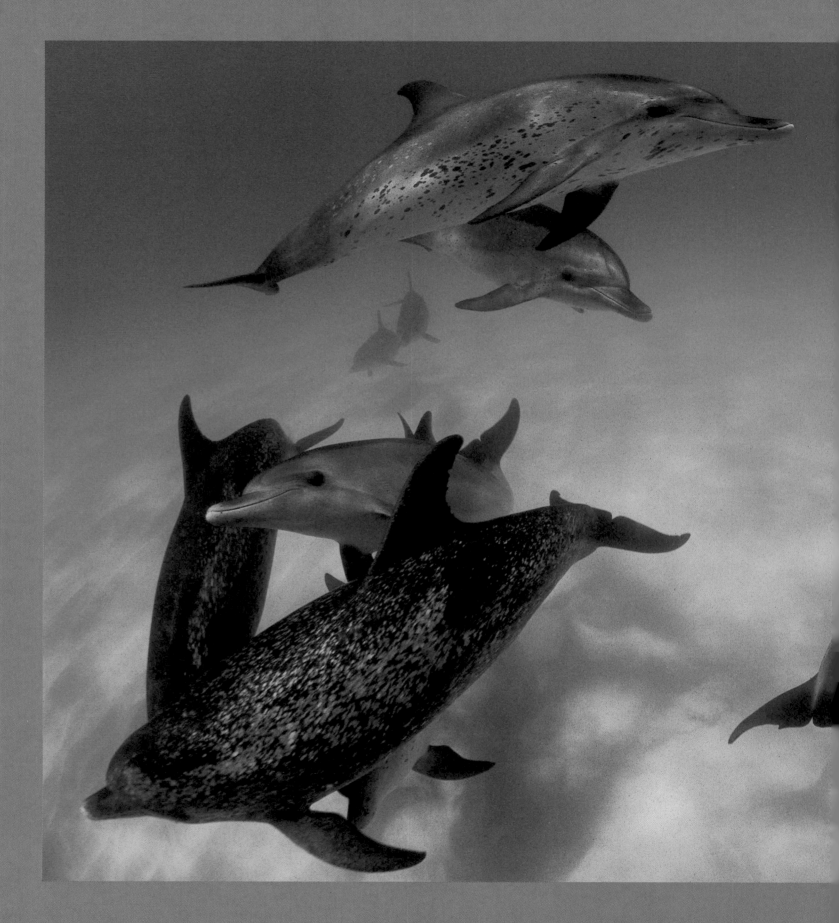

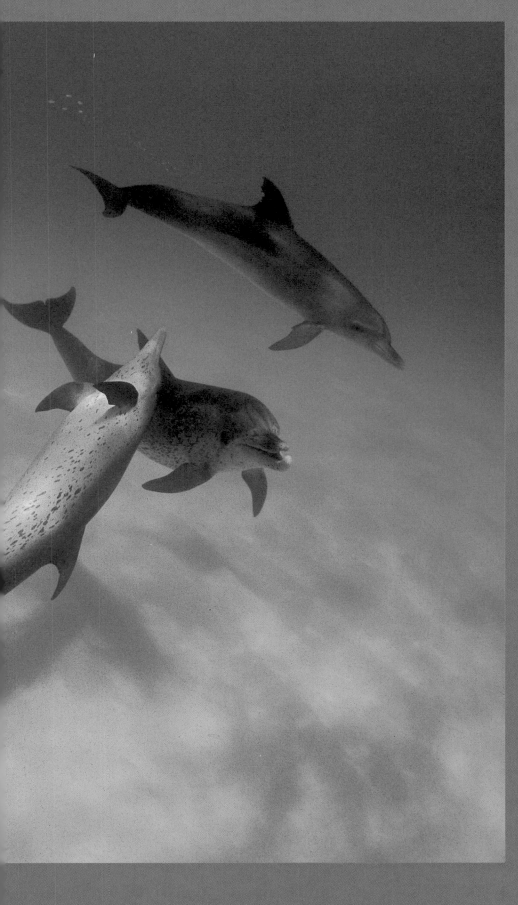

Social mammals often need to learn the correct usage and context of their behavior and dolphins are no exception. Here, a couple of adult female spotted dolphins (lower left) play with their calves while three juvenile males (upper right) use aggressive behaviors—hitting, jousting, and direct approaches—in a playful manner. When older, these males will likely use these behaviors and postures during fights with other males, potentially for access to receptive females during mating.

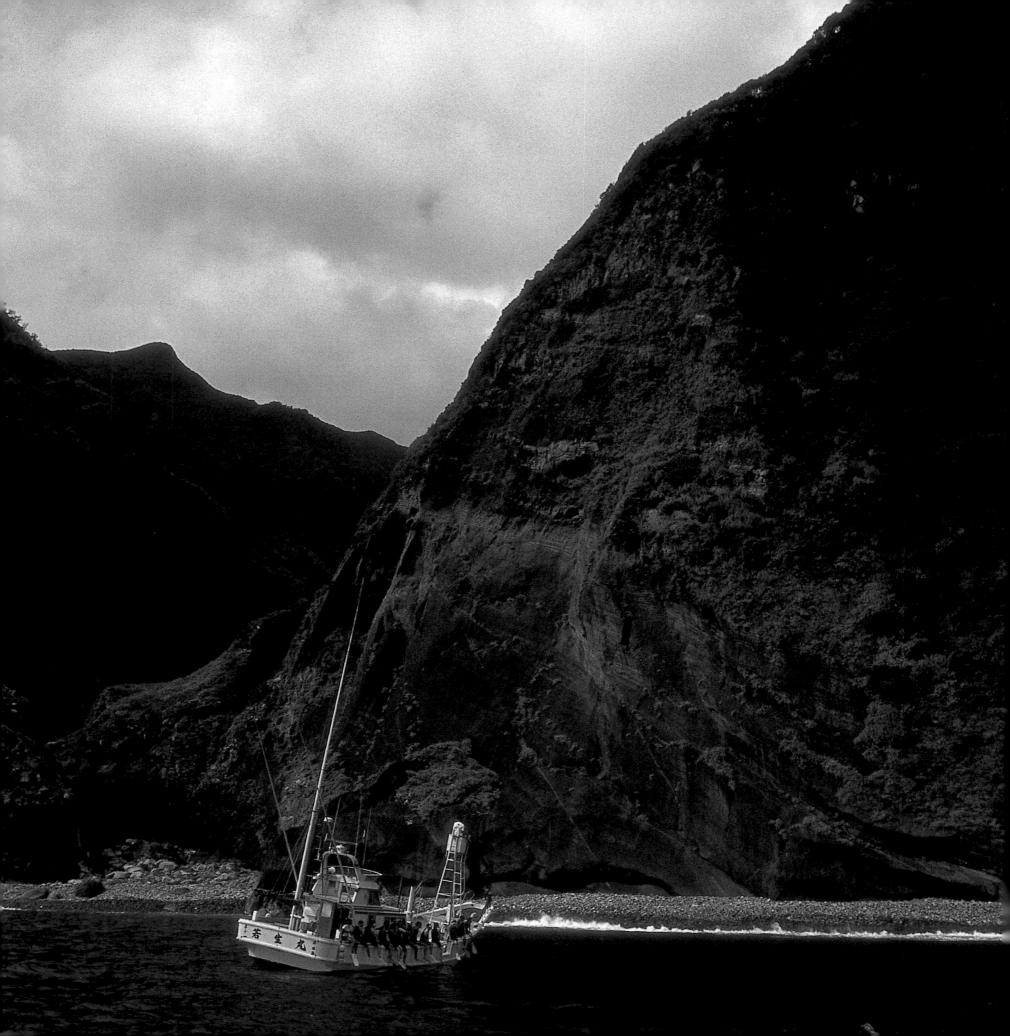

THE NIGHT BEFORE MY FIRST DOLPHIN ENCOUNTER in Japan, I had a bit of trouble sleeping. The dolphins I was likely to see would be bottlenose, but would it be a Tiao (FLIPPER BATTERS MUSH-BRAINED SCRIBE) or JoJo (MELON-HEAD AND MUSH-BRAIN IN FLUKISH FRIENDSHIP).

Kathleen and I rose before dawn and drove to Tsubota Port, one of the fishing harbors on Miyake-jima, where we boarded a fishing boat about 25 feet long and turned up in front like an elf's shoe. The dolphins could generally be found very close to the island of Mikura, about 45 minutes away. The coffin-shaped island was behind a bank of fog on this cold, blustery spring day. The water temperature was about 60 degrees Fahrenheit, and the air was probably 15 degrees cooler. Minor squalls swept across the sea; hard intermittent rain stung our faces. Seabirds flew low over the roiled surface of the sea, and the decks were awash with spray as the Japanese captain took nine foot swells head-on.

Kathleen and I, along with two of her Japanese friends, huddled behind the wheelhouse, shivering and trying to talk above the howl of the boat engines. The Japanese couple ran a dive-with-the-dolphins tour operation off Mikura during the summer months. They knew many of the dolphins and had helped Kathleen in the important initial phases of her studies, which involved identifying the animals. They had also given her those hours of dolphin-to-dolphin and dolphin-to-human encounters on videotape that Kathleen and I had reviewed in her office.

The bulk of the island of Mikura reared up out of the mist, and the captain took us to within 50 yards of shore. Almost immediately, we saw dolphins in the near distance rolling over the surface as they breathed.

"Watch this," Kathleen said. "This guy knows what he's doing. Watch him approach the animals."

The captain turned toward the dolphins, which were about 300 yards off the port bow, and stopped his engine down to idle. He drifted toward the dolphins, but at a very slow and oblique angle. For a moment I lost the dolphins, couldn't see them at all; and then suddenly, they were all around us, on all sides.

(Above) Divers wait ready in full gear at the side of the boat. Once dolphins are sighted, it can get chaotic. (Facing page) Mikura Island is the backdrop for the Wakau-maru #11, *which is carrying 12 okyaksan, or "guests," people wishing to swim with the bottlenose dolphins. Each boat has a guide to teach guests about the dolphins and to instruct on and provide safety.*

In an instant all four of us plunged, with no time at all to contemplate the swell or the chill of the dark churning sea.

The dolphins were much bigger than I had imagined. Faster too. My first impression was not that of happy squeakers or curious cuties, or mystical healers on a watery mission to enlighten humanity. I thought, *Whoa!* These guys are great *big* powerful predators! I've read accounts of dolphin-swimming encounters full of mystical epiphanies about the oneness of nature and interspecies bonding. The bond is there, no doubt —it is as old as the written word—but that was not my first impression. Instead, I thought, these creatures could kill me, if they so desired.

Perhaps the fact that dolphins can easily kill a human in the water and yet choose not to (most of the time) constitutes some part of the mystical bond. Kathleen and her friends were already engaged in their own private dolphin encounters. I turned with one of the passing animals and tried to swim at its flank. Now, I am a former collegiate swimmer—butterfly and freestyle sprints. I've set pool records at the University of Wisconsin and at Notre Dame. The fact that these records were in relays with three other swimmers, and that they lasted about a week, is of no consequence. I am proud of my swimming prowess,

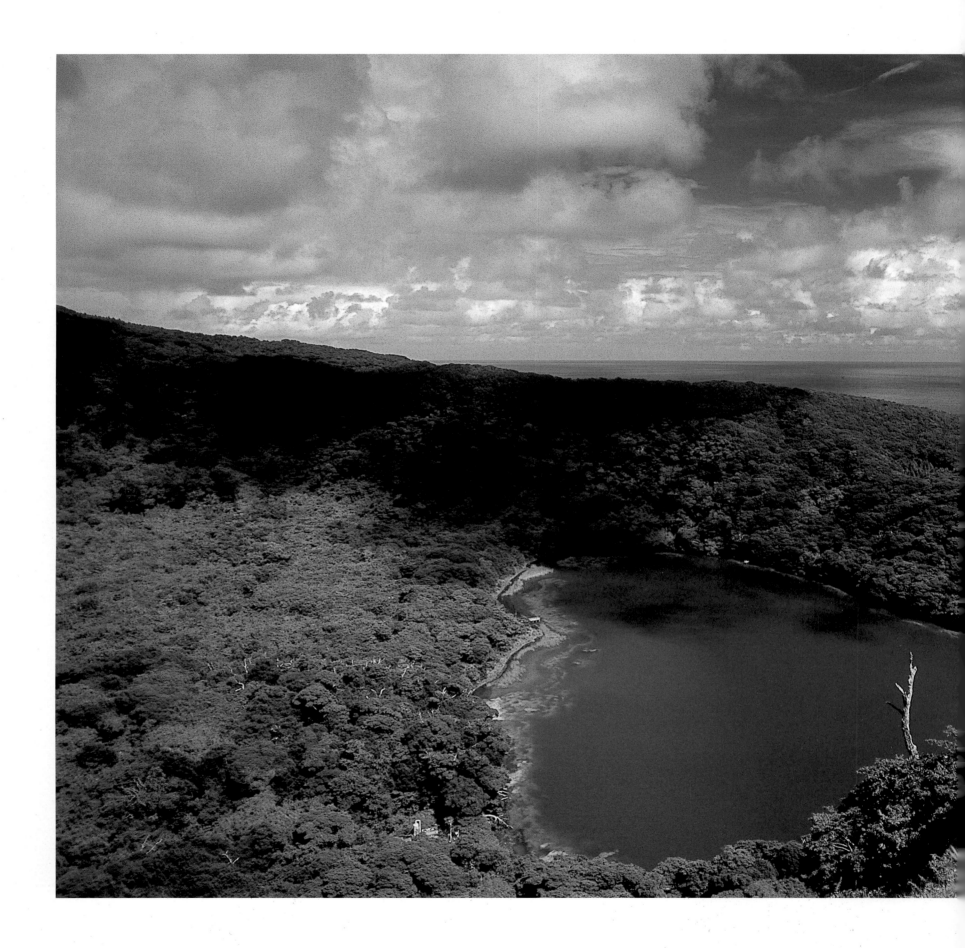

and even now, years later, I'm fast. Very fast. For a human. But the dolphins swept by me like jets past a single-prop biplane. It was confusing and chaotic, with dolphins emerging out of the troubled sea, here one second and gone the next.

As I rose to the surface to breathe, a heavily raked dolphin below rose with me so that we were both upright in the water, belly to belly, and I could see the single long genital slit low on the belly of the animal. A female, and she was moving with me, at my speed.

I took a turn before I reached the surface and curved out to my left.

"Mind your manners," I thought and tried to do everything right, just the way Kathleen had taught me and so many others: Don't touch. Don't get into a head-on-head position. Don't chase. All angles taken on the dolphin should be oblique and slanting.

The dolphin moved with me. I could see her round black eye and the anatomical smile that meant precisely nothing at all. Still, one feels obliged to smile back.

We both rose slowly to the surface. But the dolphin moved off toward more amusing pursuits as I treaded water.

The topside weather was still rough. A 20-mile-an-hour wind drove a misting rain horizontally, and our dive boat bobbed corklike in the heavy swell. The wind had blown off the mist, and to my right, only 50 yards away, the island of Mikura rose abruptly: all ebony volcanic cliffs, where small green ferns and bushes grew from every niche and ledge. Bountiful waterfalls poured from island caves set high in vertical volcanic rock. I could see falling water everywhere, gleaming silver gray against wet black rock.

Kathleen rose beside me.

"They're gone," she said. Her lips were blue in the 60-degree water, and she was shivering in the manner of children playing too long in the pool. "Was that long enough to be an encounter?" I asked. I knew that, in Kathleen's studies, she had defined a dolphin encounter as three minutes or longer.

Tairoike (Tairo Pond) on Miyake is the only freshwater lake remaining after the island's volcano erupted in 1983 and evaporated Shinmyoike, the only other freshwater lake that had been there. Tairo Pond is part of the Miyake Nature Center, and surrounding trees provide a haven for the many native bird species on Miyake. The Pacific Ocean is visible in the background.

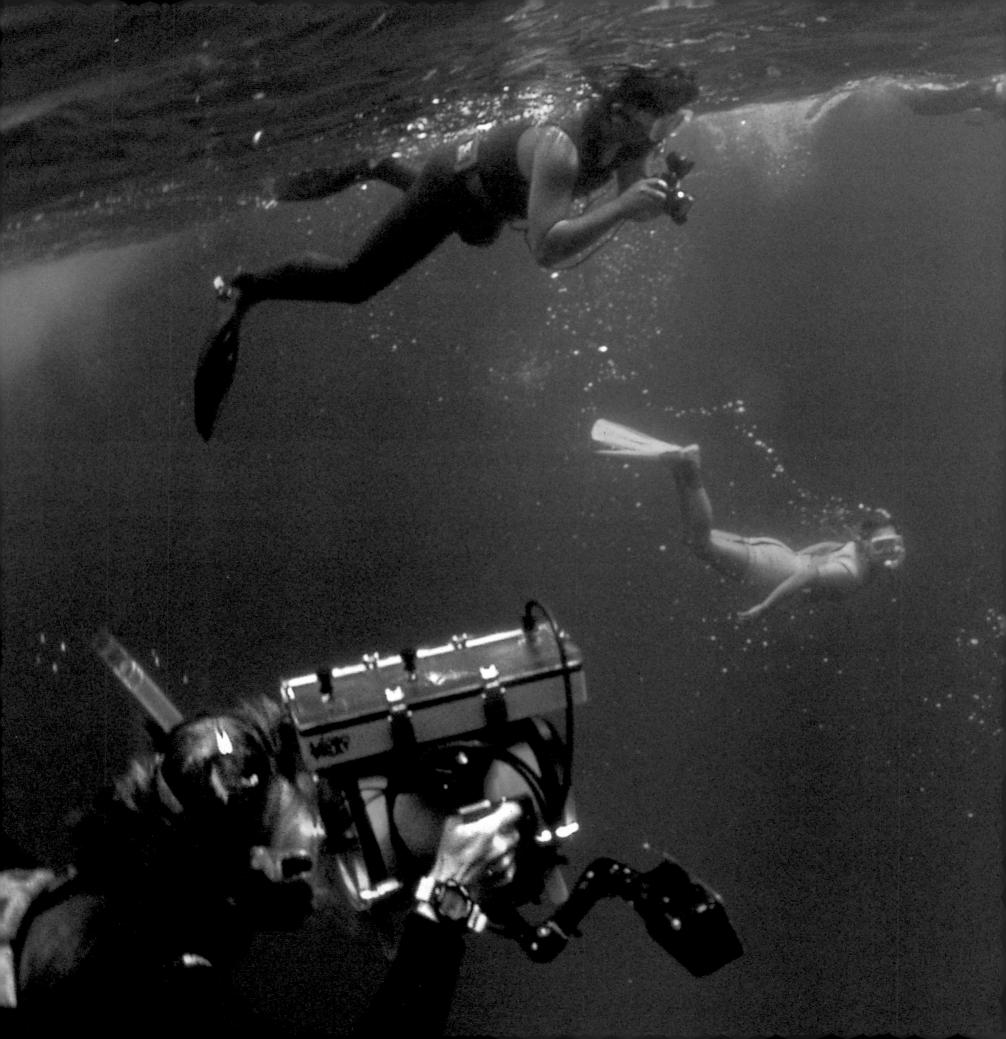

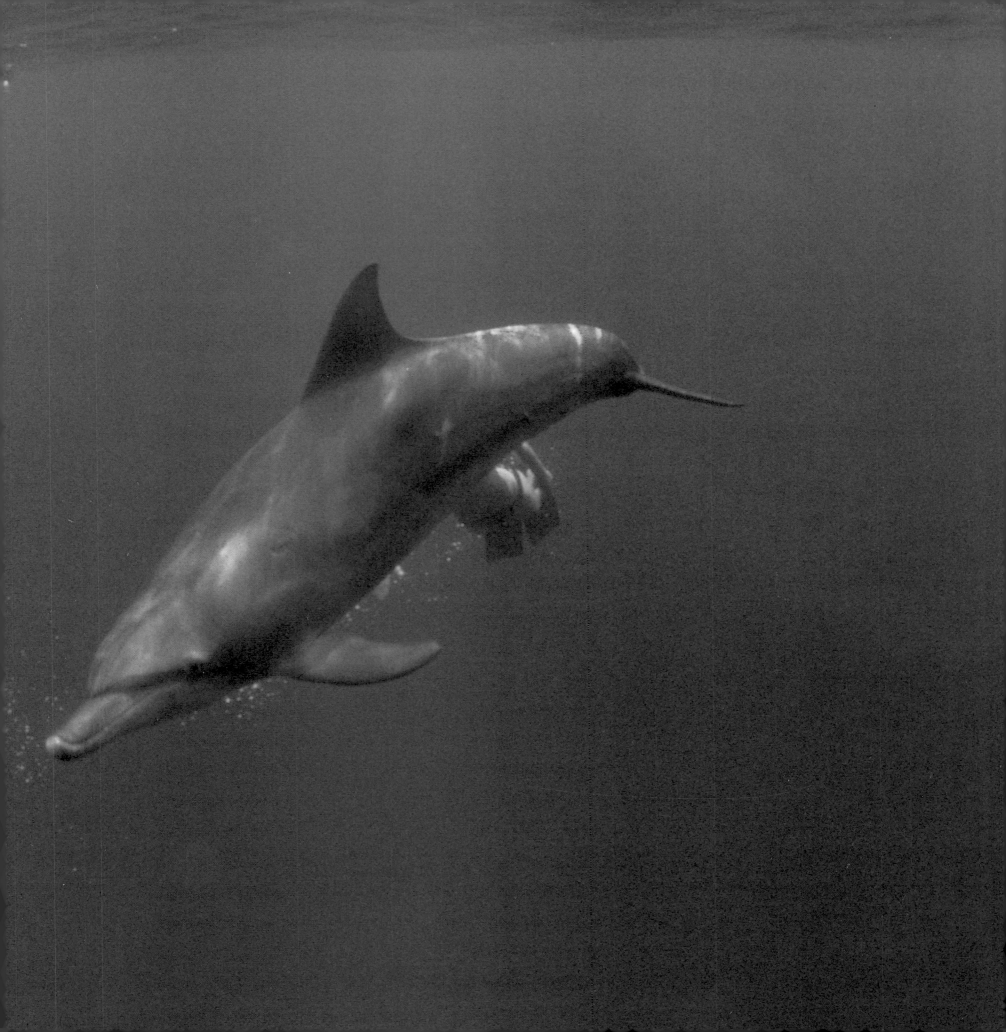

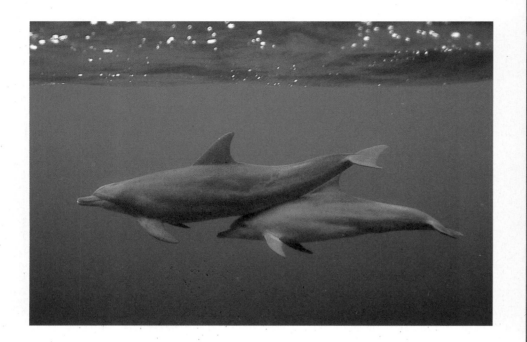

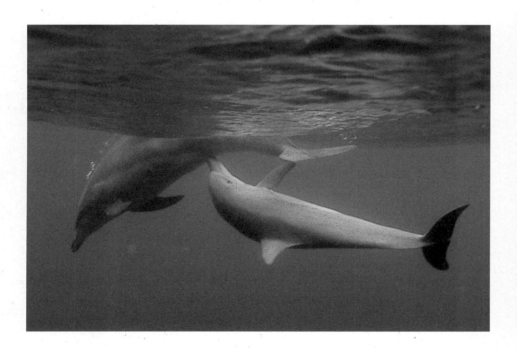

Mothers and their calves often swim close and touch frequently. When the calf swims below the mom (above), it will often press its melon to the mammary area. Nursing usually follows this contact behavior. This bottlenose calf, photographed near Mikura, continues to nurse on its side even as the mother rises to the surface to breathe. The calf's mouth touches the mammary opening but does not actually suckle: milk is squirted into its mouth by muscles around the opening. (Preceding pages) Kathleen collects data with her MVA while other swimmers interact with dolphins. Her "click detector"—the rectangular box on top of the MVA— captures echolocation signals outside the human audible range.

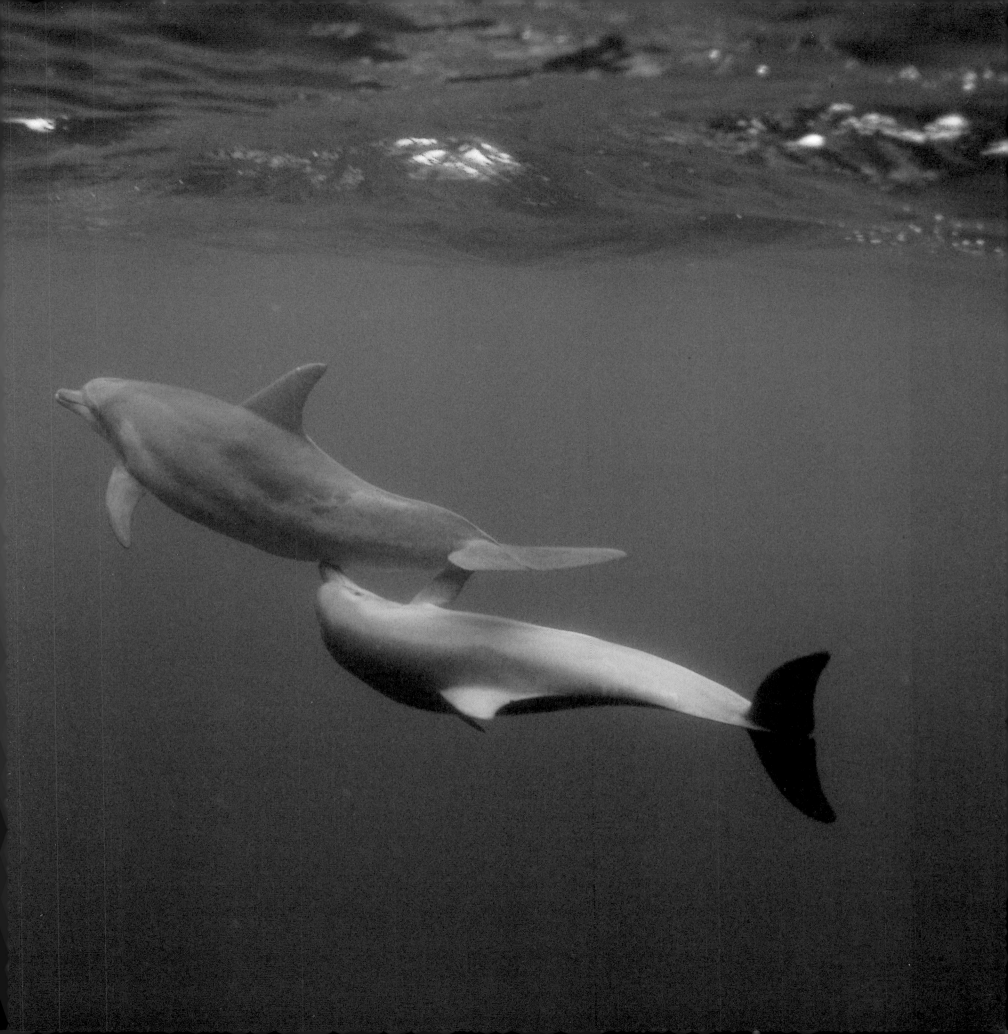

"Almost twenty minutes," she said, her teeth chattering.

I really didn't know. I honestly thought it could have been less than three minutes. "Time flies when you're having fun," I observed.

"What about you," Kathleen asked. "How was your dolphin encounter?"

"Cripes," I said, an expression I'd appropriated from Kathleen, one of the most profane in her vocabulary (she's a person who actually says "yikes" and "for heaven's sake").

"This is what you do *every* day of your life?" I asked.

"*Every* day I can get the boat time."

That night, while Kathleen worked in her office, I sat at the kitchen table under a light that flickered dim-bright, dim-bright as thunder rolled in the distance. Spread on the table before me were a dozen or more articles from general interest and science magazines along with several scientific papers on the vexing enigma of dolphin intelligence.

With no evidence whatsoever, I imagined that the dolphins I had swum with earlier in the day had displayed a high level of intelligence. I had been especially impressed by their wide round eyes: windows to the soul, we might say. The eyes alone, bright and alert, made the creatures seem sentient, self-aware, even wise. Oh, I knew very well that the dolphins' large eyes are an adaptation to relatively dark seas and are for the purpose of gathering light. Still, every time I found myself swimming along with one of the Mikura bottlenose dolphins, I would gaze sideways into one bright dolphin eye and imagine we were sharing some significant unspoken understanding.

Well, I thought, if I am at all representative of my species

—a doubtful proposition—then it may be that we humans, in what Eiseley called "our long loneliness," tend to project our desire for sentient company into an unknown universe and onto creatures as yet beyond our full comprehension. This desire may account for the popularity of a book about the intelligence of dolphins by John Lilly, *Mind in the Waters* (1967). Lilly, a medical doctor by training, was struck by the absolute size of cetacean brains. If absolute brain size is the final measure of intelligence, dolphins would, in fact, be a good deal brighter than humans.

On the other hand, one could reasonably argue that bigger animals have bigger brains in order to control bigger bodies.

TABLE 2: *Approximate brain weights as a percentage of approximate body weights of some mammals.*

SPECIES	BRAIN WEIGHT AS PERCENTAGE OF BODY WEIGHT
human	2.10
bottlenose dolphin	0.94
African elephant	0.15
killer whale	0.09
cow	0.08
sperm whale (male)	0.02
fin whale	0.01

So another examination of intelligence might be measured by brain weights as a percentage of body weight, a ratio sometimes called the cerebral quotient. In the brain-weight to body-weight sweepstakes, humans come out looking like, well, rocket scientists.

The problem is that some studies have shown that relative brain size is not necessarily related to intelligence. Pilleri, Gihr, and Kraus (1985) made an exhaustive study of rodent brain size in relation to behavior and concluded that "intelligence," whether human or animal, is not a unified brain function, but one which is "too complex to be characterized with a single numerical index," such as the cerebral quotient.

Well, then, other scientists reasoned, perhaps the very structure of the brain accounts for those behaviors we deem intelligent. What about the structure called the neocortex, the so-called "modern" part of the brain that is greatly developed in primates (including humans) and is the structure that most clearly differentiates mammals from other creatures? What if intelligence is a function of the neocortex?

TABLE 1: *Approximate brain weights and body weights of some mammals, in order of brain weight.*

SPECIES	BRAIN WEIGHT (APPROX., GRAMS)	BODY WEIGHT (APPROX., TONS)
sperm whale (male)	7,820	37.00
African elephant	7,500	5.00
fin whale	6,930	90.00
killer whale	5,620	6.00
bottlenose dolphin	1,600	0.17
human	1,500	0.07
cow	500	0.6

DOLPHIN TOOL USE

RACHEL SMOLKER—*Research Associate, Department of Biology, University of Vermont*

Here we go with more fish stories. That's what I thought when an old Aussie fisherman in Shark Bay, Western Australia, told me he had seen a dolphin with a growth on its face. Two years later, my friend and colleague Andrew Richards and I happened to be in the same area when a dolphin surfaced nearby with some sort of large brownish-red glob on its face.

It took many years of observation to discover that this dolphin (named Half-fluke, because she is missing part of her tail), is one of five female dolphins within our study area that routinely carries around sponges.

The sponges are coarsely textured like a bath sponge, but stiff, and roughly cone-shaped. The dolphins carry them by poking their beaks into the apex of the cone. Some sponges are small and snug, fitting like a yarmulke, while others are big and ungainly and flop back over the dolphin's face like a big straw sun-hat. The dolphins occasionally switch to a new piece of sponge.

Sponge carrying generally occurs only within one of the deepest channels in our study area, a small part of the much larger expanse of Shark Bay, which we call spongeland. Recently we have extended our range a little and have encountered a few new sponge carriers in other parts of Shark Bay.

From the surface, sponge carrying looks like stereotypical foraging behavior. The dolphin surfaces with the sponge on its face, takes several breaths while traveling slowly along, then dives, bringing its tail flukes out of the water, indicating a straight to the bottom dive. Once in a while we see a sponge carrier surface without her sponge, and sometimes we see them gobbling down some fish during spongeless surfacings.

We have yet to really see what the dolphins do with their sponges down below the surface, but everything we have observed so far suggests that a sponge is possibly used somehow to protect the dolphin's face while foraging around for bottom-dwelling fish. She may need protection from the spines or stingers of something noxious like a scorpionfish, or from the wear and tear of abrasion caused by poking around in the sandy, rocky bottom.

Whatever the case, sponge carrying is fascinating both because it is a clear case of a behavioral specialization involving just a few members of the Shark Bay dolphin population, mostly or exclusively females, and also because it places dolphins squarely among the ranks of tool users. Tool use was once thought to be the hallmark of human intelligence, but zoologists have since dis-covered that all sorts of animals, ranging from chimpanzees to insects, use tools. Tool use itself may no longer be a particularly good indicator of intelligence, but the interesting questions now are: Just how flexibly is the tool used? Is it learned behavior? How are the tools constructed? With the use of remote viewing and submersible vehicles for under-water observation and a lot of luck, someday we may have answers to these questions and learn more about the lives of the sponge-carriers. ■

This female bottlenose carries a sponge, the texture of a bathroom sponge, only stiffer.

One paper I read insisted that cetaceans possessed only five layers of neocortex material, while humans have six, and that the dolphin layers weren't devoted to specific functions (vision, hearing, etc.) as they are in the human brain. Therefore, it was argued, cetaceans have only a pre-neocortex. If the neocortical structure of the brain is the one true measure of intelligence, dolphins got the short end of the stick.

Another scientist, however (MacPhail, 1982), studied behavior in many different vertebrates, and concluded that both brain size and brain structure weren't very good measures of intelligence. There were too many exceptions to the rule. For instance, the echidna, an egg-laying mammal found in Australia and Tasmania, has a relatively large and highly developed neocortex. Also called the spiny anteater, the echidna is related to the platypus. It has spines like a hedge-hog and digs into termite nests with powerful claws, then gobbles up the insects using a long sticky tongue that projects out of a very small round mouth. Most scientists agree: these are not intellectual creatures. The one I saw dozing at an animal rescue facility outside Melbourne seemed professionally adapted to its chosen life, but not much brighter than a carrot. Perhaps the spiny anteater prefers to hide its light under a bushel and is, behind the dull eyes and termite diet, a philosopher of the first order. But I seriously doubt it.

I seriously doubt it, because spiny anteaters don't dream. Literally. In 1983, two scientists studied dream states in various animals, measured by rapid eye movement (REM) during sleep states. They suggested that REM sleep was a process of forgetting, or unclogging the mind and removing undesirable information and neural connections. So if REM sleep is a kind of "reverse learning," then animals, such as spiny eaters, need a large brain to accommodate information, both old and new. In the same way, a human unaware of the concept of garbage collection would need to live in a very large house. More to the point, dolphins do not exhibit REM sleep, and following the reasoning here, are possessed of large brains precisely because they do not dream. Perhaps, they have no way of throwing out the garbage.

Speculations about brain size, brain structure, and dream states as a measure of intelligence, I concluded, were clearly contradictory and open to argument. Intelligence itself is almost impossible to define, even in humans. Bernd Würsig, believes that "flexibility of behavior" may be the best criterion "because flexibility allows dolphins (and us) to quickly innovate when faced with a new, never before encountered circumstance."

Captive dolphins take stock of their new environment, rapidly assess the situation, and react in a manner humans might describe as rational. Presented with artificial obstacles, dolphins effortlessly learn things never encountered in the wild, and will behave accordingly. They innovate.

Dolphins also "learn" certain behaviors in the wild. Killer whales, for instance, are not born with an instinctual knowledge of hunting techniques, but are "taught" to snag sea lions and porpoises. Adult orcas, in the presence of juveniles, have been observed charging prey, only to turn away at the last minute, as if demonstrating survival skills. Juveniles mimic these actions of the adults. Orcas, like humans, must learn to hunt.

They must also learn to "speak," rather in the manner of human infants. The sounds dolphins make, at all bandwidths, seem to some humans—including some in the United States Navy—to be complex and even bewildering. Dolphins possess a sonar or echolocation system more sensitive and advanced than any technology humans have yet produced. It also appears that dolphins are not born knowing secrets of echolocation. As an infant grows older, it adds to its complex repertoire of sounds; and each of those sounds, perhaps, has a separate and distinct meaning. That idea is the focus of Kathleen's studies.

I was sitting at the kitchen table, with all the various and contradictory scientific papers neatly tabulated before me in a system I call the Pile-O-Dex, when Kathleen walked into the room.

"What's that gosh-awful mess," she asked, gesturing at the Pile-O-Dex.

"Peer-reviewed articles on dolphin intelligence," I said. "So what do *you* think?"

Kathleen thought intelligence wasn't a good or defining term. She preferred to think in terms of communication behaviors. To use words like affiliative and aggressive.

Umi is a Japanese beagle that grew up on Miyake Island and is Kathleen's best friend. They took long walks and often watched the sea together from various points around the island. Even though her name means "sea" or "ocean" in Japanese, Umi is actually a landlubber.

Akabakyo, this scenic point on Miyake Island, did not even exist before 1962. This section of the island was created by lava from the 1962 eruption and is still mostly covered with reddish rock bits. Some tiny plants, though, are beginning to stake claim. The road provides the tourist with a travel route.

I suggested that it didn't matter. If a dolphin could speak perfect English, we'd probably have no idea what it was saying.

It was late and the idea was, perhaps, one Kathleen had heard before. In any case, she yawned hugely. Umi the Mighty Sea Beagle snuffled at her ankle. This vexing problem of intelligence, I thought, was compounded by the fact that certain species of dolphins appear to be brighter than others.

It distressed me a bit that—perhaps predictably—the most intelligent of the dolphins occasionally engage in behavior that can be most kindly described as "bullying." We humans are guilty of the same conduct; and, at our worst, kill our fellow humans because they are considered "inferior." Measures of intelligence, despite their unreliability, are often used to justify the unjustifiable. It is with distressing frequency that ideas about aptitude have swirled about at the periphery of genocide.

And so it is, I feared, with the dolphins. If they should eventually prove less than philosophers, is it then morally correct to slaughter them out of hand? Should we only save our sympathy for the most intelligent of their race?

Kathleen boiled water for tea, then sat at the table. Umi, crawled up onto her lap, looking for affection. My thoughts took a dyspeptic turn. I saw mobs of humans shouting: "Kill the witless!" And: "Only the sentient have a soul."

I thought: It is life itself, and not simply intelligence, that is sacred.

ONE DAY AS WE HEADED TO KATHLEEN'S JAPANESE lesson, she gave me a brief driving tour of Miyake-jima.

"Oh, there's Jack Moyer's old car. It got smucked in the last eruption."

"Where?"

"There." She pointed halfway up the side of a 40 foot-high cliff of black volcanic rock. In the middle of the lava flow, I could barely make out the compressed profile of a burnt and petrified car. It looked like a protrusion of rock, except for two nearly identical crushed half-circles that, if you looked twice, would be seen for what they were: a car's wheels instead of a geologic wonder.

Today, Kathleen's lesson would be spent with Jack Moyer, a video crew, a Japanese photographer and writer, and an executive from a large multinational corporation. The Japanese lesson being taped was for a presentation on Japanese TV, with the underlying message, I gathered, that foreign scientists need not be ignorant of Japanese culture and values. This was a strategy, it seemed, designed to suggest that scientists can work with local people and are not simply outside agitators condemning, for instance, Japanese practices out of hand.

It wasn't all just public relations, though. The large corporation, for instance, was sponsoring a booklet Kathleen had helped put together. It was an example of Japanese people and foreign scientists working together for the good of the sea. The booklet, containing articles about whales and dolphins, was written by Kathleen and several Japanese scientists, a number of boat captains and local dolphin guides. It drew out guidelines for safe and respectful encounters with Japan's cetaceans.

Although some scientists feel that swimming with dolphins and boat-based dolphin watching can disrupt the animals' feeding and reproductive patterns, Kathleen feels that since the worldwide interest in dolphins is expanding exponentially—and can't be stopped—the best thing is to teach people how to swim with the animals responsibly.

"My view," Kathleen told me as we drove around Miyake-jima, "having been in the tour business, is that you are never

All the ports on Miyake-jima are girded by huge cement "tinker toys" to buffer the ocean waves' sometimes ferocious temper. Often people fish for bait or snacks from the port sides when the fishing boats are out at sea.

going to stem the tide of humans who want to dive with dolphins. There are more and more every year. Whether they know a little or a lot about dolphins, people love them—and they have ever since the time of Aristotle. Even before that. And because people are going to do it anyway, I believe we need to educate them. We need to teach people proper manners. And that's for the safety of both the dolphins and the humans."

Yet Kathleen's stand on dolphins in captivity is surprising: she is against capturing more dolphins for captivity but doesn't advocate *freeing* captive dolphins, at least not ones that have been born into captivity. "It's a death sentence," she says. "If an animal

has been in captivity for a number of years, you may not have domesticated it, but you've made it dependent on you. There is no way in God's green sea you are going to teach that animal to interact with a group or to fend for itself. It's as if you turned your dog out into the wilderness, and said, Go ahead, you're free. Fend for yourself now.

"Most attempts to rehabilitate and return animals to the sea have failed, with the notable exception of one or two. When I say fail, I mean the animals just disappeared never to be seen again, or they returned to their sea pens and wouldn't leave, or they ended up begging from boats, or they were found washed

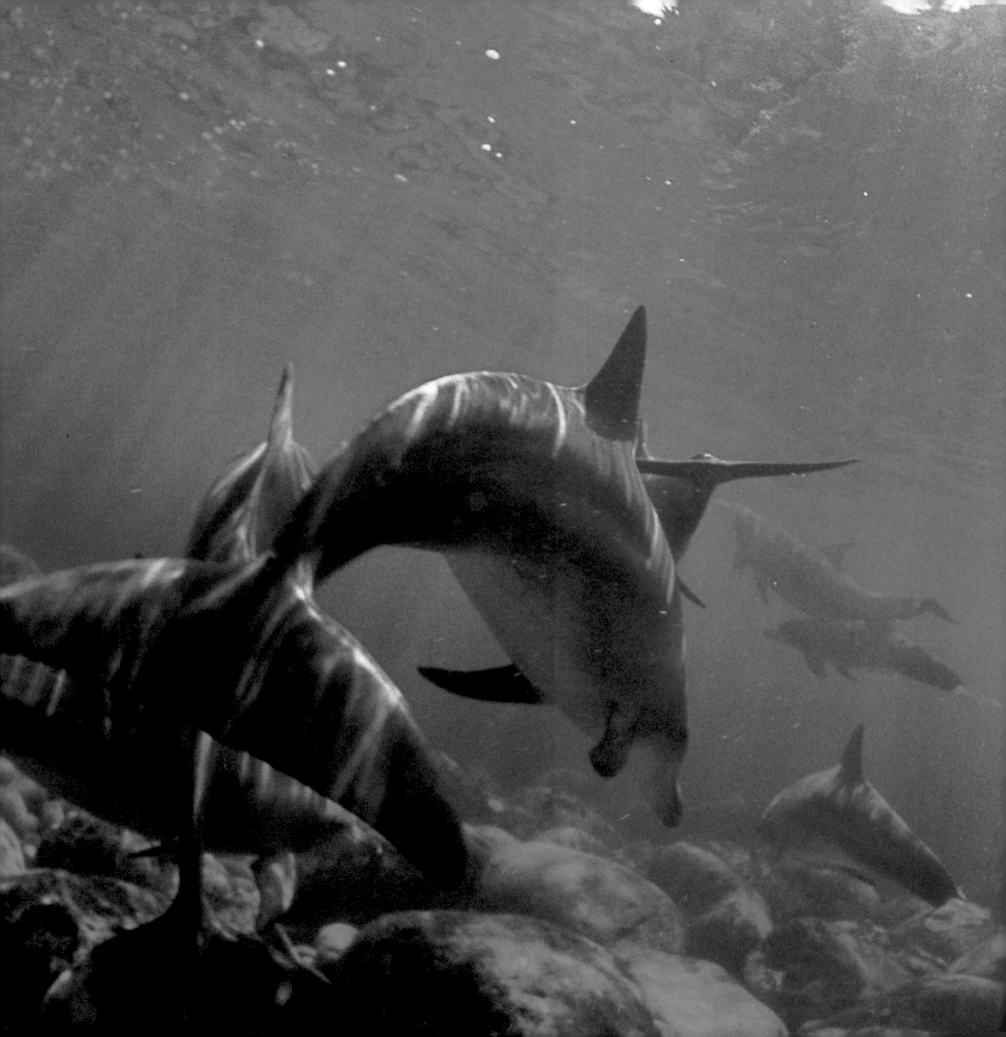

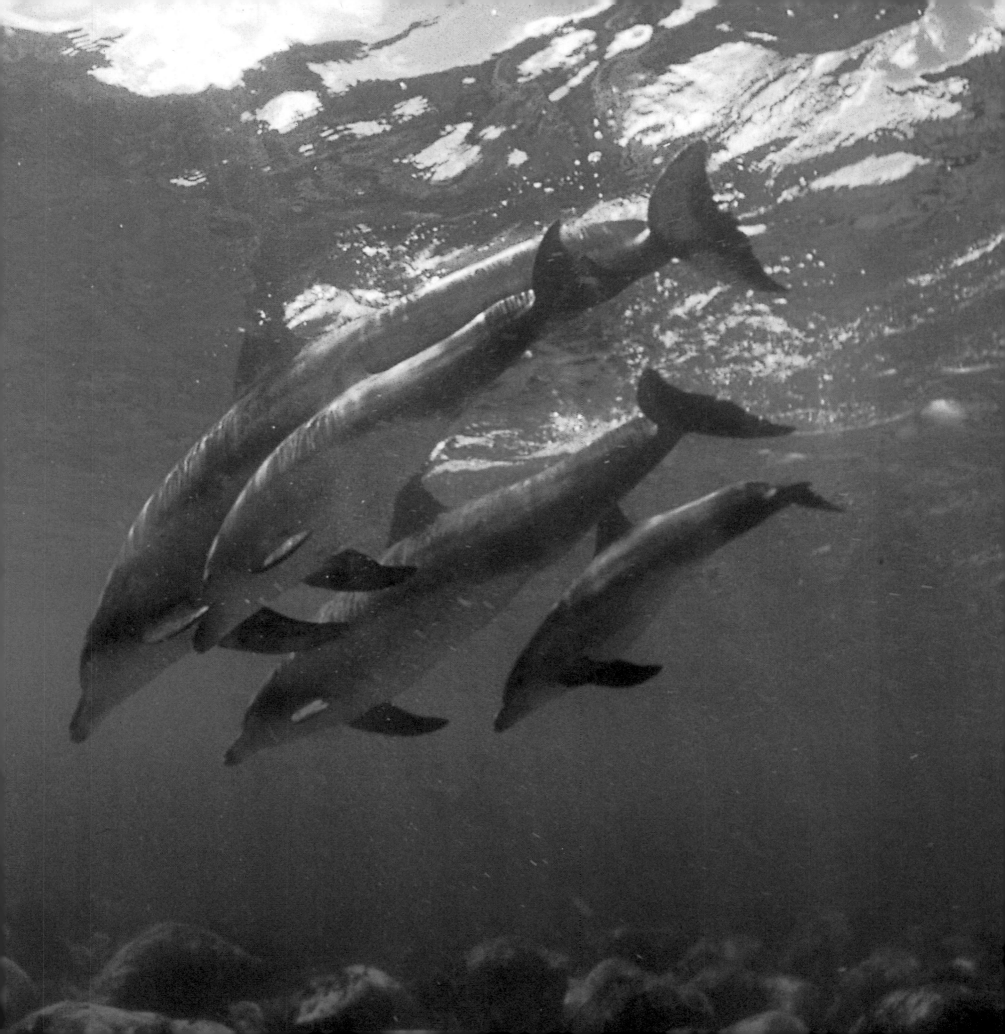

up on the beach, dead.

"Another thing: Dolphins in captivity—in the best places —are given the best health care. We learn about their health problems and can apply that to wild populations. Say that a dolphin strands itself on the beach. It's happened throughout history. But with what we learn from captive dolphins, we may be able to treat and rehabilitate and release it into the wild again—before it becomes dependent.

"I know it's an emotional issue," Kathleen said, "but I believe there are some benefits to dolphinaria. I believe that with exponential growth in the human population, there is no way that everyone is going to get a chance to experience dolphins in the wild. Some people can't afford it; some may not be physically capable of it. But most everybody can go to an aquarium. Seeing a dolphin on TV and being in the same space with it are two entirely different experiences. The experience of intimacy and the proximity to a wild animal changes our lives. It is important that we have a deep, visceral feeling for animals, in their presence—important for conservation, important for science, and important because then our understanding of animal nature is deeper.

"And dolphinaria can function as a kind of worldwide ark. Many dolphin species are endangered. The Chinese river dolphin is down to a few hundred individuals, dying, most likely due to pollution. If there is a captive-breeding population, maybe the entire species can be saved."

Kathleen paused for a moment.

"I think," she said finally, "that we have to face the reality that it's way too late to say don't capture animals. It started a long time ago. What I say is: We don't need to ever capture another wild dolphin again."

Kathleen and I continued this discussion as she drove back to the farmhouse after her Japanese lesson. Umi perched herself on my lap and pressed her nose up against the windshield. I was looking out at the charming island scenery through a series of wet smears that looked rather like some idiot's continued attempt to produce a single proper game of tic-tac-toe. But Kathleen said she'd studied the smears intensely and was certain that they were *kanji*, the complex Chinese ideographic script used to write Japanese. Umi, she said, was writing on the windshield a series of 17-syllable Japanese poems called haikus in "nose kanji."

"Have you, uh, translated any of these?" I asked.

"Oh, yes," Kathleen said. "They're all very critical of me."

According to Kathleen, I was looking at the world through a series of haikus that read: My leash is too short/the end is always too near/that's where smells begin. And: Their feasting mocks me/Here I sit tied to a tree/only rocks to eat. And: No, Umi. No. No./Umi, no. No. Umi, no./Umi, Umi, no.

MY NEXT DOLPHIN ENCOUNTER WAS MUCH THE SAME as the previous one, with the dolphins appearing out of the fine blue sea in high-speed scouting runs. They swept past at speeds in excess of 20 miles an hour, or so I guessed. When they returned, I was ready and caught the eye of a male who approached curiously and at a polite, oblique angle. I dove in a great sweeping circle, as did the dolphin, and we rotated, one about the other, as pretty as do-si-do. I was dancing with dolphins.

But I never saw any of the creatures feeding, and I asked Kathleen about that later, as we sipped tea in the farm-house kitchen.

"I think these bottlenose feed in the deep-water channel between Miyake-jima and Mikura," Kathleen said. "During the day, they hang close to the shores of Mikura, probably for the same reasons the Atlantic spotteds move to shallow water after feeding."

"Shallow waters are safer," I said.

"Maybe not safer, but predators are more easily spotted. And all those waterfalls agitate the sea bottom and make the water there dark and kind of mucky. When the dolphins feel threatened, they retreat to the dark murk under the waterfalls."

"You know the word that rang through my mind when I found myself in the water with my first wild dolphin?" I asked.

Kathleen shook her head.

"Predator," I said. "These guys are predators, and I'd really like to see them hunt." We had film of some feeding behavior in the Bahamas: dolphins using their echolocation systems to find small creatures living under the sand on the ocean bottom. The sand-dwelling creatures were nothing more than snacks. It wasn't anything like full-out hunting.

"I wonder if we could somehow film the Atlantic spotted dolphins feeding."

Kathleen was aghast. "You mean chase them?…"

"Well, no—"

THE MOVIE & THE MESSAGE

JANNA EMMEL—*MacGillivray Freeman Films*

We design giant-screen films to be opportunities for audiences of all ages to experience the natural world almost first-hand, often in exciting locations they'll never visit themselves. Produced in partnership with National Wildlife Federation, *Dolphins* is MacGillivray Freeman Films' twentieth large-format film release. Greg MacGillivray, the film's producer and director, has produced more of these specialty films than anyone: "I create films in the biggest, most beautiful film format invented because I want to put audiences right into the heart of the action, so they *feel* the excitement of learning about our world."

Giant-screen films are an experiential medium. Immersed in scenes projected on six- to eight-story-tall screens, viewers experience images larger than they can view in a single gaze. The theater's six-channel, surround-sound system envelops visitors in a rich, realistic environment. Audiences experience a much greater visceral feeling and more personal involvement in giant-screen films. This multisensory experience creates a strong impression on the viewer, which can have a profound effect in shaping attitudes.

Dolphins received major funding from Museum Film Network, an international consortium of museums and science centers and National Science Foundation's Informal Science Division, a publicly funded program that aims to increase America's appreciation and understanding of science. National Wildlife Federation chose large-format filmmaking as an entertaining and educational way to further its conservation mission. As a medium for informal education, giant-screen films bear some similarity to interactive museum exhibits. Evaluation studies show that interactive exhibits can motivate interest in a topic, raise awareness, and introduce some basic concepts and vocabulary.

"Our 40-minute film can't convey all there is to know about dolphins and the work of marine mammal scientists," says Greg MacGillivray, "but the giant-screen format has the power to captivate and to inspire a sense of wonder, while presenting accurate information. Perhaps after watching our film, you'll pay more attention to dolphin news in the headlines or care more about issues concerning marine mammals and their ocean home."

Giant-screen production and distribution companies like MacGillivray Freeman Films and National Wildlife Federation often work with the National Science Foundation to extend their films' educational reach by producing materials that accompany each film's release. When families come to see *Dolphins*, for example, they receive information about fun science activities they can do. Because school groups make up 15-20 percent of the audience, educators designed a *Dolphins* teacher's guide that contains classroom activities for students. Girl Scouts USA and ASPIRA, Inc., a Hispanic youth organization, helped design a science career unit that encourages those who are traditionally underrepresented in science to consider science an attainable career. This book you're reading is another example of how MacGillivray Freeman works with other organizations, like NATIONAL GEOGRAPHIC, to expand a film's educational impact. ■

Greg MacGillivray has been making IMAX theater films about the mysteries of our world for more than 20 years.

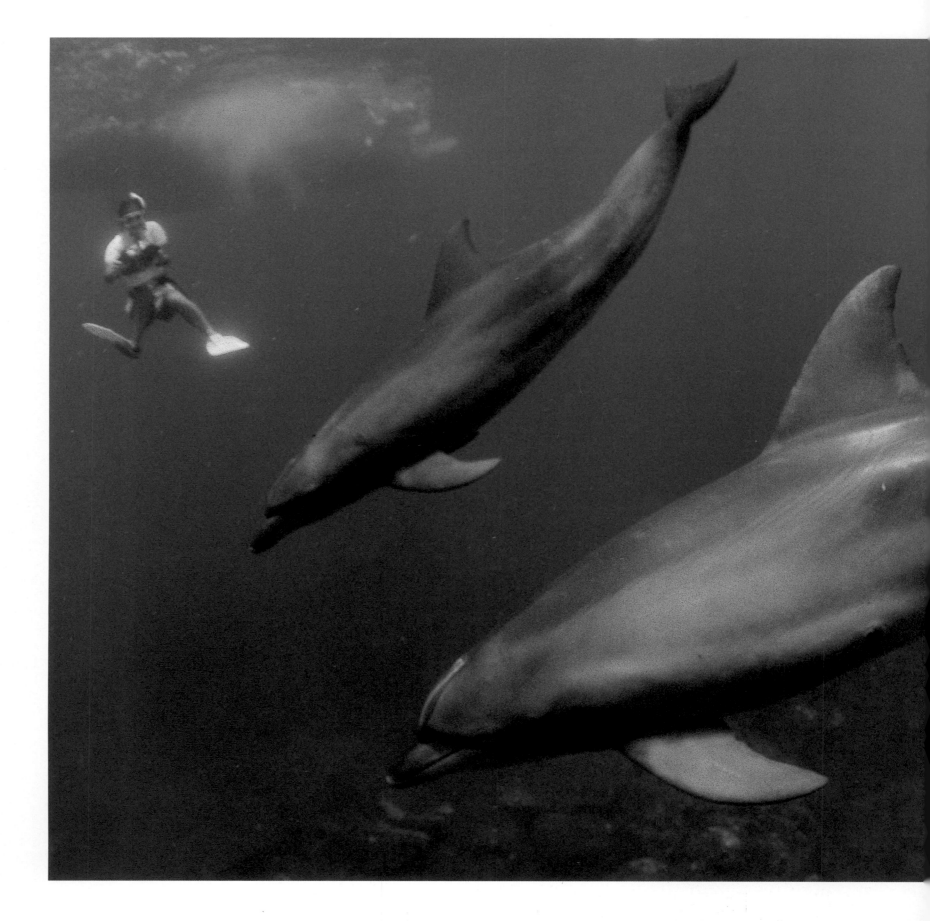

"We've built a relationship, based on *trust.*"

"So is there somewhere else we could watch them feed? See how they spend the rest of their day when they're not feeding?"

Kathleen stared at me.

"In a non-invasive manner," I added quickly.

"Well," Kathleen said, "yes, there might be."

And we began talking about the waters of Patagonia, off the eastern coast of Argentina. It was the place where Bernd Würsig had done his early work 20 years before. The cetaceans there—dusky dolphins—do not feed, mate, and socialize in different waters, as do the Atlantic spotted dolphins in the Bahamas or the bottlenose near Mikura. Kathleen thought it would be possible to observe and film all these behaviors in one of the deep water bays off Patagonia, which would bring the documentary into a better balance.

But dolphin predation strategy wasn't her field of expertise. Kathleen suggested we think about interviewing her colleague Dr. Alejandro Acevedo-Gutiérrez on camera. He'd studied bottlenose feeding ecology off Cocos Island and shared Kathleen's enthusiasm for the study of wild dolphins.

And, of course, Dr. Würsig probably knew more than anyone else on earth about the dusky dolphins off Patagonia. Together, Kathleen suggested, the three of them could put together a project that could be used in the film to show how science really works.

Also, I thought, there'd be other scientists in the film, which would somewhat mitigate Kathleen's dilemma. She wouldn't be the sole featured scientist, and this idea pleased her.

"Back when I first met Bernd," Kathleen said, "he suggested that I do my fieldwork in Patagonia, among the dusky dolphins. It was just too expensive. We couldn't figure out any way to finance it. So I ended up in the Bahamas as a shipboard naturalist. But I never stopped thinking about Patagonia."

"Would Bernd want to go," I asked.

"Oh, yes. He's been all over the world doing fieldwork

(Facing page) When traveling in pairs, dolphins may exhibit synchrony in their behavior. Sometimes dolphins will also mimic human swimmers, though here it seems these dolphins may simply be posing and "smiling" for the camera. (Pages 134 and 135) Dolphins spend most of their time in small groups, forming larger groups when socializing or, at times, while foraging.

ECHOLOCATION

Whitlow Au, Ph.D.—*Chief Scientist, Marine Mammal Program, Hawaii Institute of Marine Biology*

Millions of years ago, toothed whales developed echolocation, a sensory faculty that enabled them to survive in often murky and dark aquatic environments. It is a process in which an organism probes its environment by emitting sounds and listening to echoes as the sounds bounce off objects in the environment. With sound traveling better in water than electromagnetic, thermal, chemical, or light signals, it was advantageous for dolphins to evolve echolocation, a capability in which acoustic energy is used, in a sense, to see underwater. Synonymous with the term "sonar" (sound navigation and ranging) and used interchangeably, dolphin echolocation is considered to be the most advanced sonar capability, unrivaled by any sonar system on Earth, man-made or natural.

This ideal evolutionary adaptation has contributed to the success of cetacean hunting and feeding and their survival as a species overall. As a result, dolphins are especially good in finding and identifying prey in shallow and noisy coastal waters containing rocks and other objects. By using their sonar ability, dolphins are able to detect and recognize prey that have burrowed up to 1½ feet into sandy ocean or river bottoms—a talent that has stirred the imagination (and envy) of designers of manmade sonar. Researchers, documenting the behavior of the Atlantic bottlenose dolphins foraging for buried prey along the sand banks of Grand Bahama Island, have found that these dolphins, while swimming close to the bottom searching for prey, typically move their heads in a scanning motion, either swinging their snout back and forth or moving their heads in a circular motion as they emit sonar sounds. They have been observed digging as deep as 18" into the sand to secure a prey. Such a capability is unparalleled in the annals of human sonar development.

From one point of view, the keen sonar ability of the dolphin seems mystifying since

we can't build a sonar that can perform as well. Yet from the many studies that have been conducted, we have some basic understanding of how the dolphin sonar systems works.

The range of frequencies over which dolphins can hear sounds is very wide—from about 100 to 150,000 cycles per second. Humans typically hear sounds having frequencies only up to about 15,000 cycles per second, giving dolphins a frequency hearing range that is up to 10 times wider than humans. This wide frequency range of hearing allows dolphins to use high-frequency echolocation signals; the higher the frequency of a signal, the smaller will be its wavelength, which allows the dolphins to identify very small objects by echolocation.

The process of echolocation begins when dolphins emit very short sonar pulses called clicks, which are typically less than 50-70 millionth of a second long. The clicks are emitted from the melon of the dolphin in a narrow beam. A special

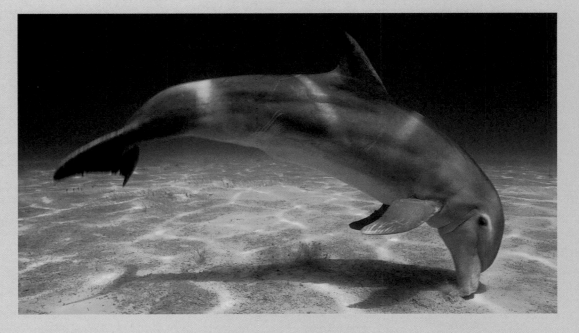

A dolphin searching for food echolocates near the sea or river bottom. As it emits echolocating sounds, it will move its rostrum, or beak, back and forth. The dolphin's sonar capabilities will detect if there are in fact any nutritious delectables hidden beneath.

fat in the melon called lipid helps to focus the clicks into a beam. The echoes that are reflected off the object are then received by the lower jaws. They enter through certain parts of the lower jaw and are directed to the ear bones by lipid fat channels. The characteristics of the echoes are then transmitted directly to the brain.

The short echolocation clicks used by dolphins can encode a considerable amount of information on an ensonified object—much more information than is possible from signals of longer duration that are emitted by manned sonar. Underwater sounds can penetrate objects, producing echoes from the front portion of the object as well as from other surfaces *within* the object. This provides dolphins with a way to gain more information than if only a simple reflection occurred at the front of the object. Dolphins are extremely mobile creatures and can therefore direct their sonar signals on an object from many different orientations, with slightly different bits of information being returned at each orientation; and since the echolocation clicks are so

brief and numerous, the multiple reflections from internal surfaces return to the animal as distinct entities and are used by the dolphin to distinguish between different types of objects. Since they possess extremely good auditory-spatial memory, it seems that they are able to "remember" all the important information received from the echoes taken from different positions and orientations as they navigate and scan their environment.

Dolphins' extremely high mobility and good auditory-spatial memory are capabilities that enhance their use of echolocation. With much of the dolphin's large brain (which is slightly larger than the human brain) devoted to acoustic signal processing, we can better understand the evolutionary importance of this extraordinary sensory faculty. Yet no one feature in the process of echolocation is more important than the other. Dolphin sonar must be considered as a complete system, well adapted to the dolphin's overall objective of finding prey, avoiding predators, and avoiding dangerous environments. ∎

—New Zealand, China, Russia, South America—but he loves those duskies. He really does. He's bursting with ideas about all the studies to be done there."

"And Alejandro?"

"I believe he talked with Bernd about doing his research in Patagonia, too. Same problems."

"So for Bernd it would be a labor of love."

"I suppose. I think he'd be proud. Former students carrying on his work."

Kathleen thought for a moment. "And I'd be proud to work with him as a peer, finally, and not a student." There was a fine hint of emotion in Kathleen's voice.

"So maybe you could bring up the idea with the producers," Kathleen suggested. "Put in more scientists, more balance, different dolphin behavior."

It occurred to me that I was being enlisted in Kathleen's effort to extract boat time out of a corporate entity in the name of science.

"And since the MacGillivray Freeman people would have to send us down there anyway…" Kathleen mused, "I'll bet they could send us down a couple of weeks early. That way, it's a real scientific expedition. We could do a preliminary study— Bernd, Alejandro, and I—and use our findings to put together a grant request for a subsequent longer-term study."

"I'll bring up Patagonia when I get back."

"Do you think it's a good idea."

"Yeah, I do."

"Then you can sell it to them, can't you," Kathleen said in about the same tone of voice she used when explaining to Umi that she was a good girl.

Well, gee, I thought, now I'm a science pimp, and that idea was ringing in my mind when I got up from the table and cracked my head on the entranceway to the kitchen, nearly falling over backward. I heard myself mutter something vile while Kathleen laughed helplessly. Flashing colored lights swam in the troubled sea of my vision.

"I'll bet," Kathleen said between gasping spasms of merriment, "that the doorways are higher in Patagonia." ■

The northeast coast of Miyake-jima offers many scenic views of the Pacific Ocean, such as this one seen from Satadomisaki.

PREDATORS, PREY, AND PRESERVATION

Training her MVA on a circling dusky dolphin, Kathleen creates simultaneous records of the dolphin's gender, identifying body marks, and vocalizations for study at a later time.

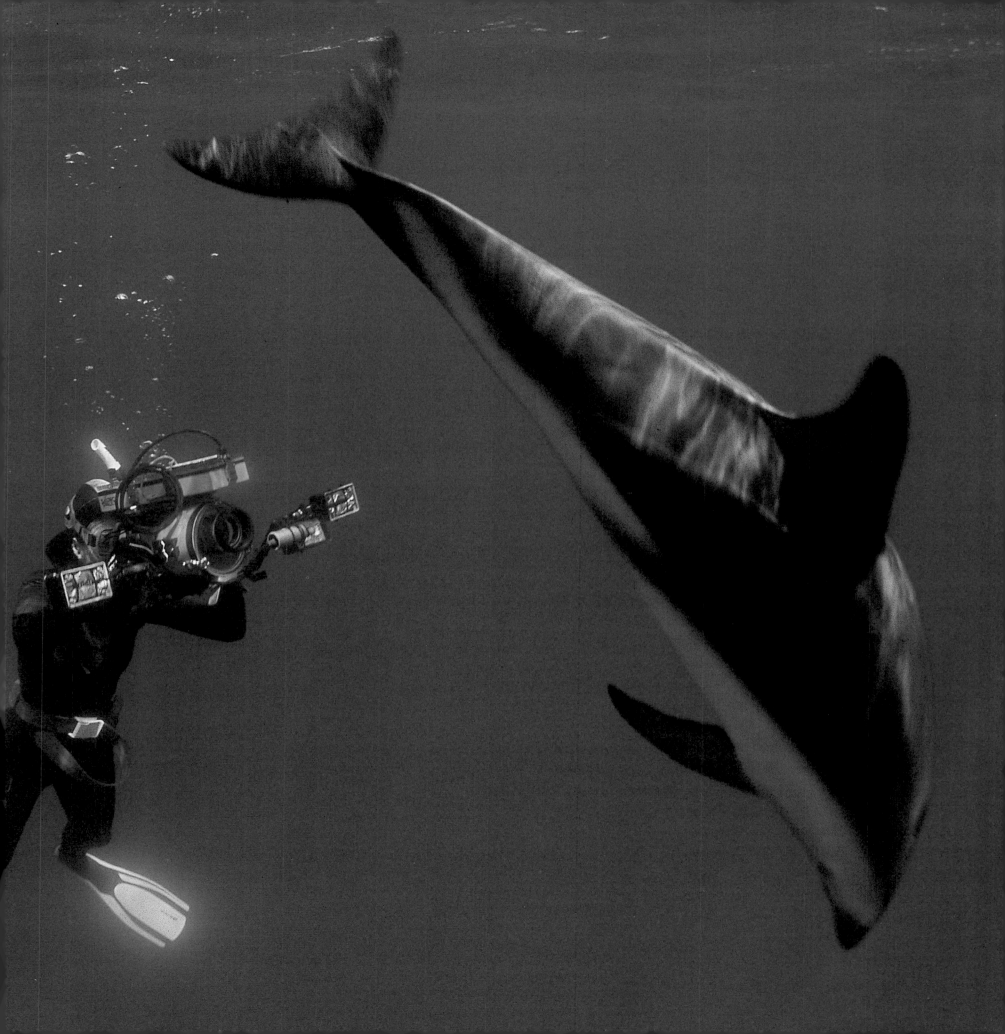

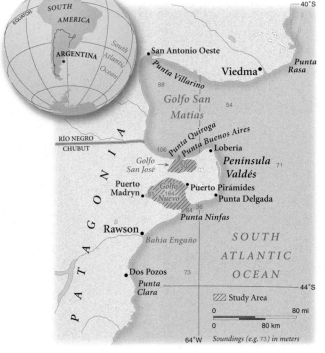

And so it came to pass…Kathleen, along with her colleagues, Bernd and Alejandro would spend a month in Argentina doing research. The only time everyone had free was over the winter holiday and academic break. December 15th or so, until January 15th: it would be the height of summer in Argentina. Christmas day would be spent in the water with the dolphins, doing research.

Of course, no one expected the research to yield groundbreaking or amazing discoveries. Two weeks isn't a lot of time to draw any important conclusions. The three scientists would collaborate on what was to be a pilot study. The preliminary observations would be refined, analyzed, and then the scientists would write up a grant proposal in order to secure funds that might allow them to continue their research. The National Science Foundation was one of the likely targets of such a proposal. There was a highly charged emotional element added to the expedition as well. Kathleen and Alejandro, having recently been awarded their doctorates, would be working with Bernd Würsig, their Ph.D. advisor, for the first time as colleagues rather than students. They must have felt rather like young actors sharing a star billing with an older and highly respected actor, say, Robert DeNiro or Sir Laurence Olivier.

Duskies swim in shallow water (opposite) very close to shore as they feed and socialize during the day. Their striking two-toned body coloration, short dark beak, and black eye patch are key identifying features of this species.

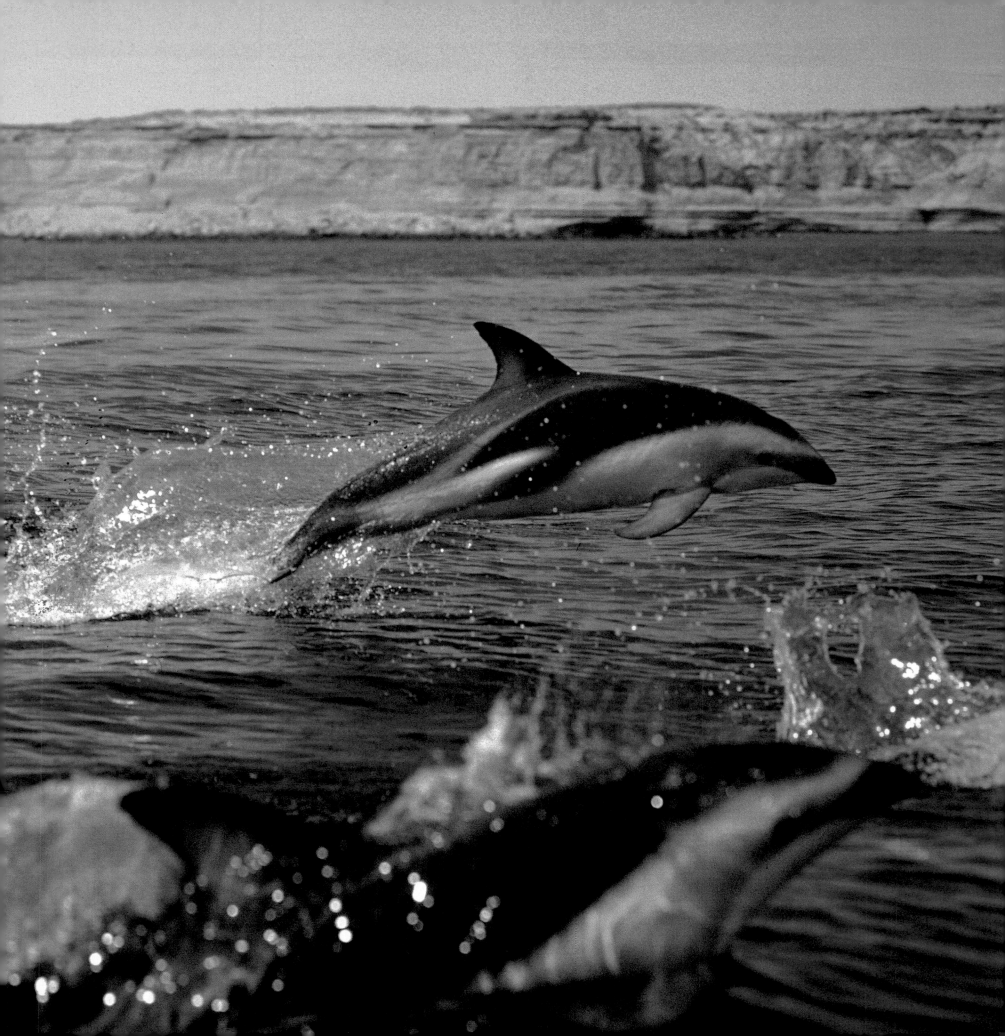

In his distinguished career, Bernd had studied dolphins and whales pretty much all over the world, but there was a soft spot in his heart for dusky dolphins—he routinely described them as "my beloved duskies—and for the land, Patagonia, where he'd first encountered them.

Patagonia is that cold, parched, windy region—isolated, and thinly populated— that extends some 1,200 miles south of the grasslands of the Pampas of Argentina, to the end of the Americas at Tierra del Fuego. The oceans and beaches of Patagonia are a marine biologist's fantasy outdoor laboratory. Southern sea lions and elephant seals mate on the gravelly beaches, southern right whales (toothless, or baleen) whales, are seen for six months out of the year, and penguins nest along the sloping headlands. Orcas, the largest of the dolphins, haunt the shorelines, preying on sea lions. Bottlenose dolphins are frequent visitors. Dusky dolphins—Bernd's beloved duskies—are year-round residents of certain bays.

In the early 70s, Bernd and his new bride and fellow researcher, Melany, began what would amount to several seasons of fieldwork in Patagonia. Few people had studied dolphins in the wild at that point. Scientist R. L. Brownell wrote of the duskies, in 1974: "Nothing is known about the food habits or other aspects of its life history." It was hard, frustrating, sometimes unrewarding work. Early on, Bernd and Melany lived in a tent that had to be taken down when the fierce wind kicked up, which was often. Patagonia is famous for its unrelenting wind.

So the couple lived outdoors in the worst of weather, studied dolphins, and their love deepened in spite of the difficulties of life. Eventually, the Würsigs' research began coming together. Bernd's considerable reputation is built on the solid base of the work he did in central Patagonia in the early and mid-1970s. He recalls the wild and windswept beaches, the sere headlands, and even the incessant wind with a nostalgic affection.

I FLEW OUT OF THE UNITED STATES ON CHRISTMAS DAY, 1998 and spent the holiday, alone with a couple of hundred strangers, at 30,000 feet. We landed in Buenos Aires late the next morning. I had just enough time to eat a steak big enough to seriously injure

This vintage airplane flies along the abrupt cliffs of Golfo San José, Patagonia, a major habitat for dusky dolphins.

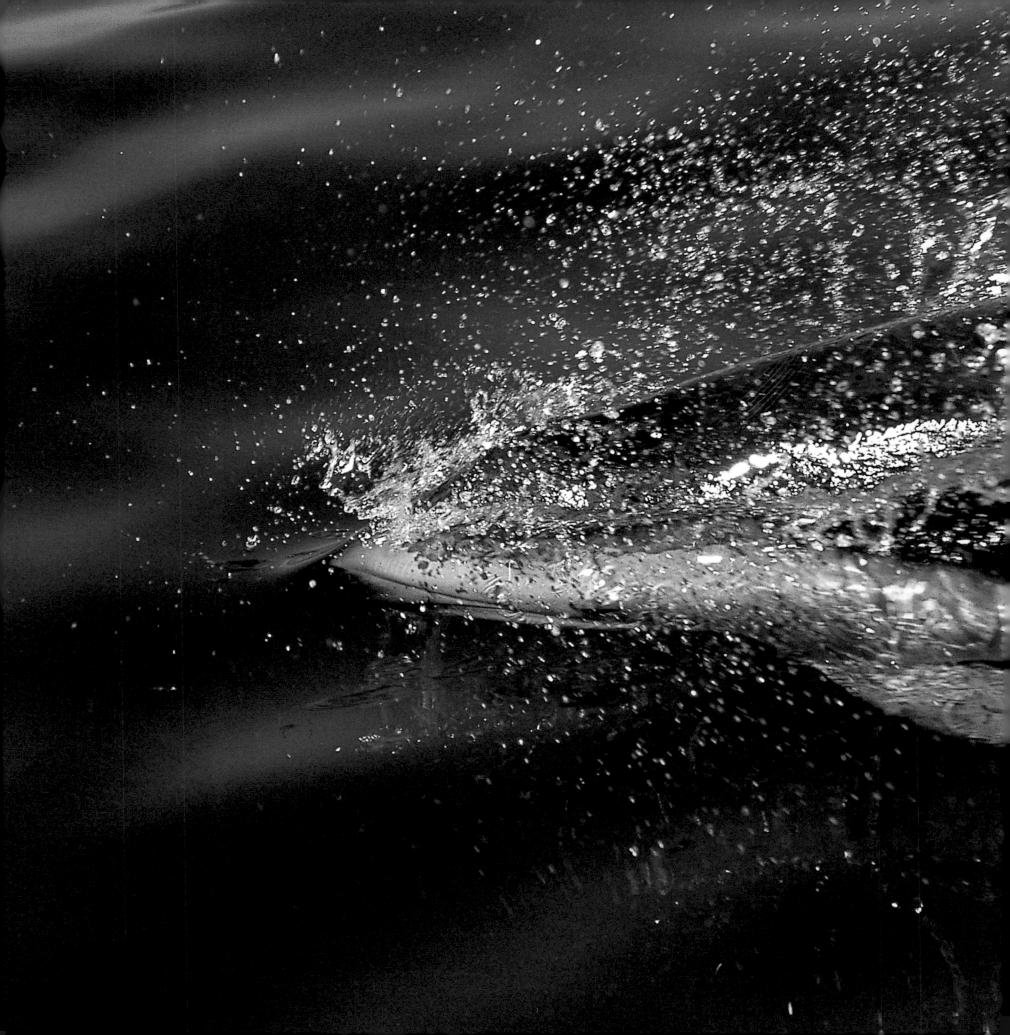

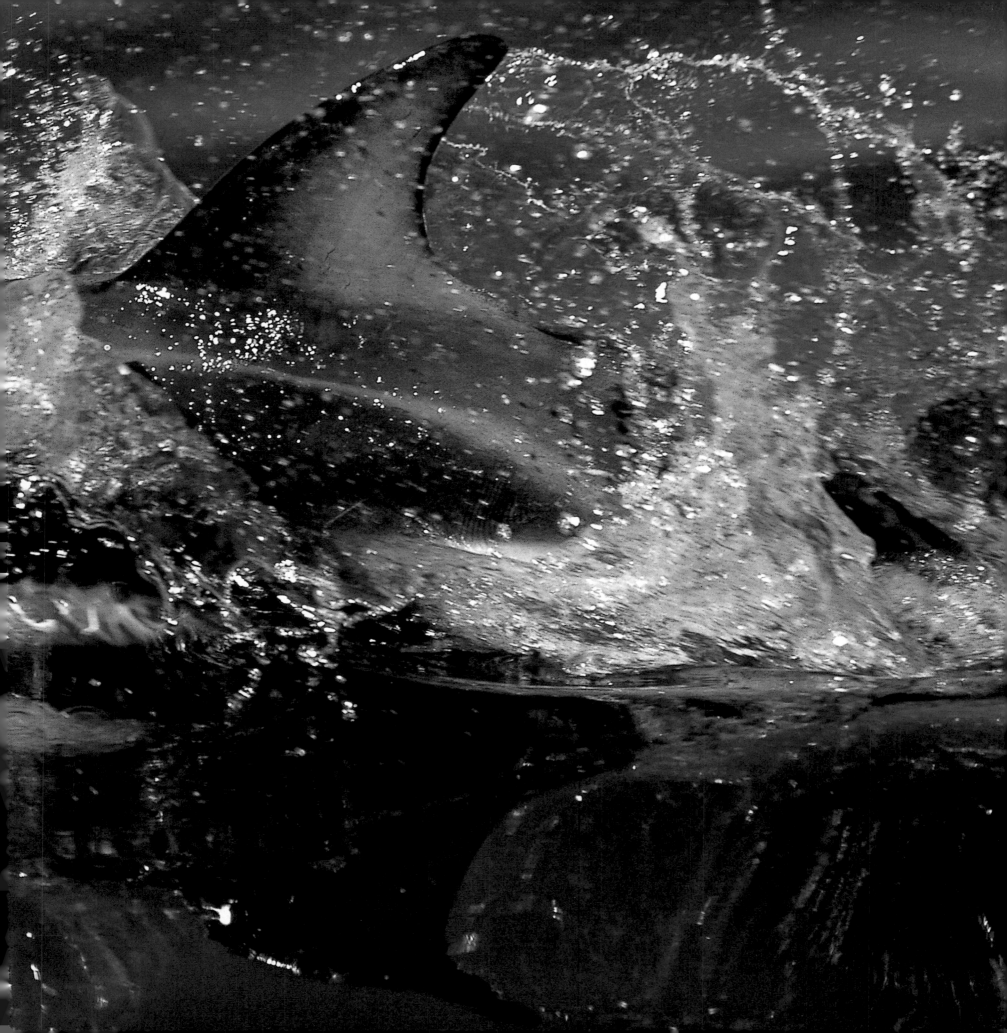

The dusty little hamlet of Puerto Pyramide (above) is a tourist Mecca for whale and dolphin watching, but it still retains the charm of a small Patagonian fishing village. (Preceding pages) A dusky surfaces to breathe, here traveling rapidly in search of food. Its tall dorsal fin is falcate (shaped like a sickle) and can have a light-to-dark-gray crescent shading on the rear edge of the fin. Under the belly, one of its pectoral fins, or flippers, is visible just beneath the surface of the Golfo Nuevo's clear blue Patagonian waters.

a cat if it fell off the table, then boarded a plane for Trelew, the town nearest our research site on the Peninsula Valdés, located in what is called central Patagonia, at about the 42nd parallel south.

The expedition research site, the Peninsula Valdés, was several hours north of Trelew, just off Argentine Route 3. This fast well-paved two-lane highway blasted through a monotonously flat, arid landscape covered over in *nuneo*, a plant that looked remarkably like sagebrush and filled the same ecological niche, which is to say, it is a ubiquitous arid-lands ground cover. The place felt rather like central Nevada, minus the mountains.

The road to the peninsula narrowed considerably. On a map, the peninsula looks like an enormous hatchet thrust out into the Atlantic Ocean. It is situated a little less than halfway between Buenos Aires and the tip of South America at Cape Horn. The handle of this peninsular ax is, of course, connected to the mainland. South of the handle, in the great enclosed bay formed by the southern head of the hatchet, is a body of water called Gulfo Nuevo. North of the handle is another gulf, Golfo San José, surrounded by the mainland and the projecting northern head of the Valdés hatchet.

Set on the seaward end of the south side of the handle of the peninsula is the little town of Puerto Pyramide. It is set below the sparsely vegetated cliffs of the headlands: a loose conglomeration of a few dozen tourist restaurants, guide services, and gift shops—all of them clustered close to the beach. In back of them, along the main road through town, are a few hotels, several private homes, and one car campground—Argentines seldom backpack but typically drive to commercial campsites. Not much was available in the way of accommodations during the holiday season, but I knew the scientists had booked their rooms at a place called the Paradise. At the far end of town, just before the paved road gave way to gravel, I found the Paradise Pub, a pleasant restaurant overlooking the gulf. It was ten in the morning and the door was open, but there was no one about.

I strolled around the hardwood tables and past the large picture window facing the beach. Photos of local celebrities hung from the walls: southern sea lions, ostrichlike rheas, foxes, southern right whales, elephant seals, and penguins. One framed picture, designed to look like a wanted poster, featured sepia-toned photos of two men known to the world as Butch Cassidy and the Sundance Kid. In the early years of the twentieth century, the two outlaws, along with Etta Place, bought a ranch in the mountains a few hundred miles to the west of Paradise Pub where they raised cattle for over four years.

Presently, a strongly built curly-haired man named Mumo stepped out of the kitchen and asked if he could help me. He looked more European than Latin and spoke Spanish with a lilt and bounce that sounded almost Italian to me. Mumo was the chef and proprietor of the Paradise Pub. He informed me that the whale-watching season was over but that tourist boats were still taking clients out to see the southern sea lions that were just setting up their season's residence on various rocky beaches a few miles from town.

I explained I was working with the scientists who, I had been told, were staying in the motel rooms behind the pub.

Mumo said that they would all be out on the water now. They left early every morning, seldom coming back until four or five in the afternoon. Sometimes they found the dolphins and sometimes they didn't; but in any case, the scientists could usually be found late in the afternoon at one of the long wooden tables in the pub, where they spread out maps, consulted laptop computers,

Kathleen, Alejandro, and the skipper head out to sea to look for feeding duskies.

and generally bantered among themselves until the dinner crowd started to arrive, which in Argentina was about 9:30 or 10 o'clock.

If I wanted, Mumo suggested, I could meet up with the scientists as they came off the water by going down to the main beach later that day, say around five, which worked out well, because it took most of the rest of the day to secure my own room.

I showered and walked down to the main beach. There were no dock and no pier of any kind. The boats piloted by fishermen and tourism outfits had to be towed onto the beach on a strange vehicle locally called a "mosquito," or "spider." This was a large box, basically the metal frame of what had been a large tractor, with wheels and elevated six to eight feet off the ground. The driver sat on an open seat behind an open engine. Hitched to the spider was a flatbed trailer. When a boat was coming in, a message was radioed to one of the half dozen or so spider operators working the beach, and the spiderman backed out into the surf. The boat captain throttled down and coasted gently onto the trailer, carefully avoiding the high metal rails on each side. Not much room for error.

I saw a spider waiting out in the shallows, about 150 yards off the beach, and a fair-sized boat was just edging up to the trailer. It drew closer and I could see Kathleen standing near the port bow. Bernd and Alejandro, both of whom I had previously met at a conference in California, were standing to either side of the captain, a burly man with a full head of curly

153

THE AQUATIC ACROBAT

Randall Davis, Ph.D.—*Professor of Marine Biology, Texas A&M University,* and Bernd Würsig—*Professor of Marine Mammalogy, Texas A&M University*

Whales and dolphins are the most aquatic of marine mammals and exhibit the most extreme specializations of any mammals to the marine environment. Some of these specializations include a streamlined body shape, reduction in limbs, flukes for efficient propulsion and physiological adaptations for prolonged breath-holding. Although leaping is considered a behavior and diving a physiological adaption, both are propulsive and locomotive and enable dolphins to navigate boldly and beautifully through the aquatic environments of the world.

Leaping is clearly performed above the surface of the water, where dolphins spend about 15 percent of their lives; and the other activity, diving, takes up most of the remainder of the time. For the biologists, ecologists, acousticians, and physiologists that find cetacean natural history worthy of study, research has been very frustrating because observation of dolphins underwater is so difficult. While this book has many exquisite underwater pictures of dolphins, the technology to methodically observe and study the lives of these natural athletes has been able to provide only fleeting glimpses of this highly mobile group.

There is much to be learned about leaping, but it is certain that there are at least three types: the head-first-reentry leap that serves to move efficiently and to dive well; the side-slap type of noisy leap that serves to communicate presence to others; and the acrobatic leap that may serve a social facilitation function. "We have fed and are predator-free. Let's have fun…and let's get to know each other!"

Dolphins and porpoises leap: some do so only occasionally, with a simple side-slap or a forward arc; others are demonstrably showy, arcing high, twisting, somersaulting, spinning rapidly, and slapping back onto the water surface in a welter of foam and spray. The leaps for speedy travel and for initiating steep dives are distinguished from others by the fact that they are snout-first reentry leaps, creating hardly a splash. It is the side slaps and belly slaps that create noise, and this is where we believe communication to be important. While splashing onto the water after a leap, dolphins create a loud underwater (and in-air) slapping or cracking sound. It has been postulated that leaping serves as a general acoustic communication signal to others to maintain cohesion of the group or school. But there is more to a leap than this.

When moving very rapidly, dolphins will leap in long arcs, up to about three times their own body length forward and three body lengths high. They propel themselves underwater with three to six rapid fluke beats, then cross the water-air interface, and use the forward momentum created in the dense medium of water to glide for a greater distance. Penguins do the same, and so do porpoises. But as bodies become larger, this method of rapid propulsion becomes less efficient. The largest of the Delphinids, the killer whales, do a modified leap during rapid travel, but only with about the top two-thirds of their bodies crossing the interface. The result is a surge with a significant amount of adjacent whitewater.

And then there are the truly acrobatic leaps, of spins and somersaults and an inventive mixture of other gyrations. These we believe to be mainly a display of exuberance, an outgrowth of a high level of energy or motivation for socializing. Indeed, many acrobatic leaps occur while dolphins are interacting in a close manner, and often sexually. Such acrobatics may occur most often when the animals are not in danger of attacks by killer whales or sharks and after they have been feeding for some time.

Dolphins also leap when they are busy corralling prey below. They breathe and quickly shoot up, exhale and inhale in two swift motions, overshoot the water surface, turn in-air, and use the weight of their bodies to rapidly propel themselves down to the fish that have been swept into a ball beneath the surface. Experienced skin divers do something similar (though not so they can feed on balls of circulating fish) by kicking their legs high above the water upon submerging. In this way, the in-air weight for part of their body propels them downward with greater efficiency. But dive depth for small-toothed whales (most dolphins), as well as humans, could never match the acrobatic performance of the larger toothed whales.

The deepest diving whale, or any air-breathing vertebrate for that matter, is probably the sperm whale with a maximum recorded depth of 2,035 meters (about 1.2 miles). Although our lack of information makes it difficult to generalize, breath-holding ability and maximum dive depth probably scale roughly to body size. Therefore, the smaller toothed whales dive less deeply. For example, smaller pilot whales can dive to at least 610 meters and beluga whales to 650 meters. Trained bottlenose dolphins can achieve depths of 535 meters, although they do not routinely dive this deep in the wild. Although baleen whales include in their group the largest of all whales, among which is the largest animal that possibly ever existed (the blue whale), they tend to dive less deeply— probably because of the smaller oxygen stores in their tissues and the fact that their prey tend to be closer to the surface than most prey for toothed whales. The search for squid is

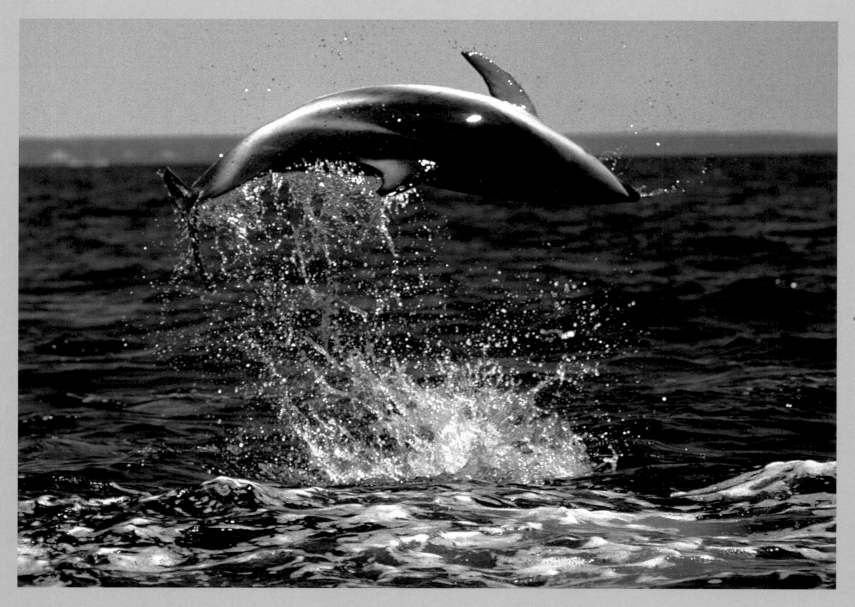

A dusky somersaults and twists in an exuberant display that very well might be saying, "I'm being social. Come join me!".

likewise the reason that sperm whales, which have large stores of oxygen in their tissues, penetrate into the dark, cold realm of the deep sea. Imagine a sperm whale at a depth of 2,000 meters in search of one of its favorite foods, the giant squid. It is pitch-dark and the temperature is near freezing. Because the tissues of whales have a density similar to sea water, they are close to neutrally buoyant—or, in other words, the whale is nearly free from the forces of gravity. This alien environment is as close to being in space as is possible on earth, but with one major exception: the pressure at this depth is a crushing 200 atmospheres, equivalent to a pressure of nearly 3,000 pounds per square inch. Such high pressure would be lethal to humans and other land mammals. How deep-diving marine mammals avoid the effects of such extreme pressure remains a mystery.

Today, technology is providing a better understanding of marine mammal diving and hunting behavior. Scientists at Texas A&M University have developed an animal-borne video system/data logger that enables humans to travel vicariously with deep-diving marine mammals. This new technology has been used with dolphins, seals, and sea turtles. It is providing new information on the hunting behavior of these animals and predator-prey interactions. Such research, although still in its infancy, is revealing the hidden lives of these highly specialized mammals and their roles in the marine ecosystem. ∎

brown hair. The captain stepped away from the wheel and Alejandro took his place. He guided the boat onto the trailer quite skillfully and without incident.

The spider pulled the boat up onto the beach, and the three scientists clambered down, carrying various duffles and bags containing diving gear, wetsuits, still cameras, notebooks, tape recorders, navigation maps, two-way radios and, of course, Kathleen's mobile video/acoustic array.

I was greeted with *abrazos,* hugs all around, and Bernd introduced me to the captain, an ebullient jokester called Pinino. Another man, Pepe, was a representative of the Argentine government, whose duty it was to make sure that our scientists and filmmakers did not harass the dolphins. In Argentina, off Puerto Pyramide, it is illegal to swim with the dolphins, just as it is off the coasts of the United States. Special permission is sometimes granted to legitimate scientists and filmmakers.

Apparently it had been a good day on the water. Several small groups of about a dozen dolphins had been sighted early in the morning, and there had been a lot of leaping. "Awesome leaping!" exclaimed Alejandro, a useful description to this most enthusiastic of scientists.

"Sometimes," Kathleen added, "20 or 30 leaps in a row." She was not familiar with this sort of behavior. Atlantic spotted dolphins in the Bahamas and bottlenose dolphins off Mikura Island in Japan sometimes perform water-clearing leaps, but almost never repeatedly. In fact, duskies are known for this ebullient display. Bernd, who knew the duskies best of all, was the featured scientist in *Jump for Joy,* a 1970's nature documentary all about the duskies. I asked if the dolphins were in fact jumping for joy today.

"No," he said. "I don't think so—not today."

"Why not?" I asked.

"Lots of reasons. Let's talk about it later, after you've been out on the water," Bernd said. He was short, bearded, very fit, and the wire-rimmed glasses he wore gave him a certain elfish aspect. Bernd laughed loudly and often, sometimes at his own jokes.

He was, by his own admission, a shameless punster.

The low-sloping beach of Puerto Pyramide necessitates using customized elevated tractors for launching or docking small boats. This homemade contraption was dubbed "El Mosquito" by its owner.

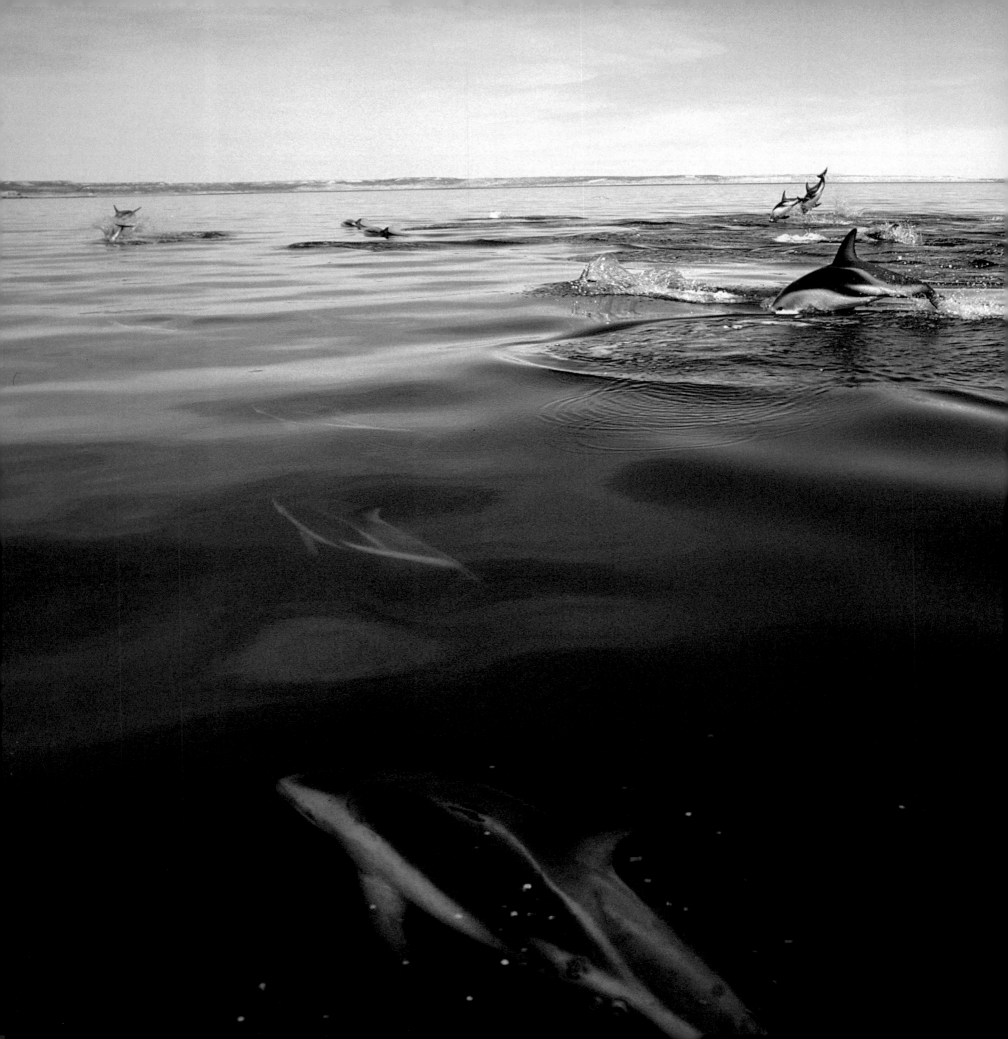

Here, a group of dusky dolphins herds anchovies by pushing the small fish in front of, and underneath, them. This dolphin group is preparing to feed on a "bait ball" of anchovies; but at this point, the widely dispersed dolphins are an indication that the fish are too widely spread. During early stages of prey aggregation, dolphins near the center of the group dive steeply in an apparent attempt to bring prey up toward the surface. Those on the periphery zig-zag back and forth, probably to keep wandering prey from escaping the ever tightening prey ball.

While much of feeding on bait balls is simply due to the natural schooling tendencies of dolphin prey, the coordinated and somewhat predictable actions of the dolphins indicate that they work hard to contain the prey in as tight a ball as possible.
—Bernd Würsig

Bernd Würsig takes his work very seriously, indeed, but seems devoid of the kind of self-importance and condescension some distinguished scientists develop over time. A professor of marine mammalogy, director of the Marine Mammal Research Program and co-director of the Institute of Marine Life Sciences, all at Texas A&M University, Bernd has authored 70 peer-reviewed papers, worked on 13 films, and published 40 articles for the public as well as numerous reports in the fields of animal behavior, behavioral ecology, social systems, and conservation biology.

A versatile, innovative, and concerned scientist, Bernd serves as an advocate and consultant for the ethical treatment of animals and has devised noninvasive methods to study cetaceans as well as solutions for protecting them. His reputation precedes him, as I found out in a recent and unrelated interview with the director of the newly built Hong Kong airport. The huge new airport facility had been constructed by tearing down a mountainside and filling in the shallow waters of the bay. I had asked the director if the noise and pollution of the massive landfill project had disturbed the resident population of Chinese white dolphins. He said that it had not. Incredibly elaborate precaution had been taken. A new habitat area had been constructed nearby, for instance, and a series of forced-air pipes blew bubbles into the water in order to mask construction sounds, which can disturb the dolphins' habitat and social life.

"We're proud to say that our local population of dolphins is both thriving and multiplying," the director said.

"Who helped with this plan," I asked.

"A scientist from Texas A&M," he said. "The fellow's name is Bernd Würsig."

At seven that evening, just as the Paradise Pub proprietor had said, everyone was hard at work, poring over maps spread out over one of the long tables. They were estimating the number of dolphins they'd sighted that day, pinpointing the locations, marking the maps, and entering the information on a pair of laptop computers.

Dinner, at 9:00, consisted of beef ribs grilled over wood and served with *chimichuri*, a uniquely Argentine condiment made with mild red peppers, oregano, garlic, and vinegar.

I trudged back down the dusty street to my solitary cabin, fell into bed, and woke to the insistent honking of my alarm clock about five minutes later. Or so it seemed. Actually it was six in the morning: time for breakfast at the Paradise Pub, followed by a brisk walk to the beach, where we all climbed into a pair of boats already hitched up to their separate spiders.

The three scientists took the lead boat. I was placed in a second vessel with Paul Atkins, a filmmaker who would be shooting the Argentine portion of the film. He was scouting the area, and, if the occasion arose, actually doing some filming if we ran into any interesting dolphin behavior. We were accompanied by Michelle Wainstein, a young Ph.D. candidate and member of the scientific team for the IMAX movie. She would be collecting and recording data on the location, number, and behavior of any dolphins we encountered.

The spiders backed us out into the ocean, and as we bobbed side by side, Kathleen called out to us that we should all synchronize our watches. *When* the dolphins were sighted was just as important as *where*.

"Let's synch at 7:10," Kathleen shouted over to us. We all stared at our watches. "Okay," Kathleen shouted, "synching at 7:09, and I have 7:08 and 30 seconds…31 seconds, 32, 33, 34, 35…"

Bernd Würsig, his voice full of alarm, shouted: *"We're synching. We're synching!"*

Pretty *punny*, I thought, but quickly realized that the others had heard that one before.

"Starting again," Kathleen shouted. "Synching at 7:10, and I have 7:09 and 15 seconds. 16 seconds, 17, 18…"

And then with all our watches all properly "sunk," we motored off in different directions, looking for dolphins. It was a windless day and the sea was flat calm, a mirror to the pale blue sky above.

An hour passed.

Our captain called Kathleen on a two-way radio. They hadn't seen anything either. This was unusual but not unheard of. We'd keep looking, moving to the south.

Meanwhile I spoke with Paul Atkins, who has shot film in most of the oceans on Earth, including—and not incidentally—in Golfo Nuevo and Golfo San José. His last project in the area had been at Punta Norte, the northernmost point of the head of the hatchet that is the Peninsula Valdés. He had been shooting

Bernd Würsig watches and takes notes on a vessel that MacGillivray Freeman Films uses as a camera platform during filming off Patagonia.

some sequences that the more sentimental among us might call "dolphins behaving badly."

Atkins said he spent six weeks at Punta Norte, working with Juan Carlos Lopez, Argentina's best known orca expert. The scenes he shot there, on that bloody beach, are as frightening and appalling as they are unforgettable.

Here is one of those images: a baby southern sea lion is trundling along the brown and pebbly beach at the edge of the ocean; there is something of Charlie Chaplin in its awkward side-to-side waddle, something charming and endearing and, yes, loveable. Cut to: a shot from the beach. Looking out to sea

we see several large black dorsal fins, some of them six feet high. These fins saw back and forth through the waves, impossibly close to the beach.

Back to the baby sea lion: it stares out into the world in bright-eyed and innocent bewilderment. We are irresistibly drawn to this infant. It is what some biologists call fubsy. The theory has it that we, as humans, are hard-wired to protect our progeny, and because of this, we are also instinctively protective of creatures that possess attributes common to human infants. Clumsy or uncoordinated animals with large eyes, big heads, and short limbs are said to be fubsy. This baby sea lion is so

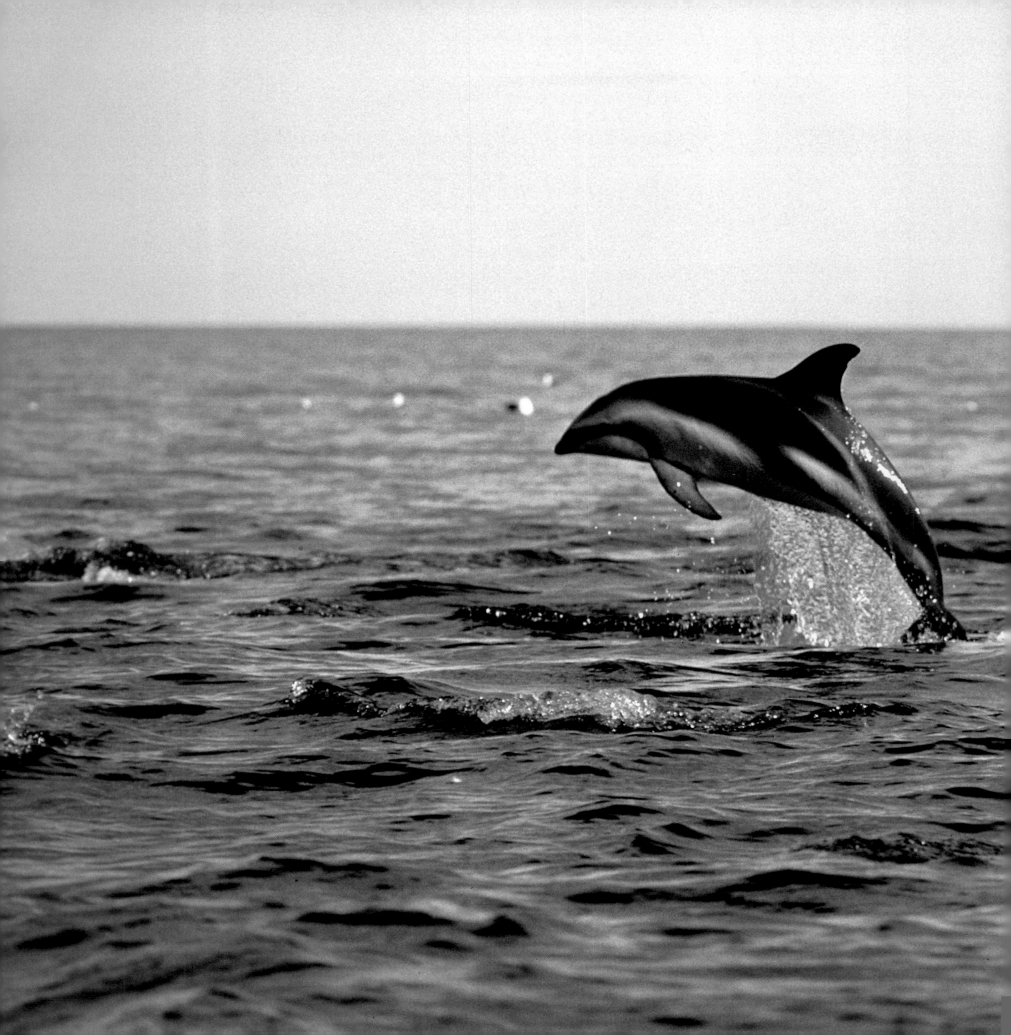

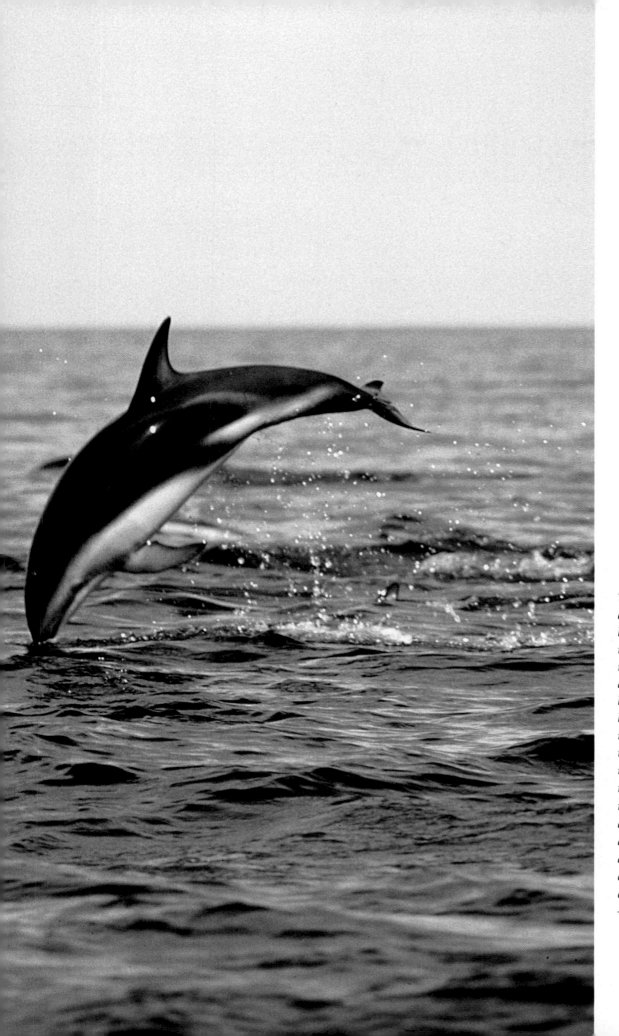

Two dolphins breathe and dive in tandem as they coordinate food herding activities below. Two main behaviors are evidenced in this photograph. One, the head-first entry leaps are designed for the animals to rapidly dash out of depth, breathe in air, and shoot back down to depth. They are working below, and take only the minimum time off to breathe. Their overshooting of the surface by leaping in air is due to their high speed, but it also allows them to use their in-air weight to give them a natural push downward as they descend. Second, the tandem nature of leaping indicates that these two individuals are, indeed, working together at depth. Perhaps they both corral the prey ball from different angles; perhaps one will blow bubble blasts at the prey while the other one circles tightly. Such coordinated activity—apparent cooperation—is common among foraging dolphins.
—Bernd Würsig

THE REALM OF THE SENSES

LOUIS HERMAN, PH.D.—*Director of the Kewalo Basin Marine Mammal Laboratory, Honolulu.*

Most of what we know about the sensory systems of oceanic dolphins has come from studies of a few species in laboratory settings, particularly the bottlenose dolphin. The marine world is a dynamic environment, filled with a myriad of life forms, noises, topographical features, differing substrates, changing water qualities and movements, temperature, pressure, chemical variations, and objects of various sorts. Evolution has provided the dolphin with many sensory specializations and enhancements to sense and interpret these variations. The basic senses of hearing, vision, taste, and touch have been retained, often in modified form, but smell has been abandoned. Olfaction is of little use to an air-breathing mammal that spends most of its time underwater and no longer sniffs the air. And it has been suggested that dolphins possess a magnetic sense used for navigation.

Hearing. Attending to and interpreting sounds is made possible by the extraordinary development of the dolphin's hearing system. The external ears have disappeared, promoting a more streamlined body shape better suited to rapid swimming, and new sound pathways have evolved. The lower jaw as well as broad areas around the sides of the dolphin's head conduct sound particularly well to the inner ear. Modifications of the inner ear mechanisms allow the dolphin to detect sounds across a broad spectrum of frequencies, including frequencies eight to ten times above the upper limit of adult human hearing. The large auditory nerve and the extensive auditory centers of the dolphin's brain allow for the rich interpretation of sounds. Small differences in frequency (pitch) can be discriminated, helping the dolphin to distinguish among the variety of unique whistle-sounds ("signature whistles") of its schoolmates. The two inner ears are isolated acoustically from each other, enabling the dolphin to precisely locate vocalizing schoolmates or other sources of underwater sound. Through passively listening to its world, the dolphin may be able to detect the sounds of prey and locate their origin, link up with vocalizing distant schoolmates, become aware of shallow, shoaling water, hear the whine of a boat engine and perhaps swim toward it to ride the bow wave, or "tune in" on the echoes produced by a neighboring echolocating dolphin.

Vision. Because of the exceptional hearing and echolocation capabilities of the dolphin, and the importance of sound in the underwater world, dolphins were traditionally thought of as primarily auditory animals. Vision was believed to be not particularly well developed, and of secondary importance at best. We now know this to be untrue. Although river dolphins living in the extremely turbid waters of the Ganges, Indus, or Yangtze Rivers do have greatly reduced vision, oceanic forms, such as the bottlenose dolphin, have excellent vision. Research has shown that dolphins can see about equally well underwater and in air. Adaptations of the optical qualities of its cornea and lens allow it to see well in both situations. The lens is of ovoid shape, and most closely resembles the lens of a fish. Typically, when looking at objects in air, the dolphin positions itself differently than when looking at objects underwater. This results in light passing through different portions or layers of the lens (and cornea) in air than in water, and apparently functions to produce sharp images in each medium. The dolphin eye, though lacking color vision, is highly sensitive to light in the blue region of the visible spectrum, which is in keeping with its offshore blue-green underwater world and the fact that blue-green light penetrates to deeper depth in the open ocean than does red-yellow light. Mirror cells act to amplify the light entering the eye, making it possible for the dolphin to see well at night or in the dim light of its underwater world. Dolphin eyes are laterally placed, enabling the dolphin to see forward, laterally, and even rearward; in addition, the dolphin's eyes act independently. In the wild, underwater vision helps the dolphin to capture swift-moving prey and to keep in contact with schoolmates swimming nearby. It also helps to identify its own species, recognize familiar individuals from its social group, and to interpret behavior in the context of age, size, and sex differences. In-air vision helps the dolphin keep in contact with distant leaping members of its group, to detect circling birds that may indicate the presence of prey fish, and to recognize land features of its coastal habitat. Dolphins can attend to and interpret human gestures, monitor rapidly occurring visual symbols appearing on a television screen and report the occurrence of certain key symbols, and easily recognize the same objects across the senses of vision and echolocation. It is clear that we should regard dolphins as both auditory and visual specialists.

Taste. The areas of the tongue of adult dolphins that lie closer to its base appear to have pits and budlike structures that may represent taste receptors. Studies have shown that dolphins can detect the four primary taste qualities of salty, bitter, sweet, and sour, although sensitivity to these seems to be less than human sensitivity. Even though taste may be somewhat limited, there is value in being able to detect at any level the various waterborne chemical products that are produced by biological organisms or by natural processes. For example, large aggregations of prey

species will leave or disperse chemical traces of their presence that may guide the dolphin toward that location. Likewise, schoolmates may also be detected through the chemical traces produced by their frequent urination. Different "tastes" of water may possibly assist in recognition of certain regions of the dolphin's habitat. More importantly, perhaps, taste may help dolphins detect the sexual, or receptive, state of other members of their species. Excreted urine may contain pheromones (chemical messages) that can be sensed through taste. There is other suggestive evidence that urine may contain alarm pheromones that signal some perceived danger. Beluga whales, for example, have been described as fleeing the scene where earlier other members of their species were shot at by hunters.

Touch. The skin of dolphins is richly provided in nerve endings. Studies that examined the dolphin's response to touch have found highly sensitive areas around the blowhole, eyes, snout, lower jaw, and melon—areas where nerve bundles are especially prominent. The measured sensitivity around the eyes and blowhole was comparable to the levels of sensitivity of humans in their most sensitive skin areas, the fingers and lips. Sensitive touch receptors may help the dolphin in feeling and snapping at prey swimming near the front of its mouth, an area that may not be visually available. Touch also seems to be part of the normal social interchanges; touching where and how vigorously can be a sign of affiliation or an indicant of aggression or annoyance. Pressure, as well as touch, may be sensed by the dermal ridges in the skin, and may provide useful information during diving or high-speed swimming. Detection of the pressure wave produced by the mother dolphin as she swims forward is apparently sensed by the calf who coasts

along in the wave, enjoying a free ride. Bow-wave riding and wave surfing may also be aided by pressure and touch receptors. The dolphin's body, except for its pectoral fins, dorsal fin, and tail flukes, is well insulated by a thick blubber layer. Detection of temperature, therefore, if used by dolphins, would likely be restricted to those appendages without blubber, although there appear to be no studies directly investigating temperature sensitivity, nor studies examining for deep pressure sensitivity or pain.

Magnetic sense. Some studies have suggested that dolphins may possess a magnetic sense that enables them to use the Earth's magnetic field for orientation and navigation. Evidence for a magnetic sense is still tentative and consists in part of correlations between regions where many strandings of dolphin species have occurred and the presence of geomagnetic anomalies or

disturbances in these regions. Other suggestive evidence comes from the presence of iron oxide crystals (magnetite) in various locations in the head region of some dolphin or whale species. Magnetite can provide a mechanism for detection of magnetic fields, but the receptors associated with these magnetite crystals have not yet been identified. Perhaps the most suggestive evidence that cetacean species possess a magnetic sense comes from the recent satellite tagging of several humpback whales off the coast of the island of Kauai in the Hawaiian chain. Two of these whales were tracked for long distances as they migrated toward their summer feeding grounds in the higher latitudes near Alaska. The whales deviated hardly at all from a magnetic north heading, a feat that seems possible only through some sort of magnetic (compass) sense. ■

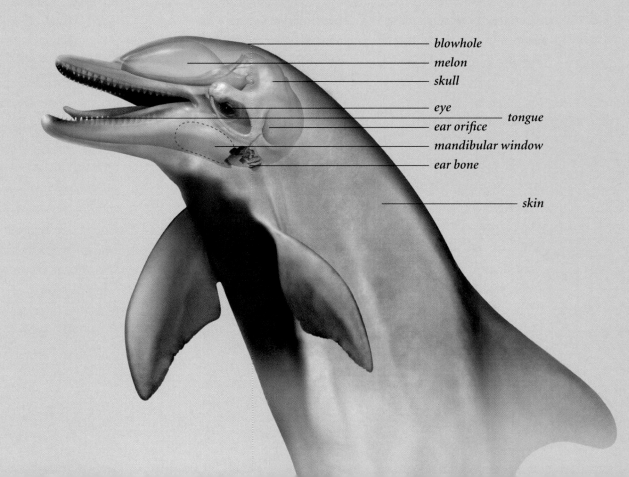

blowhole
melon
skull
eye
ear orifice
tongue
mandibular window
ear bone
skin

The MacGillivray Film crew and their vessel return to Puerto Pyramide after a successful day of filming duskies in the South Atlantic Ocean, inside Golfo Nuevo. Some days duskies would be found within a mile of Puerto Pyramide, while on others the crew traveled tens of miles for a only a bit of film footage.

excessively fubsy, we are convinced it cannot long survive without our help.

And so it is. On a crashing, discordant note, an immense black and white killer whale, an orca, the world's largest dolphin, makes a run for the shore, powering in through the surf, and right up onto the sloping beach. It's a big male weighing perhaps five tons, and it snaps up the baby sea lion like a canapé, shaking it about this way and that, because orcas just hate it when their hors d'oeuvres fight back. The triumphant killer slides back down the slope of the beach in a series of hunching side-to-side movements.

"What we noticed," Atkins told me, "is that while there may have been a dozen sea lions on the beach, adults and pups, the orcas invariably took the pups. I thought they were using sonar, you know, echolocating, but now we know they are completely silent during these raids. So they must locate their prey by sight."

After several weeks, Atkins and Lopez, certain that they didn't look at all like baby southern sea lions, took to the water, where they shot film of killer whales charging the beach from an underwater perspective.

It was now closing in on 8:30 in the morning, and we still hadn't seen any dolphins. Paul and I were engaged in what can only be called a macho shoot-out. So he'd been in the

water with killer whales, in dangerous circumstances. Well, I've been in the water with great white sharks. So had Paul. How about tiger sharks? Yep, he'd done that too.

I felt Michelle Wainstein had pretty much been left out of the conversation. Maybe she had some girl-type macho tale to tell. She had done some of her fieldwork in marine biology on the Peninsula Valdés, working with elephant seals. The creatures were big: elephant seal males can grow up to 15 feet long and weigh in excess of 4 tons. They fight bloody battles among themselves during mating season. The fights are as savage as anything I'd ever seen in any nature documentary. Michelle said her research was designed to answer the question: which male sired which infants.

"How would you figure that out?" I asked.

"Well," she said, "We took blood samples from them and then tested the DNA."

"What did you find out?"

"About what you'd expect: the biggest and strongest males sire the most infants."

It suddenly occurred to me exactly what Michelle meant.

"You took *blood* samples?" I said incredulously. "From an *elephant* seal? How did you do *that*?"

"Well, you stand over them when they're lying down. You do it with a needle, and then you paint a number on their backs."

Now that, I thought, was a scary job. "Did one of those big males ever bite you?" I asked. It was a joke. Anyone bitten by an elephant seal, I imagined, would die pretty much instantly.

"See this scar on my leg," she said. "One of the males bit me right there. Luckily it was cold and I was wearing several layers of pants."

"One of those big guys bit you and you survived?" I asked in stunned amazement. She nodded an affirmation. Paul and I shared a quick capitulatory glance. Michelle had won the macho shoot-out hands down.

Feeling uncharacteristically humble, I looked out to sea and spotted what looked like dolphins a few miles off the port bow. There seemed to be a dozen or more, leaping in what can only be described as a kind of acrobatic ecstasy. Michelle recorded the time and location of the sighting in her notebook.

We approached at speed, then throttled down into an idle when we were a few hundred yards away. Some of the dolphins

Back at Mumo's Place , also known as the Paradise Pub, the three cientificos *talk about the day's events at sea.*

approached, still leaping, each in his or her own manner. Some actually did somersaults in the air, while others landed with distinct tail slaps or belly flops. It was like standing in one spot as an entire circus of tumblers approached doing cartwheels and front flips and moonwalks.

They were smaller than bottlenose dolphins—the largest duskies run to about seven feet long—and their backs were quite dark, with a highly contrasting white belly. Duskies are the most acrobatic of all the dolphin clan.

One, for instance, moved across the surface of the sea like a stone skipping across the waters of a still pond. Several others in the foreground leaped in various odd and seemingly awkward angles, while others, farther away, rose in a series of intertwining loops. One of the dolphins streaked through the looping display in a stone-skipping manner, except that it chose to land tail first in a kind of slapping motion. I was counting the number of absolutely identical tail-slapping leaps. Four, five, six…

It was not quite nine in the morning, and the sun was still low in the sky, so that the dusky's tail-splashing slaps caught and fractured the light. There were more than a dozen small arcing rainbows falling back into the sea before the dusky got only halfway through its 24th leap and dropped into the water, apparently exhausted.

I had never seen anything like it. And they were fast. Michelle confirmed this. She had been in the water with them.

"Sometimes," she said, "after a while, one will start swimming with you, real slow, right at your flank, and then, *wham*, it begins to shoot around like a mad mammal. *Zip, zip, zip.* All of a sudden, it seems, they get the 'zooms.'"

"The zooms?"

"Like a puppy. You know: one minute the puppy is dozing, then it suddenly gets this urge to run around hysterically. *ZZZip.* I call that the zooms."

Unfortunately, the fast moving duskies were receding into the distance, leaping black and silver against the sun. We throttled up to circle them and waited, but never saw another dolphin.

I wondered, What was all that incredible leaping about? Was there a purpose beyond pure athletic joy?

One of the topics discussed in the Paradise Pub is dusky dolphin foraging sounds. This visual/graphic display—created in Canary computer software, designed to aid in analysis of animal sounds—shows both a waveform and spectrogram of dusky dolphin vocalizations recorded.

THAT NIGHT AT DINNER, I SAT NEXT TO BERND AND chatted with him about his life and career. He was born in Germany, but his family moved to the United States when he was not quite eight years old. The Würsigs settled in Fremont, Ohio, not far from Toledo, and the largest body of water Bernd ever saw until he was an adult was Lake Erie.

His parents had some books in German, and, at the age of nine, Bernd remembers being strongly influenced by one about the Maldives Islands, written by a marine biologist named Hans Haas. A picture book. Bernd still has it, and firmly believes that that one single book ignited his life-long love of the sea.

Bernd had a lot on his mind—he was studying zoology *and* German literature—and it was only by a conscious act of will that he avoided scraping plates for an entire year.

In the summer of 1968, Bernd worked at a resort as a cook. "A short-order cook," said the extremely short professor, laughing. It was there that he met Melany, who was to become his wife and collaborator. Together, they have co-authored almost a dozen scientific papers.

In 1969, Melany and Bernd traveled to Italy together.

"It was the first time I'd swum in the sea," Bernd said. "Livorno, Italy. I remember it vividly. I was 20 years old."

The next year, Bernd and Melany were married while both were at the university. "Melany is from Venezuela," Bernd

told me. "I took Spanish classes and she took German. We wanted to be able to talk to one another in our native languages."

It was, in fact, Melany's Spanish that got the Würsigs down to Patagonia in the first place. Bernd was in his first year of grad school, and he'd heard there was a position for a research assistant job, working with a well-known marine biologist named Roger Payne. "I was qualified for the job," Bernd said. "I had already had a lot of experience driving boats on Lake Erie, and I taught diving at Ohio State. But guys like me were a dime a dozen. I think the real reason I got taken on as an assistant was because of Melany. Roger didn't speak Spanish well back then, and Melany could translate as well as tutor the four Payne children."

Eventually Roger Payne completed his work on the Peninsula Valdés, but the Würsigs stayed on in Patagonia for four seasons of over six months apiece. The research was labor intensive but results poor. Melany and Bernd, who at the time were living in a wind-battered tent, began to despair.

"I wrote a letter to a fine scientist named Ken Norris. Do you know who he is?"

"Isn't he the guy who came up with the idea of making big Dumbo ears to listen to the dolphins underwater?"

"Yes. So in a way he's the father of Kathleen's research." Norris, Bernd said, did pioneering work with marine mammals,

Continued on page 181

PLAY

Bottlenose dolphins line up to surf a long near-shore wave off a South African beach.

Perhaps our most impressionable view of dolphins at play is when they ride the bow, stern, side and rear waves of moving vessels. What they are doing is surfing on pressure waves. One could argue that the dolphins surf to get a free ride from point A to B, but since closer observations have shown that they generally swim back to point A, it seems likely that this is not so purposeful, just merely dolphins playing.

Dolphins may also ride the "bows" of large surging whales such as sperm, right, and humpback whales, rapidly swimming back and forth around the eyes and snout of a whale—until the whale surges forward from, it seems, the disturbance. The dolphin takes its place on the pressure wave created off the left and right jaws of the lunging leviathan. There even seems to be a "dolphin" blow that whales emit as this happens, a loud plosive chuff that sounds like an angry roar.

Spinner dolphins of Hawaii and duskies in Argentina and New Zealand often carry around bits of flotsam—a piece of kelp, a large leaf, a scrap of plastic. The playful bauble (called, by the great Ken Norris, dolphin jewelry) is often seen on their snout, dorsal fin, front edge of a flipper, or draped over the leading edge of a fluke. They often let the object slide off an appendage, only to adroitly pick it up with another of their body parts, again and again. They mouth it gently, then let it slide onto an appendage or pass it to a colleague nearby. "Here, you have a try."

Then there is what I call the dolphin's impish nature. I've seen duskies, after sating themselves on southern anchovy and when in a highly social mood, nosing v-e-r-y s-l-o-w-l-y toward a gull or black-browed albatross sitting at the ocean surface, digesting, preening, oblivious to what is going on below. Then they, woosh, pull the creature underwater by gently mouthing one or both of the bird's feet hanging enticingly below the surface. The dusky tugs hard, and the bird may be dragged down 20 inches or so. It flails its wings and feet to get free. The dolphin opens its mouth and the hapless waterborne avian bobs to the surface like a cork, but a particularly aggravated, soggy, and frantic one. The dusky slowly cruises off with an enigmatic smile that seems to say, "Hee-hee, I got another one but good this time!"
—Bernd Würsig

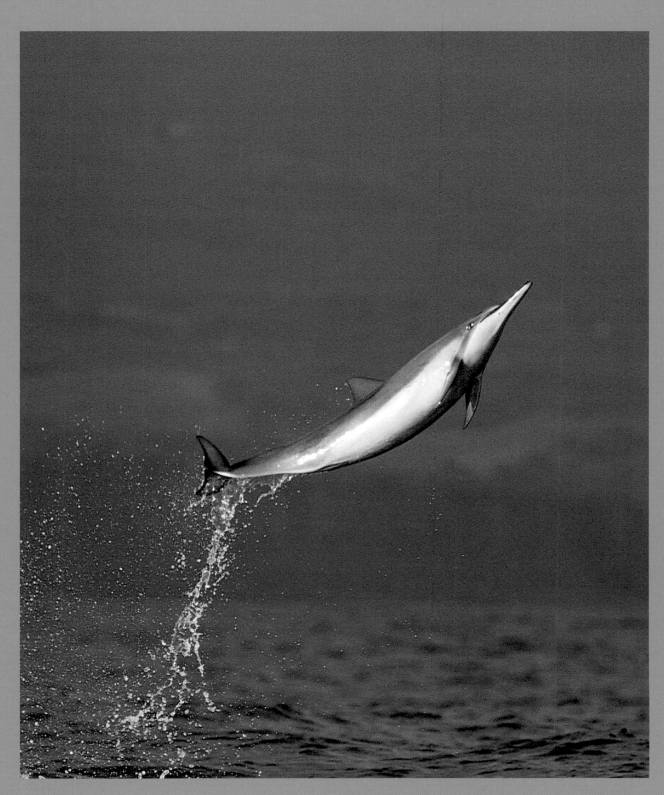

The graceful spinner dolphin breaches off Hawaii, here not in a spin but an exuberant high leap.

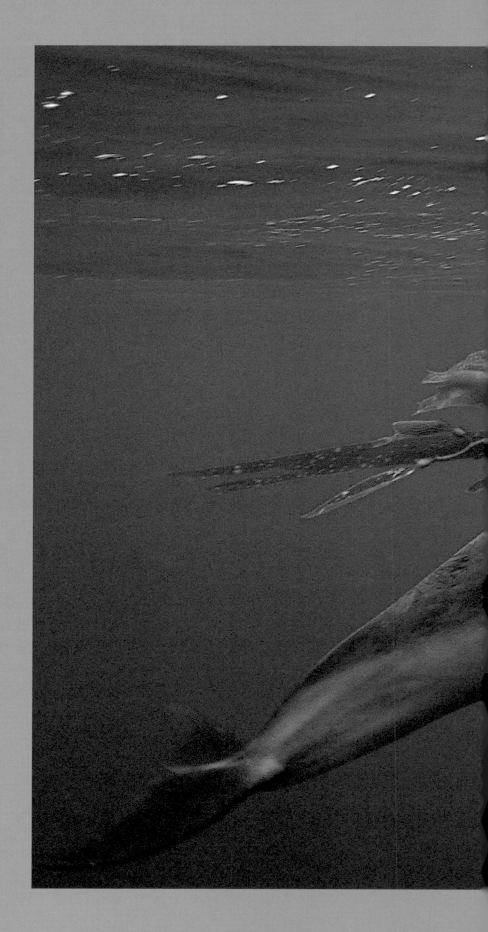

This Pacific white-sided dolphin is not entangled in kelp but is playing with its own particular brand of "jewelry."

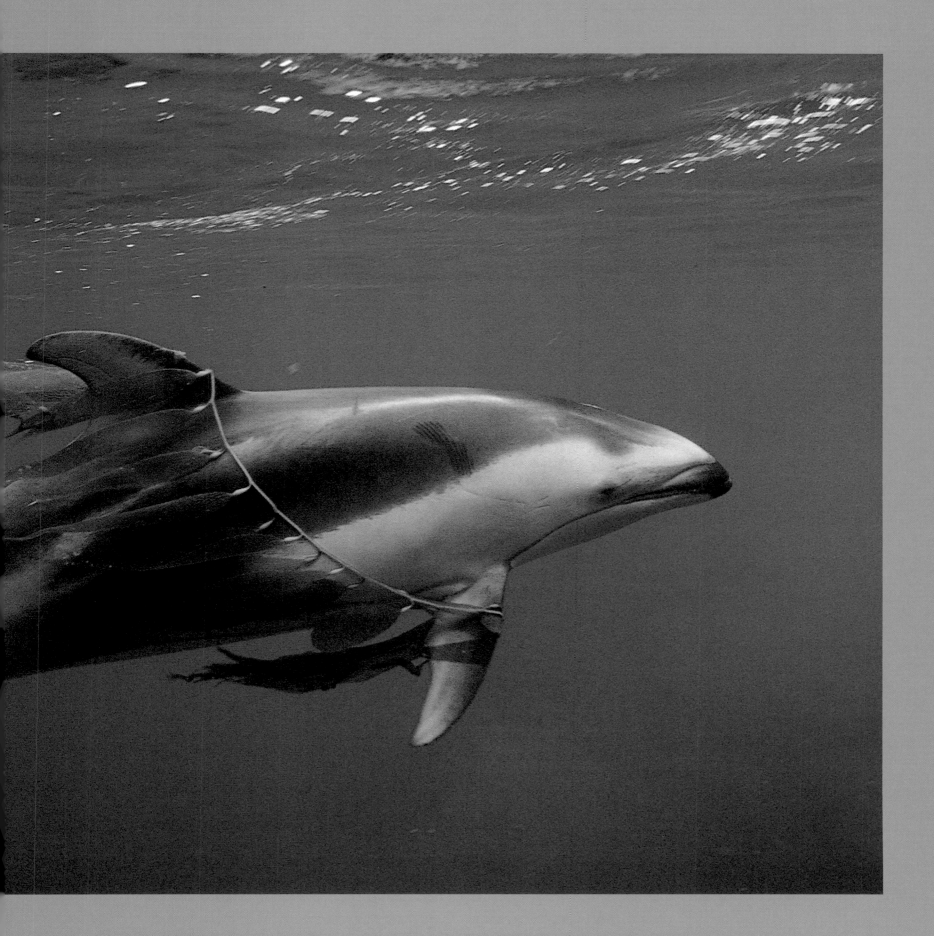

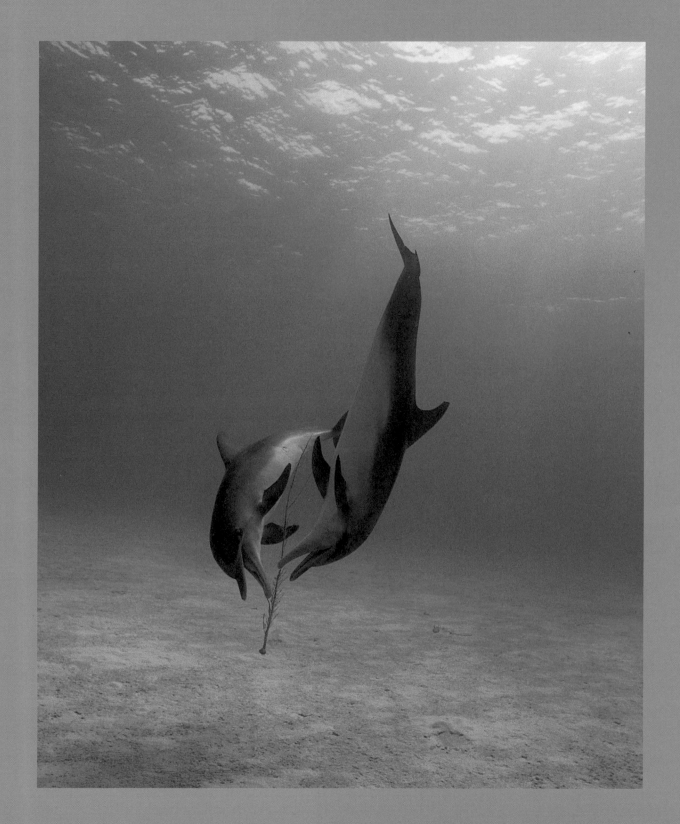

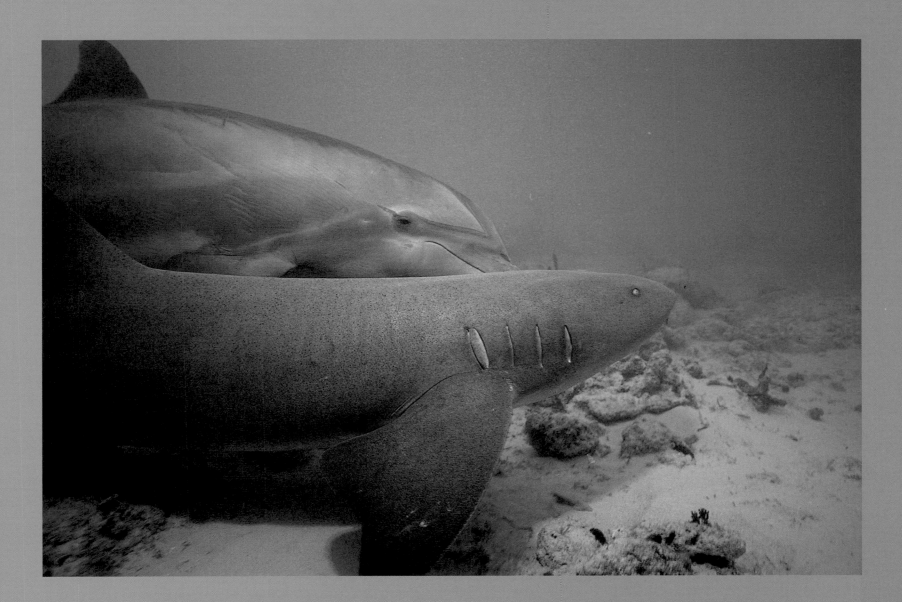

This bottlenose dolphin (above) of the Turks and Caicos Islands in the Caribbean appears to be playfully nuzzling a harmless nurse shark, which is primarily a bottom dweller that feeds along the seafloor.

Two Atlantic spotted dolphins (left) play with a sea fan at Bahamas Bank, Caribbean.

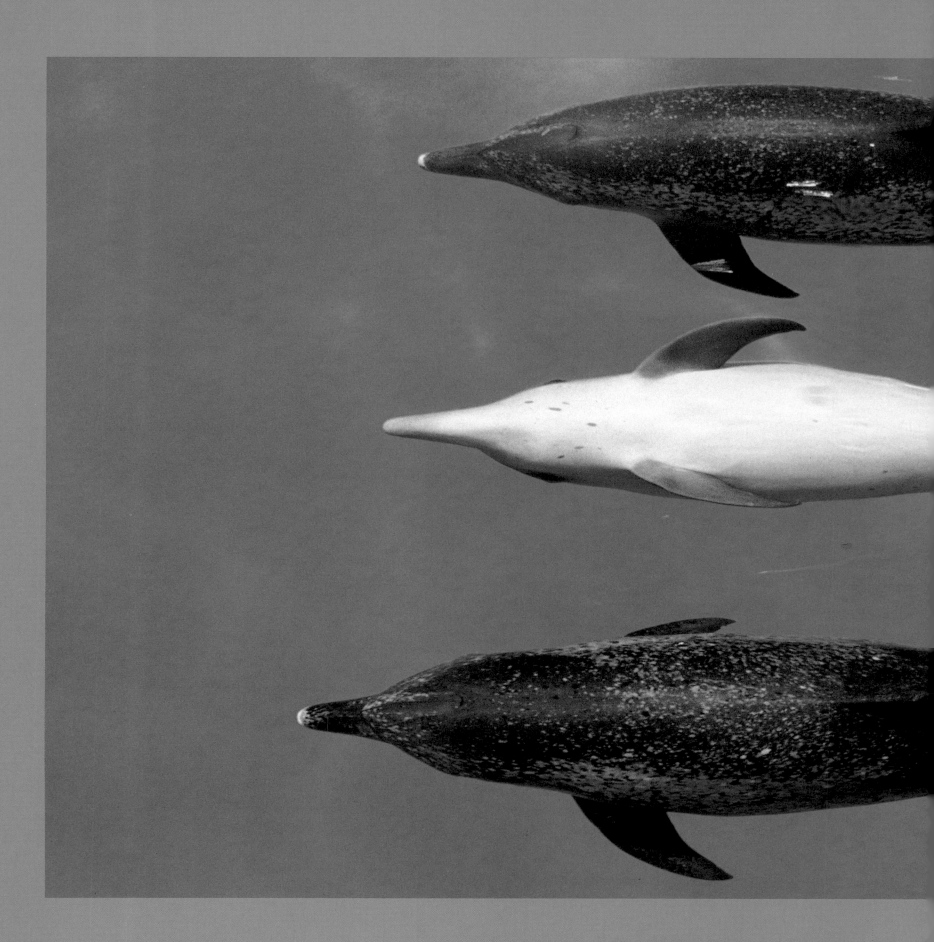

Atlantic spotted dolphins of the Bahamas, like so many other dolphin species worldwide, enjoy riding the bow pressure waves of boats. The center dolphin is swimming upside-down, perhaps to get a better view of the creatures looking over the bow of the vessel?

Continued from page 169

particularly dolphins, and he almost single-handedly transformed their study into a modern science. His work, for instance, led to the verification of dolphin echolocation. Almost as important, Bernd thought, was the fact that Ken Norris was an inspiration to other scientists.

"What did your letter to the great man say," I asked.

"Oh, I just told him what we were doing, and how little we had learned so far, and how long it took to wrest information from the animals." Passed here a few months of Patagonian wind until the letter came back from Dr. Norris. "It was typed on this vintage typewriter," Bernd said, "which I would get to know so well when I later worked with the man in Hawaii. It was a lovely answer, full of the purest and most sincere encouragement. And it was the one thing that made me want to continue my work here."

Bernd and Melany's work consisted of setting up shore-based theodolite tracking stations. A theodolite is a basic surveying instrument: a telescope mounted to swivel both horizontally and vertically. It measures angles between objects sighted, a process from which distances can be calculated fairly precisely.

"We measured the speeds of various dolphin groups as they moved," Bernd said. "We measured the distance between feeding groups. Very basic things, and in this way we started to learn something about the way the dolphins carry on their lives.

"We found," he said, "that duskies live a kind of fission/fusion existence. In the mornings they are found patrolling the bay in small groups of 6 to 15 animals that may be searching for schools of bait fish. When fish are located, the dolphins come together to feed. Sometimes there are as many as 300 of them. After feeding there is a lot of social activity, including mating. That's the fusion, and it is followed by a splitting apart once again into the smaller groups. Fission."

Bernd sipped his wine. "It was actually quite fortuitous that we were here when so few people had done that kind of long-term research on wild dolphins. And I think that's what helped me become somewhat known in marine biology. I didn't do anything very sophisticated," he modestly explained, "I just did it at the right time."

Southern sea lions aggregate just off the beach of Puerto Pyramide. They form another highly visible part of the rich marine-mammal fauna of Patagonia.

Shall We Eat, Everyone?

Alejandro Acevedo-Gutiérrez Ph.D.—*Post-Graduate Researcher, Institute of Marine Sciences, University of California, Santa Cruz*

Dolphins use a wide array of behaviors to pursue and capture prey. The behaviors are influenced by attributes of the habitat, such as physical barriers, type of water bottom and water depth; type of prey; and the escaping maneuvers of fish.

One way to observe the influence of habitat is by looking at populations of one species in geographically distinct regions. Bottlenose dolphins in Shark Bay, Australia, carry sponges on their beaks, perhaps to flush prey by disturbing the sediment or to protect their beak from the spines and stingers of fishes such as scorpionfishes or stingrays. Along the Atlantic coast of the United States and in the Gulf of California, Mexico, bottlenose drive individual fish to exposed mud-flats, briefly coming halfway onto land to retrieve their prey with their mouths. Other bottlenose dolphins from various parts of the world such as Australia and the United States are known to take advantage of the fishing industry—stealing fish from all kinds of fishing gear and feeding on fish flushed by trawlers. A friend of mine in Bahamas has observed bottlenose dolphins using their beaks as shovels to dig for fish that are buried in the sand. And in Costa Rica, I have witnessed these dolphins tossing a recently captured yellowtail back and forth until the fish became a pulp of flesh. This behavior presumably allowed dolphins to swallow the fish, which sometimes measured 75 centimeters (about two and a half feet).

The variety of dolphin feeding behaviors also depends on the type of prey a particular group of dolphins will eat. It may be surprising, but populations of the same species that even live in close proximity to each other do feed on different marine animals. This is true for two non-interacting populations of killer whales (orcas) that are found in the eastern North Pacific.

These two populations—termed residents and transients (because scientists at first believed these were the movement patterns; although they have since found out that the terms are incorrect, the labels have stuck)—have developed very different feeding behaviors. Residents feed almost exclusively on fish in deeper water, particularly salmon; transients prey mostly on small marine mammals, such as harbor seals. It has been postulated that these two killer whale populations were at one time part of a single population that fed on a single type of prey (fish or marine mammal); and that they diversified from this single group when, at some point in time, one group began to feed on the alternative type of prey.

Feeding behaviors are further diversified by factors that are perhaps connected to the success of both hunting and capturing prey. Residents travel in groups that typically number nine individuals and frequently produce echolocation clicks to find prey; whereas transients feed in groups that may number our individuals, and their vocalizations are infrequent and resemble random noise. The frequent vocalizations of residents may have developed because the hearing sensitivity of fish to the vocalizations of killer whales is not as acute as that of marine mammals, and thus the whales could both echolocate and succeed in capturing their prey. Transients, on the other hand, must minimize their detection by aurally sensitive mammalian prey by simply making less noise.

Feeding behavior is also now known to influence the structure of dolphin societies. For only one population so far, transient orcas, there is evidence that they can maximize their individual caloric intake if they feed in groups of three. As it turns out, this is the size of the group in which they live. The small size of these groups is

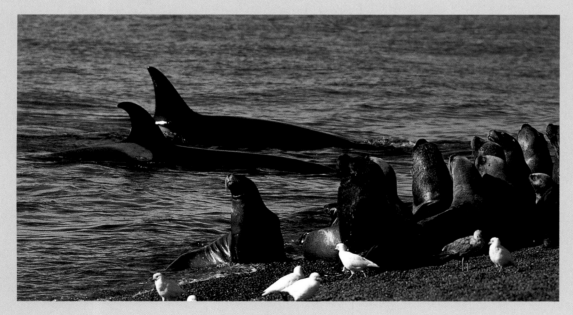

Killer whales swim close to shore while hunting for sea lions on the beach at Point Valdes, Argentina. The whales sometimes snatch sea lions right from the shoreline.

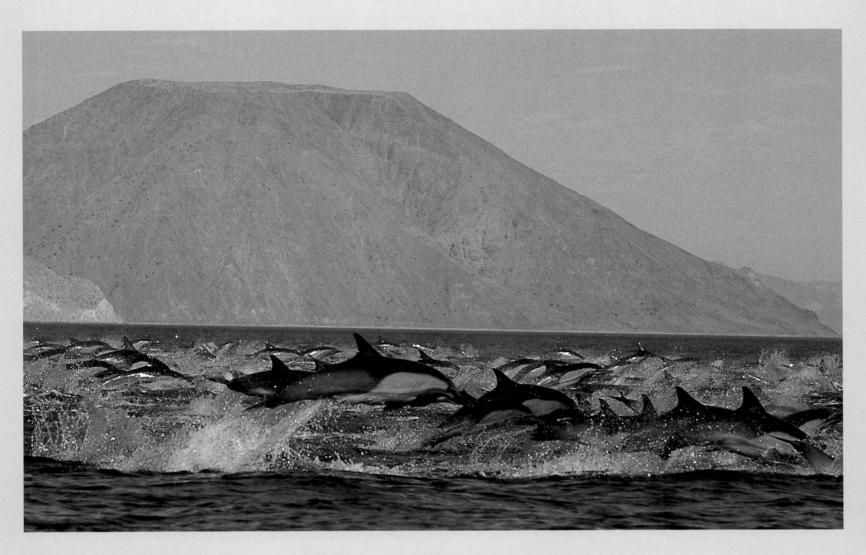

A large school of long-beaked common dolphins races along during hunting and feeding in Bahia de Los Angeles, Baja.

apparently maintained by the departure of all female offspring and all but one male offspring from their maternal group. Transients apparently split from their maternal groups and live in small units due to the benefits of feeding in a group of this size.

Such communal hunting illustrates how the type of prey hunted influences a group's, or a species', feeding behaviors. During communal hunting, individuals combine their efforts to pursue and capture prey. When dolphins feed on small fish found in shoals, they use a particular type of communal hunting behavior, called prey herding. By encircling shoals of fish and creating a tight, motionless ball of prey, the entire group can then grab individual fish with their mouths. Although this herding of prey has been best documented in dusky dolphins in Argentina, it has been reported for other species, such as bottlenose dolphins, common dolphins, killer whales, clymene dolphins, and Atlantic spotted dolphins. It is difficult to document this behavior; only one study has successfully quantified evidence of dolphins herding prey. In fact there are other factors to consider when we observe what we think is herding. I have found that bottlenose dolphins off the Cocos Islands, Costa Rica, pursue scattered fish and seldom herd their prey. This has led me to conclude that the escaping maneuvers of fish may be contributing to what we believe to be dolphins herding. Shoaling fish coalesce into a tight ball as a defense mechanism against predation, so dolphins may only be responding to this behavior rather than actively aggregating the fish.

Feeding behaviors of dolphins are a reflection of numerous factors—habitat, prey, and the behavior of prey. Yet it is fascinating and perhaps more important to consider that the type of prey dolphins feed on may influence their societies and determine the size of the group in which cetaceans live out their lives. ■

Alejandro plays guitar while relaxing between research outings in Patagonia.

The dinner table had been cleared and both the science and film crew had gone off to bed. Tomorrow, like yesterday, was going to come early.

"I'm just sorry Mel can't be here," Bernd said. "She had prior commitments. It nearly broke her heart. This is where we began our careers. It was so damn hard and we had so much damn fun. If I was an emotional guy, I might start tearing up right now."

"You *are* tearing up," I pointed out.

Bernd laughed. For such a slight person, he has a big jolly fat-man's laugh. Then he became serious.

"I'll tell you the last time I really did tear up. It was in Russia, just over four months ago now. I was doing some work with gray whales when we got word that Ken Norris had died. August 16th was the date."

Bernd finished his wine and got up to leave. He didn't scrape his plate.

"So," I said, "being back here brings it all to the forefront. Melany. The good Doctor Norris. Why, a lesser man might get nostalgic. Emotional."

"Well, there's a little of that," Bernd admitted. "I could also get a little sentimental about the fact that two of my best former students are down here carrying on my work."

"But you won't," I said.

"Won't what?"

"Get all sentimental about it."

"No, I'm not an emotional guy." A quiet smile graced the professor's lips as he ambled out of the pub.

SURE ENOUGH, THE NEXT DAY CAME EARLY.

The research boat had been dragged down to the beach. Everyone was ready to go at 6:30 in the morning, but the wind was howling off the ocean at about 60 miles an hour, and the sea was a solid mass of whitecaps of the type local folks call "little sheep."

Kathleen, Bernd, Alejandro, and I stood looking out at the angry sea. The sand stung our faces. It was like a barrage of needles.

The wind could blow all day or it might stop in an hour. That was the way of things in Patagonia. The research boat was packed full of diving gear, changes of clothes, cameras, binoculars, and tape recorders. Alejandro and I agreed to guard the boat. Everyone else went back to the motel where we were staying. Kathleen, Michelle, and Bernd made noises about catching up on their notes. When they were gone, I said to Alejandro, "Any money they all go back to bed?"

"*I* would," replied Alejandro.

Then we sat on the sand, our backs against the boat, which we were using for a wind shelter. Some women who worked at a gift shop on the far side of the beach strolled past, wrapped in white bed sheets against the stinging sand.

"Looks like an Arab country," Alejandro said. He swung his arm out to encompass the blowing sand and the women wrapped head to toe in sheets. Unfortunately, he was holding a cup of Coke at the time, and the gesture slopped the sticky liquid all over my legs.

"Oh, man. I'm sorry. I am such a klutz." He said it in the way another man might say, "I'm French" or "I'm tall." It was an unchanging condition of his life; something remarked upon by his friends and family. I had a sense that Alejandro's occasional awkward moments were occasions of great hilarity among those close to him.

One dusky in a group appears to be eyeing the photographer with some suspicion, but it is really only curiosity—and the absence of fear—that brings it so close to humans. A small distinguishing notch is just barely visible in the center of another one of the duskies' flukes (upper right corner).

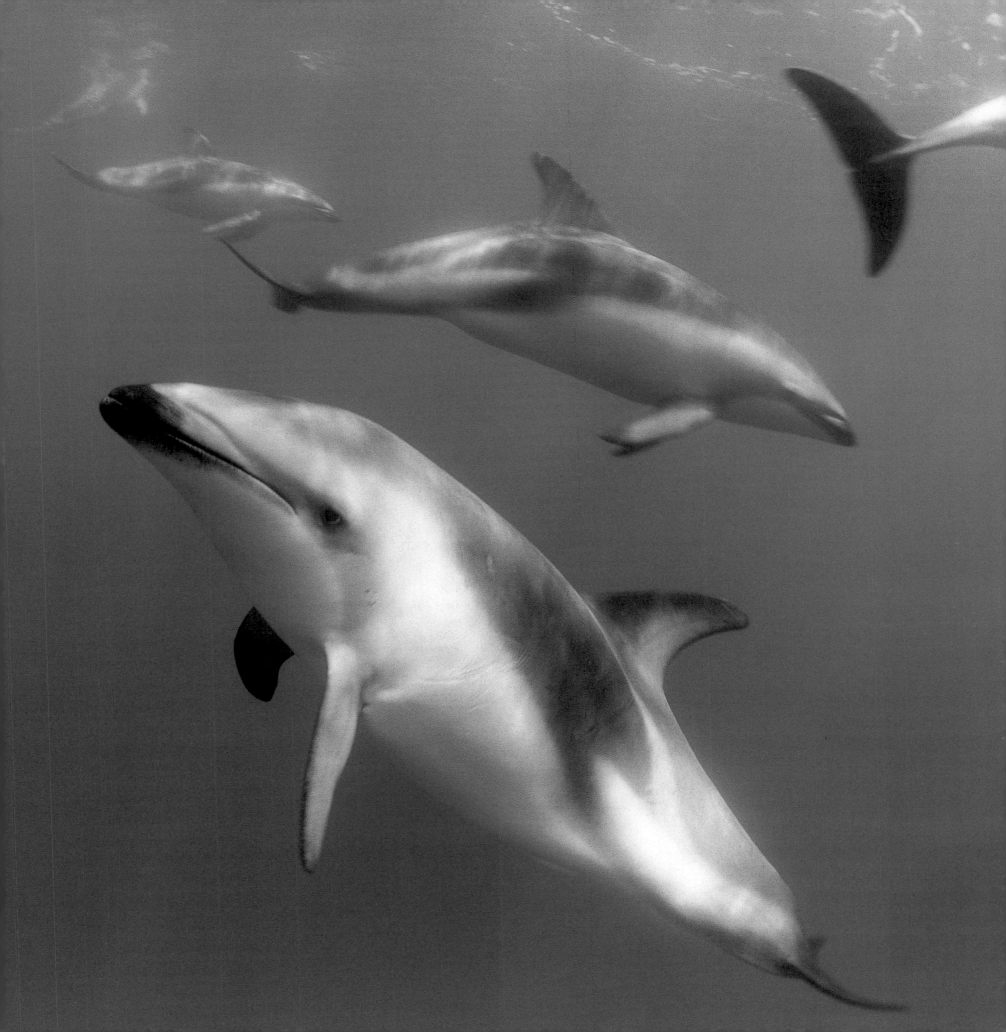

Waiting on shore for the winds of Patagonia to abate, Kathleen, missing and thinking of Umi, plays with a local dog. Because of the long plane trip (and quarantine laws) between Japan and Patagonia, Umi stayed with friends on Miyake while Kathleen studied the duskies with Bernd and Alejandro.

It is very strange: Alejandro is a rather good athlete. He plays a fast, bruising brand of soccer, rides mountain bikes, surfs, and handles the boat with great skill when Captain Pinino turns it over to him. He is a big man with big hands and big feet, and he has about him an air of bemused gentleness, rather like an ambling well-fed bear.

Alejandro was born in Mexico City into a solidly middle-class family. His father worked for PEMEX, the state-run oil company; his mom was a housewife.

Alejandro said he knew very early on that he wanted to be a scientist. "I used to read a lot as a kid," he said. "First it was comic books. Especially dinosaur comics. Then it was animals in general, and soon enough I was reading real books. We had an encyclopedia at home. I was interested in what animals do all day and why they do it. Those articles in the encyclopedia always referenced some scientist. You know: According to Dr. so and so. I was maybe 12 years old at the time, and I thought: A doctor knows all there is to know about animal behavior. I want to know about animals. So I have to be a doctor. That was my little kid reasoning."

It wasn't an entirely linear path to the doctorate, however. There were some emotional hurdles to be cleared, some aspirations Alejandro believes were misplaced.

"In high school, my friends were all upper middle class. A kind of yuppie environment in which we were very concerned about how we dressed, the way we looked. Material things were very important to me."

Alejandro spent a semester and a half studying biology in Mexico City, and then transferred to the University of Baja California South, located in La Paz, on the Gulf of California. Some scholarship students came from backgrounds of very real poverty, and Alejandro began re-examining his priorities in life.

While in La Paz, Alejandro enjoyed the kind of hands-on education that wasn't available in Mexico City. "We learned about invertebrate zoology by going out to the ocean, the tide-pools, and just collecting everything. Sea anemones. Mollusks. Stuff like that. Most of these creatures ended up dead. I used to call it mass extinction class.

"Eventually," Alejandro said, "we went into marine mammal stuff, and I became excited about that." He volunteered to study gray whales on the Pacific coast of Mexico's Baja Peninsula, and there he met two Americans (Bernie Tershy and Don Croll) who were working with Bernd. Alejandro wrote Bernd and eventually met him in January 1989.

"Partially because Bernie and Don argued my case so vigorously, Bernd took me on as a student, a doctoral candidate," Alejandro said. "I wanted to compare group size and feeding habits of dolphins living close to shore and those off shore. Bernd got me thinking of Costa Rica. I went there and ended up studying dolphins near shore in what is called Golfo Dulce, and in the deep water near *Isla del Coco*. In English, you'd say Cocos Island."

"And what were the differences," I asked.

"Golfo Dulce," Alejandro said, "was sort of like being in love with a trusted friend. I knew the dolphins that lived close to shore, and even now, years later, I can tell you all their names. I knew a lot about their lives, who came to the boat, who associated with whom. But Cocos was an island surrounded by deep water, and it was more like being lost in love with an incredibly exciting but totally mysterious person: there were so many dolphins constantly coming and going. We couldn't get film developed on a regular basis, so it was very hard to know the dolphins, to identify them."

Continued on page 193

A bottlenose dolphin's head breaks the water's surface during its high-speed ocean cruising—and respiration. The exhalation, or blow, has just occurred and the dolphin's blowhole is fully open as it inhales. The entire action of surfacing, blowing, inhaling, and diving can take as little as one second.

CETACEAN OLYMPIANS

TERRIE M. WILLIAMS, PH.D.—*Physiologist, University of California, Santa Cruz*

With all respect to their unwavering smiles, the most impressive thing about dolphins is their effortless, high-speed swimming. They can cruise through the seas at 2 meters per second without a perceptible change in breathing or heart rate; and just for fun, they'll break into a sprint, reaching 10 meters per second (5 times faster than the world's best Olympic swimmers). The dolphin's ultimate athletic boast is a leap two stories high into the air followed by a splash landing. Marvelous displays of grace, speed, and power fascinate humans and rank dolphins among the elite athletes of the animal kingdom.

As a scientist, I've monitored, measured, and categorized the locomotor movements of porpoises and dolphins. Over the centuries, yacht designers have, in an attempt to improve racing hull performance, sought out the secret of the dolphin's speed. Even Olympic champions have taken to mimicking the fluke movements of dolphins to increase their swimming speed, but with moderate effect. In our individual ways, we are doomed to failure. I've found that the dolphin's swimming power is not just a matter of superb hydrodynamics, which leaves us bobbing in awe in their wake; or even the hidden mechanics between contracting muscle and bone. Nor is it that dolphins possess a streamlined anatomy, perfect for slipping through water.

The secret behind the swimming power of these marine mammals is simpler than that. It is the dolphin's sheer, unrestrained exuberance. They seem to delight in conquering the oceans and challenging the physical forces in their midst. They'll eagerly surf waves generated by winds, moving boats, and other whales—and all the while seek out others to join in the fun. But despite their enthusiastic invitations to play with humans, we are poor swim mates. We ineffectively splash and flounder on the water's surface with limbs designed for moving on solid ground. Fortunately, dolphins are tolerant of our obvious aquatic shortcomings and will gladly entertain us with feats of athletic wonder and precision. ∎

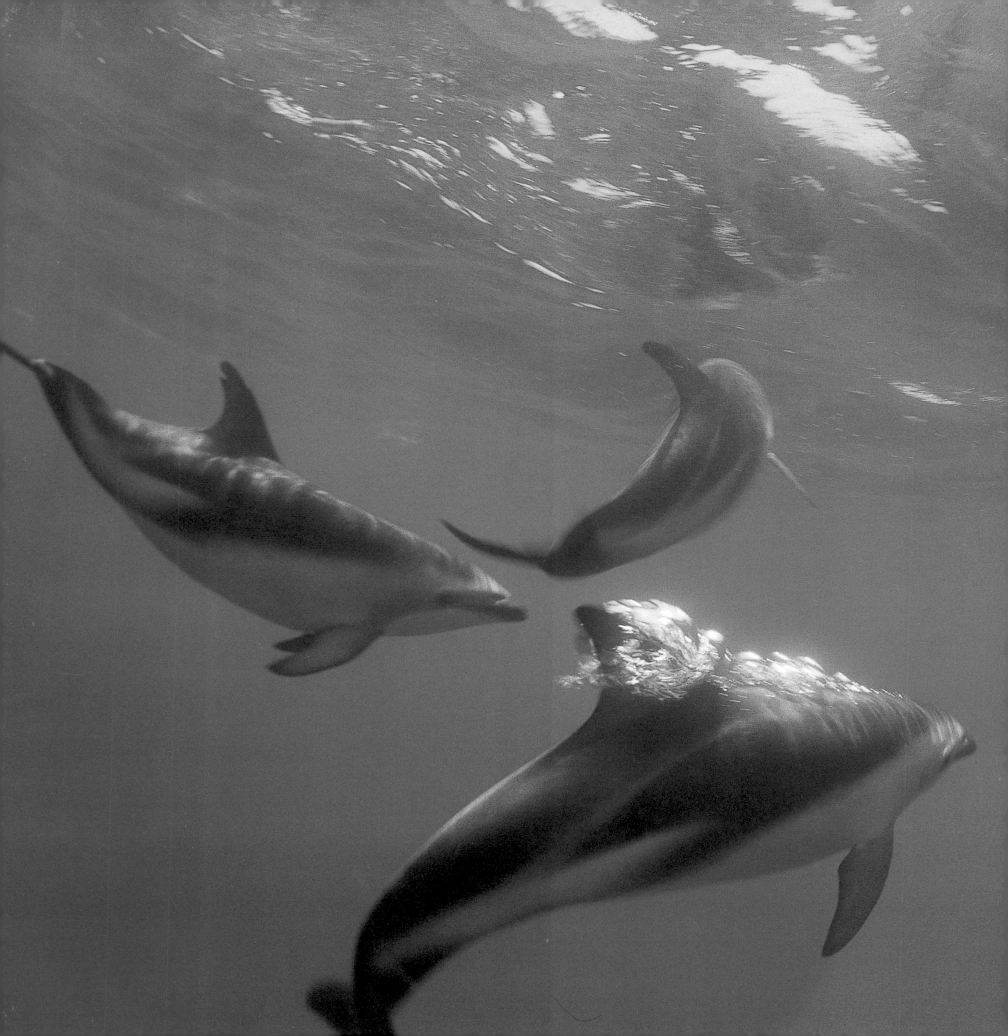

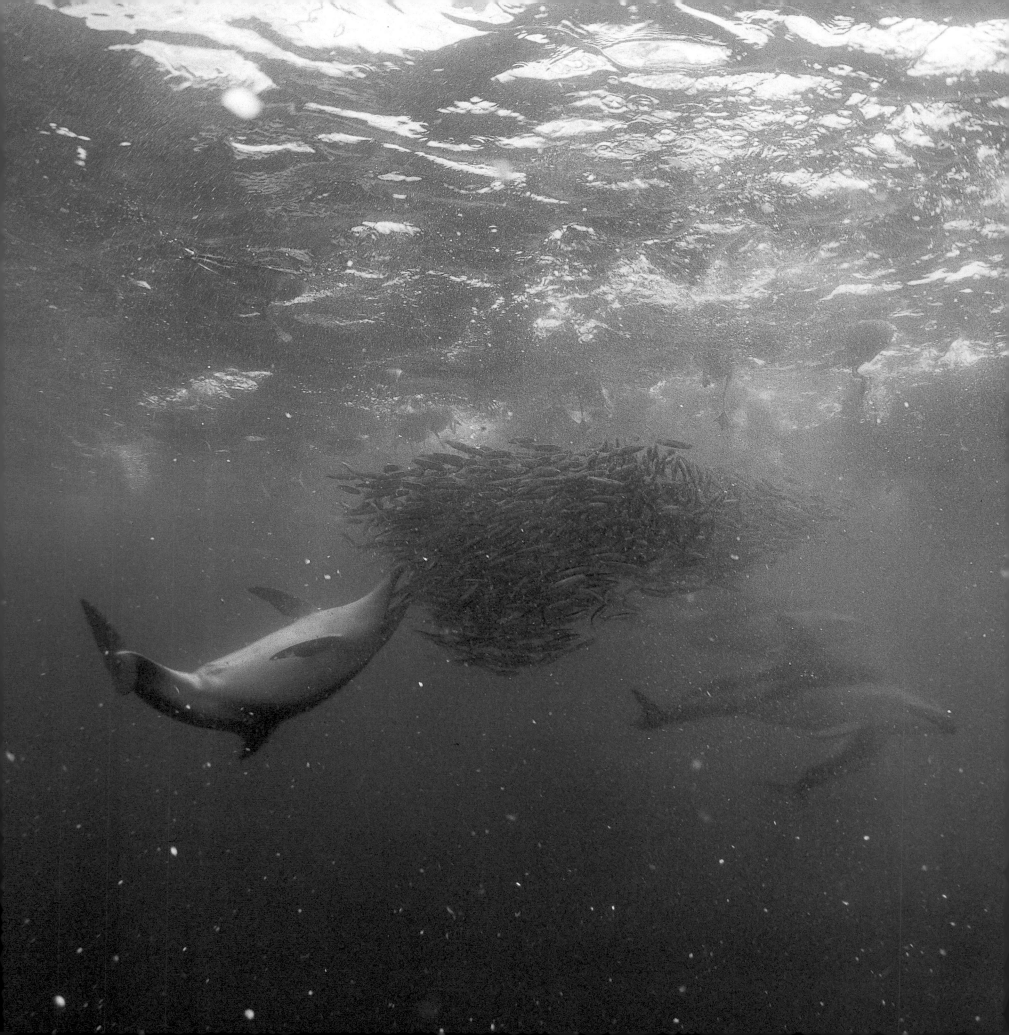

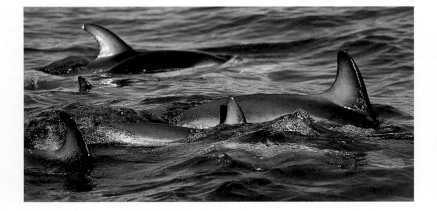 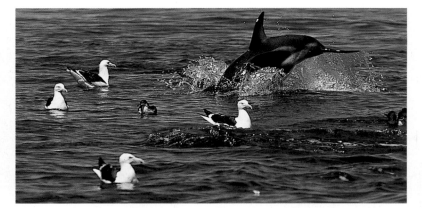

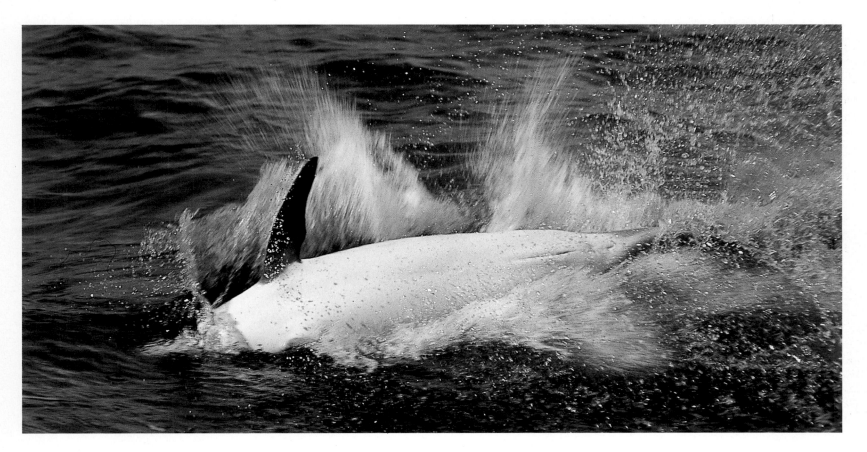

While an individual dusky dolphin (facing page) snacks on the periphery of the bait ball, others patrol the sides and below to keep the prey tightly herded. Above the surface, dolphins circle around the prey in tight formation, (top left), leap at the bait ball sides from above (top right), and splash nearby (bottom), all in an apparent attempt to keep the prey herded tightly. Kelp gulls (top right) and smaller open-ocean petrels take advantage of food herded close to the surface by the dolphins. A dusky approaches a ball of anchovy and blows a large bubble blast (preceding pages)—an apparent attempt to cause the prey to bunch into an even tighter school.

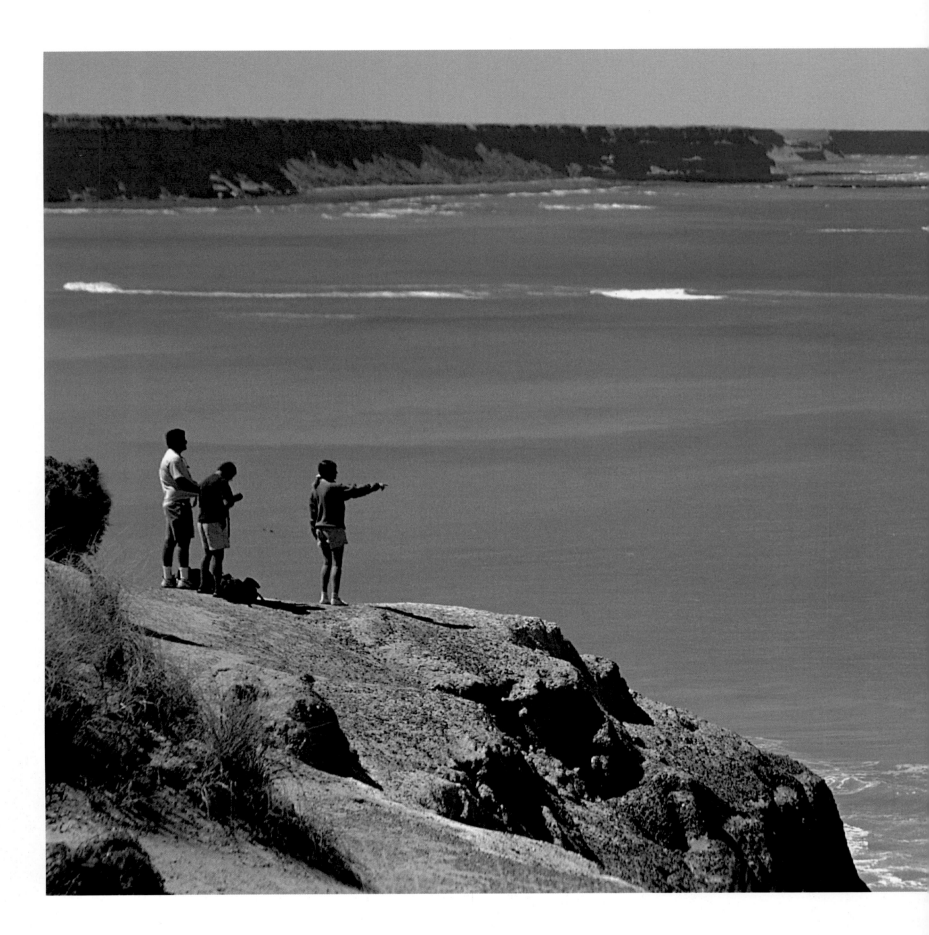

Continued from page 186

Cocos Island is a 15-square-mile island rising 500 feet above the deep blue waters of the Pacific. It is located about 300 miles off the coast of Costa Rica, and is said to be the island Michael Crichton had in mind when he wrote the script for *Jurassic Park* (though the movies were filmed elsewhere). The island's real history, however, is not about dinosaurs but pirates: Cocos is Robert Louis Stephenson's *Treasure Island.*

There may in fact be more than one unimaginably rich treasure buried on the island, which is covered with thick jungles and ringed with dozens of waterfalls of a hundred feet or more. Cocos is also a Costa Rican National Park. The land and the waters, to a diameter of five miles around its shores, are protected, so Alejandro needed a permit. For many months, he lived in a tent while working, which, he reported, "didn't protect me and my associates from the rain, really. In the winter, it rains every day in the afternoon. It's like someone dumping buckets. We had a good expensive tent, but it couldn't stand up to that kind of rain. The park rangers finally built a wooden roof over the tent so we could stay just a little dry."

Alejandro, living wet and happy on the island, had finally forsaken his yuppie aspirations. Science was so much more interesting.

The relatively small reef ringing Cocos, for instance, attracts an amazing array of underwater life. There are hammerhead sharks, silky sharks, manta rays, and, of course, dolphins—which, around Cocos, are mostly bottlenose.

"I knew there would be sharks at Cocos," Alejandro said, "I was just surprised at how many of them there were. And many times they were feeding on the same schools of fish that the dolphins were. Everybody eating the same thing, all these fish scrunched together in what we call a bait ball. It attracts birds, a bait ball. We'd see brown-footed and red-footed boobies diving on the school at the same time the sharks and dolphins were feeding.

"Sometimes, very rarely, the dolphins would drive off the sharks. They'd just start swimming toward the sharks, making noises, charging them broadside, and the sharks would just sort of slide on out of there."

At Punta Hercules, the three scientists peer at southern sea lions on one of the last days in Patagonia.

"Then what," I asked.

"In some places dolphins herd fish, drive them into a more compact ball." explained Alejandro. "Though, I'm careful about saying that they do it in Cocos. It's very complex. I believe the impact of dolphin herding is overrated and the fish behavior of tightening into a ball is underrated. But that's one of things I'm looking into here: feeding ecology."

We looked out to sea and it was still full of "little sheep." The wind, if anything, was gathering speed. It was nearly noon.

"There were an awful lot of sharks in the Cocos," Alejandro said. "I remember one time we were out five or six miles in an inflatable boat. I saw some frigate birds diving and thought there might be a bait ball and some dolphins out there. So we motored over. And there was a big school of bait fish but no dolphins. Just several hundred silky sharks, all of them seven or eight feet long. They were feeding on the fish, and the fish went under our boat. The fish might have thought the boat was cover. Except the boat didn't seem to stop the sharks at all. They were coming up all around, their mouths open, and we could hear them—*thump, thump, thump*—hitting the underside of the boat."

It was a rubber inflatable boat, and shark teeth had a deleterious effect on it. The tubing on one side began leaking. It looked like a collapsed balloon.

And so Alejandro and his friends found themselves in a sinking boat in the midst of a silky shark feeding frenzy. Moving as fast as the small motor could drive the leaking boat, Alejandro and his friends ran for shore. "I was seeing the last scenes of *Jaws* in my mind," he said.

THE NEXT DAY DAWNED FAIR, AND I WAS ALLOWED TO accompany Kathleen, Alejandro, and Bernd as they searched the gulf for dolphins. We spotted a small group almost immediately. They were leaping once again, but not in a single spot. They seemed to be moving steadily, even rapidly, all in the same direction, to the southwest.

Kathleen recorded the sighting into a portable recorder. Alejandro wasn't watching the dolphins. He was scanning the far horizons with binoculars.

"We may get lucky today," announced Bernd.

"Why?" I asked.

"Well, as I told you earlier, these animals have what I call a fission-fusion society. In the mornings, they seem to be spread out all over the gulf in a number of small groups. They spend the early daylight hours looking for schools of bait fish. And when they find them, they signal other groups. The leaps are probably signals."

"Other dolphins can see these leaps?"

"A dolphin's eye," Bernd said, "is adapted to see underwater, of course, but they can also see well in the air. I think they scout for bait fish by leaping."

"There it is," Alejandro shouted. He pointed into the distance. I could see dozens of birds hovering and diving over a section of sea about half the size of a football field. Pinino, our captain, throttled up and we ran for the diving birds.

"Now," Bernd explained to me, "those birds are almost certainly feeding on a school of bait fish. When the dolphins leap, they can see the birds just like we can. Human fishermen use this technique too. We know birds dive on bait fish. And where there're bait fish, there are bigger fish below, feeding on them as well."

"So the dolphins leap for the same reason Alejandro uses his binoculars," I said.

"Partly," Bernd agreed, as we sped toward the diving birds. A few of the duskies were now riding our bow waves, essentially hitching a ride to a hearty morning feed. Other dolphins, off at a small distance, were racing our boat on a linear path, leaping low to the water in shallow arcs about five times the length of their own bodies. Underwater, they propelled themselves with a few rapid beats of their tail flukes, then rose up in another arc, entering again with hardly a splash. Dolphins can move much faster in the medium of air, which is 800 times less dense than water.

As we approached the diving birds, several dolphins rose in a variety of jumps. One, I noticed, performed a long series of elaborate back-over flips, each one the mirror image of the last.

Kathleen was already formulating a question she'd like to answer. Were the dolphins that were already feeding on the ball of bait fish using leaps to call in other dolphins? Were these highly intricate and complex leaps signals to other groups of patrolling dolphins that dinner was served?

"Or," Alejandro suggested, "the leaps could be a way of calling in the reserves." There were, Alejandro added, other and

not mutually exclusive explanations as well: leaps could be a by-product of the high activity level involved in feeding; they could be used to capture fish more efficiently, or to scan the feeding activities in the area. In any case, Alejandro was interested in the optimal number of dolphins it took to feed on a certain size bait ball. Too few dolphins, he supposed, and the ball could break up into dozens or hundreds of small schools and escaping fish. If there were too many dolphins, not every dusky would be able to feed.

As Captain Pinino throttled down and we coasted toward the bait ball, Bernd and Alejandro noted the number and types of the diving birds. There were commorants, and terns, and gulls, and petrels. "The Magellanic penguins aren't here yet," Bernd told me. "They can't fly. The poor devils have to swim all the way."

I looked out to sea and, approaching from every direction, were groups of dolphins. The scientists were donning scuba and snorkeling gear. Kathleen now had a second mobile video/acoustic array that Alejandro would use. He would choose a focal animal and hoped to catch it feeding. When he lost that one, he'd find another. The resultant film would only begin to give him an idea of how many fish each dolphin was able to devour, but this was, after all, a pilot study, a process that had more to do with formulating questions than with answering them.

So the people with scientific permits entered the water, along with the dolphins and their prey, which were southern anchovies. I stood on the deck, not at all disappointed, because the dolphins were putting on an above-water acrobatic display that must be considered one of the great wonders of the natural world. I understood at once why Bernd constantly referred to these creatures as "my beloved duskies."

The dolphins working the bait ball rose and slapped down on the surface of the sea with enormous splashes. They landed on their sides or bellies; and they did so at the periphery of the bait ball, keeping the terrified fish in a compact ball.

No doubt there were other dolphins working the bait ball from below, driving the fish to the surface, which acted as a wall. The dolphins were working cooperatively, herding the fish like cowboys riding the deep range.

Sometimes a dolphin rose up out of the water to a height of 15 feet or more. The creature arced its body and reentered beak, or rostrum, first, with no splash, the weight of its body

driving it into the sea with incredible velocity. It was feeding on the anchovies in the manner of a diving bird.

And the birds themselves had multiplied, benefiting from the dolphin strategy of driving the bait ball to the surface. There must have been more than 500 of them, and more than half a dozen species. They dove constantly; their wings folded, their legs stretched out behind them, and they hit the water with an explosive sound, like the firing of a distant shotgun. The anchovy were in frantic disarray below, and the entire effect was that of an air war on a major city. After about 40 minutes, the dolphins began leaping in a less purposeful but even more acrobatic manner. They came up out of the water, leaping 10 feet and higher, all the while spinning or turning front flips or back flips, or combining these maneuvers in highly individual styles.

Penguins had begun to arrive, swimming rapidly and looking, for all the world, like birds in flight. Except that they were swimming.

Alejandro surfaced for a moment, breathing heavily.

"What's happening down there?" I asked.

"It's awesome," he said, which was his polite way of saying, "please don't bother me when I'm working."

And now there were dolphins leaping all over, throwing off rainbows of spray as the penguins fed on the disintegrating bait ball. The dolphins' acrobatic display lasted another half hour or so, and then they were gone.

On the way back to town, the scientists compared notes and filled me in on what they'd seen under the surface of the sea.

Alejandro was not willing to say that the dolphins had actually herded the bait fish. The anchovies might have been feeding near the surface, and the dolphins could have simply been taking advantage of the fact.

I told him that he was, in effect, full of it. There had been dolphins below, driving the fish to the surface. Others had tail-slapped around the periphery of the bait ball, keeping it in a tight formation.

"There's no doubt that dolphins herd fish," Alejandro said. "I'm just not willing to say that that is what we saw today. It needs further study."

Kathleen was as excited as I'd ever seen her. She had never been able to film mass feeding behavior in the Bahamas or in

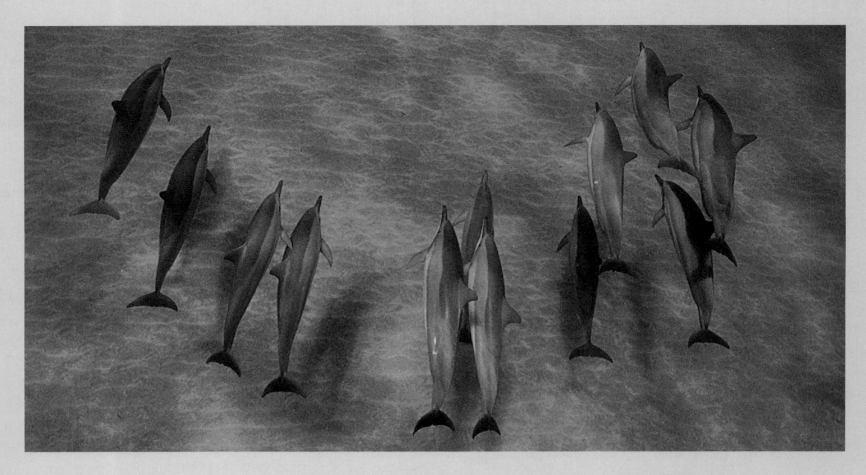

A small group of Hawaiian spinner dolphins rests near the sandy bottom. Resting in shallows is probably important because dolphins will not be surprised by approaching sharks or the occasional killer whale (orca), both of which spend most of their time in deeper water.

Sleep and Solidarity

Bernd Würsig, Ph.D.—*Professor of Marine Mammalogy and Director of the Marine Mammal Research Program, Texas A&M University*

A dolphin school is a vibrant active assemblage of social mammals with much interaction: a subgroup of young males over here, six moms and their calves over there, and a nipping, jostling, circling, group of mating ones out there on the periphery. Squeaks and squawks and whistles and buzzes of communication and echolocation fill the water and indicate to listeners, "The dolphins are here!"

But what is this?! All action and sound seem to fade into the distance. As they descend into rest, the group turns quiet, and individuals bunch tightly together. One lazy eye per dolphin is open and an occasional echolocatory click sequence indicates that although "asleep," they are still scanning their environment—for sharks, killer whales, that rocky outcropping that is here somewhere. This is a dangerous world, and it does not do to turn off all senses as the dolphins —even when resting heavily—continue to travel through it.

A boat approaches from the left and the people in it hope for a show of exuberance. But the dolphin school parts ahead of the boat, almost in the fashion of a disturbed fish school, coalescing into one group again behind the vessel.

The dolphins, moments before alert, interacting highly social mammals, are now relying on the partial "awareness" of others. A look here, an echolocation there, a touching to feel the intention movements of nearby colleagues, and the coordinated unit manages to survive. The dolphins are asleep, but move as one unit. They form what biologists call a "sensory integration system" as they each rely on the whole. This dolphin school is no longer made up of "intelligent" self-acting and thinking mammals. Each individual needs the other, no one is dominant, and all— during rest—are equal. ∎

Japan. Some of the dolphins, she noticed, swam at the outer diameter of the bait ball, keeping it intact, while others took turns shooting through the middle of the terrified fish, gobbling up as many as six or seven anchovies at a pass.

As we approached the shore and Pinino called in for a spider, Bernd mentioned that "there was a lot of mating going on down there…. very typical in a fission-fusion society."

"And all that incredible after-dinner leaping?" I asked. "What's the significance of that? I mean, I saw one guy do 14 somersaults in a row, one after the other."

"We think it could be a display of pure exuberance," Bernd said. "Some scientists are now willing to say that dolphins may do things for the pure fun of it, like humans."

"They jump for joy?"

"Maybe. It's also true that acrobatic leaping is often associated with sexual activity. And it most often happens when the dolphins are well fed and not in danger of attacks by sharks or other predators. I think that having fun may be a very important way to establish and maintain the kind of social bonds that allow entire groups of dolphins to function as an integrated and cooperating unit."

"Sort of the way having fun with each other can hold a marriage together?" I suggested.

"You *could* say that."

I wondered if he was thinking of Melany.

I AM ASHAMED TO ADMIT THAT NEW YEAR'S EVE CAME and went without me. In defiance of all known stereotypes, the writer fell asleep and completely missed the party, while the scientists danced until three in the morning at the Paradise Pub. The pilot scientific project was over and IMAX filming would start on January 2. New Year's Day was wide open for anything anyone wanted to do, and I gathered up Alejandro, Bernd, and Kathleen in my rental car and drove off down the gravel road into the heart of the Peninsula Valdés. We were going sightseeing.

The peninsula is littered with sagelike *nuneo* and spare grasses. To some eyes it may seem a flat and featureless monotony, though it in fact rose and fell in a series of gentle undulations like great sighs. There were several large ranches on the peninsula, and they ran sheep, cattle, and horses. The sheep were so heavily wooled that, in the Austral winter, rainstorms were potentially

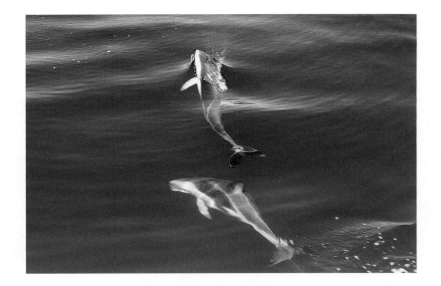

Staying almost stationary in one area and slowly surfacing to breathe indicate that these two dusky dolphins, part of a larger group of perhaps a dozen, are resting.

fatal. Or so Bernd insisted. Sheep literally fell to the ground, overweighed by their own wet wool, and it was a ranch hand's job to ride the sopping range, putting toppled animals back on four legs.

Closer to the edge of the peninsula, the land did not precisely fall off to the sea but rose almost imperceptibly like the lip on a dinner plate. The clay gave way to sand, and sea grasses rose all about in greenish brown clumps. We were moving north along the Atlantic coast, at the head of the Valdés hatchet, and Bernd suggested we pull off at an empty but apparently legal parking lot near an abandoned cement building, somewhere between Punta Delgada and Caleta Valdés.

A short path ended at a cliff face perhaps 700 feet high. The headlands, extravagantly ridged with the mark of retreating seas, extended 20 miles in either direction, curving about in looping arcs that formed windswept coves and bays. The whole effect was that of exuberant and soaring isolation. The beach, far below, was golden brown, and it fell sharply into an emerald green surf that, in its turn, faded into the cobalt blue of deep water where unseen swells caught the sun and glittered like so many mirrors. Sea lions, hundreds of feet below, basked on platforms of rock set half a mile out to sea. Waves exploded against the rock, sending spray 20 feet into the air, and grunting calls from the sea lions floated faintly on the wind.

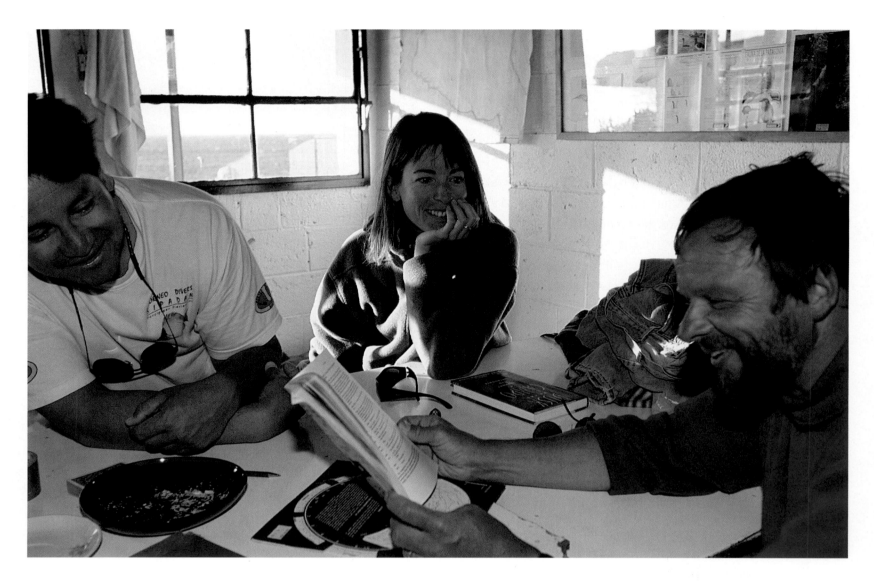

Alejandro and Kathleen share a laugh with Bernd as he reminisces about a funny episode from his and his wife Mel's research in the early 1970s. The three scientists are sitting in the same research station—owned and operated by the New York Zoological Society and the government of Chubut Province, Argentina—where Mel and Bernd lived 25 years ago.

We sat for a time, enjoying the ocean-scented breeze and the warm sun. Kathleen, the workaholic, had already begun drafting part of the grant proposal that might fund a return to Golfo Nuevo. She would study communications; Alejandro, feeding ecology; and Michelle Wainstein, who'd have her Ph.D. by then, could do DNA studies to determine the family relationships between the dolphins.

The DNA collection technique would be noninvasive. It was developed and tested by Bernd and another of his students. "You take a sponge and fix it to the end of a mop handle,"

Kathleen explained. "When the dolphins start bow-riding your boat, you just touch them with the sponge. It'll pick up enough exfoliated skin to do a DNA analysis."

Bernd and I left the two young scientists to their work and strolled down a trail at the edge of the headlands.

"They're very keen," I said.

"Aren't they," Bernd replied, and I heard genuine pride in his voice.

We walked a bit in silence as I considered the difficulties and rewards of research on wild dolphins. Captive dolphins

could be monitored 24 hours a day, of course, but they were essentially imprisoned, a condition more and more people think is unacceptable, both morally and emotionally.

Kathleen, Alejandro, and Bernd worked with wild dolphins. They lived in leaky tents and in ramshackle farmhouses, because it was important to them that they understand dolphins as they actually lived, free and wild, and—as yet—almost completely beyond human ken. There was, I thought, a kind of fine morality to their work.

When we gathered together again, we didn't discuss virtue or ethics but drove toward the far northern head of the Valdés hatchet. On the way, there was a colony of Magellanic penguins living just off the road. They were stout little birds, two and half feet high, and they nested on the slope of the headlands, in holes they'd dug. We stopped for pictures, then drove on to Punta Norte, where Paul Atkins had filmed killer whales swimming up onto the beach to capture sea lion infants. We parked in a paved lot along with half a dozen other cars and walked down a gentle slope, stopping at another fence a few dozen yards from the beach proper. Sea lions—males, females, and a number of fubsy pups—littered the beach, but there were no orcas in sight. Bernd said that, in this very place, over 20 years ago, he'd been attacked, after a fashion, by a killer whale.

He had come to Punta Norte from his study site, some distance away, and was taking still photos of the killer whales exploding up onto the sloping beach to take sea lion pups. At one point, the sea lions were some distance away, and Bernd was lying on the beach, just at water's edge, shooting the orcas and their fubsy prey with a long lens. It was windy—it's always windy at Punta Norte—and Bernd had pulled the hood on his parka up over his head. Through the narrow view of his telephoto lens, it looked as if the killer whales had gone away. So there he was, Bernd Würsig, a 140-pound baby sea lion-sized package, lying just in harms way. Suddenly the entire world fell into shadow. When he looked up, a killer whale was beached no more than a yard from him. The orca's mouth was wide open. Bernd stared directly into a great expanse of fleshy pink. "Its tongue," Bernd said, "was pressed behind its lower teeth, and water dripped from every one of its upper teeth." Bernd, while not at all homely, is, it must be said, entirely lacking in the fubsy department. "I think the orca realized I was not a sea

lion and dug its belly into the beach to stop." The orca lay on the beach for some time, jaws agape, as if dumbfounded. Bernd had time to run down the beach, snapping photos over his shoulder and likely composing the scientific paper he eventually published about the encounter.

THE LAST STOP WAS CAMP 39, BERND'S STUDY SITE, where he first met his beloved dusky dolphins. As we drove down the interior road toward the camp, through the dust and nuneos, Alejandro and Kathleen discussed the best way to put together the study they both hoped would be funded. The sort of thing, I imagined, scientists do on their day off. The fun never stops.

We parked just off the gravel, climbed a fence, and walked down a dirt path toward the sea. Camp 39 faced the northern gulf, Golfo San Jose, but the hills ahead hid the sea.

"I remember when I walked this path the first time," Bernd said. "I was alone, and I came up over the hill and saw the ocean all spread out, glittering in the moonlight. And I could hear the sounds of whales passing. Southern right whales breathing out there in the night."

We came over the summit of the hill and looked down into a cove containing the pretty white house that Bernd and Melany had helped build during their last few seasons in Patagonia. The half-moon shaped bay seemed immense, and the headlands rose to 170 feet and more. There was a research team staying at the house, but they were gone at present, though Bernd had secured permission to enter the property.

We stood on the beach, just in front of the house Bernd knew so well. There was a series of small holes to one side of the porch, and an animal the size of a cat peeked out of its burrow.

"A hairy armadillo," Bernd said. "No doubt a descendent of the one that lived under our bed in 1975."

Inside the house there were worktables, piles of scuba gear, and maps on the wall. Bernd wandered around absently, lost in a haze of nostalgia. We followed him about like puppies. There was something meaningful going on here.

"This was my office," he said. And then: "Oh, my God." He had found a sheaf of black-and-white pictures. All dolphins. "We used these to identify the animals. Look! Oh, oh, oh. I know this guy. And this one."

DOLPHINS UNDER THREAT

CHRIS PALMER—*President and CEO of National Wildlife Productions, and* JILL LEWANDOWSKI—*National Wildlife Federation*

From the majestic orca, nearly 30 feet long, to the 5-foot, seldom-seen black dolphin of Chile, related whales, dolphins, and porpoises are amazingly diverse. Many thrive, but some are endangered; and all face environmental challenges. Human behavior is the root cause. You can do a great deal to help. First, understand that dolphins are not fish; they are mammals. Among the many differences this signifies, one of the most striking is the differential in reproductive rate. A skipjack tuna, for instance, may live only 10 years, but in a single 90-day spawning season it may produce 2 million eggs. A female dolphin, in contrast, may live 35 years but give birth to only a dozen young in her life.

At least seven species of dolphins and porpoises are considered endangered. Three of the most critically pressured species have relatively restricted ranges in rivers and bays that are heavily used by humans. The Baiji dolphin (*Lipotes vexillifer*) is endemic to the Yangtze River. The construction, already underway, of the controversial Three Gorges Dam further imperils the Baiji dolphin, of which only 300 remain. Vaquita (*Phocoena sinus*), also known as the Gulf of California harbor porpoise because of its limited habitat, was discovered by scientists only in 1958. It now numbers perhaps fewer than 200. The Indus and Ganges River dolphins (*Platanista minor* and *Platanista gangetica*) are closely related. Both are severely endangered, restricted in range, and isolated in groups because of damming.

Other endangered dolphin species include Indo-Pacific and Atlantic humpbacked dolphins (*Sousa chinensis* and *Sousa teuszii*), coastal dolphins that have fallen prey to gill nets and pollution, particularly near crowded areas like Macau and Hong Kong; Franciscana (*Ponotoporia blainvillei*), a small dolphin inhabiting the eastern coast of South America, often taken as bycatch in the shark fishery; and Hector's dolphins (*Cephalorhynchus hectori*), native to the shores around New Zealand. Vulnerable to gill nets, this dolphin had high bycatch levels in the late 1980s. The establishment of a sanctuary near the fairly populous Banks Peninsula promises hope.

From a dolphin's point of view, then, the world is a dangerous place, and threats are manifold. Pollution and habitat degradation are two of the biggest threats. Coastlines are heavily settled. Ship channels are polluted with petroleum-stained waters and toxic discharges. Offshore waters are affected by agricultural and urban runoff. Shorelines, with their protective mangrove forests and seagrass meadows, are being torn up for marinas and resorts. Dolphins are losing clean living space and a food supply.

Dolphins, with a coat of blubber that protects them from cold, are especially vulnerable because they absorb toxic pollutants in this band of fat. When a dolphin has to call upon its bodily food stores, as in times of stress, the pollutants are released into its system. Beluga whales in the heavily industrialized St. Lawrence River between the United States and Canada are down to 500 animals from a population that once numbered about 5,000. The dead that have washed ashore have been found to contain such high levels of heavy metals, PCBs, and DDE, that their bodies are treated as toxic waste. Periodic die-offs have affected its populations in the North Atlantic and Gulf of Mexico.

Commercial fishing nets are another problem. Although the situation has improved in recent years, two types of nets—drift and purse-seine nets—spelled doom for millions of dolphins that ended up as bycatch.

Used since the 1980s, the drift net is made of nearly invisible monofilament, against which dolphins' sonar is no protection. Drift nets can extend up to 40 miles, entangling whales, dolphins, seabirds, and other creatures, as well as the targeted catch. If lost at seas in storms or cut loose when damaged, ghost nets, as they are called, can drift for weeks, killing everything that crosses the path, until they finally collapse to the seafloor with the weight of the dead. The United Nations banned large-scale drift nets in 1992, but some nations still cast miles-long nets.

Purse-seine nets were introduced by the tuna fishery in 1959 and since then have been responsible for cutting in half the numbers of spinner and spotted dolphins in the Eastern Tropical Pacific waters. Between 1960 and 1970, half a million dolphins a year died in these nets. A procedure developed in the 1970s known as backdown, in which the ship backs into the net, lowering the edge of the net below the waterline so that dolphins can escape, saved many lives. Careful seiners kill fewer than 200 dolphins a year now, although the ultimate goal is to reduce dolphin mortality to zero.

Dolphin-drive fisheries, another threat, take their name from the procedure by which the mammals are rounded up and trapped in enclosures before being slaughtered by hand for consumption and bait. In recent years, dolphin drives have declined, partly because of bad publicity and partly because the number of dolphins have been depleted, although a dolphin-drive industry continues in the Faroe Islands of northern Europe and Iki Island off the northwest coast of Japan, where the target species is bottlenose.

Perhaps the most preventable threat is inappropriate human interactions. At a resort on Shark Bay in western Australia, about half a

This little Hector's dolphin of New Zealand drowned because it became entangled and could not reach the surface.

dozen female dolphins are regularly fed by tourists. Ostensibly wild dolphins, they are now habituated to humans. A recent report cites declines in the survival rates of calves born to these mothers. In one case, a newborn was attacked by a shark while its mother was seeking handouts on the beach. Elsewhere in the world, wild dolphins have been known to ram and bite people who got too close. In one case in Brazil, a dolphin killed a man who was harassing it.

Feeding, swimming with wild dolphins, noise, collisions between boats and dolphins, trashing the waterways, and human crowding and harassment, all threaten the independence of these wild animals. This is one area in which individuals can really make a difference.

In the United States, the Marine Mammal Protection Act (MMPA) makes it a crime to feed, harass, hunt, capture, or kill dolphins.

Never feed or impinge upon wild dolphins. Dolphins are hunters, not beggars. When they lose their natural wariness, they can become targets for vandalism and shark attack. If you wish to observe dolphins in the wild, stay at least 50 yards away and remain quiet so as not to disturb the animals. Support Watchable Wildlife campaigns, sponsored by organizations like the National Wildlife Federation, that strive to educate the public on respectful viewing practices of wildlife.

Insist on clean waterways and oceans. Chemicals washed into the rivers and seas work their way up the food chain. Dolphins, as top predators, ingest large amounts of fish daily, and chemical levels can build up in their bodies. When dolphins get sick, they alert us to changes in our water quality. Legislation is an important tool in creating safe marine environments.

Support "dolphin-safe" consumer campaigns and legislation. The simple refusal of large numbers of people to buy tuna that have been caught by harming dolphins forced fishermen of many nations to change their methods. Because of consumer pressure, millions of dolphins have been saved, although continued vigilance is necessary. The U.S. Congress passed the International Dolphin Conservation Act (IDCA) in 1997, which amended the MMPA to lift trade bans on tuna products but further designated conservation measures for participating countries and the use of tougher dolphin-safe tuna labeling.

What will be the image of dolphins as we enter the 21st century: tragic symbols of degraded ecosystems or, as in earlier times, hopeful symbols of rebirth? The fate of these graceful and social marine mammals is a reflection of human choices. ■

Kathleen and Alejandro took seats at the table, and Bernd dealt out photos like hands of poker. They began talking about the animals in the arcane manner of scientists common the world over.

Since I was invisible and of little interest, in any case, I went outside to sit on the porch and wait for the sun to set over the Gulf. I felt rather like the participants on Kathleen's tours in the Bahamas. The more I learned about dolphins, the more concerned I had become about their continued survival. I thought for a moment about those species teetering on the brink of extinction: the Chinese river dolphin, the vaquita, the Indus River dolphin. Other dolphins around the world are threatened by overfishing of their prey, by pollution, by accidental entanglements in fishing nets.

But what I needed to know—what every concerned human needed—was exact information about wild dolphins: their numbers first of all, along with reliable reports about whether populations are declining or not. We need to know the dolphin's prey, and whether those creatures are declining, and if so, why.

Bernd had told me, during one of our dinner conversations, that "we need to know our animals in order to argue for their well-being."

It occurred to me that the scientists were working in realms of reality that had real meaning for anyone concerned with dolphin conservation. Science—the kind of science Kathleen did, and Bernd, and Alejandro—was of direct use in conservation efforts. I strolled along the beach, thinking that I was proud to know these people, and to actually work with them, if only in a peripheral manner.

I gave myself permission to feel more than a little sentimental, and I wondered what the visit to this place felt like to Bernd. He had lived here, on and off, for four years; fallen more deeply in love here; learned from a great scientist named Roger Payne; been encouraged by one of the greatest pioneers in wild dolphin research, Ken Norris. While he was here, Bernd had been a pioneer in such research himself. And now two of his brightest students would be coming back to Patagonia to carry on his work—with his beloved duskies.

I heard the scientists talking, sometimes about ethics, but very seldom about morality, which is the realm of philosophers and not marine biologists. Kathleen believed strongly in education—always had—and was convinced that it was the key to the conservation of life on the planet. As did Alejandro. And Bernd.

I reflected on the knowledge scientists sought. It wasn't about power, and no real scientist would actually say it was really about love, but sometimes it is. The studies envisioned by today's scientists are ever more noninvasive. Kathleen's ingenious mobile MVA was one example, as was the plan to swab bow-riding dolphins with sponges to obtain DNA samples. These ideas and innovations, it seemed to me, involved the highest respect for dolphins as dolphins.

Inside the house, I could again hear a bunch of science talk going on. Knowledge was being pounded and pummeled into existence by dedicated scientists. Presently, Bernd came out onto the porch. I thought he must be proud and nostalgic and very happy. I tried to speak with him, but he turned away and walked down to the beach. I hurried after him.

"Bernd," I said, "what's wrong?"

"Nothing." He turned to me and there was a kind of teary glaze in his eyes. "I just don't like to think I'm an emotional guy," he said.

But he was, and I liked him all the better for it. I left Bernd to wander aimlessly about and thought, for a moment, about his beloved duskies and about dolphins in general.

Were the creatures capable of language, as humans know it? Could they feel love, or sorrow, or grief?

The questions veered off into philosophy, and are, at present, unanswerable. The highest moral position, it seemed to me, was that dolphins were wild and free and deserving of our deference and admiration. And if no one can say with certainty that they are joyous creatures, it is equally true that they inspire that emotion in the human heart. The bond between our species is older than the written word and it would be pretty to think that as long as humans populate the land, dolphins will frolic in the seas. In the end, I'm afraid, that cheerful scenario depends wholly on the actions of the most feared predator on the planet, which is to say: The dolphins' fate lies in our hands. ■

A dusky dolphin leaps as if to bid farewell to the research crew on their last day in Patagonia.…

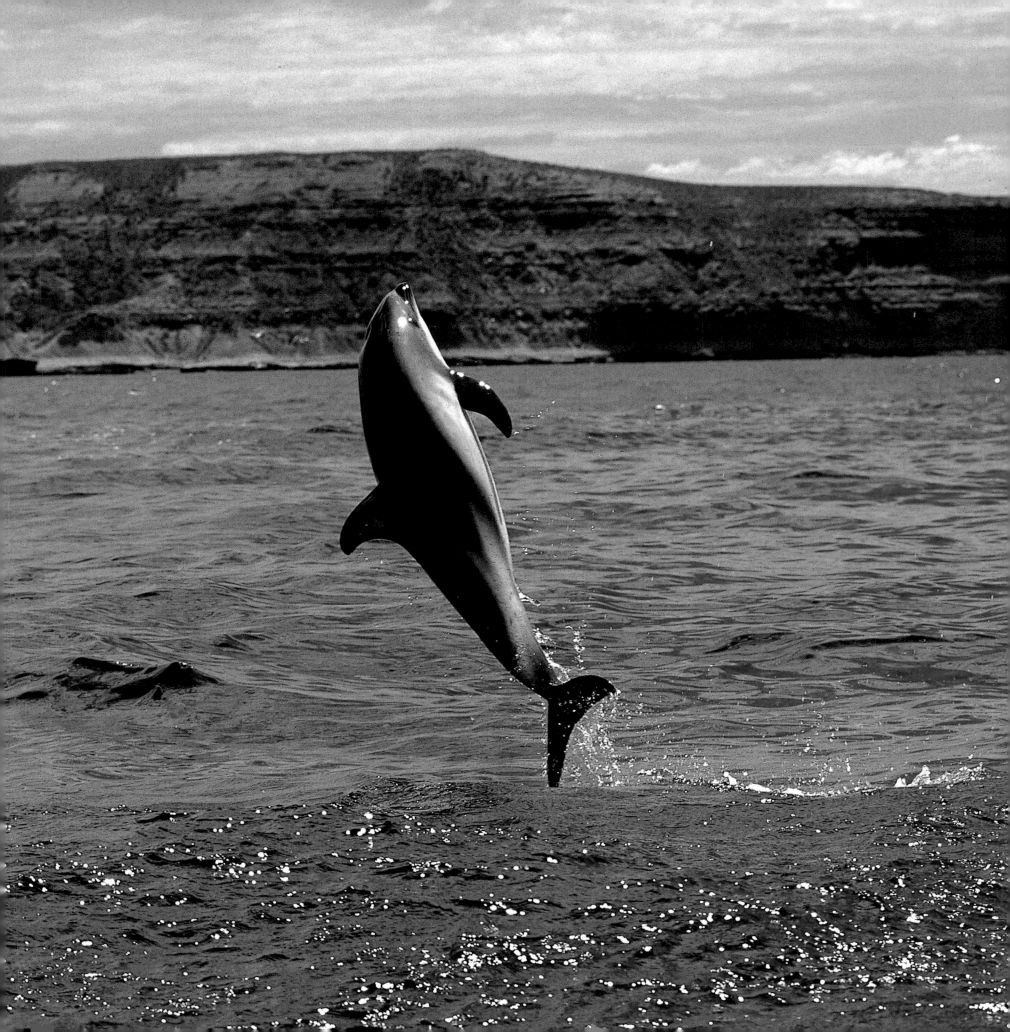

DOLPHINS: A FILMMAKER'S JOY

For me, there is nothing more beautiful than an ocean wave. As a surfer, I've searched 40 years for that perfect, six-foot, glassy break. In my teens and early twenties, with my 16 mm camera in tow, my friends and I introduced surfing to people living on remote islands and beaches all over the world. Surfing inspired my film career, and it also shaped me into an "ocean person," someone who feels profoundly connected to the sea and its creatures. ¶ One late afternoon years ago, as two friends and I filmed underwater scenes in the Banda Sea off Indonesia, a group of pilot whales approached our boat from a half-mile away. We dived into the water as a hundred of the 10-foot-long creatures stampeded over our heads, leaping through the water in exuberant display as they sped above us. The whistles of their loud "chatter" filled our bodies with sound. In a minute, it was over. Out of breath, we climbed back aboard our boat just as the sun was setting, burnt orange on the deep blue. We all couldn't (didn't want to) contain our shouts of joy. It was a peak, perfect moment in my life, when I was so happy to be alive that I nearly burst. Moments like these—priceless and unpredictable—are a gift not to be taken for granted. ¶ Whether I'm surfing, diving, sailing, or filming, I love experiencing the ocean's moods, movement, colors, and constant change: except one change. It's become sadly obvious that we humans disregard the life of the sea. When I surfed the waters of Brazil in 1966, the ocean teemed with life. It was stunningly beautiful. When I returned four years ago, I was shocked. The waves were brown and sudsy, filled with dangerous toxins. The waters of Rio de Janeiro are being polluted by the exploding human population on shore. This coastline is not unique. Pollution wreaks havoc on every shoreline, in every sea. ¶ Troubled by these changes, I have resolved to do what small things I can to make amends. Over the next 20 years I'll fund and produce at least six IMAX theater films about Earth's oceans. The first film was the Academy Award-nominated documentary THE LIVING SEA, and DOLPHINS, the IMAX theater film that is the subject of this book, is the second. ¶ Each giant-screen film we produce reaches 14-to-24 million people around the world. The clarity, beauty, and honesty of the giant-screen images captivate audiences. No other experience, except the real one, better reveals the fragility, vibrance, and significance of the sea, than this film genre. If you have an important message to convey, and I believe I do, then this is a very powerful medium for relaying it. ¶ Our films also have proved to be memorable. During the editing of DOLPHINS, we audience-tested cuts of the movie as it progressed, as we do with all our films, to measure the story's appeal and to examine how much audiences are learning from the film. We were pleased to discover that viewers increased their knowledge of dolphins by 250 percent. In my view, the more

people learn about dolphins, the more they will care about them. When Dolphins *reaches theaters, it is accompanied by educational tools, such as books, lectures, curriculum and science career guides, videos, and television programming. Our reach now becomes wider; perhaps upwards of 40 million people will have contact with our message.* ¶ *What is the message? Dolphin expert Ken Marten of Hawaii, who spent many years monitoring by-catch on tuna boats, estimates that two-thirds of some dolphin populations in the eastern tropical Pacific have been killed in the past 50 years. Whereas 5 of the species of dolphins in the world are currently "endangered" or "seriously vulnerable," more than 40 are insufficiently known to make such assessments. And experts say we are endangering all of them with our pollution, deadly fishing techniques, thoughtless waste, and ignorance. Simply, dolphins* ARE *in trouble. With my films, though, I also want to show the wild, mysterious beauty that still exists. I want audiences to fall in love with the ocean, as I did, so that they, too, will be inspired to save it.* ¶ *One of the pleasures of working on this film was collaborating with scientists who share my concern for dolphins and the ocean. All that we know about marine mammals comes from their research of habitat, feeding, mating and mothering behavior, societies, and physiology. Their good science helps us understand what we all yearn to protect, what we must protect, even as it points us in the direction of how we might get it done.* ¶ *"Jump for joy" is a favorite expression of mine. I've seen my children jump for joy when they play on the beach. I experienced that feeling with the pilot whales years ago, and I've surfed next to dolphins leaping in and out of the water in what seems to be an expression of joy. Someday, I hope we all unabashedly, wholeheartedly, jump for joy in celebration of the health and well-being of the ocean and one of its most scintillating animals—the dolphin.*

*—*Greg MacGillivray
Producer and Director of Dolphins
Everest, To Fly! *and* The Living Sea

As producer, director, or photographer, Greg MacGillivray has worked on more than a hundred films, including the Oscar-winning films *Sentinels of Silence* and *The Towering Inferno* as well as *Jonathan Livingston Seagull, Big Wednesday, The Shining, Bladerunner,* and the highest grossing documentary of all time, *To Fly!* In 1996, *To Fly!* was selected for inclusion in the National Film Archives, honoring the top 150 films in the first hundred years of cinema. In the same year, MacGillivray was inducted into the International Surfing Hall of Fame.

*You, personally, can help save the dolphins of the world by calling 1-877-3*DOLPHIN, *or visit our website at www.dolphinsfilm.com. Thank you.*

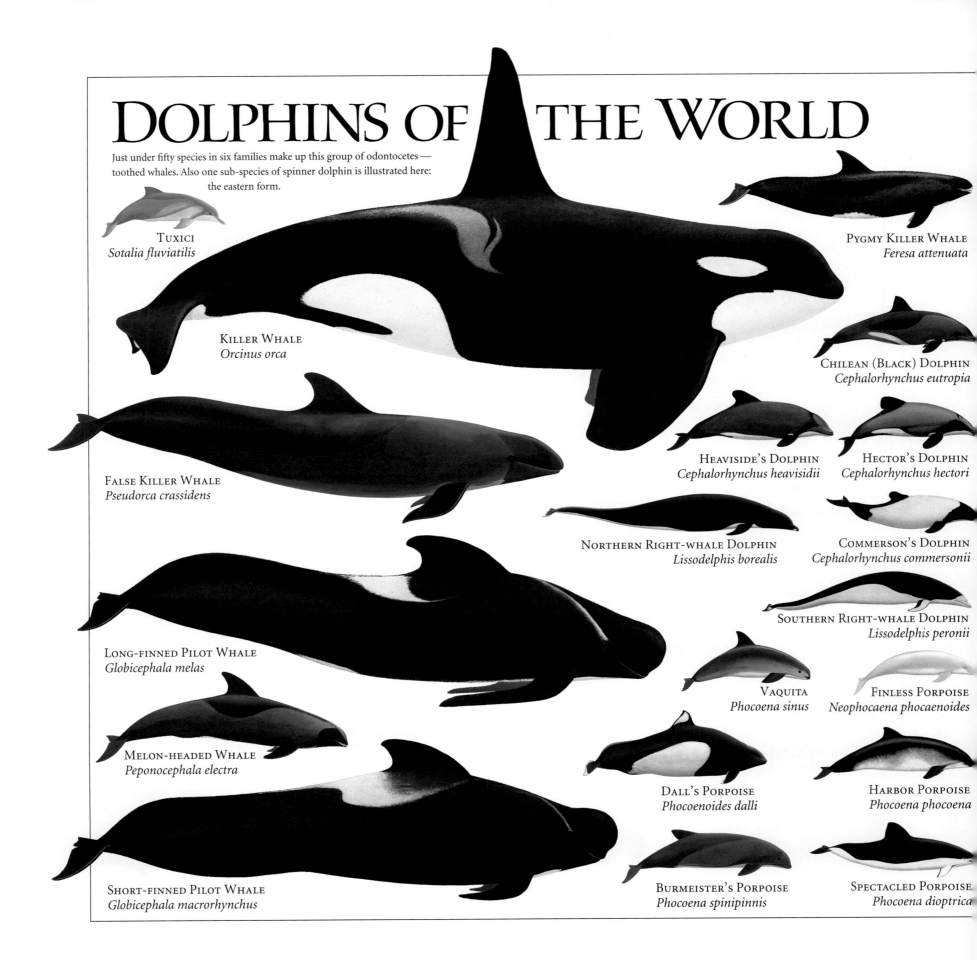

DOLPHINS OF THE WORLD

Just under fifty species in six families make up this group of odontocetes —
toothed whales. Also one sub-species of spinner dolphin is illustrated here:
the eastern form.

TUXICI
Sotalia fluviatilis

KILLER WHALE
Orcinus orca

FALSE KILLER WHALE
Pseudorca crassidens

LONG-FINNED PILOT WHALE
Globicephala melas

MELON-HEADED WHALE
Peponocephala electra

SHORT-FINNED PILOT WHALE
Globicephala macrorhynchus

PYGMY KILLER WHALE
Feresa attenuata

CHILEAN (BLACK) DOLPHIN
Cephalorhynchus eutropia

HEAVISIDE'S DOLPHIN
Cephalorhynchus heavisidii

HECTOR'S DOLPHIN
Cephalorhynchus hectori

NORTHERN RIGHT-WHALE DOLPHIN
Lissodelphis borealis

COMMERSON'S DOLPHIN
Cephalorhynchus commersonii

SOUTHERN RIGHT-WHALE DOLPHIN
Lissodelphis peronii

VAQUITA
Phocoena sinus

FINLESS PORPOISE
Neophocaena phocaenoides

DALL'S PORPOISE
Phocoenoides dalli

HARBOR PORPOISE
Phocoena phocoena

BURMEISTER'S PORPOISE
Phocoena spinipinnis

SPECTACLED PORPOISE
Phocoena dioptrica

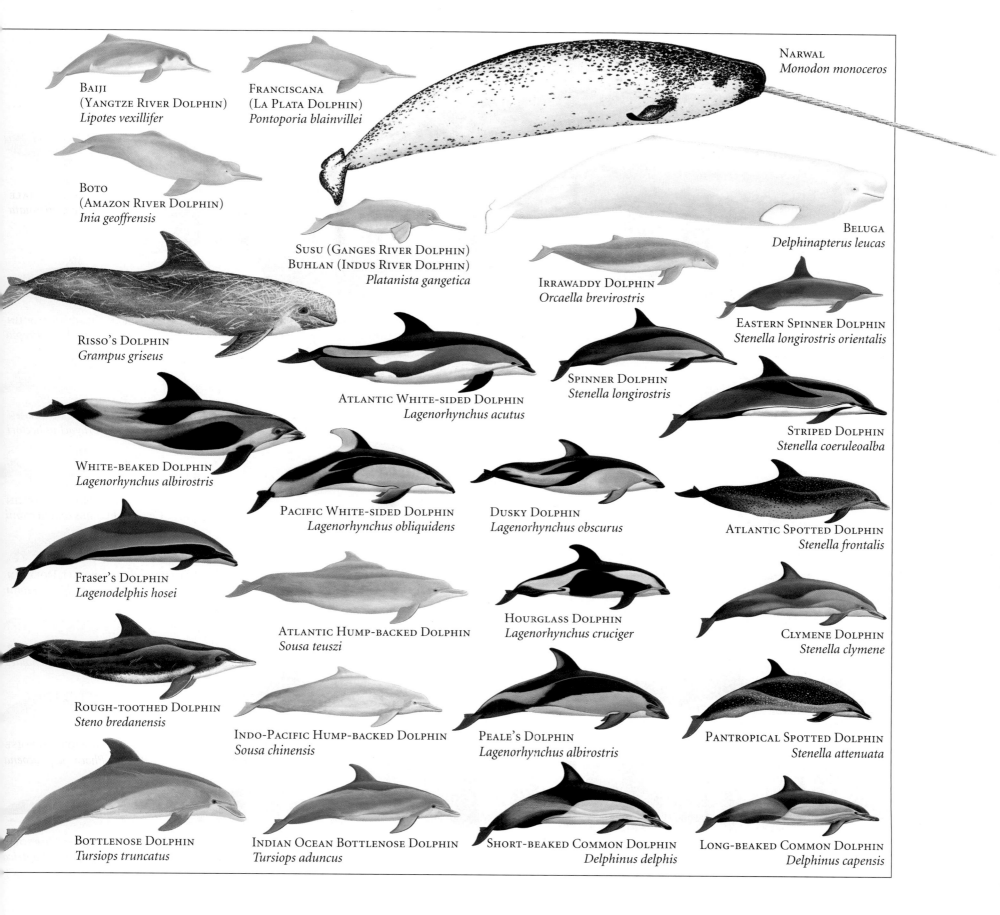

BAIJI
(YANGTZE RIVER DOLPHIN)
Lipotes vexillifer

FRANCISCANA
(LA PLATA DOLPHIN)
Pontoporia blainvillei

NARWAL
Monodon monoceros

BOTO
(AMAZON RIVER DOLPHIN)
Inia geoffrensis

SUSU (GANGES RIVER DOLPHIN)
BUHLAN (INDUS RIVER DOLPHIN)
Platanista gangetica

IRRAWADDY DOLPHIN
Orcaella brevirostris

BELUGA
Delphinapterus leucas

EASTERN SPINNER DOLPHIN
Stenella longirostris orientalis

RISSO'S DOLPHIN
Grampus griseus

ATLANTIC WHITE-SIDED DOLPHIN
Lagenorhynchus acutus

SPINNER DOLPHIN
Stenella longirostris

STRIPED DOLPHIN
Stenella coeruleoalba

WHITE-BEAKED DOLPHIN
Lagenorhynchus albirostris

PACIFIC WHITE-SIDED DOLPHIN
Lagenorhynchus obliquidens

DUSKY DOLPHIN
Lagenorhynchus obscurus

ATLANTIC SPOTTED DOLPHIN
Stenella frontalis

FRASER'S DOLPHIN
Lagenodelphis hosei

ATLANTIC HUMP-BACKED DOLPHIN
Sousa teuszi

HOURGLASS DOLPHIN
Lagenorhynchus cruciger

CLYMENE DOLPHIN
Stenella clymene

ROUGH-TOOTHED DOLPHIN
Steno bredanensis

INDO-PACIFIC HUMP-BACKED DOLPHIN
Sousa chinensis

PEALE'S DOLPHIN
Lagenorhynchus albirostris

PANTROPICAL SPOTTED DOLPHIN
Stenella attenuata

BOTTLENOSE DOLPHIN
Tursiops truncatus

INDIAN OCEAN BOTTLENOSE DOLPHIN
Tursiops aduncus

SHORT-BEAKED COMMON DOLPHIN
Delphinus delphis

LONG-BEAKED COMMON DOLPHIN
Delphinus capensis

by Bernd Würsig

page 26, col. 2, end of par. 2
We all know that dolphins have large brains, but there is considerable debate on what dolphins do with them. They are group hunters who tend to be highly social, and these traits—as in terrestrial carnivores—favor the ability to innovate, learn from others, and remember. At the same time, they are amazingly adept at processing acoustic information, both with whistle-type communication and with click sounds used for echolocation. Perhaps these evolved traits are sufficient to explain large brain size and apparent intelligence. We also tend to forget that "dolphins" encompasses about 40 different species, with varying degrees of behavioral complexity among them. Very few species—perhaps most notably the bottlenose dolphin, rough-toothed dolphin, and killer whale—stand out as so intelligent as to potentially rival the behavioral flexibility of some of the great apes. For a very readable account on the subject, see the chapter by P. Tyack called "Communication and Cognition" in the book *Biology of Marine Mammals*, by Reynolds and Rommel, 1999 *(see suggested reading)*. A more general but excellent book is by D. R. Griffin, *Animal Minds*, 1992. The University of Chicago Press.

page 30, col. 1, par. 3
Dolphins and other toothed whales do not chew their food. They cannot move their jaws sideways, but can only chomp up and down. Their teeth, often interlocking top to bottom, like the teeth of a zipper, are sharp and are excellent for grabbing, tearing, and biting but not chewing. All teeth of all dolphins are homodont, meaning that they

have the same conical, interlocking design; except for the teeth of the Amazon river dolphin, the boto, which has molars in the back of its jaws. These molars are not for grinding but for crushing prey, probably mainly hard-shelled mollusks and other invertebrates. For a description of mouth types and feeding, see Chapter 11 of *Marine Mammals: Evolutionary Biology*, by Annalisa Berta and James L. Sumich, Academic Press, San Diego, California. 1999; and Chapter 2 of *Biology of Marine Mammals*, edited by John. E. Reynolds III and Sentiel A. Rommel, Smithsonian Institution Press, Washington, D.C. 1999.

page 30, col. 2, par. 2 & 3
Earning a Ph.D., or "Doctorate of Philosophy," in any branch of science is often misunderstood as a set of aggressive interactions between a submissive student and demanding, authoritative, professors. This may be so at times but is certainly not the norm. In the United States, at least, the major professor (often called the chair) and his or her committee serve as protective parents: cajoling, gently questioning, attempting to steer and set right. "Guidance" is probably the best term. When they question, they question in an attempt to help along the ideas and hypotheses of the student, never to destroy them. A very wise account of how professors deal with their students is found in a lovely book by one of the fathers of marine mammalogy, K. S. Norris, *Dolphin Days: The Life and Times of the Spinner Dolphin*, 1991, W.W. Norton Press, New York.

page 34, col. 2, par. 5
Ever since J. C. Lilly published a series of books on dolphins (most notably,

The Mind of the Dolphin, 1967, Doubleday Press, New York), much of the Western public has been fascinated with reputed language capabilities of dolphins. The fact is that these bright social mammals have at least a rudimentary capability of language but appear to have no special need to put detailed semantic structure to their communicative interactions in nature. Instead, they appear to work out interanimal relations with fine-tuned knowledge of each individual of a group, and a concomitant memory of past social interactions. The best of descriptions of behavioral flexibility and cognition can be found in the book *Dolphin Cognition and Behavior: A Comparative Approach*, edited by R. J. Schusterman, J. A. Thomas, and F. G. Wood, 1986, Lawrence Erlbaum Publishers, Hillsdale, New Jersey.

page 40, col. 1, par. 1
The speed-of-sound difference has to do with how far ears are set apart and reflects different arrival times of sound at each ear. Another reason that our ears do not very well discriminate the direction of sound underwater is the different densities of the medium. Water and mammalian tissue is about 800 times more dense than air, and our ears directionalize in large part by isolating the ears with tissue and bones of the skull. An airborne sound that enters both ears is perceived as louder in the ear pointing most directly to the sound source, because it is "shaded" by the skull and its tissue on the other side. Underwater, sound travels in a medium of very similar density as the mammalian head, and therefore goes "right through" our terrestrially-adapted head at essentially the same loudness on both sides. The sound appears to come from all directions.

Dolphin (and whale) ears have changed to accommodate this. Their middle and inner ears are encased in very dense bones so that the sides can be better differentiated. Besides this density, the earbones are separated from the rest of the skull, hang on ligamentous attachments to the skull, and isolate the vibrations of the skull from the dense earbones. There is an opening on one side of each earbone, placed just so as to let the sound from each side come into that ear relatively unaffected by the surrounding tissue. For a fine review on this topic, see chapter 8, pp. 222-226 of *Marine Mammals and Noise*, by W. John Richardson, Charles Greene, Jr., Charles Malme, and D. H. Thomson. Academic Press, San Diego, California 1995.

page 69, par. 9
While spotted dolphin spot patterns may be important in helping to camouflage or confuse predators and prey, it is likely that there is a more simple explanation: The amount and type of spotting indicates age and thereby some manner of relative status within the society. Unspotted youngsters also need to hunt prey and avoid predators; perhaps, because of small size, even more so than the heavily spotted older animals. But, by being unspotted, youngsters avoid the often rather aggressive encounters among older animals. Both young and most older animals are nevertheless somewhat counter-shaded, with a generally lighter belly and darker back. This is what keeps them camouflaged, not the spot patterns. As almost an aside, *very* old animals have just as dark a belly as their back, and perhaps this signifies, "I am surviving despite my obvious handicap of not being countershaded (and therefore, I must be attractive, what humans term 'sexy', to the opposite

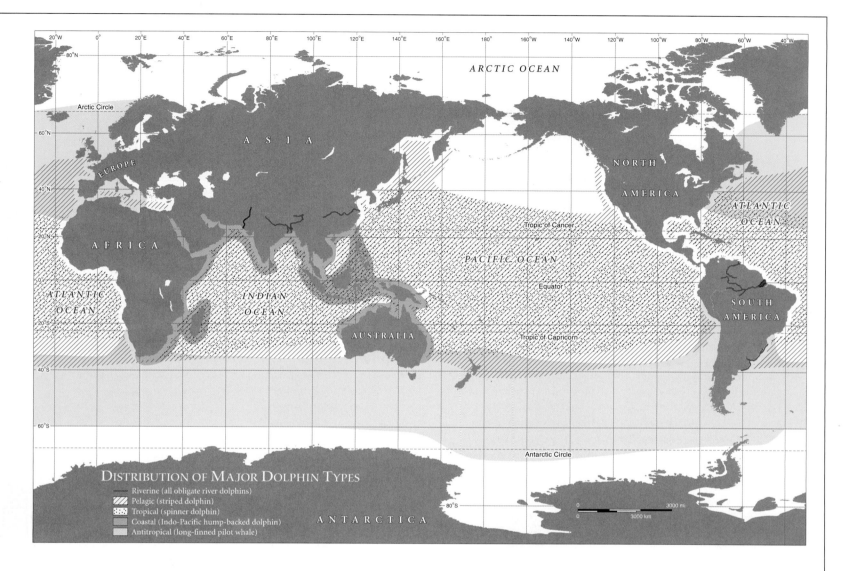

DISTRIBUTION OF MAJOR DOLPHIN TYPES

— Riverine (all obligate river dolphins)
▨ Pelagic (striped dolphin)
▨ Tropical (spinner dolphin)
▨ Coastal (Indo-Pacific hump-backed dolphin)
▨ Antitropical (long-finned pilot whale)

gender)." More can be read about dolphin pigmentation patterns in "Color Pattern of the Eastern Pacific Spotted Porpoise, Stenella graffmani Lönnberg," by W. E. Perrin, 1970, *Zoologica* 54, pp. 135-149.

page 72, par. 5
The genital organs are totally internal in dolphins, and this is especially important for the testes, which descend outside the body in most terrestrial mammals, so that sperm can stay relatively cool and therefore viable. It is obvious why the testes are inside dolphins—to keep them protected and to keep the swift-moving dolphins' hydrodynamic shape. But how do sperm survive? The testes are amply supplied by an arterial/ vein connection running to them directly from the dorsal fin and the tail. The testes are cooled by a "radiator" system that allows internal body heat to be dissipated and shunted to the outside. Indeed, recent deep body core temperature measurements show an appreciable lowering of body heat around the testes, despite very strong muscular exertion such as during rapid swimming. An excellent description of this adaptation is provided by D. A. Pabst, S. A. Rommel, and W .A. McLellan in "The Functional Morphology of Marine Mammals," 1999, *Biology of Marine Mammals*, edited by Reynolds and Rommel *(see suggested reading)*.

page 76, col. 2, par. 8
The cookie cutter shark of the Isistius genus has evolved to take chunks out of large fish and marine mammals by quickly grabbing the flesh, rotating, and excising a 4-cm-wide round piece of skin and blubber. It cuts right to the underlying muscle, and must be very painful indeed. Relative to the size of its prey, this 40-cm-long shark is a tiny predator that may occasionally kill, due to infection of the tissue. Usually, however, it only hurts and scars for life. Other external attackers such as large leopard or great white sharks—and the ubiquitous larger cousin the killer whale—are much more dangerous. External hitchhikers also exist, such as stalk barnacles that hang onto the trailing edges of flukes and dorsal fins where they use the swift movements of their hosts to bring plenty of food to them as they are dragged through the water. The remora, a fish with a modified sucking mouth, hangs onto the side of dolphins or whales for the same reason. It does not cause damage to the

skin, but a 30-cm-long remora on a 3-m-long dolphin can cause plenty of drag and require an extra expenditure of energy. P. G. H. Evans discusses external and internal parasites, as well as predation, in the *The Natural History of Whales and Dolphins (see suggested reading).*

page 78, col. 2, par. 2
The successful conservation of animals, plants, and ecosystems can usually not be solely realized by government regulations and enforcement. It must become a grassroots realization at the individual and community level. There must be local awareness of the problem, usually coupled with a financial incentive, for a change in human behavior to occur. For example, until recently (the early 1990s), it appeared that there was an unsolvable problem of over-killing of nearshore dolphins along the Peruvian and Chilean coasts. Dolphin meat was being used for baiting crab pots, as fertilizer, and for wildlife and human consumption. The governments outlawed the activities, but they continued on the black market. However, a developing tourism trade, often centered on whale and dolphin watching, is bringing the realization that this marine mammal resource is more sustainable when animals are kept alive. See *Save the Dolphins,* by M. Donoghue and A. Wheeler, 1990; and *Conservation and Management of Marine Mammals,* edited by J. R. Twiss, Jr. and R. R. Reeves, 1999 *(see suggested reading).*

page 102, par. 1
Many stories exist of dolphins and other toothed whales who habitually associate with humans to the apparent exclusion of their own kind. Although probably multiple reasons account for this behavior, it is most likely that such individuals became lost or were "thrown out of" their groups. Dolphin societies often evidence quite a bit of aggression,

and a subdominant animal who is harassed may strike out on its own. But being alone for a highly social creature is potentially devastating, so it associates with humans—or with individuals of other species. Lone dolphins have been seen in groups of other kinds; for example, a southern right whale dolphin with a school of dusky dolphins, and a short-finned pilot whale with Atlantic spotted dolphins. When we see this kind of "loneliness," however, we must not immediately assume that the dolphin does not also affiliate with its own kind. For example, a large oceanic bottlenose dolphin nick-named "Maui" has been affiliating with humans and dusky dolphins off New Zealand for close to ten years now. Several years ago, it disappeared for a few months and then returned to the shore with a newborn calf, proof that it was having at least some very important affiliation with other bottlenose dolphins.

page 160, col.1, par. 2
Bubble screening is a recently developed technique to keep loud noises made by a stationary industrial source from traveling out into the environment. The idea is somewhat like the concrete noise attenuation walls you see beside highways and adjacent family dwellings in city suburbs. In that case, an object (the wall) with high density disrupts the sound that travels in air, at lower density. In the bubble screening case, a perforated hose on the seafloor surrounds the industrial activity—a pile driving rig for example. Air is forced through the hose and its myriad holes to form a screen of rising air bubbles around the activity. Here, the light air provides a reflective and absorptive surface relative to the water, which is 800 times more dense than air. The density, or impedance, mismatch is what reduces the sound on the other side of the bubble wall. The method for deployment is described by B. Würsig, C. R. Greene,

Jr., and T. A. Jefferson in "Development of an Air Bubble Curtain to Reduce Underwater Noise of Percussive Piling," 1999, *Marine Environmental Research,* 48:1-15.

page 166, col. 1, par. 1
Killer whales are superb hunters. They use a kind of flank formation to keep prey from escaping to the sides. This is very much what lion prides do when stalking. In a few places, killer whales also take turns rushing onto a sloping beach, always with an advancing wave, "surfing" if you will, to snap up young elephant seals, sea lions, or other pinnipeds in the turbulent surf zone. These large predators actually beach their bellies, even though water still flows around them. Such activity requires great skill to home in on a single prey and is also quite dangerous, for the whale must be certain not to rush up so far as to become permanently beached. Excellent long-term observations by the Argentine researchers J.-C. and D. Lopez ("Killer Whales of Patagonia and Their Behavior of Intentional Stranding While Hunting Nearshore," 1985. *Journal of Mammalogy* 66:181-183) indicate that older animals teach youngsters to hunt in this fashion, patiently beaching themselves in sham runs without taking prey, then giving the youngsters a turn.

page 166, col. 2, par. 1
Elephant seals are the most polygyn of any of the marine mammals. That means that it is almost exclusively a few oldest and largest adult males who get to mate with all females of a colony. The aggressive fights and the incredible energy it takes for males to attempt to climb the social ladder to success results in about 90 percent to 95 percent of them dying without ever achieving dominance. Despite the dominant males practice of forcing themselves onto females, the females nevertheless have some choice of who gets to mate with

them. They protest loudly when males mount them, squealing and squawking. Other males hear this protest, and any other dominant males in the area will attempt to challenge the mounting one. If the challenger succeeds, the sequence starts over. In this way, the female is sure to be mated by the most dominant male on that section of beach. More detail is found in *Elephant Seals,* edited by B. J. Le Boeuf and R. M. Laws, 1994, University of California Press, Berkeley.

page 194, col. 1, par. 2
The natural schooling behavior of many species of fishes means that dolphins do not necessarily have to work hard to contain their prey. Nevertheless, there is some evidence that they herd stragglers back to the school, keep the school from splitting into myriad smaller schools, and attempt to pin the school against the surface of the water. It is an interesting truth that many of the reasons for schooling—looking like a super-organism to a predator, hiding within the school, avoiding being eaten by the sheer statistics of being safer if a predator can eat only so many at a time—become self-defeating when a cooperating predator school, e.g. the dolphins, concentrates on a schooling "bait ball" and decimates a high proportion of it in one feast. The continuation of tight schooling by prey as a predator-avoidance strategy must mean that there are many more dangers from less coordinated predators than dolphins. As well, schooling in fishes has gone on for several hundred million years, while efficient social feeding by dolphins is relatively new in evolutionary time. A very readable account of predator-prey interaction in the sea is presented by D. Weihs and P. W. Webb in the study "Optimal Avoidance and Evasion Tactics in Predator-Prey Interactions," 1984, *Journal of Theoretical Biology* 106:189-206. Any good marine

biology textbook will provide the basics of schooling advantages for dolphins.

page 195, col. 2, par. 2
A dusky dolphin surface feeding activity is a spectacular sight largely because of the hundreds to thousands, of up to 12 species of birds that gather in a tight area, plunge diving, skimming, careening. All take advantage of the fish dolphins have brought to the surface. It is very likely that terns usually see the activity first. Gulls and cormorants pay attention to feeding terns and come flying in from their beach roosts. Then come pelagic shearwaters, petrels, and albatrosses. Finally, paddling as rapidly as they can and often arriving late, are the flightless Magellanic penguins. These birds are a beacon to other dolphin groups, marking the success of a feeding activity. The activity is described for the lay reader by B. Würsig, M. Würsig, and F. Cipriano in "Dolphins in Different Worlds", 1989, *Oceanus* 32:71-75.

page 199, col. 2, par. 1
The biological camp known on Peninsula Valdés as "Lota Treinta y Nueve" (Lot 39) was established by Roger and Katy Payne in 1972, then of the New York Zoological Society. Bill Conway, the long-term head of that society, was the driving force in making it happen, along with cooperation from the Argentine government. Roger Payne went on to become one of the finest of marine mammal researchers, educators, and conservationists. Katy Payne discovered low frequency ("infra-sonic") communication in elephantsand has done ground-breaking research in that field. For an account of the early history of Lota Treinta y Nueve, see R. Payne, 1995, *Among Whales (see suggested reading)*.

SUGGESTED READING

Payne, R. S. 1995. *Among Whales.* Scribner and Sons, New York, New York.

This is a scientist and naturalist's account of his most memorable interactions with whales and dolphins and the adventures he and his family had along the way.

Pryor, K. and K. S. Norris, Editors. 1991. *Dolphin Societies: Discoveries and Puzzles.* University of California Press, Berkeley, California.

Two superb researchers request research papers from 20 authors, and then comment in wise and whimsical fashion. A treasure for those interested in dolphin social structure and behavior.

Richardson, W. J., C. R. Greene, Jr., C. I Malme, and D. H. Thomson. 1995. *Marine Mammals and Noise.* Academic Press. San Diego, California.

An amazing compilation of knowledge about underwater sounds, underwater audition of marine mammals, and problems of human-made noise. This scientific treatise boasts close to 1,000 references of the primary literature and is a treasure of sound-related information.

Schusterman, R. J., J. A. Thomas, and F. G. Wood, Editors. 1986. *Dolphin Cognition and Behavior: A Comparative Approach.* Lawrence Erlbaum Associates, Hillsdale, New Jersey.

This is the most important book to come out on dolphin cognition to date.

Herman, L. M., Editor. 1980. *Cetacean Behavior: Mechanisms and Functions.* Krieger Publishing, Malabar, Florida.

A classic of information on dolphin sensory systems, communication, school structure, social ecology, cognition, and behavior in captivity.

Evans, P. G. H. 1987. *The Natural History of Whales and Dolphins.* Facts on File Press, New York, New York.

This single-authored summary of

knowledge is an important resource, especially for its excellent comprehensive bibliography through 1985.

Norris, K. S., B. Würsig, R. S. Wells, and M. Würsig. 1994. *The Hawaiian Spinner Dolphin.* University of California Press, Berkeley, California.

This compilation of research on spinner dolphins is one of the most thorough single-species descriptions of any cetacean. Information on schooling, sensory integration, and communication goes far beyond spinners by describing dolphin life in general.

Norris, K. S. 1991. *Dolphin Days: The Life and Times of the Spinner Dolphin.* W.W. Norton Press, New York, NY.

The popular and charming companion to the scientific book on the same subject published by the University of California Press.

Donoghue, M. and A. Wheeler. 1990. *Save the Dolphins.* David Bateman Press, Auckland, New Zealand.

This book is a well-written, impassioned plea for helping endangered populations and species of dolphins worldwide.

S. Leatherwood, R. R. Reeves, and L. Foster. 1983. *The Sierra Club Handbook of Whales and Dolphins.* Sierra Club Books, San Francisco, California.

Although almost 20 years old, this little book remains an excellent guide to cetaceans. Its color plates by wildlife artist Larry Foster are a treasure.

Carwardine, M., E. Hoyt, R. Ewan Fordyce, and P. Gill. 1998. *Whales, Dolphins, and Porpoises.* Weldon Owen Press, Sydney, Australia.

A colorful up-to-date popular guide to cetaceans. Of special note is the chapter on where and how to watch whales.

Rice, D. W. 1998. *Marine Mammals of the World.* Special Publication No. 4 of the Society for Marine Mammalogy, P.O. Box 1897, Lawrence, Kansas.

A scientific and opinionated treatise on the author's perception of the latest taxonomy of all marine mammals. It makes a good companion to both the Leatherwood et al. and Carwardine et al. texts mentioned above.

Berta, A. and J. L. Sumich. 1999. *Marine Mammals: Evolutionary Biology.* Academic Press, San Diego, California.

Finally, a university-level text to guide undergraduate students through a course in marine mammalogy! The best and most up-to-date text currently available.

Würsig, B., T. A. Jefferson, and D. J. Schmidly. 2000. *The Marine Mammals of the Gulf of Mexico.* Texas A&M University Press, College Station, Texas.

Twenty-five toothed whales and dolphins are found in the Gulf of Mexico, and this book makes them come alive with narrative, color drawings by acclaimed artist Larry Foster, and photos. The book also has skull keys and morphology keys to aid in identification, as well as chapters on diversity and conservation needs.

Reynolds III, J. E. and S. A. Rommel, Editors. 1999. *Biology of Marine Mammals.* Smithsonian Institution Press, Washington, D.C.

The ten long chapters cover everything from functional morphology to sensory systems, energetics, reproduction, communication, cognition, behavior, population biology, and problems of contamination. This is an authoritative up-to-date scientific compilation on general biology of all the marine mammals.

Twiss, J. R., Jr., and R. R. Reeves, Editors. 1999. *Conservation and Management of Marine Mammals.*Smithsonian University Press, Washington, D.C.

The present authoritative compilation of environmental and other problems of marine mammals, with explorations of potential solutions.

Author Acknowledgments

TIM CAHILL WISHES TO THANK Greg MacGillivray for his vision, Patrice Silverstein for her editorial expertise, Barbara Lowenstein for her acumen, and Lori Rick for her diligence. Most of all, he wishes to thank Bernd Würsig, Alejandro Acevedo-Gutiérrez, and Kathleen Dudzinski who all allowed him to invade their lives, and who, with the patience of saints, explained, and re-explained, various theories, concepts, and methodologies. Dr. Würsig, as the science editor, spent what must have been many frustrating days correcting errors of fact in the manuscript. His desire to "finally get it right" was frankly inspiring. A note of special thanks to Dr. Dudzinski who first introduced the author to dolphins in the wild.

Contributing Writers

Alejandro Acevedo-Gutiérrez, Ph.D, specializes in studying the feeding and foraging strategies of marine mammals with a special emphasis on both whales and dolphins. Raised in Mexico City, Acevedo received his Ph.D. at Texas A&M University in 1997 where he wrote his doctoral dissertation on the feeding behavior of bottlenose dolphins and their interactions with silky sharks in Costa Rica. He is currently a post-graduate researcher at the University of California, Santa Cruz, in the Marine Mammal Laboratory where he is studying the foraging ecology of fin and blue whales.

Whitlow Au, Ph.D., is the chief scientist of the Marine Mammal Research Program of the Hawaii Institute of Marine Biology at the University of Hawaii. He is a fellow of the Acoustical Society of America (ASA) and the Animal Bioacoustics associate editor for the *Journal of the Acoustical Society of America*. He is also the chair of the Animal Bioacoustics Technical Committee of the ASA. In October, 1998, he received the silver medal presented by the ASA for his scientific contributions to the field of Animal Bioacoustics. He has been involved with bioacoustics research for more than 25 years.

Jean-Michel Cousteau, son of legendary Jacques Cousteau, has spent his life exploring the world's oceans and communicating to people of all nations his love and concern for our planet. He is co-founder of Oceans Futures Society, a non-profit foundation dedicated to uniting the world's people in a global effort to halt marine devastation. An impassioned spokesman for the environment, Cousteau delivers dozens of speeches around the world annually, inspiring thousands with his own unique vision for our water planet.

Randall Davis, Ph.D., is professor of marine biology and director of the Laboratory for Aquatic Animal Performance at Texas A&M University. For the past 20 years, his research has focused on the physiology, behavior, and ecology of marine mammals and birds, primarily in polar environments. He also serves as the Program Manager for the U.S. Dept. of the Interior study on the distribution and abundance of cetaceans in the northern Gulf of Mexico. Davis received his Ph.D. from the University of California, San Diego, and has authored or co-authored 50 peer-reviewed journal articles and book chapters, 2 books, 23 technical reports, and 7 popular articles. He has been presenter or co-author of 49 presentations at professional meetings.

Kathleen Dudzinski, Ph.D., has been researching cetacean social behavior and communication for more than a decade. In 1990 Dudzinski entered Texas A&M University as a doctoral candidate in Wildlife and Fisheries Sciences, studying under Dr. Bernd Würsig. Dividing her time between Texas and the Bahamas, where she documented Atlantic spotted dolphin behavior while working as a naturalist aboard a tour boat, Dudzinski was awarded her Ph.D. in 1996. Dudzinski recently completed a post-doctorate research post in Miyake-jima, Japan, where she studied the communication behavior of bottlenose dolphins. She is the author of the children's book, *Meeting Dolphins: My Adventures in the Sea* published by the National Geographic Society.

Janna Emmel has worked in the giant-screen industry with MacGillivray Freeman Films for almost 12 years. In addition to writing fundraising proposals and promotional material, she researches film content from pre-production through the final cut. Proof that you don't need to be near dolphins to love learning about them, Emmel resides in the Black Hills of western South Dakota.

Louis M. Herman, Ph.D., is the founder and director of the Kewalo Basin Marine Mammal Laboratory in Honolulu. Herman is a tenured professor in the Department of Psychology of the University of Hawaii, a cooperative faculty member of the department of Oceanography, and co-founder and president of the Dolphin Institute, a nonprofit organization dedicated to dolphins and whales through education, research and conservation. Herman is known internationally as a leading expert on dolphin cognitive abilities. He has published over 100 scientific articles and is editor or co-editor of two books on dolphins and whales. His work has been featured in more than 180 media presentations.

John E. Heyning, Ph.D., is deputy director of research and collections and curator of mammals at the Natural History Museum of Los Angeles County, which includes 20 scholarly disciplines and collections of more than 33 million objects representing our natural and cultural world. Heyning is a mammalogist whose research focuses on the natural history, anatomy, evolution, and conservation of whales, dolphins, and porpoises. Heyning also serves as an adjunct associate professor of biology at the University of California, Los Angeles. He is the author of one book and more than 50 scientific and popular articles. His second book, *Cetacean Evolution*, is scheduled for publication by Academic Press in 2000.

Jill Lewandowski holds a biology degree from the University of Virginia and has been active in marine mammal conservation issues for many years. Previously, she has worked as an animal trainer and public educator at the Dolphin Research Center, with the marine animal rescue team at the National Aquarium in Baltimore, and with the marine mammal protection program at the National Marine Fisheries Service.

Chris Palmer is president and CEO of National Wildlife Productions. He leads the television, film, and multimedia programs of the National Wildlife Federation, the nation's largest member-supported conservation group with more than four million members and supporters. Since joining the National Wildlife Federation in 1994, Palmer has

directed NWF's launch into broadcast, cable, syndication, home video, new media, large format, and international markets. Palmer has creative and financial responsibility for nearly a hundred hours of television programming for networks like TBS Superstation and Animal Planet, as well as children's programming, feature films, giant-screen films, and interactive multimedia programs.

Brenda Peterson is a novelist and nature writer, author of eight books, and co-editor of the popular anthology *Intimate Nature: The Bond Between Women and Animals.* For two decades, she has studied and written about dolphins and whales for national magazines and newspapers. Her essays have appeared in the *New York Times, Reader's Digest, Orion, Utne Reader,* and *Sierra;* her environmental commentaries have aired on National Public Radio. With co-editor Linda Hogan, she is bringing out the second of the Women in the Natural World Series this spring, entitled *The Sweet Breathing of Plants.* She is also working on a book about the gray whale for National Geographic. Her new book, *Singing to the Sound: Visions of Nature, Animals, and Spirit* is just out from New Sage Press.

Rachel Smolker is a research associate in the Biology Department at the University of Vermont. She has studied dolphin behavior and communication in Shark Bay, West Australia, for many years. Her general interest in animal behavior has also led her to watch various primate species in other locales.

Randall Wells, Ph.D., is a conservation biologist with the Chicago Zoological Society in Brookfield, Illinois. In this capacity, Wells also serves as the director of the Center for Marine Mammal and Sea Turtle Research for Mote Marine Laboratory in Sarasota, Florida. Additionally, he is an adjunct associate professor of ocean sciences at the University of California, Santa Cruz. Much of Wells's current research examines the behavior, ecology, health, and population biology of bottlenose dolphins along the central west coast of Florida. Wells has authored or co-authored more than 55 peer-reviewed journal articles and book chapters, 42 technical reports, and 11 popular or semi-popular pieces. He has been presenter or co-author of 95 presentations at professional meetings and 80 invited public or university lectures.

Terrie M. Williams, Ph.D., is a comparative exercise physiologist with the Department of Biology at the University of California, Santa Cruz. For the past 20 years she has investigated the energetics of swimming, diving, and running in a wide diversity of mammals. Her research has taken her to Africa to study running cheetahs, Alaska to investigate sea otters, and Antarctica to examine Weddell seals. Most recently, she has published a series of papers concerning the swimming and diving of bottlenose dolphins. These studies have revealed remarkable behavioral strategies and physiological mechanisms that make dolphins unique athletes in the seas.

Bernd Würsig, Ph.D., is professor of marine mammalogy, director of the Marine Mammal Research Program, and co-director of the Institute of Marine Life Sciences at Texas A&M University. Würsig has been studying cetaceans for more than 20 years. His pioneering studies of the dusky dolphins of Patagonia, Argentina, and off the shores of New Zealand are the most comprehensive work being done on the species. Würsig has authored or co-authored 70 peer-reviewed papers, 42 articles for the public, four books, and numerous reports in the fields of behavior, behavioral ecology, social systems, and conservation biology. He has also co-produced, narrated or advised on 13 films since 1976.

PHOTOGRAPHY AND ILLUSTRATIONS CREDITS

Front Matter
2-3, Flip Nicklin/Minden Pictures
4-5, MacGillivray Freeman Films
6-9 (both), Leonard J. Aube
10-11, Masa Ushioda/Innerspace Visions
12-13, Doug Perrine/Innerspace Visions
14-15, Windland Rice/Jeff Foott Productions

Chapter One: Dancing With Dolphins
18-19, MacGillivray Freeman Films
21, Doug Perrine/Innerspace Visions
22-27 (all), MacGillivray Freeman Films
29, Flip Nicklin/ Minden Pictures
32 (both), Doug Perrine/Innerspace Visions
32-33, Norbert Wu/www. norbertwu.com
35, Kathleen M. Dudzinski
37, Doug Perrine/Innerspace Visions
38-40 (both), MacGillivray Freeman Films
42-43, Doug Perrine/Innerspace Visions
44-45 (both), Bob Talbot
46-49 (both), MacGillivray Freeman Films
50-51,Doug Perrine/ Innerspace Visions
53, Steve Drogin/Innerspace Visions
54-55, Windland Rice/Jeff Foott Productions
56, Norbert Wu/www.norbertwu.com
57, Flip Nicklin/Minden Pictures
58-59, Konrad Wothe/Minden Pictures
60, Doug Perrine/Innerspace Visions
62-63, Carlos Eyles
64, Tui De Roy/Minden Pictures
65, Norbert Wu/www.norbertwu.com
66-67, Doug Perrine/Innerspace Visions
68, MacGillivray Freeman Films
70 (upper),Flip Nicklin
70 (up center), Todd Pusser/Innerspace Visions
70 (low center), Thomas Jefferson/Innerspace Visions
70 (lower), Peter Howorth/www.norbert wu.com
72-73, Phillip Colla/Innerspace Visions
74-75, Leonard J. Aube
77, Keith Kasnot
79, Norbert Wu/www.norbertwu.com

Chapter Two: Matters of Mind
80-88 (all), David Doubilet
89, Akakokko-Kan
90-91, David Doubilet
93, Jeff Foott
95-97 (both), David Doubilet
99, Doug Perrine/Innerspace Visions
100-101, David Doubilet
103-106 (all), MacGillivray Freeman Films
108, Kaoru Soehata
109, David Doubilet
110-116 (all), Doug Perrine/Innerspace Visions
117, Leonard J. Aube
118-119, Doug Perrine/ Innerspace Visions

120-123 (all), David Doubilet
124-125, Hamano
126-127 (all), David Doubilet
128 (tables), Klinowska, Margaret, "Brains, Behavior and Intelligence in Cetaceans (Whales, Dolphins and Porpoises)," *11 Essays on Whales and Man,* second edition, 26 September, 1994, High North Publications
129, Rachel Smolker
131-133 (all), David Doubilet
134-135, Carlos H. Barbosa
137, MacGillivray Freeman Films
138-139, David Doubilet
140-141, Keith Kasnot
141, James D. Watt/Innerspace Visions
142-143, David Doubilet

Chapter Three: Predators, Prey, and Preservation
144-145, MacGillivray Freeman Films
147, Bill Curtsinger
148-149, MacGillivray Freeman Films
150-151, Grace Niska Atkins
152, MacGillivray Freeman Films
153, Grace Niska Atkins
155, Bill Curtsinger
155-157, MacGillivray Freeman Films
158-159, Bill Curtsinger
161, Grace Niska Atkins
162-163, Bill Curtsinger
165, Keith Kasnot
166, Grace Niska Atkins
167, Jeffrey Girard
168-169 (both), MacGillivray Freeman Films
170-171, Pete Frieden/*Surfing Magazine*
173, Michael S. Nolan/Innerspace Visions
174-175, Phillip Colla/ Innerspace Visions
176, Norbert Wu/www.norbertwu.com
177, Doug Perrine/Innerspace Visions
178-179, James D. Watt/Innerspace Visions
180-181, Grace Niska Atkins
182, Des & Jen Bartlett
183, Michael S. Nolan/Innerspace Visions
184, Grace Niska Atkins
185, MacGillivray Freeman Films
186, Grace Niska Atkins
187, Robert Pitman/Innerspace Visions
188-190 (both), MacGillivray Freeman Films
191 (upper left), Grace Niska Atkins
191 (upper right), Alejandro Acevedo-Gutiérrez
191 (lower), Grace Niska Atkins
192, Jeffrey Girard
196, Flip Nicklin
197, MacGillivray Freeman Films
198, Grace Niska Atkins
201, Stephen Dawson
203, Grace Niska Atkins

Afterword
206-207, Pieter Arend Folkens/A Higher Porpoise Design Group

Dolphins
Tim Cahill

Published by the National Geographic Society

John M. Fahey, Jr., *President and Chief Executive Officer*

Gilbert M. Grosvenor, *Chairman of the Board*

Nina D. Hoffman, *Senior Vice President*

Prepared by the Book Division

William R. Gray, *Vice President and Director*

Charles Kogod, *Assistant Director*

Barbara A. Payne, *Editorial Director and Managing Editor*

David Griffin, *Design Director*

Staff for This Book

Kevin Mulroy, *Project Editor*

Patrice Silverstein, *Text Editor*

Jeff Girard, *Art Director*

Bernd Würsig, *Science Editor*

Melissa G. Ryan, *Illustrations Editor*

Johnna M. Rizzo, *Assistant Editor*

Carl Mehler, *Director of Maps*

Michelle H. Picard, *Map Production*

R. Gary Colbert, *Production Director*

Lewis R. Bassford, *Production Project Manager*

Ashley Taylor, George Pryor, *Production Assistants*

Gillian Carol Dean, *Design Assistant*

Meredith C. Wilcox, *Illustrations Assistant*

Peggy J. Candore, *Assistant to the Director*

Anne Marie Houppert, *Indexer*

Manufacturing and Quality Control

George V. White, *Director*

John T. Dunn, *Associate Director*

Vincent P. Ryan, *Manager*

Phillip L. Schlosser, *Financial Analyst*

MacGillivray Freeman's *Dolphins*

An IMAX Theater film

Produced by MacGillivray Freeman Films, *Laguna Beach, California*

Produced in association with the National Wildlife Federation

Major funding provided by the National Science Foundation and the Museum Film Network

Production Team

Greg MacGillivray, *Director and Producer*

Steve Judson, *Co-Writer and Editor*

Alec Lorimore, *Producer*

Christopher N. Palmer, *Executive Producer*

Brad Ohlund, *Director of Photography*

Bob Talbot, *Underwater Sequence Director and Cinematographer, Bahamas Unit*

Paul Atkins, *Underwater Sequence Director and Cinematographer, Argentina Unit*

Teresa Ferreira, *Production Manager*

Debbie Fogel, *Production Controller*

Book Production

Lori Rick, *Project Manager*

Matthew Muller, *Image Reproduction Supervisor*

Film Production/Distribution Team

Janna Emmel, Bill Bennett, Bob Harman, Mike Lutz, Myles Connolly, Robert Walker, Chris Blum, Alice Casbara, Mike Kirsch, Denise Robinson, Kaeran Sudmalis, Ken Richards, Eric Anderson

Advisors to the Film

Bernd Würsig, Ph.D.

Kathleen Dudzinski, Ph.D.

Alejandro Acevedo-Gutiérrez, Ph.D.

Randall Wells, Ph.D.

Peter Tyack, Ph.D.

Louis Herman, Ph.D.

Whitlow Au, Ph.D.

Mote Marine Laboratory

The world's largest nonprofit scientific and educational organization, the National Geographic Society was founded in 1888 "for the increase and diffusion of geographic knowledge." Since then it has supported scientific exploration and spread information to its more than nine million members worldwide.

The National Geographic Society educates and inspires millions every day through magazines, books, television programs, videos, maps and atlases, research grants, the National Geography Bee, teacher workshops, and innovative classroom materials.

The Society is supported through membership dues and income from the sale of its educational products. Members receive NATIONAL GEOGRAPHIC magazine—the Society's official journal—discounts on Society products, and other benefits.

For more information about the National Geographic Society and its educational programs and publications, please call 1-800-NGS-LINE (647-5463), or write to the following address:

National Geographic Society
1145 17th Street N.W.
Washington, D.C. 20036-4688 U.S.A.

Visit the Society's Web site at www.nationalgeographic.com.

Library of Congress Cataloging-in-Publication Data
Cahill, Tim.
 Dolphins / Tim Cahill.
 p. cm.
 ISBN 0-7922-7594-2
 1. Dolphins. 2. Dolphins—Research. I. Title.

QL737.C432 C25 2000
599.53—dc21

99-086772